FORUM
ANGEWANDTE LINGUISTIK
F.A.L. BAND 70

Hrsg. von der Gesellschaft für Angewandte Linguistik

Die in dieser Reihe erscheinenden Arbeiten werden vor der Publikation durch die F.A.L.-Redaktion geprüft sowie einem Double-Blind-Peer-Review-Verfahren durch mehrere Gutachter/innen unterzogen.

The quality of the work published in this series is assured both by the editorial staff of the F.A.L. and by a double-blind peer review process by several external referees.

Gesellschaft für Angewandte Linguistik e.V.

Gesellschaft für
Angewandte Linguistik e.V.

FORUM

ANGEWANDTE LINGUISTIK

F.A.L. BAND 70

Roman Lietz / Milene Mendes de Oliveira /
Luisa Conti / Fergal Lenehan (Hrsg./eds.)

Sprache und Interkulturalität in der digitalen Welt / Language and Interculturality in the Digital World

PETER LANG

Lausanne · Berlin · Bruxelles · Chennai · New York · Oxford

Bibliografische Information der Deutschen Nationalbibliothek
Die Deutsche Nationalbibliothek verzeichnet diese Publikation in
der Deutschen Nationalbibliografie; detaillierte bibliografische
Daten sind im Internet über http://dnb.d-nb.de abrufbar.

Bundesministerium
für Bildung
und Forschung

Gefördert vom Bundesministerium für Bildung und Forschung
Dieser Band wurde im Rahmen des Verbundprojekts ReDICo
(Researching Digital Interculturality Co-operatively, www.redico.eu) erstellt.

Umschlaggestaltung: © Olaf Gloeckler, Atelier Platen, Friedberg

ISSN 0937-406X
ISBN: 978-3-631-88131-6 (Print)
ISBN: 978-3-631-88132-3 (Ebook)
ISBN: 978-3-631-88133-0 (EPub)
DOI: 10.3726/b21349

PETER LANG

2024 Peter Lang Group AG, Lausanne

Verlegt durch Peter Lang GmbH, Berlin, Deutschland

info@peterlang.com http://www.peterlang.com

Diese Publikation wurde begutachtet.

Gesellschaft für Angewandte Linguistik e.V.

Die Reihe *Forum Angewandte Linguistik (F.A.L.)*, herausgegeben von der Gesellschaft für Angewandte Linguistik (GAL) e.V., vereint Monografien und Sammelbände zu allen aktuellen Themen der Angewandten Linguistik. Angewandte Linguistik wird hierbei verstanden als wissenschaftliches Betätigungsfeld, das sich in Forschung, Lehre und Weiterbildung mit der Analyse und Lösung von sprach- und kommunikationsbezogenen Problemen auf allen Gebieten menschlicher und gesellschaftlicher Interaktion befasst. Diese Zielsetzung erfordert oftmals eine interdisziplinäre Arbeitsweise sowie eine Vermittlung zwischen Theorie und Praxis. Die Reihe will den Dialog über die Grenzen traditioneller Sprachwissenschaft hinweg und zwischen den verschiedenen Arbeitsfeldern der Angewandten Linguistik fördern. Zu diesen Arbeitsfeldern gehören der Muttersprachen- und Fremdsprachenunterricht ebenso wie die Herausforderungen, die beispielsweise migrationsinduzierte Mehrsprachigkeit und interkulturelle Kommunikation mit sich bringen, Fachkommunikations- und Verständlichkeitsforschung, Gesprächsforschung, Lexikographie, die Kommunikation in und mit neuen Medien sowie die Phonetik und Sprechwissenschaft, um nur einige Beispiele zu nennen.

Die GAL als Herausgeberin der Reihe verfolgt das Ziel, die wissenschaftliche Entwicklung in allen Bereichen der Angewandten Linguistik zu fördern und zu koordinieren, den Austausch wissenschaftlicher Erkenntnisse zu beleben und ihren Transfer in die Praxis zu sichern sowie die Zusammenarbeit der hieran interessierten Personen und Institutionen national und international zu intensivieren. Hierzu gehört auch der Kontakt mit Wirtschaft und Industrie, Behörden, Bildungseinrichtungen sowie Institutionen des öffentlichen Lebens.

Die GAL ist Mitglied der *Association Internationale de Linguistique Appliquée* (AILA), des internationalen Dachverbands der Gesellschaften für Angewandte Linguistik.

Kontaktdaten der GAL: http://www.gal-ev.de/

Inhaltsverzeichnis

Milene Mendes de Oliveira / Roman Lietz

Einführung: Sprache und Interkulturalität in der digitalen Welt

1. Sprache, Interkulturalität und die Digitale Welt

Sprache und Kultur ist als Phrase (nicht nur) im akademischen Bereich weit verbreitet: Sie findet sich etwa in Buchtiteln oder in den Bezeichnungen von Sprachinstituten an Hochschulen auf der ganzen Welt. Dabei kann die Konjunktion *und* entweder auf die Vermischung der Begriffe hinweisen, wobei *Sprache und Kultur* in diesem Fall eine wechselseitige Wirkung aufeinander haben, oder sie weist auf die Unterscheidbarkeit der beiden Begriffe hin, das heißt auf ihre Existenz als zwei unabhängige Konstrukte, deren Merkmale zwar getrennt sind und bleiben, die aber Berührungspunkte haben können. Wir sind überzeugt, dass die Verortung der beiden Begriffe auf unterschiedlichen Seiten dazu führt, dass Gemeinsamkeiten und mögliche Synergien ungerechtfertigterweise vernachlässigt werden, und betrachten daher das *und* als eine verbindende Konjunktion.

Auch wenn die Überlegungen zum Einfluss von Sprache auf Kultur schon Jahrhunderte zurückreichen, hat sich Busch (2022) zufolge die Sprachwissenschaft eine gewisse Distanz zu Diskussionen über Kultur bewahrt. Den großen Fragen der Kultur hat sie sich erst genähert, nachdem sich andere Geisteswissenschaften dem Cultural Turn längst verschrieben hatten. Besonders angeregt durch Dell Hymes, John Gumperz und andere öffnete sich die Linguistik der Erforschung von Sprachgebrauch in Zusammenhang mit Kultur.[1] Deren Studien bildeten einen Rahmen, in dem Kultur als etwas, das Menschen *tun*, und nicht unbedingt als etwas, das Menschen *haben*, analysiert wurde. Mittlerweile wird diese soziolinguistische Denkschule stärker in der linguistischen Ethnografie vertreten (Rampton, 2022; Copland/Creese 2015), wenngleich sie noch

[1] Für einen Überblick über Gumperz' Werk siehe Mendes de Oliveira (2023).

immer Distanz zur traditionellen Linguistik hält, die sich weiterhin auf die Beschreibung von Sprache konzentriert (Busch 2022).

Im digitalen Zeitalter, das durch die schnelle Verbreitung und Verarbeitung von Informationen (z. B. durch Nachrichtenportale, Messenger-Dienste, Social Media) sowie von Superdiversität (Vertovec 2007; Blommaert/Rampton 2011) gekennzeichnet ist, sind die Verbindungen von *Sprache* und *Kultur* jedoch zu offensichtlich, um ignoriert werden zu können. Im vorliegenden Band finden wir dazu Beispiele, die sich etwa mit der Aushandlung der Bedeutungen von *Sprache und Kultur* auf Twitter, in YouTube-Videos und ihren Kommentarsektionen, in Foren und in Kundenbewertungsportalen befassen. Darüber hinaus müssen wir jedoch im Blick behalten, dass die Phrase *Sprache und Kultur* auch in essentialistischen Strömungen ihre Attraktivität genießt, die nicht selten neue Rechte Ideologien nähren, zum Beispiel jene, die Linguistik mit vermeintlicher sprachlicher Reinheit verknüpfen möchten (Horner/Weber 2014; siehe auch Contis Beitrag in dieser Ausgabe).

In diesem Band haben wir uns entschieden, Abstand von *Sprache und Kultur* als Referenz zu nehmen und wollen stattdessen von *Sprache und Interkulturalität* sprechen. Interkulturalität wird vom deutschen Kultur- und Kommunikationswissenschaftler Jürgen Bolten (2015: 118) als „unvertraute Vielfalt" beschrieben und bezieht sich auf Situationen, in denen sich Individuen in mehrdeutigen und unvorhersehbaren Situationen wiederfinden, die sie nicht ohne Weiteres durchschauen oder einordnen können und die jenseits ihrer „Normalitätserwartung" liegen. Diese terminologische Annäherung ist insofern hilfreich, als sie es ermöglicht, Kultur losgelöst von Nation (und den damit verbundenen Stereotypen) zu sehen, und stattdessen auch detaillierter die Herausforderungen für individuelle Begegnung in einem neuen Handlungsfeld in den Blick nimmt. Das kann ein neues Heimatland sein, aber auch ein neuer Verein, eine neue Arbeitsstelle oder eine neue Online-Community. Auch international wird dieser Diskurs von unterschiedlichen Wissenschaftsgemeinschaften aufgegriffen, etwa durch MacDonald und Laadegard (2022) in ihrer Sonderausgabe des Journals Language and Intercultural Communication.

Unsere Präferenz für den Begriff Interkulturalität ist auch durch die unterschiedlichen Kulturbegriffe begründet, die sich von struktur- zu

prozessorientierten Perspektiven (Bolten 2007) erstrecken.[2] Heterogen ist in diesem Sinne auch der jeweilige Kulturbegriff in den einzelnen Beiträgen in diesem Band. Bei einigen Autor*innen ist diese Vielfalt an Kultur- und Interkulturalitätskonzepten und die Selbstzuschreibung der Akteur*innen gar der Anlass für die durchgeführten Untersuchungen (siehe die Beiträge von Kreß und Barbosa in diesem Band).

Mit der Beziehung zwischen *Sprache und Interkulturalität* im Hinterkopf wollen wir uns nun der Frage widmen, wie *das Digitale* hier hineinspielt und das Thema in ein Praxisfeld *Digitaler Interkulturalität* verwandelt. Dass durch das Internet Nutzer*innen weitreichende Möglichkeiten zur aktiven Teilhabe an öffentlichen Diskursen bekommen haben und relativ barrierefrei eigenen Content erstellen können, ist mittlerweile kein Geheimnis mehr. Aus Konsument*innen (Engl. *users*) wurden Prosument*innen (Engl. *produsers*) (Bruns 2008).[3] Dieser Paradigmenwechsel eröffnet einen Raum, in dem die eigene Position sichtbar gemacht wird, sei es als Ausdruck politischer Teilhabe (siehe Lenehan in diesem Band), sei es im Verteidigen des Stakes in internationalen Kollaborationen (siehe Mendes de Oliveira/Conti), in Peer-Feedback in dezentralen pädagogischen Konzepten (siehe Schluer/Liu) oder durch Online-Bewertungen von Dienstleistungen (siehe Schröder).

2 Bolten (2020: 94) plädiert für die Verwendung des Begriffs „Interkulturalität" in Anerkennung der Vielschichtigkeit des Begriffs, anstatt ihn durch „Transkulturalität" (Welsch, 1999) zu ersetzen. Er argumentiert, dass die Berücksichtigung verschiedener Perspektiven bei der Betrachtung von Kultur notwendig ist „(v)or dem aktuellen Hintergrund wiedererstarkender nationaler Abgrenzungsstrategien, rechter und rechtspopulistischer Konfrontationsstrategien, die letztlich Reaktionen auf als zu schnell empfundene Veränderungsdynamiken und die damit einhergehenden Unsicherheiten darstellen (wie u. a. die Flüchtlingsströme in Richtung Europa)."

3 Selbstverständlich muss hier darauf hingewiesen werden, dass – entgegen frühen Hoffnungen – das Internet nicht nur ein demokratieförderndes Medium ist, sondern auch ein Instrument der Überwachung und Kontrolle sein kann; namentlich sogar durch die Plattformen selbst (wie Twitter und TikTok). Diesbezüglich merken Fish et al. (2011: 157, zitiert in Friese 2020) an, dass man heute „nicht einmal mehr klar benennen kann, was Teilhabe am Internet überhaupt ist: Konsum, Kollaboration, Wahlen, Protest, Zugehörigkeit, Freundschaft, Instrumentalisierung, Liken, Lobbyismus, Ehrenamt, Arbeit, Freizeit oder Sucht?" (eigene Übersetzung).

Die Teilhabemöglichkeiten selbst werden operativ durch die Funktionen der Plattformen und Online-Tools bereitgestellt. Diese Funktionen, auch „affordances" (Gibson 1986) genannt, sind „spezifische von den digitalen Medien erschaffene Möglichkeiten, um Handlungen zu erlauben." (Jones/Chik/Hafner, 2015: 10; eigene Übersetzung). Dazu gehören der Like-Button und die Retweet-Funktion (Twitter) ebenso wie Kommentarsektionen oder Übersetzungs-Apps, die über jedes Smartphone bedient werden können (siehe Meyer/Kolloch in diesem Band). Jones/Chik/Hafner weisen jedoch zurecht auf die nichtdeterministische Nutzung dieser Funktionen hin: De facto können Nutzer*innen die Technologien auch ganz anders als von den Entwickler*innen intendiert verwenden.

Das Verhältnis zwischen Nutzer*innen und Online-Funktion wird auch als *Cultures of Use* bezeichnet. Dabei darf nicht vergessen werden, dass Technologien für verschiedene Gemeinschaften voneinander abweichende Bedeutungen, Anwendungen und Wertigkeiten haben können und auch die Handlungsfähigkeit der Akteure in der Technologie-Nutzer-Relation eine wichtige Rolle spielt. (Thorne, 2016). Vor allem darf man nicht vergessen, dass nicht die Technologien für eine Varianz sorgen, sondern die menschlichen Akteur*innen, die die nahezu unendlichen Möglichkeiten nutzen, medialen Content zu erstellen (Videos, Bilder, Texte,…), um – oft auch gemeinschaftlich – fluide Identitäten online zum Ausdruck zu bringen (Androutsopoulos 2016; siehe Lietz in diesem Band).

In diesem Band untersuchen wir das Zusammenwirken von Sprache, Interkulturalität und Digitalität und verknüpfen es durch die Vorstellung einer *Digitalen Interkulturalität*. Diese haben wir[4] kürzlich als „komplexes Zusammenspiel des Digitalen mit dem Interkulturellen" sowie als eine spezielle „Hyper-Interkulturalität der digitalen Welt mit einer unendlichen Zahl von neuen und diversen Verbindungen" (Lenehan, 2022: 6, eigene Übersetzung) charakterisiert, wobei selbstverständlich eine tiefere Theoretisierung noch aussteht. Unser Vorhaben wird auch von den Internet Studies beeinflusst, einem recht neuen und höchst interdisziplinären Feld, welches sich aus verschiedenen Perspektiven den sozialen und

4 Das Team des wissenschaftlichen, vom BMBF (2020 – 2024) geförderten Projekts ReDICo (Researching Digital Interculturality Co-operatively): Luisa Conti, Fergal Lenehan, Roman Lietz, Milene Mendes de Oliveira.

kulturellen Implikationen der Internetnutzung widmet (Dutton 2013: 1). Konkret betrachten die Internet Studies schwerpunktmäßig drei Felder: (a) Technologie (*technology*), (b) Recht (*policy and law*) und – für (Sozio-) Linguist*innen sicherlich am interessantesten – (c) Nutzung (*uses*) (Dutton 2013: 2). Natürlich werden in diesem Band auch Aspekte von Technologie und Recht gestreift, doch der Fokus liegt naturgemäß auf *use*. Wir wollen dabei über die reine Praxis hinausblicken und Praxis eher im Bourdieu'schen Sinne als „eine Handlung mit einer Geschichte" (*an action with a history*, Scollon/Saint-Georges 2012, eigene Übersetzung) begreifen, schließlich sind wir davon überzeugt, dass Handlungen immer in soziokulturelle Bedeutungen eingebettet sind und ohne diese nicht verstanden werden können. Daher widmen wir uns hier – angelehnt an Dutton (2013: 3) der zentralen Frage: Wer verhält sich in der digitalen Interkulturalität, auf welche Weise und mit welchen Resultaten?[5]

Stellvertretend für diese Handlungen stehen oft vielfältige und fluide Formen von manchmal überraschenden „Texten", zu denen auch mündliche Diskussionen, Videos oder auf engstem Raum gebündelte Informationen in Tweets oder Emojis gehören. Auch wenn die Erforschung dieser Art von variantenreichen Texten quantitativ, also schematisch und in großen Datenmengen, erfolgen kann, gibt es – so Bakardijewa (2011: 61) – durchaus ein großes Interesse, die Diskurse in und um Online-Erzeugnisse(n) interpretativ und kritisch, also qualitativ, zu analysieren. Dieser interpretative, kritische, qualitative Ansatz steht im methodologischen Zentrum der folgenden Beiträge, die in ihrem Zusammenspiel eine große Vielfalt abbilden und uns dabei unterstützen und motivieren, das Verständnis von digitaler Interkulturalität zu schärfen.[6]

5 Dutton (2013:3) fragt: „Wer nutzt das Internet auf welche Weise." (eigene Übersetzung).

6 Eine zentrale Frage, der sich unsere Forschungsgruppe widmet, ist, inwiefern die Logiken des Digitalen die tradierten Vorstellungen von Interkulturalität verändern. Mit daran anknüpfenden Fragen setzen sich auch Forscher*innen in anderen Feldern, wie der digitalen Diskursanalyse (Jones/Chik/Hafner 2015) oder digitalen Pragmatik (Meier-Vieracker et al. 2023), auseinander.

2. Die Beiträge in diesem Band

Dieser Band basiert auf der Zusammenstellung und Erweiterung von Beiträgen, die im September 2021 auf der jährlichen Konferenz der Gesellschaft für Angewandte Linguistik (GAL) in der Sektion *Interkulturelle Kommunikation* (Sektionsvorsitz: Bernd Meyer und Beatrix Kreß) vorgetragen wurden. Wir setzen mit diesem Band einen Diskurs fort, den wir als ReDICo-Team in einer Sonderausgabe des Interculture Journal (Lenehan et al. 2022) begonnen haben und mit dem wir dem Begriff der *Digitalen Interkulturalität* weitere Substanz geben wollen, indem wir Fallstudien digitaler Praktiken mit einem Schwerpunkt auf Sprache zusammentragen. Diese Fallstudien behandeln unterschiedliche Aspekte von Online-Kommunikation, so zum Beispiel Feedback und Positioning. Ergänzt werden sie durch anthropologische und soziokulturelle Kontextualisierungen zu Aspekten wie Identität(en), Zugehörigkeit und Kultur der Digitalität (*culture of digitality*, Stalder 2019). Wir sind davon überzeugt, dass digitale Interkulturalität nur interdisziplinär erforscht werden kann. Daher vereint dieser Band unterschiedliche Perspektiven aus den Sprachwissenschaften und den Interkulturellen Studien. Er betrachtet Sprachgebrauch, Sprachakteur*innen und digitale Funktionen, die erst durch ihr Zusammenwirken interkulturelle digitale Praktiken hervorbringen.

Das erste Kapitel, **Aushandlung von Interkulturalität in der Online-Welt**, umfasst drei Beiträge, die aufzeigen, wie Akteur*innen in Situationen mit großer Komplexität miteinander diskutieren und (digital interkulturelle) Praktiken aushandeln. **Milene Mendes de Oliveira und Luisa Conti** berichten von einem Hochschulsetting, bei dem Student*innen in einem interkulturellen Online-Spiel über Zoom miteinander interagieren. Die Autorinnen zeigen, mit welchen interaktionalen Handlungen Spielrollen ausgehandelt werden. Im Detail werden kommunikative und interaktionale Handlungen analysiert, in denen Spieler*innen eine Rolle für sich oder ein*e Kolleg*in beanspruchen und damit eine Gruppeninklusion anstreben oder (unbeabsichtigt) die Exklusion anderer bewirken.

Beatrix Kreß präsentiert eine Untersuchung aus dem Bereich der linguistischen und der funktionalen Pragmatik. Im Zentrum stehen zwei englischsprachige Expatriates in Deutschland, die mittels ihrer YouTube-Kanäle Beobachtungen, Emotionen und soziale Erfahrungen aus ihrem

Leben teilen. Es wird herausgearbeitet, dass die Vloggerinnen kulturelle Unterschiede unter anderem durch verbale, para-verbale und non-verbale Mittel hervorheben und somit einerseits Kulturkontraste hervorheben und andererseits sich selbst als Expertinnen für den Umgang mit diesen Kontrasten positionieren. Die Autorin schlussfolgert, dass die Konstruktion von kulturellem Kontrast erst die Grundlage für den webproduzierten Content der Vloggerinnen bietet.

Adriana Barbosa Fernandes widmet sich ebenfalls der Video-Plattform YouTube und betrachtet die Kommentarsektionen von Videos auf dem Kanal des Goethe-Instituts, in denen Interkulturalität aufgegriffen wird. Die Videos drehen sich inhaltlich um regionale Besonderheiten oder Fragen des Alltags. Die Autorin untersucht, wie YouTube-Nutzer*innen durch ihre Kommentare (soziale) Identität konstruieren und sich in einen Bezug zum Inhalt der Videos setzen, vor allem auch als Reaktion auf Äußerungen anderer Nutzer*innen. Dabei werden die für Online-Kommentarsektionen üblichen Reziprozitätshandlungen und diskursiven Dynamiken bei der Positionierung und beim Beanspruchen von Expertenwissen sichtbar gemacht.

Das zweite Kapitel, **Digitale Interkulturalität in Institutionellen Kontexten**, beinhaltet drei Beiträge, die die digitale Interkulturalität in den Settings gesteuerter Spracherwerb, Hotelier-Gäste-Kommunikation und Polizei-Ausbildung betrachten. Die Untersuchung von **Jennifer Schluer und Yarong Liu** diskutiert aus einer kritischen Perspektive die Handhabung von Peer-Feedback in gesteuerten Lernumgebungen. Die Autorinnen präsentieren ein dynamisches Modell zu Peer-Feedback in interkultureller Online-Kommunikation. Das Modell berücksichtigt individuelle und kontextuelle Faktoren und soll eine Unterstützung für Englischlehrer*innen darstellen, die Peer-Feedback als ein Mittel einsetzen möchten, welches nicht nur Lernerfolge steigert, sondern in Lernenden auch ein kritisches Bewusstsein für interkulturelle Online-Kommunikation weckt.

Tilman Schröder legt eine Studie über Online-Bewertungen von Hotels auf den Plattformen Holidaycheck und Tripadvisor vor. Konkret geht es darum, wie Kund*innen negative Kritiken äußern und wie die Hoteliers auf diese reagieren. In den untersuchten Interaktionssituationen nehmen die Feedbackgeber*innen und -empfänger*innen unterschiedliche Positionen ein, kommen aus unterschiedlichen Ländern und sprechen

verschiedene Erstsprachen. Die Studie zeigt nicht nur unterschiedliche Sprachhandlungen (Engl. *moves*), die von den Hoteliers angesichts kulturell beeinflusster Beschwerden vollzogen werden, sondern bietet auch eine weitere Reflexion über Ethnozentrismus und Stereotypisierungen in Kundenbeziehungen in digital-interkulturellen Settings.

Bernd Meyer und Annalena Kollochs Beitrag beleuchtet eine Institution, die in der Vergangenheit nur selten einen Feldzugang gewährt hat: Die Polizei. Die Autor*innen nutzten für ihre Studie die Gelegenheit, zur Ausarbeitung eines Moduls im Rahmen der Polizeiausbildung eingeladen worden zu sein. Sie untersuchen wie Polizeianwärter*innen angesichts (inszenierter) unerwarteter, mehrsprachiger Situationen reagieren. Unter anderem beobachten sie, welche unterschiedlichen Formen der Sprachmittlung zum Einsatz kommen oder ignoriert werden. Sie stellen fest, dass, ungeachtet der spezifischen Maßnahmen zur Überwindung von Sprachbarrieren, vor allem inklusive Kommunikationsstrategien in interkulturellen Interaktionen erfolgversprechend sind, so zum Beispiel die Verwendung einer Lingua franca oder der Einsatz von digitalen Hilfsmitteln (Übersetzungs-Apps).

Das dritte Kapitel, **(Sozio-)Kulturelle Reflexionen und Fallstudien zu Digitaler Interkulturalität,** widmet sich mit Sprache verbundenen aber primär psychologischen, gesellschaftlichen bzw. politischen Implikationen, die aus interkulturellen Online-Phänomenen entstehen. **Roman Lietz'** Beitrag reflektiert, wie sich der Identitätsbegriff ideengeschichtlich entwickelt hat und wie er sich – ebenso wie Aspekte der sozialen Kohäsion – auf die komplexe und mehrdeutige Online-Welt anwenden lässt. Die theoretische Diskussion wird durch zahlreiche illustrative Beispiele von narrativen Prozessen und Positioning aus verschiedenen Online-Plattformen untermalt und kulminiert in einer Fallstudie über eine YouTube-Kommentarsektion, in der (vermutlich) in Deutschland lebende türkische und griechische Fußballfans soziale Kohäsion auf narrative und reziproke Weise erzeugen.

Fergal Lenehan widmet sich dem Hashtag #DenkEuropaMit, der 2021 vom Twitter-Account @PulseOfEurope ins Leben gerufen wurde, um die Bundestagswahl zu europäisieren, also auf die Notwendigkeit, europäische Themen im Wahlkampf aufzugreifen, hinzuweisen. Unter anderem charakterisiert der Autor in Anlehnung an Stalders „Culture of Digitality" Re-Tweets und Social-TV-Praktiken, bei denen zum Beispiel Prominente

aus Medien und Politik getagged wurden, als Referenzialität. Er erkennt eine Form des digitalen Aktivismus, mit der Absicht einer politischen Einflussnahme. Lenehan sieht hier ein von ihm als „digitaler Europäismus" bezeichnetes Phänomen, bei dem digitale Praktiken mit traditionellen Ideen über Europa zusammengeführt werden.

Luisa Conti bereichert den Band mit einer Betrachtung des Heimat-Begriffs. *Heimat* ist dabei ein sensibles und kontroverses Konzept, das verwendet wird, um sich als Individuum in einer sozialen Umgebung zu verorten, das aber auch als Fremdzuschreibung Anwendung findet. Die Autorin untersucht die Bedeutung von *Heimat* angesichts der Digitalisierung des Alltags. Als Schlussfolgerung erarbeitet sie einen semantischen Vorschlag, der zeitgemäße postdigitale Erfahrungen von Heimat beschreibt. Das vorgeschlagene Modell von Heimat als Netzwerk verwirft ausgrenzende Diskurse und zeigt stattdessen die Bedeutung einer offenen Haltung für die Förderung des Gedeihens der individuellen Heimat und damit des sozialen Zusammenhalts der Gemeinschaft als Ganzes.

Die vorstehend skizzierten Beiträge in diesem Band reflektieren auf interdisziplinäre Weise verschiedene Perspektiven aus der angewandten Linguistik und den Interkulturellen Studien. Die Begegnung dieser beiden Felder ist selbstverständlich nicht die einzige mögliche interdisziplinäre Herangehensweise im Bereich der digitalen Interkulturalität: Mit unserem Projekt möchten wir eine Vielzahl von Wissenschaftler*innen (und auch Praktiker*innen) dazu einladen, sich mit ihren Perspektiven, Methoden und Ansätzen am Diskurs zu beteiligen. Großes Potential sehen wir zum Beispiel in einem Dialog mit und zwischen Pädagog*innen, Sprachtrainer*innen, Medienwissenschaftler*innen und Vertreter*innen der Internet Studies. Ebenso sind wir davon überzeugt, dass die unterschiedlichen Methoden aller Felder, wie Diskursanalyse, digitale Ethnographie, digitale Hermeneutik und viele mehr, dazu beitragen, ein größeres Verständnis von digitalen interkulturellen Praktiken zu erlangen.

Unser letzter Hinweis betrifft die Entscheidung zugunsten einer bilingualen anstatt einer monolingualen Ausgabe: Sowohl im Rahmen der zugrunde liegenden GAL-Konferenz als auch bei der Erstellung dieser Ausgabe des Forums Angewandte Linguistik haben wir die bewusste Entscheidung getroffen, den Beitragenden die Verwendung der von ihnen präferierten Sprache zu ermöglichen. Damit wollen wir Mehrsprachigkeit

auch in der akademischen Welt fördern. In Anlehnung an die Diskurse um multilinguale Praktiken (z. B. Horner/Weber 2014) müssen wir anerkennen, dass die Wahl der Sprache – sowohl bei der Ausarbeitung wissenschaftlicher Erkenntnisse als auch im täglichen Umgang mit Freund*innen oder Kolleg*innen – häufig von unzähligen sozialen Aspekten bis hin zu Sprachideologien beeinflusst wird.[7] Durch unser Angebot, Beiträge auf Deutsch oder Englisch einzureichen, möchten wir Autor*innen, aber auch Leser*innen, eine bessere Möglichkeit geben, sich am Diskurs über *Sprache und Interkulturalität in der Digitalen Welt* zu beteiligen.

Bibliografie

Androutsopoulos, Jannis K., 2016: „Digitale Medien: Ressourcen und Räume für interkulturelle Praktiken". *Networx* 74.

Bakardijewa, Maria, 2011: „The Internet in Everyday Life: Exploring the Tenets and Contributions of Diverse Approaches." In: Consalvo, Mia/Ess, Charles (Hrsg.) (2011): *The Handbook of Internet Studies*. Hoboken: Wiley-Blackwell, 59–82.

Blommaert, Jan/Rampton, Ben, 2011: „Language and Superdiversity". *Diversities* 13(2), 1–21.

Bolten, Jürgen, 2007: *Interkulturelle Kompetenz*. Thüringen: Landeszentrale für politische Bildung.

Bolten, Jürgen, 2015: *Einführung in die Interkulturelle Wirtschaftskommunikation*. Göttingen: V&R.

Bolten, Jürgen, 2020: „Interkulturalität neu denken: Strukturprozessuale Perspektiven". In: Giessen, Hans/Rink, Christian (Hrsg): Migration, Diversität und kulturelle Identitäten, Berlin: Metzler, 85–104.

Busch, Dominic, 2022: „Soziales und Kulturelles in der Sprache". In: Földes, Csaba/Roelcke, Thorsten (Hrsg.): *Handbuch Mehrsprachigkeit*, Berlin: De Gruyter, 83–104.

Copland, Fiona/Creese, Angela, 2015: *Linguistic Ethnography: Collecting, Analysing And Presenting Data*. London: Sage Publications.

7 Da Costa/Dyers/Mheta (2014) argumentieren, dass Sprachideologien mitunter die Funktion erfüllen, Machtasymmetrien intakt zu halten.

Da Costa, Dinis F./Dyers, Charlyn/Mheta, Gift, 2014: „Language Standardisation". In: Bock, Zannie/Mheta, Gift (Hrsg.): *Language, Society and Communication. An Introduction*, Pretoria: van Schaik, 333–346.

Dutton, William, 2013: „Internet Studies: The Foundations of a Transformative Field". In: Dutton, William (Hrsg.): *The Oxford Handbook of Internet Studies*. Oxford: University Press, 1–26.

Fish, Adam/Murillo, Luis F. R./Nguyen, Lilly/Panofsky, Aaron/Kelty, Christopher, 2011: „Birds of the Internet". *Journal of Cultural Economy* 4(2), 157–187. Retrieved 9.3.2023 from https://doi.org/10.1080/17530 350.2011.563069.

Friese, Heidrun, 2020: Einleitung. In: Friese, Heidrun/Nolden, Marcus/Rebane, Gala/Schreiter, Miriam (Hrsg.): *Handbuch Soziale Praktiken und Digitale Alltagswelten*, Wiesbaden: Springer VS, 1–18.

Gibson, James J., 1986: *The Ecological Approach to Visual Perception*. Abingdon: Routledge.

Horner, Kristine/Weber, Jean Jacques, 2014: Introducing Multilingualism: A Social Approach. Milton Park: Taylor & Francis.

Lenehan, Fergal, 2022: „Vorwort/Editorial". *Interculture Journal* 31/26, 5–9.

Lenehan, Fergal/Conti, Luisa/Lietz, Roman/Mendes de Oliveira, Milene (Hrsg.), 2022: *Cyber-Utopia/Dystopia? Digital Interculturality between Cosmopolitanism and Authoritarian Currents. Interculture Journal* 31/26.

Jones, Rodney/Chik, Alice/Hafner, Christoph, 2015: *Discourse and Digital Practices: Doing Discourse Analysis in the Digital Age*. Milton Park: Taylor & Francis.

MacDonald, Malcom N./Ladegaard, Hans J. (Hrsg.), 2022: *Twentieth Anniversary Special Issue: Issues, Controversies and Difficult Questions. Language and Intercultural Communication* 22/3.

Meier-Vieracker, Simon/Bülow, Lars/Marx, Konstanze/Mroczynski, Robert, 2023: „Digitale Pragmatik. Einleitung". In: Meier-Vieracker, Simon/Bülow, Lars/Marx, Konstanze/Mroczynski, Robert (Hrsg.): *Digitale Pragmatik*. Berlin: Springer, 1–12.

Mendes de Oliveira, Milene, (in Druck): „John Grumperz' 1982 Discourse Strategies". *Interculture Journal* 22/38, 12–15.

Rampton, Ben, 2022: *Encounters: Vol. 21. Linguistic Practice in Changing Conditions.* Multilingual Matters, retrieved 9.3.2023, from https://doi.org/10.21832/9781800410008.

Scollon, Suzie W./de Saint-Georges, Ingrid, 2012: „Mediated Discourse Analysis". In M. Handford, Michael/Gee, James Paul (Hrsg..): *The Routledge Handbook of Discourse Analysis* (pp. 66–78). Milton Park: Routledge.

Stalder, Felix, 2019: *Kultur der Digitalität.* Berlin: Suhrkamp.

Thorne, Steven L., 2016: Cultures-of-use and Morphologies of Communicative Action. *Language Learning & Technology*, 20, 185–191.

Vertovec, Steven, 2007: „Super-Diversity and its Implications". *Ethnic and Racial Studies*, 30(6), 1024–1054.

Welsch, Wolfgang, 1999: „Transculturality: The Puzzling Form of Cultures Today". *Spaces of Culture: City, Nation, World*, 13(7), 194–213.

Milene Mendes de Oliveira / Roman Lietz

Introduction: Language and Interculturality in the Digital World

1. Language, Interculturality, and the Digital World

The phrase *language and culture* is widely used in academia: it can be found in book titles and names of language departments in higher-education institutions across the globe. The conjunction *and* in the phrase may suggest either the blending of the notions, assuming their dependency on one another, or the distinctiveness of both concepts, i.e., their existence as two independent constructs whose features are and remain separate but may become intertwined. However, we maintain that placing these two notions on different sides leads to a neglect of the commonalities and possible points of synergy that they share.

While reflections upon the influence of language on culture date back hundreds of years, Busch (2022) argues that the discipline of linguistics has kept a certain distance from discussions surrounding culture, with linguistics only approaching these discussions after other fields in the humanities had already committed themselves to a cultural turn. It was, however, a branch of sociolinguistics, with Dell Hymes and John Gumperz as leading figures, which took a leading position in the exploration of the connection between language use and culture.[1] These studies established frameworks that enabled the analysis of culture as something people *do*, and not necessarily as something people *have*. This sociolinguistic school of thought is currently well-represented in linguistic ethnography (Rampton 2022; Copland/Creese 2015), though still separated from core linguistics, which remains focused on language description (Busch 2022).

In the digital age, characterized by the rapid spread of information through online communication streams (e.g., news portals, messaging services, and social media) and superdiversity (Vertovec 2007; Blommaert/Rampton 2011), the blending of *language* and *culture* has become too obvious to be

1 For a review of Gumperz's work, see Mendes de Oliveira (forthcoming).

ignored. Examples to be found in this volume deal with the negotiation of meaning around the notion of *language and culture* on Twitter, YouTube videos coupled with comment threads, and platforms with online customer reviews. Nevertheless, the label *language and culture* has been adopted/co-opted by movements with essentialist orientations that nurture right-wing ideologies, including those around linguistic and cultural purity (Horner/ Weber 2014; see Conti's article in this volume).[2]

In this volume, a decision was taken to avoid the reference to *language and culture* and use the phrase *language and interculturality* instead. Interculturality has been described, by the German scholar Jürgen Bolten (2015: 118), as "unfamiliar multiplicity", which refers to situations in which an individual finds herself immersed in ambiguity and unpredictability to the confrontation with a setting which cannot be easily made sense of as it is beyond her perception of "normality". This definition is useful as it allows for associations that reach far beyond the prototypical nation-based orientations and can also be used to describe an individual's commencement in new fields of action, be they a new country, a new club, a new job, or a new online platform/community. On an international level, this concept has also been discussed in several academic communities (see, for instance, the 2022 special issue of the journal *Language and Intercultural Communication*, edited by MacDonald and Laadegard). Our choice of *interculturality* is also informed by the multiple understandings of culture, ranging from structural to process-oriented perspectives (Bolten 2007),[3] represented in this volume. Some chapters even make the multiplicity of definitions of interculturality their object of study (see the chapters by Kreß and Barbosa in this volume).

2 See Wolf (2014) on the dangers of ignoring widespread conceptualizations of language and culture.

3 Bolten (2020: 8) argues in favor of the use of "interculturality" grounded in the recognition of the term's multifacetedness instead of replacing it with "transculturality" (Welsch 1999). He argues that the consideration of different perspectives in the study of culture is necessary "[a]gainst the current background of resurgent national demarcation strategies and right-wing populist confrontational strategies, which are ultimately reactions to the perception of rapidly changing dynamics and the associated uncertainty (such as the flow of refugees towards Europe)."

With the relationship between language and interculturality in mind, we can now turn ourselves to how *the digital* may come into play in practices of *digital interculturality*. As is now widely known, with the internet, consumers have gained a multiplicity of active participatory possibilities in public debates by producing their own content, which has marked their reframing from mere users of content controlled by the media industry to "produsers" (Bruns 2008).[4] This paradigm shift opens space for the 'raising of voices' in terms of political participation (see Lenehan's chapter in this volume), international collaboration (see Mendes de Oliveira/Conti in this volume), decentralized pedagogies (see Schluer/Liu in this volume), and online reviews of service encounters (see Schröder in this volume).

Of course, this participation is enabled by the features available on certain platforms and online tools. These features, often referred to as "affordances" (Gibson 1986), have been described as "particular ways digital media make certain kinds of actions possible" (Jones/Chik/Hafner, 2015, p. 10) such as the like button in different platforms, the (set-up of) the comment section of YouTube videos, the retweet function on Twitter or the translation function every smartphone carries (see Meyer/Kolloch in this volume). Jones/Chik/Hafner call attention, however, to the non-deterministic value of affordances and their relation not only to technology but also to the users of technology, which can be evidenced in the fact that users sometimes engage with technical functionalities in ways which had not been anticipated by developers. Closely related to the relationship between user and affordance is the notion of "cultures of use", a concept that refers to technologies assuming variable meanings, functions, and values for different communities, forming ecologies with agency distributed throughout the system (Thorne, 2016). Moreover, it is not only technologies that assume variable features; human actors engage in endless

4 Of course, it is also important to take into account that what was previously conceived as potentially democracy-fostering practices have turned out to be intertwined with another form of surveillance and control; namely by the platforms themselves, such as Twitter and TikTok. On this note, Fish et al. (2011: 157, cited in Friese 2020) state critically that "it's not even clear what to call participation today: consuming, collaborating, voting, protesting, belonging, friending, exploiting, liking, lobbying, volunteering, working, laboring, relaxing, or becoming addicted?"

possibilities to refer to media content (videos, pictures, text) to express and (co-)construct fluid identities online (Androutsopoulos 2016; see Lietz in this volume).

In this volume, we investigate the blending of language, interculturality, and digitality in connection with the concept of *digital interculturality*, which we[5] have previously defined as: "the complex merging of the digital and the intercultural" as well as "the hyper interculturality of the digital world with its potential for a myriad of new and diverse connections" (Lenehan, 2022: 6), though still recognizing that further theorization is necessary. Our endeavor here is partly inspired by and draws from internet studies, a young and highly interdisciplinary field, focusing on theory and research on various questions concerning social and cultural implications of internet use (Dutton 2013: 1). More precisely, internet studies comprise three fields of investigation: (a) "technology", (b) "policy" (and law), and, not least and for (socio-)linguists rather of major importance, (c) "uses" (Dutton 2013: 2). While matters of technology and policy are referred to, it is the focus on *use* that characterizes this volume. With *use* we look to go beyond the notion of action and to extend it to *practice*, with practice being understood, in line with Bourdieu, as an action with a history (Scollon/Saint-Georges 2012), i.e., an action embedded in sociocultural significance. Thus, leaning on Dutton (2013: 3), these questions are central in this volume: Who engages in practices of digital interculturality, in what ways, and with what implications?[6]

These practices often resort to a diverse and fluid variety of "texts" such as oral discourses, videos or highly condensed information units bundled in tweets or emojis. While the study of such a variety of texts in large datasets may be treated quantitatively, there is also a high demand for examining them interpretatively, qualitatively, and critically (Bakardijewa 2011: 61). This interpretative, qualitative, and critical treatment is reflected in the coming chapters which display the multifacetedness of digital

5 The scientific team of the project ReDICo (Researching Digital Interculturality Co-operatively), funded by the German Federal Ministry of Education and Research (2020 – 2024): Luisa Conti, Fergal Lenehan, Roman Lietz, Milene Mendes de Oliveira.

6 Dutton (2013:3) asked "who uses the Internet and in what ways?"

interculturality and motivate us to sharpen our understanding and defini-
tion of this phenomenon.[7]

2. The Volume and the Chapters

This edited volume is a collection of papers presented at the yearly confer-
ence of the German Applied Linguistics Association (GAL) in September
2021, organized by the ReDICo project[8] in collaboration with the chairs of
the section *Intercultural Communication*, Bernd Meyer and Beatrix Kreß.
In the volume, we build on the Special Issue of the *Interculture Journal*
(Lenehan et al., 2022), also edited by the ReDICo team and published in
2022, and look to further substantiate the notion of *digital intercultura-
lity* through empirical case studies on digital intercultural practices with a
focus on language. These case studies deal with various aspects of online
intercultural communication, from peer feedback to positioning in various
(virtual) contexts. They are complemented by anthropological and socio-
cultural contextualization centering on matters of identities, belonging,
and the culture of digitality (Stalder 2019). We make the case that the
study of digital interculturality necessitates an interdisciplinary approach.
For this reason, this volume brings together perspectives from applied lin-
guistics and intercultural studies in investigating the interplay of language
use, language users, and digital affordances inherent to digital intercultural
practices.

The first section, **Negotiating Interculturality in the Online World**,
comprises chapters that showcase how actors, in situations of great
complexity, discuss, negotiate, and (co-)construct practices of digital
interculturality. In the chapter by **Milene Mendes de Oliveira and Luisa
Conti**, the authors describe a study featuring higher-education students

7 A central question we pursue in our research group is the extent to which the
 digital setting changes the existing theories of interculturality (versions of this
 question are being addressed in other fields such as digital discourse analysis
 (Jones/Chik/Hafner 2015) and pragmatics (Meier-Vieracker et al., 2023)).

8 ReDICo: Researching Digital Interculturality Co-operatively is a four-year joint
 project funded by the Federal Ministry of Education and Research and run by
 researchers at the Friedrich-Schiller University of Jena, the Johannes Gutenberg-
 University of Mainz, and the University of Potsdam.

meeting online via Zoom to play an intercultural game. They show how players negotiate their roles in the group and which interactional practices they choose to support this negotiation. They also detail how players resort to claims of knowledge and entitlement as resources to aid their own or their colleagues' inclusion in the group. However, it is also demonstrated how this practice can lead to the (unintentional) exclusion of other players.

Beatrix Kreß presents an analysis of YouTube vlogs by expatriates based on analytical tools of linguistic and functional pragmatics. The focus is on two female anglophone YouTubers who find themselves in Germany as migrants and use their YouTube channels to share observations, display emotions, and report on social experiences. The vloggers are shown to stress cultural contrasts using verbal, para-verbal and non-verbal communication, thereby claiming difference and positioning themselves as experts in coping with these differences. The author concludes that the display of cultural contrast constitutes the basis of the content produced by the vloggers.

Adriana Barbosa Fernandes also investigates YouTube as a platform where interculturality is displayed in the comment sections of videos from the channel of the Goethe Institute. The author focuses on how YouTube users co-construct personal and social identities and position themselves in relation to the content of the videos (dealing with aspects of regional particularities as well as questions of everyday life) and most notably in response to comments made by other users. Her findings point to the discursive dynamics of positioning, claims of knowledge, and actions of reciprocity that are displayed by users in online comments.

The section **Digital Interculturality in Institutional Contexts** comprises contributions that discuss and showcase digital interculturality in relation to language education, hotel-guest communication, and police training. **Jennifer Schluer and Yarong Liu**'s contribution discusses the practice of peer feedback in learning environments from a critical perspective and proposes a model representing the dynamic dimensions of peer feedback in intercultural communication in online contexts. The model, containing both individual and contextual factors affecting peer feedback, is intended to provide pedagogical support to teachers of English as a foreign language willing to use the technique which, besides improving learning,

can also help learners develop critical awareness of online intercultural communication.

Tilman Schröder's chapter presents a study of online reviews of service encounters, with a focus on how service providers in the hotel industry respond to negative customer reviews on the online platforms HolidayCheck and Tripadvisor. In this context, the feedback providers and feedback recipients occupy different positions in the digital interaction, come from different countries, and speak different first languages. The study not only identifies a series of linguistic moves (following speech-act structures) that hoteliers resort to when dealing with culture-related complaints but also proposes a wider reflection upon ethnocentrism and stereotypification in the context of customer interaction in digital-intercultural settings.

Bernd Meyer and Annalena Kolloch's chapter sheds light on an institution that in the past rarely granted field access, namely the police. The authors examine how future police officers in vocational training react to unexpected situations that comprise language barriers during enacted police interventions. Among other findings, they observe the ways in which different forms of language mediation are used or ignored. They come to the conclusion that regardless of the concrete means taken to handle the language barriers, it is inclusive communication strategies (such as use of a lingua franca as well as digital translation apps) that have proven successful in intercultural interactions.

Our last section, (Socio-)Cultural Reflections and Case Studies on Digital Intercultural Phenomena, comprises contributions that deal with language use in online settings in connection to psychological, societal, and political issues. Roman Lietz's chapter provides an epistemological review of *identity* and its relation to social cohesion and community building taking place in a complex and ambiguous online world. This discussion is complemented by examples of narrative processes of positioning on various online platforms and culminates in a case study of a YouTube comment section by Greek and Turkish football fans who presumably reside in Germany, showing how cohesion is created narratively and reciprocally.

Fergal Lenehan's chapter focuses on the hashtag #DenkEuropaMit, disseminated by the Twitter account @PulseOfEurope, and created in an attempt to europeanize the 2021 election for the German federal parliament.

The author investigates retweets and "social TV practices" combined with the tagging of relevant public figures and characterizes these actions as examples of referentiality, one of the three dimensions in Stalder's notion of "culture of digitality". The author regards these referential practices as a type of digital activism, given their attempt to influence the political discourse on TV. Lenehan concludes that the Twitter account combined digital practices with a more 'traditional' literary and ideas-oriented type of Europeanism, which the author characterizes as a form of "digital europeanism".

Luisa Conti's contribution centers on the German term *Heimat*, a sensitive and at times controversial concept which expresses the embeddedness of individuals in their social environment as well as their community of belonging. In this chapter, the author questions its meaning in light of the digitalization of daily life and elaborates upon a semantic proposal which allows for the description of the contemporary postdigital experience of *Heimat*. The proposed model of *Heimat* as a network discards exclusionary discourses showing instead the importance of an open attitude for fostering the thriving of the individual *Heimat* and, through it, the social cohesion of the community as a whole.

The contributions outlined above put forth applied linguistics and intercultural studies perspectives and lend an interdisciplinary quality to this book project. This is not to say that this is the only kind of interdisciplinarity we find worth pursuing. In fact, one of the aims of our project on *digital interculturality* is to stimulate insights by researchers from a variety of fields and using a number of methodological and analytical tools. For example, we see great potential for further dialogue with – and between – fields such as pedagogy, language education, media and internet studies among others. We also find that the methods of discourse analysis, digital ethnography, and digital hermeneutics, to mention only a few, can help us acquire a deeper understanding of empirical data featuring digital intercultural practices.

A final point must be made concerning our choice of a bilingual, instead of a monolingual, volume. Both at the GAL conference and in the organization of this volume, we took a conscious decision to give our authors the chance to choose the language of their contributions with a view to fostering and nurturing multilingualism within academia. Following research

on multilingual practices (e.g., Horner/Weber 2014), we acknowledge that the choice of language – either for a piece of writing or for an ordinary conversation with a friend or a co-worker – is often influenced by a myriad of societal issues as well as language ideologies.[9] In offering space for contributions in German or English, the idea was to give both authors and readers varied possibilities to enter the discussion on language and interculturality in the digital world.

Bibliography

Androutsopoulos, Jannis K., 2016: "Digitale Medien: Ressourcen und Räume für interkulturelle Praktiken". *Networx* Nr. 74.

Bakardijewa, Maria, 2011: "The Internet in Everyday Life: Exploring the Tenets and Contributions of Diverse Approaches." In: Consalvo, Mia/Ess, Charles (eds.) (2011): *The Handbook of Internet Studies.* Hoboken: Wiley-Blackwell, 59–82.

Blommaert, Jan/Rampton, Ben, 2011: "Language and Superdiversity". *Diversitites* 13(2), 1–21.

Bolten, Jürgen, 2007: *Interkulturelle Kompetenz.* Thüringen: Landeszentrale für politische Bildung.

Bolten, Jürgen, 2015: *Einführung in die Interkulturelle Wirtschaftskommunikation.* Göttingen: V&R.

Bolten, Jürgen, 2020: *Rethinking Interculturality: Structure-Process Perspectives.* retrieved 9.3.2023 from https://www.researchgate.net/profile/Juergen-Bolten/publication/339726754_Rethinking_Interculturality_Structure-Process_Perspectives/links/5e615c60458515163551e79b/Rethinking-Interculturality-Structure-Process-Perspectives.pdf

Busch, Dominic, 2022: "Soziales und Kulturelles in der Sprache". In: Földes, Csaba/Roelcke, Thorsten (eds.): *Handbuch Mehrsprachigkeit*, Berlin: De Gruyter, 83–104.

Bruns, Axel, 2008: "Anyone Can Edit': Vom Nutzer zum Produtzer." *kommunikation@gesellschaft* 10/3, 1–23, retrieved 27.3.2023, from http://nbn-resolving.de/urn:nbn:de:0228-200910033.

9 Da Costa/Dyers/Mheta (2014) argue that language ideologies may serve a standardizing function that helps to keep power asymmetries intact.

Copland, Fiona/Creese, Angela, 2015: *Linguistic Ethnography: Collecting, Analysing and Presenting Data*. London: Sage Publications.

Da Costa, Dinis F./Dyers, Charlyn/Mheta, Gift, 2014: "Language Standardisation". In: Bock, Zannie/Mheta, Gift (eds.): *Language, Society and Communication. An Introduction*, Pretoria: van Schaik, 333–346.

Dutton, William, 2013: "Internet Studies: The Foundations of a Transformative Field". In: Dutton, William (ed.): *The Oxford Handbook of Internet Studies*. Oxford: Oxford University Press, 1–26.

Fish, Adam/Murillo, Luis F. R./Nguyen, Lilly/Panofsky, Aaron/Kelty, Christopher, 2011: "Birds of the Internet". *Journal of Cultural Economy* 4(2), 157–187, retrieved 9.3.2023, from https://doi.org/10.1080/17530 350.2011.563069.

Friese, Heidrun, 2020: Einleitung. In: Friese, Heidrun/Nolden, Marcus/Rebane, Gala/Schreiter, Miriam (eds.): *Handbuch Soziale Praktiken und Digitale Alltagswelten*, Wiesbaden: Springer VS, 1–18.

Gibson, James J., 1986: *The Ecological Approach to Visual Perception*. Abingdon: Routledge.

Horner, Kristine/Weber, Jean Jacques, 2014: Introducing Multilingualism: A Social Approach. Milton Park: Taylor & Francis.

Lenehan, Fergal, 2022: "Vorwort/Editorial". *Interculture Journal* 31/26, 5–9.

Lenehan, Fergal/Conti, Luisa/Lietz, Roman/Mendes de Oliveira, Milene (eds.), 2022: *Cyber-Utopia/Dystopia? Digital Interculturality between Cosmopolitanism and Authoritarian Currents. Interculture Journal* 31/26.

Jones, Rodney/Chik, Alice/Hafner, Christoph, 2015: *Discourse and Digital Practices: Doing Discourse Analysis in the Digital Age*. Milton Park: Taylor & Francis.

MacDonald, Malcom N./Ladegaard, Hans J., 2022 (eds.): *Twentieth Anniversary Special Issue: Issues, Controversies and Difficult Questions. Language and Intercultural Communication* 22/3.

Meier-Vieracker, Simon/Bülow, Lars/Marx, Konstanze/Mroczynski, Robert, 2023: "Digitale Pragmatik. Einleitung". In: Meier-Vieracker, Simon/Bülow, Lars/Marx, Konstanze/Mroczynski, Robert (eds.): *Digitale Pragmatik*. Berlin: Springer, 1–12.

Mendes de Oliveira, Milene, (2023): "John Gumperz' 1982 Discourse Strategies". *Interculture Journal* 22/38, 12–15.

Rampton, Ben, 2022: *Encounters: Vol. 21. Linguistic Practice in Changing Conditions*. Multilingual Matters, retrieved 9.3.2023, from https://doi.org/10.21832/9781800410008.

Scollon, Suzie W./de Saint-Georges, Ingrid, 2012: "Mediated Discourse Analysis". In: Handford, Michael/Gee, James Paul (eds.): *The Routledge Handbook of Discourse Analysis* Milton Park: Routledge, 66–78.

Stalder, Felix, 2019: *Kultur der Digitalität*. Berlin: Suhrkamp.

Thorne, Steven L., 2016: Cultures-of-use and Morphologies of Communicative Action. *Language Learning & Technology*, 20, 185–191.

Vertovec, Steven, 2007: "Super-Diversity and its Implications". *Ethnic and Racial Studies*, 30(6), 1024–1054.

Welsch, Wolfgang, 1999: "Transculturality: The Puzzling Form of Cultures Today". *Spaces of Culture: City, Nation, World*, 13(7), 194–213.

Wolf, Hans-Georg, 2014: "Language and Culture in Intercultural Communication." In: Sharifian, Farzad (ed.): *The Routledge Handbook of Language and Culture*, Milton Park: Routledge, 461–475.

1 Aushandlung von Interkulturalität in der Online-Welt

Negotiating Interculturality in the Online World

Milene Mendes de Oliveira / Luisa Conti

Displaying and Negotiating Power through Entitlement Claims in Newly-Established International Online Groups

Abstract English: Remote meetings have become a popular collaboration format. Some of these meetings feature groups whose members get to interact with each other for the first time. In this chapter, we investigate one such setting in the context of a simulation game in which students from two higher-education institutions come together and start to work jointly on a collaborative project. We recorded students' interactions throughout the gameplay and analyzed a high-stakes task in the first session of the game in which students were negotiating the roles they would assume throughout the sessions (for instance, who would be the moderator, the person responsible for PR/marketing among others). Deploying an interactional analysis based on conversation-analytical notions, we show key interactional actions that help participants demonstrate and strengthen affiliation and, at the same time, steer power negotiation. One such practice is the display of entitlement for the role in which players either claim entitlement for themselves or for their fellow players. We close the paper with a discussion on participation patterns and the importance of a dialogical attitude in such online-collaboration scenarios.

Abstract Deutsch: Online-Meetings sind mittlerweile eine übliche Praxis im Arbeitsalltag geworden. Diese werden häufig auch einberufen, um die Zusammenarbeit zwischen verschiedenen Teams zu ermöglichen. In diesem Beitrag geht es insbesondere um die Begegnung zwischen zwei Teams, die zum ersten Mal aufeinander treffen. Eine solche wurde im Rahmen eines Planspiels gezielt herbeigeführt, indem Studierende zweier Hochschulen zusammenkamen, um gemeinsam ein kollaboratives Projekt in Angriff zu nehmen. Die Interaktionen der Studierenden wurden aufgezeichnet und ihre Handlungen während der ersten Sitzung des Spiels analysiert. In dieser mussten die Studierenden Rollen aushandeln, die sie im weiteren Verlauf des Planspiels einnehmen würden (z. B. Moderation, PR/Marketing u. a.). Mithilfe einer Interaktionsanalyse, die auf einer konversationsanalytischen Herangehensweise basiert, werden in diesem Beitrag wesentliche kommunikative Handlungen aufgezeigt, durch die Zugehörigkeitsverhältnisse

signalisiert, verfestigt bzw. geändert wurden und dadurch die Entwicklung von Machtverhältnissen innerhalb der Gruppe lenkten. Eine dieser Praktiken ist der implizit oder explizit vorgetragene Anspruch auf Berechtigung (*entitlement*) für eine der Rollen, wobei die Spieler*innen diesen Anspruch entweder für sich selbst oder für ihre Mitspielenden erheben. Zum Abschluss des Beitrags werden Beteiligungsmuster und die Bedeutung einer dialogischen Haltung in derartigen Online-Kollaborationsszenarien diskutiert.

Keywords: power, entitlement, participation, virtual intercultural teams, video conference

1. Introduction

The diffusion of the internet and ancillary technologies have extended the space and scope of human fields of action. One of the core features of the digital world is the facilitated sharing of information that fosters a culture of participation that can go beyond the digital world. Indeed, the digital sphere is not to be understood as a separate reality. Instead, it should be regarded as a ubiquitous and pervasive reality, in which members of the "network society" can get connected (van Dijk 2006; Castells 1996).

This widespread communication network is of course associated with risks of several kinds, including hate speech and cyberbullying. However, it can potentially contribute to societal cohesion in that it creates new possibilities of encounters and interactions. An example is the phenomenon of videoconferencing, which has given co-workers, friends, and families new ways to stay in contact and has provided the means for the creation of new groups and teams in educational and workplace settings among many others.

In this chapter, we show the main results of a fine-grained analysis of interactions occurring in a simulation game played over the videoconferencing software Zoom. The aim of the study is to identify factors that impact self-determined and sustainable participation in online intercultural encounters. This configuration is referred to as *intercultural* since it is in line with Bolten's definition of interculturality as "unfamiliar multiplicity" (Bolten 2015b: 118), i.e., a situation in which the commonality and normality of *culture* is lacking. In the simulation game, students from two different higher education institutions meet for the first time

and start negotiating patterns of participation — and related power displays — from scratch.

The study depicted in this chapter is part of the sub-project *Digital Communities and Online Intercultural Competence.*[1] In an earlier study in the scope of the same sub-project, we collected and analyzed players' perceptions of the game and of the relationships they developed with their teammates (Conti/Mendes de Oliveira/Nietzel 2022). This time, we focus on the actual interactions with the following research questions in mind: How was participation distributed in the selected intercultural encounters between two groups? What interactional practices aided participants to negotiate role assignment? And finally, guided by the ideal of inclusion, we also ask: What practices are shown to foster a more egalitarian participation in the game?

The remainder of this chapter is organized in the following way: first, we give an overview of the theoretical and analytical notions that oriented our analyses. These include power, entitlement, and dialogue, all of which considered in their interplay with the notion of *participation*. After that, we describe our study design, including the settings of the intercultural simulation game *Megacities* (Bolten 2015a) and our methodological framework. Subsequently, we proceed to our fine-grained analysis of interactional phenomena in the game that have a bearing on the evolving participation patterns identified. This is followed by discussion and concluding remarks.

2. Theory and literature review

Participation is an abstract notion that has been studied from many perspectives. In the following, we depict three of these perspectives that were considered relevant in our study: power, entitlement, and dialogue.

1 The sub-project is one of the actions of the research collective ReDICo, Researching Digital Interculturality Co-operatively, funded by the German Ministry of Education and Research.

2.1 Participation and power

Previous studies of participants' perceptions of the simulation game Megacities showed that language-related aspects seem to impact the willingness of some players to participate in the tasks. The presence of first and second-language speakers (L1 and L2) of a specific language in the same group was described as intimidating by several participants, as some of the L2 speakers felt disadvantaged due to perceived lack of communication skills and to *a priori* hierarchical relations that positioned L1 speakers as more knowledgeable and more entitled to move the discussions and negotiations forward (Conti/Mendes de Oliveira/Nietzel 2022: 202–203; Stang/Zhao 2020: 30–31).

Thus, participation can be said to be connected to *perceived* power. A more recent approach to the study of power in organizations follows an interactional orientation. This approach, within the field of ethnomethodology, suggests that

> power should be understood from the point of view of participants in social settings. The questions to be answered then are not what is power and how does it work, but rather how do participants accomplish what count as power relations for them in particular social settings (Schneider 2007: 185).

This definition of power fits our focus on participation as a phenomenon that is related to the distribution of rights to speak in a way that promotes (a) the agency of group members or (b) the creation of hierarchies. Power is also related to concentrating the right to speak into the hands of a few people, thereby disregarding others. Thus,

> power can be understood as a practical achievement in social settings, in which some voices dominate other voices, some points of view prevail in being considered better or more appropriate [...]. In short, power might be seen as a question of whose account [...] counts. (Schneider 2007: 188)

2.2 Participation and entitlement

Related to such a view on power is the matter of how displays of knowledge contribute to the distribution of rights to speak during an interaction. Stivers/Mondada/Steensig (2011) write about two dimensions of knowledge that have proved particularly fitting as analytical notions for our study: epistemic access and epistemic primacy.

Epistemic access is connected to two social norms according to which speakers are expected to make claims to which they have access (as in Gricean's quality maxim) and that speakers should not inform already knowing recipients about some state of affairs. Stivers/Mondada/Steensig (2011) explain that, often, epistemic access can be implied in the very design of a turn. For instance, by offering a news announcement (e.g., "I got a new job"), the speaker is treating the recipient as unknowing. By contrast, when requesting a piece of information (e.g., "what time is it?"), they are treating the recipient as knowing.

There are several interactional resources that show epistemic access, or lack thereof. In German, for instance, by using 'achso,' a speaker indicates a shift from "not knowing to knowing" (Golato/Betz 2008 cited by Stivers/Mondada/Steensig 2011: 12). On the other hand, markers such as 'I think', 'maybe' and 'probably' work to downgrade the degree of access to a certain state of affairs.

Epistemic primacy is related to the rights to know, tell others about, and assess some state of affairs. According to Stivers/Mondada/Steensig (2011: 14):

> There [...] appears to be a norm that speakers should make assertions only when they have sufficient knowledge and rights to do so and that speakers with more detailed and in-depth knowledge have primary rights to make assertions and assessments regarding this domain (see Heritage/Raymond 2005; Stivers 2005). Consider the difference between the kind of knowledge two people might have about life in Tokyo: one person has lived there for ten years and another has only visited. Although both have epistemic access to the place's merits and deficits, there is a qualitative difference in the depth of that knowledge—a difference in epistemic authority.

This difference results in the former person being regarded as having epistemic primacy to the subject at hand. An interactional resource to show epistemic primacy is the sequential position of one's interactional contribution. Being the first to make assertions about a certain topic is an implicit claim of higher relational closeness to the topic at hand. Often, however, when claims are made in first position by a "less knowing speaker", this can be heard as a request for confirmation by a "more knowing speaker" (Stivers/Mondada/Steensig 2011). Furthermore, displays of epistemic primacy can derive from (a) social categories such as teacher-student

and mother-son, and (b) more local interactional roles such as teller or listener.

Closely related to epistemic access and primacy is the notion of **entitlement**. Asmuß/Oshima (2018: 886) explain that "entitlement addresses the social practice of orienting to the rights and obligations of performing specific interactional work." Entitlement can be displayed through claims to epistemic access and primacy. In their study on strategy making through multimodal displays of entitlement, Asmuß/Oshima (2018) investigate how proposals are designed within a strategy meeting in a company and how they are negotiated in relation to roles enacted by participants. The authors focus on proposals (when participants propose changes to the strategy document on which they are working together at the time of the interaction) and show how agreement on a proposal can go hand-in-hand with entitlement displays (by the CEO and the HR director of a company), but also how the renegotiation of entitlement to make decisions about a certain topic can lead to the postponement of a decision. They also show the enactment of multiple strategy roles within a single decision sequence, thereby stressing the fact that role assignment is managed interactionally.

Another analytical notion that can be deployed for the investigation of proposals is **deontic authority** (*deon* is an ancient Greek word that means "that which is binding"), which refers to the right of "determining how the world 'ought to be' ", or, said in another way, the right to determine the future actions of others (Stevanovic/Peräkylä 2012: 298). Thus, Stevanovic/Peräkylä (2012) maintain that utterances regarding joint actions imply the understanding of how deontic rights are distributed among the participants (i.e., who has the right to make a proposal in the first place? How much authority do they have over the proposal?). For instance, interactional resources often employed as a response to a proposal are the lexical items 'all right' and 'okay', which imply that the second speaker accepted a constraint in their future actions as imposed by the first speaker, as shown in interactions in church meetings in which pastors and cantors are discussing their future joint tasks (Stevanovic/Peräkylä 2012).

2.3 Participation and dialogue

In an in-depth review of the notion of dialogue as considered in literature and philosophical studies, Conti (2012) explained that this notion can

underlie either the *concrete* meaning of dialogue as a synchronous verbal exchange or the *abstract* concept of dialogue as an attitude, a vision, an ideal (Conti 2012: 104). Even though it is the notion of *interaction* that has established itself in linguistics and applied linguistics (Imo 2016), considering dialogue as an attitude can be productive in providing a macro understanding and a reference to positive practices found in talk-in-interaction that foster participation and mutual respect.

Conti (2012: 104–105) explained that dialogue is characterized by flat hierarchy, active and balanced participation of the individuals involved, appreciation of diversity, and respectful openness towards it. In a study on participants' perceptions of virtual exchanges, Conti (2021) argued that such a dialogical attitude can be reached when participants are able to satisfy core human needs. When these needs are met, they lead to well-being and motivation to engage in groups. The core needs identified in participants' perceptions were the following: (a) feeling competent, comfortable with one's own role, and in control of the situation; (b) feeling familiar in a community which shares responsibilities and care for each other; (c) feeling acknowledged and appreciated; (d) feeling that one's own resources are used in an efficient and fruitful way in the group process; and (e) feeling that participation is not regulated by hierarchy but is self-determined in a context of equal dignity and right to participate (Conti 2021: 44). Thus, through dialogical attitude, feelings of familiarity and safety can develop, and personal trust can expand (Meyerson/Weick/Roderick 1996; Stegbauer 2002; Conti 2021).

Nevertheless, our previous study has also shown that building trust is more challenging in online settings (Conti/Mendes de Oliveira/Nietzel 2022). Physical distance makes it more difficult (though not impossible) to create feelings of closeness and reliability. As Robert/Dennis/Hung (2009) show, in virtual teams there is a bigger need for "swift-trust" (Meyerson/Weick/Kramer 1996), that is, the initial trust needed by new groups to interact as if they had known and developed trust for each other before. Indeed, knowledge-based trust is harder to build online, as it is more difficult to perceive the "ability, integrity, and benevolence" (Robert/Dennis/Hung 2009: 265) of the other team members. For instance, keeping cameras off during video calls, if not explicitly justified, can harm trust-building processes (Conti/Mendes de Oliveira/Nietzel 2022: 200).

The notions and frameworks introduced above are relevant to the analysis and discussions presented in the remaining sections of this chapter. Before we move on to the analytical section, we first turn to the set-up of our study. Below, we give information on our study design including the organization of the simulation game in which our participants engaged.

3. Study design

3.1 Study setting

The simulation game *Megacities* (Bolten 2015a) was designed to help players develop intercultural skills through collaborative tasks. The tasks revolve around creating a development plan for a piece of land. The game concept can be adapted to specific contexts and to specific goals pursued by lecturers or trainers. The two games considered in this paper were structured in the same way and were facilitated by the same people. The first game took place in May 2021 and the second one in November 2021. Each game comprises five online sessions (via Zoom), each lasting approximately two hours. In the kick-off session of the game, the players were divided into sub-groups that act as representatives for cities that neighbor the piece of land for which the development plan was to be created. These sub-groups (representing fictitious cities) develop an identity for their own city first before they proceed to subsequent stages of the game.[2] The task we analyzed for this study took place in the kick-off session of the game.

3.2 The game session and the game task

Three institutions participated in the two games mentioned above: German University 1 (GU1), German University 2 (GU2), and Finnish University 1 (FU1). The first game, in May 2021, was played by students from GU1 and GU2. The second game (November 2021) was played by students from GU1 and FU1 (see game configurations in Figure 1 below). The kick-off session of the game was the first encounter of players from two

2 In the middle of the game the sub-groups are strategically mixed. The aim of the reorganization of the sub-groups is to have participants learn to deal constructively with uncertainty and to successfully conclude the game by delivering a fully-fledged concept for the new area.

participating universities. Thus, while players were already acquainted with each other within their own institutions, they were not acquainted with players from the other institution. In that sense, the kick-off session is a key moment in the game: it is when the players from two institutions meet and set the basis for their cooperation. In the kick-off session, there is therefore familiarity or "common ground" — i.e., "mutual knowledge, mutual beliefs, and mutual assumptions" (Clark/Brennan 1991: 127) — only among the players from the same university.

Figure 1: Games 1 and 2 and their configurations

For our analysis, we selected sequences that took place within a particular task in the kick-off session. It revolved around assigning responsibilities within the newly formed sub-group. The instructions for the task are shown in Figure 2 below:

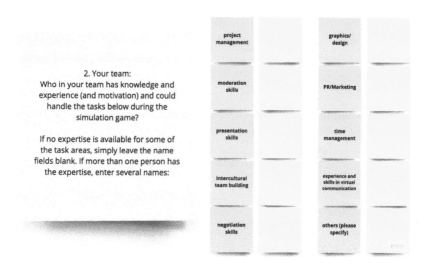

Figure 2: Screenshot of the task on the online collaborative board[3]

Besides the information given above, the following facts should also be considered: (a) there was no external facilitator, and the facilitation role had not been given beforehand to anyone in the group; (b) the decisions the group was expected to make were very relevant to its members, as they dealt with their roles (and therefore, future actions and responsibilities) during the game; (c) according to the assignment, the roles could be shared among various participants, however, they were expected to consider "knowledge, experience and motivation" when choosing them. The interactions taking place in this task are therefore very interesting, as they reveal how the power dynamics can develop and how participation can be fostered or hindered.

3.3 Study methodology

Apart from joining the Zoom encounters, at the end of the game students were asked to fill in reflection reports, writing about their experiences and impressions of the game, as well as their own and their group's

3 Conceptboard and Miro were used in Games 1 and 2, respectively.

performance. All sessions of each game were recorded, and an automated transcript was generated by Zoom. We selected sequences of the recordings and refined the automated transcript following the GAT2 minimal transcription (Selting et al. 2011) conventions (listed in the appendix).

The interactional analysis was inspired by conversation analysis. We conducted an in-depth analysis of the excerpts guided by the analytical notions depicted in section 2 of this chapter (for a similar approach, see Grønkjær et al. 2011).

For this study, one sub-group was selected from each game (see Figure 3 below). Our choice of sub-groups for the fine-grained analysis was motivated by the students' reflections on their and their colleagues' participation patterns during the game, as shown in their reflection reports. Some participants of sub-group 1 (Game 1) reported not feeling integrated into the group while the players in sub-group 2 (Game 2) reported high levels of integration.

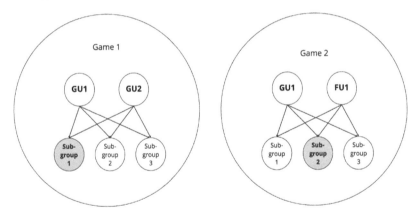

Figure 3: Configurations of each game and the sub-groups chosen for in-depth analyses (in pink)

The figure shows the configurations of sub-groups in Game 1 and Game 2. The lines illustrate how students from the participating institutions were divided into sub-groups. Thus, each subgroup contained players from GU1 and GU2 (Game 1) or GU1 and FU1 (Game 2).

3.4 Study participants

Sub-group 1 comprised students from Germany, China, as well as a few students from Italy and Ireland who were enrolled in GU1 and GU2.[4] Sub-group 2 included players from Germany and Finland, GU1 and FU1, respectively. The participants' backgrounds are diverse.

For confidentiality reasons, real names were replaced with other names alluding to the same gender and to the original language, followed by an indication of university (e.g., Nora-GU2, meaning she is a member of GU2). In the following, we briefly give an overview of participants in sub-groups 1 and 2:

Sub-group 1		Sub-group 2	
German University 1 – GU1	German University 2 – GU2	German University 1 – GU1	Finnish University 2 – FU1
Alexa-GU1	Aylin-GU2	Jakob-GU1	Helmi-FU1
Anton-GU1	Lixin-GU2	Klaus-GU1	Sakke-FU1
Olena-GU1	Maren-GU2	Lukas-GU1	
(and others who do not appear in the transcripts)	Nora-GU2	Petra-GU1	
	Sofia-GU2		
	Xiang-GU2		

Here, a note is required concerning the terminology used in the analytical section: whenever we refer to interactional sequences depicting students from the same university (e.g., GU1), we will refer to in-groups or in-group members, thereby highlighting the fact that they were acquainted with each other before the start of the game.

4 GU1 receives Erasmus students from European countries and GU2 offers exchange programs for Chinese students, who account for more than half of its student body.

4. Analysis

In the following, we show how displays of entitlement, deontic, and epistemic authority are evidenced in sub-groups 1 and 2 and how these impact participation patterns. First, we consider the design of proposals and their connection to the notion of entitlement discussed in section 2 above.

The following excerpt shows the common practice, in sub-group 1, to display epistemic primacy and therefore claim entitlement for oneself.

4.1 Claiming entitlement for oneself

```
(1)  Sub-group 1

00:07:03-00:07:38

01    NoraGU2    ehm:
02               (0.5)
03    NoraGU2    so: h°
04               (1.2)
05    NoraGU2    who is good with (-)
06               any of these ((giggles))
07               (1.2)
08    NoraGU2    does anyone have (.) suggestions?
09    AlexaGU1   i would like to do:
10               the presentation part (.)
11               because i am (-) especially good at presentation and
12               moderation (-)
13               and by default all the other ones (.)
14               are (.) not (.) that great
15               and jus- just in case you don't see me
16               i can (.) °h also write my name in that h° (.)
17               uhm: (-) in [that bracket]
18    NoraGU2                [uhm:       ] (-)
19               so it was presentation [skill]
20    AlexaGU1                          [yeah ]
21               ((NoraG2 types))
22    AlexaGU1                                  [oh yeah]
23    NoraGU2    <<typing the name on the board> [a:    ] (.) le: (.)
24               xa> ((pronouncing the real name of the other player))
```

In this excerpt, which also sets the beginning of a game task, Nora-GU2 initiates the discussion and frames the activity with the question "who is good with any of these?" (line 03), mirroring the way the task is described. Since no one answers, Nora-GU2 tries again (line 08). After that, Alexa-GU1 answers by volunteering to take responsibility for presentation tasks and justifying this by means of displaying epistemic primacy (i.e., she is "good at it", and thus possesses the knowledge required for it) and, therefore, entitlement (lines 09–12).

Alexa-GU1's offer to write her own name on Conceptboard — which seems to reinforce her deontic authority and leave even less room for a possible rejection — was not taken by Nora-GU2, who had already started typing Alexa-GU1's name on the board (line 21), thereby acquiescing fully to Alexa-GU1's proposal — and related deontic authority — to be made responsible for "presentation".

Claiming epistemic access and primacy, while proposing that somebody (either oneself or somebody else) takes responsibility for a task, was a recurring practice in this game, triggered by the very description of the task. While in excerpt 1 it was Alexa-GU1 who claimed epistemic access and primacy for herself, in the following excerpt we present an example of how someone claims epistemic primacy for another in-group member (vis-à-vis the other group), thereby making claims about their entitlement to take responsibility for a task in the game.

4.2 Claiming entitlement for an in-group member

(2) Sub-group 2

00:08:54–00:00:09:54

```
01   KlausGU1   okay great
02              (1.0)
03   KlausGU1   so uh (.) who wants to become project management h°
04              (6.5)
05   PetraGU1   ((clicks)) u[hm:]
06   KlausGU1             [any] (.) volunteers
07              (4.1)
08   HelmiFU1   i just (.) uh wanted to say at first
09              that i think sakke has experience in: (.)
10              °h (.) uh: virtual communication (.)
11              like zoom or: (.) miro (.)
12              wa- wa- wa- was it right sakke that you even done this in
13              your work
14              (.)
15   SakkeFU1   yeah well uh: my work is: (.)
16              where i basically host these two systems and offer like (.)
17              °h uh: remote support for (.) people trying to join the::
18              sessions and (-)
19              whatever (.) problems they might have with that
20              (1.0)
21   HelmiFU1   yeah h° (2.0)
22              so i think we might put your name (.)
23              there (.) to the: (.)
24              virtual communication (.) [expert        ]
25   SakkeFU1                             [yeah (why not)]
26              (3.9)
```

The excerpt above shows the same moment in the game as in excerpt 1, but this time in sub-group 2, with similar interactional moves at the beginning. Here, however, we want to focus on how Helmi-FU1 refers to Sakke-FU1's experience with virtual collaboration (lines 08–13), thereby attesting to his epistemic access and primacy with regard to this domain. This turns out to be a common practice within in-groups both in sub-groups 1 and 2: by making claims of epistemic primacy in relation to another in-group member, participants show affiliation towards group mates and, in the case of the excerpt above, facilitate their mates' inclusion into the team. Even if the task does not create direct competition, as there can be several people responsible for the same task, the talk about professional experience might be face-threatening to the players who might not feel experienced enough to be appointed in this task. We will come back to the task design in the discussion section below.

The following excerpt also shows how entitlement is made relevant by an in-group member. However, this is accomplished through exclusionary practices towards another (in-group) member.

4.3 Claiming entitlement for an in-group member and displaying lack of entitlement for oneself

```
(3) Sub-group 1
00:07:37-00:08:34

01   NoraGU2      ((types something))
02   AlexaGU1                                [oh yeah]
03   NoraGU2      <<typing the name on the board> [a:    ] (.) le:
04                (.) xa> ((pronouncing the real name of the player))
05                (1.5)
06   AylinGU2     can i do the time management
07                (1.0)
08   NoraGU2      oops
09                (1.8)
10   NoraGU2      ehm:: (1.9)
11                yeah you can put your name (.)
12                y- i don't know who- who just said it ((giggles))
13                (1.3)
14   AntonGU1     maybe that's a good idea
15                because i think for (-) both incoming (.)
16                or every incoming culture there is always uh difficulties
17                with pronouncing names
18                so maybe (.) everyone when he's putting in his or her name
19                (-) or they nam- <<wondering> their: names> (.)
20                °h their name (.)
21                uhm: (.) just (-) type your name and maybe (.)
22                say how it's pronounced
23                so maybe we (.) all get a chance to get it right the first
24                try
25                (4.0) ((NoraGU2 writes MarenGU2's name on conceptboard))
26   MarenGU2     hm: time management was aylin right
27                (1.7)
28   MarenGU2     [not me]
29   AylinGU2     [yes   ] (.) yes ((giggles))
30   MarenGU2     yeah
31                ((somebody types Aylin's name on conceptboard))
32   NoraGU2      i put- i put maren because i think you're good at
33                <<laughing> time management>
34   MarenGU2     <<laughing> thanks>
```

One of the participants wishing to have her name added to Conceptboard, Aylin-GU2, does not have her camera on. She comes in with a question that, in contrast to Alexa-GU1's turn (in sub-section 4.1 above), displays no entitlement at all (line 06). Actually, by asking the question "can I do time management?", she gives deontic rights to her colleagues to decide whether she is a suitable candidate for the task she chose. At the time Aylin-GU2 utters her turn, Nora-GU2 was busy with Conceptboard. In line 08, she makes this relevant by uttering "oops" to refer to a mistaken action on the collaborative board. Apart from this distraction, Nora-GU2 was not able to see who uttered the turn in line 06, since the speaker did not appear on camera. Moreover, Aylin-GU2's turn design displayed no entitlement. All these factors seem to have led Nora-GU2 to take a different action than the one following Alexa-GU1's turn in 4.1 above (when Nora-GU2 actually wrote Alexa-GU1's name on Conceptboard). In the present excerpt, Nora-GU2 requested the speaker to add her own name to Conceptboard and explained why ("I don't know who just said it"), as shown in lines 11–12. However, Aylin-GU2's name is only added to Conceptboard later, just before the conclusion of the task (line 31). Actually, after Anton-GU1's turn (lines 14–24), Nora-GU2 displays a great deal of deontic authority when writing Maren-GU2's name (and not Aylin-GU2's) as the person responsible for time management on Conceptboard (line 25).

However, upon seeing her name on the board, Maren-GU2 goes on to clarify that it was Aylin-GU2 who actually offered to take responsibility for time management (line 26), to which Aylin-GU2 replies with "yes, yes" (line 29). Nora-GU2 then explains that she was the one who wrote "Maren" on the board. Her justification ("I think you are good at time management", lines 32–33), based on epistemic primacy, displays Maren-GU2's entitlement for the job. Maren-GU2 aligns to this ("thanks", line 34). The shared smiles and laughter between Maren-GU2 and Nora-GU2 also display affiliation.

The practice to display somebody else's epistemic primacy to a certain kind of knowledge (knowledge required to accomplish certain types of tasks), as in lines 32–33 ("I think you are good at time management"), is repeated a few times in this game task. The practice is mostly identified in relation to in-group members; thus, in this kick-off session, except for one case (section 4.5, example 5a below), students assign entitlement to another student from the same university (the in-group).

Thus, a striking difference between the previous excerpt (4.2) and this one (4.3) is that here, displaying entitlement for somebody else includes constraining the deontic rights of a third person, namely Aylin-GU2, who does not seem to claim deontic rights to herself either. Indeed, since Aylin-GU2 is part of Nora-GU2's in-group, a feeling of exclusion might arise, as Nora does not praise her skills, but those of a person who had not even volunteered for that position.

In the following sequence, Nora-GU2 seems to reframe the task slightly with her action "to just put herself into intercultural team building." Another aspect revolves around the contributions by Lixin-GU2, Xiang-GU2 and Olena-GU1, all concentrated in a specific moment of the interaction, without further elaboration by the speakers.

4.4 Making a proposal without entitlement displays

```
(4)  Sub-group 1:
00:09:49-00:11:03

01    NoraGU2      i'll just put myself (.) into: (.)
02                 inter: (.) intercultural team building
03                 (1.3)
04                 that sounds nice
05    LixinGU2     uhm (.) [i          ]
06    xxxxxxxx            [(i'll put)] my name (.) hm_mm
07                 (1.0)
08    XiangGU2     uh (-) i would like to put my name in (.) design
09                 (1.0)
10    NoraGU2      hm_mm (.) yeah
11                 (2.7)
12    LixinGU2     i would like to uhm: do the: (.) pee ar and marketing
13                 but (.) i think uh nora is more uhm (.) professional (.) as
14                 me ((laughs, ca. 1.5))
15    NoraGU2      <<:-)> okay we can (.) we can both do: (.) marketing>
16    LixinGU2     yeah ((laughs))
17                 (3.8)
18    OlenaGU1     (yeah also i) would like in uh: design
19                 (5.7)
20    NoraGU2      so you can just put your: name
21    OlenaGU1     okay
22    NoraGU2      there if you want
23                 (2.2)
```

In this sequence, Nora-GU2 reframes the condition for taking over a task from expertise, as originally formulated in the task instruction (see 3.2 above) to pure interest (lines 01–04). Afterwards, some participants take the chance to say what they would like to do without making any statement on their own expertise and knowledge related to the task chosen.

Even though Lixin-GU2, Olena-GU1, and Xiang-GU2 participate in this excerpt, their practice shows low or no entitlement at all, with Lixin-GU2 even claiming lack of entitlement for himself and higher epistemic access and primacy to another in-group member, Nora-GU2 (lines 12–14). Lixin-GU2's contribution also displays affiliation with his in-group colleague and promptly invites her to take a stance towards Lixin-GU2's assertion. Nora-GU2 seems to interpret the previous turn as an invitation for collaborative work (line 15).

Olena-GU1's contribution is also minimal (line 18) and Nora repeats the practice adopted in response to Aylin's proposal in excerpt 4.3, namely to ask the player to write her name herself (lines 20 and 22).

So far, when referring to claims of entitlement for another person (Excerpts 2 and 3), we referred to displays of epistemic primacy among in-group members who had already worked together. However, the following examples show how entitlement can be granted on the basis of observed communicative behavior of members of the other groups.

4.5 Being granted entitlement for moderation based on previous communicative behavior

(5a)Sub-group 1

00:08:49-00:09:22

```
01    AntonGU1    °h uhm (-) but since that part is taken
02                i would just go ahead and (.) if no one (.) objects i would
03                (.) do project management
03                (1.2)
04    NoraGU2     sure
05                (1.4)
06    AntonGU1    and: h° (.) my name is: (-) <<german pronunciation> anton>
07                (.) or anton (.) if you want to pronounce it the english
08                way h°
09                (1.8)
10    AntonGU1    uhm:
11    SofiaGU2    i think you should also be included in moderation skills
12                because you were (.) the one that did the communication
13                like back then
14    AntonGU1    yeah i'm quite [extroverted]
15    SofiaGU2                   [((laughs))  ]
16    AntonGU1    so <<:-)> i- i'll take that as well> (xxx) ((smiles, moves
17                his chair))
15    SofiaGU2    i think (it's good)
```

In this excerpt, in lines 11–13, a student from GU2 claims entitlement for a student from GU1 (thus, not an in-group member) on the basis of observed communicative behavior in the game. After being addressed in Sofia-GU2's turn, Anton-GU1 aligns with the suggestion (line 14). A similar practice happens in the other group, but the uptake of the proposal is quite different. Prior to the excerpt below, students in sub-group 2 had already sorted out who would be responsible for most of the listed tasks, but some were still lacking, such as moderation and presentation:

(5b)Sub-group 2

00:14:49-00:15:53

```
01   KlausGU1   [okay       ]
02   LukasGU1   [that leaves] klaus (-)
03              [where do] you see
04   KlausGU1   [yeah    ] (.) i- i'm fine (.) thank you
05   LukasGU1   ((laughs))
06   PetraGU1   well klaus (.) uh: you're obviously moderating this thing
07                here
08              so(.) uh (.) maybe
09   LukasGU1   and maning (.) managing our project (.) appar[ently]
10   SakkeFU1                                              [yeah:]
11   PetraGU1   yeah
12   KlausGU1   no no i don't see myself in those roles apparently (.)
13   PetraGU1   ((types klaus's name in a sticky note for the moderation
14              role on conceptboard))
15   KlausGU1   [(modesty)      ]
16   PetraGU1   [see (.) it says] (.) big name klaus
17   KlausGU1   ((laughs))
18   PetraGU1   see it
19   KlausGU1   <<laughing> [where does it] come from>
20   PetraGU1               [(xxx) that   ]
21   KlausGU1   okay
22   PetraGU1   okay
23   KlausGU1   sure (.) uhm: (.) yeah i'm fine with moderation (.) uhm
24              what about presentation
25              (2.5)
26   PetraGU1   are you fine with that too klaus ((smiles))
27              (1.6)
28   KlausGU1   do i have a choice
29   PetraGU1   [((laughs)) (-) well]
30   LukasGU1   [     yes (.) uh be]tween absolutely (.) and of course
31   KlausGU1   i'll take the second one
32   KlausGU1   okay
33              (5.1)
34   KlausGU1   okay (.) anybody interested in graphics and design (.)
35              does <<laughing> anybody have a talent> in drawing or (.)
36              creating i don't know (.) powerpoint presentations
```

The sequence above is, like the previous one (example 5a), based on granting entitlement to somebody else due to their previous communicative behavior in the game. What is different this time is the fact that this excerpt plays out almost entirely among in-group members, which explains the jokey style, complementary turns, and fully functional uptakes of transition points, based on established common ground. Another difference is the post-expansion of proposal sequences: instead of accepting the proposals to take up the responsibilities — as established in the game task (Anton-GU1 in 5a above, for example) — Klaus-GU1 jokes around twice. First, he delays acceptance of the proposal made by his colleagues for him to take up the role of moderator in the task (lines 04, 12, 15, and 17), thereby delaying the decision. Later, he simulates uncertainty in relation to another proposal (line 28), until he finally accepts it with an "okay" in line 32. These delays in decision making seem to downgrade the entitlement granted to Klaus-GU1 by other players. However, they could also be interpreted as displaying maximized deontic authority (i.e., his relative power to make suggestions and proposals to the others): by having colleagues insist, Klaus-GU1 increases his deontic authority. But all seems to be done on a performative level, given that all GU1 members in this game are pretty well-acquainted with one another and jokes are a common practice among them.

The following excerpt shows some additional techniques that fostered a welcoming atmosphere for players from FU1 in sub-group 2.

4.6 Fostering participation of non-in-group members through explicit speaker selection and displays of affiliation

```
(6)Sub-group 2
00:10:57-00:12:25

01    PetraGU1    we can also enter several names (.)
02                if you would like to have two inter: (-)
03                °h what was that what's sakke doing
04    KlausGU1    experience and skills with virtual communication
05    PetraGU1    yeah h°
06    KlausGU1    okay so uh (.) yeah i just wrote you down sakke
07                i hope it's fine with you:
08    SakkeFU1    yeah
09    KlausGU1    uhm (-) anyone else (-)
10                helmi (.) what ar- (.) an- anything you're curious about
11                (.) anything you're interested in
12    HelmiFU1    uhm: (.) yeah i'm just reading through these so:
13                hm: (.) °h no- nothing in particular right now (.)
14                uhm: (3.0) at least not time management
15                or [(.) <<giggling> not project management>]
16    PetraGU1       [((laughs))                              ]
17    HelmiFU1    <<:-)> i'm not good at managing things>
18    PetraGU1    ((laughs)) (3.5) hm:: Figure 4 - see below
19    KlausGU1    how about [uh    ]
20    HelmiFU1             [i thin-]
21    KlausGU1    in- (.) intercultural team building
22    HelmiFU1    (-)°h yeah i was thinking about that or negotiation skills
23                (.) uh: in my work i: (.) i teach uhm: for example i teach
24                finnish to immigrants and i have also teached
25                °h uh: english and (.) uh: french and swedish to: (.) to
26                people and (.)
27                i worked a lot with people from from di- different
28                countries
29                and different cultures so: (.)
30                °h so maybe something like that
31    KlausGU1    alright (.) so uhm (.) sounds like intercultural team
32                building to me:
33    HelmiFU1    [yeah  ]
34    KlausGU1    [are you] fine with that
35    HelmiFU1    yeah yeah
```

Figure 4: Reaction to Helmi's "I'm not good at managing things" (Helmi is in the bottom left corner)

Some strategies used by Klaus-GU1 include (a) checking whether Sakke-FU1 agrees with the role assigned to him in lines 06–07 (note that this sequence takes place after Helmi-FU1 suggested that Sakke-FU1 should take responsibility for virtual communication, given his knowledge and prior experience with it), and (b) asking Helmi-FU1 if she's curious about, or interested in, any of the tasks presented on Conceptboard (lines 10–11). With (a), Klaus-GU1 downgrades his own deontic authority and gives Sakke-FU1 agency in deciding whether his name should be assigned to the task or not, thereby also displaying affiliation. With (b), Klaus-GU1 reframes the task (which instructed participants to make the selection based on prior knowledge, see section 3.2 above), reformulating it in a less face-threatening way. Moreover, in her answer to this open question, Helmi-FU1 inaugurates a practice that becomes recurring in this game session, which revolves around showing lack of knowledge around a certain domain, thereby displaying a lack of epistemic primacy in a joking way (lines 14–15 and 17). Then, Klaus-GU1 takes a further step by proposing that Helmi-FU1 should take responsibility for a specific task in the game (intercultural team building) (lines 19 and 21). He is confirmed in his deontic rights by Helmi-FU1's affirmative answer and elaboration, which touches upon her epistemic access and entitlement (lines 22–30). Nevertheless, he still asks for confirmation, one more time, in line 34. This seems to display affiliation and point to a feeling of well-being in the team.

5. Discussion

The analyses depicted above pursued to answer the following questions: How was participation distributed in the selected intercultural encounters between two groups? What interactional practices aided participants to negotiate role assignment? Our findings show how participation in the role-division task is linked to entitlement displays. Specifically, we identified the practices of: (a) claiming entitlement for oneself, (b) displaying entitlement for an in-group member, and (c) displaying entitlement for a player of the other group. Moreover, we also analyzed situations in which entitlement displays are lacking.

Regarding the practice of claiming entitlement for oneself, we showed that it is linked, in our data, to displaying epistemic access and primacy. These claims seem to get assessed as legitimate by the group. In relation to entitlement displays for an in-group member, it also seems to be connected with claims of epistemic access and primacy. These claims are regarded as legitimate due to acquaintance and familiarity between the members. Furthermore, entitlement was also shown to be claimed for members of the other group. However, acquaintance and familiarity are lacking, since this is the first encounter between the involved members. In such cases, the claims were connected to perceptions of communicative behavior of the fellow player in the initial moments of the game. Finally, we also showed examples of when proposals are made by speakers who make no claims of entitlement whatsoever. This results in magnifying the deontic authority of the moderator to the detriment of the authority of the person making the proposal.

The other question guiding our study was: what practices are shown to foster more egalitarian participation in the game? Our findings show that displays of entitlement directed at a third-party — be they towards an in-group or a non-in-group member — can potentially provide an opportunity for participants who are less vocal in expressing themselves. This opportunity arises after having their entitlement displayed by somebody else. However, this practice can be linked to exclusionary actions too, as paving the way for some people often means constraining the participation of others.

These considerations on egalitarian participation take us back to the notion of *dialogue* as an attitude and an ideal (Conti 2012), discussed in section 2 of this chapter. Having the characteristics of dialogue in mind — flat hierarchy, active and balanced participation of the individuals involved, appreciation of diversity, and openness — it is easy to see that conscious actions aimed at ensuring balanced participation (through speaker selection techniques), reducing hierarchy and showing appreciation of diversity and openness (through strengthening the deontic authority of non-in-group members and through displays of affiliation towards the same people) are useful and thoughtful practices. The above-named practice of inviting someone to speak is also a typical technique of dialogic facilitation (Baraldi/Joslyn/Farini 2021; Conti 2020). It bridges the lack of power and confidence that produces insecurity and non-participation, and it helps participants to take risks and to share. The dialogical attitude also presupposes participants' agency, which is related not only to the quality, but also to the amount of contributions: whoever takes no or very limited chances to contribute to group interactions will have reduced chances to experience acknowledgment by other participants. It is then highly unlikely that the others will develop a feeling of affiliation, above all in video-conferencing contexts, where communication flows mainly through verbal communication. Therefore, the more a person participates, the more likely it is that the person will keep on engaging.

An aspect that is not to be forgotten is the fact that the study was based on a simulation game, with a set of constraints of its own, which can be, we argue, quite different from real-life contexts. In this connection, the session of the game that we analyzed is peculiar in that it is the very first moment in which students from different groups come together and are expected to suddenly engage in a conversation. Following this, they tell each other about their knowledge and expertise as a step to decide who takes over each task during the following sessions of the game. As shown in section 2, feeling competent and comfortable with one's own role has an impact on the well-being of a person in a group and therefore on one's motivation to participate as a fully-fledged member (see Mendes de Oliveira/Tuccillo, 2024). This opening phase of the game is therefore quite challenging, as the participants need to solve a core task without having had the chance to build trust or common ground with all the members of the newly formed team.

This constraint is closely connected to task design. In the game, participants were expected to tell the others about their knowledge and expertise, which can be challenging for some people. The challenges might lie in the disproportion between a relatively intimate task and the poor trust basis that the mixed group had at the beginning. Even if unlikely, it was possible that someone might question the statements made about one's own competence and knowledge, and that could have an impact on one's self-image and self-confidence (Goffman 1967). This risk of a defiant objection by the others might have hindered some to join proactively, above all the ones who did not feel a safe connection to others. Such a risk is indeed less likely for a person in a power position and/or who feels well integrated. Members who can more easily feel swift-trust (i.e., trusting others without knowing them), or have already developed knowledge-based trust with a few other members and feel well-bounded, could more easily display epistemic primacy, or get their epistemic and deontic authorities displayed by an in-group colleague. However, while sharing personal information requires more swift-trust, it also boosts interpersonal trust. In this connection, some team-building methods[5] have been developed that foster a feeling of closeness among the participants in online environments. A start with a low threshold team-building method could have, thus, made it easier for members of a newly founded team to share personal information and build trust before engaging in other potentially face-threatening tasks.

A further reason which might explain the difficulties that some players experienced — both in relation to the display of entitlement but also more general participation practices in the game — might be linked to their cultural socialization. Verbalizing one's own abilities might be easy to enact for some participants and difficult for others. Different cultural practices related to courtesy and politeness (Ehrhardt/Neuland 2021; Haugh/Chang 2015) influence how public, positive self-descriptions are perceived; either as a demonstration of honest and healthy self-confidence or as an act of vanity and a lack of humbleness. This is, again, related to task-design. A task is a cultural product which sets culturally shaped

5 SHARMED-method (Conti 2020), in which people share personal stories by presenting a private photo.

expectations to the participants. It sets the conditions under which participation is possible and implies cultural adaptation. The task design in the game might favor players socialized in educational systems that foster such a mindset and such practices.

The last factor we want to call attention to is language, as language skills have been shown, in previous investigations, to impact the development of power relations in virtual groups. In our game, the language spoken in both groups was English as a lingua franca. The willingness and easiness to communicate in a foreign language is a further important factor that regulates participation. As shown in other studies, it depends on various factors, such as the perception of the skills of the others (Conti/ Mendes de Oliveira/Nietzel 2022: 202–203; Stang/Zhao 2020).[6]

All in all, in this chapter we have shown practices that attest to the display and negotiation of power in interactions in newly-established virtual groups. The practices we identified — claims of entitlement towards in- and out-group members as well as inclusion-oriented moves — are, however, only puzzle pieces and need to be complemented by further findings and insights if an encompassing understanding of the interplay between (digital) interculturality and power (as an interactional accomplishment) is to be achieved.

6 On English as a lingua franca and interculturality, see Mendes de Oliveira (2023).

Transcription conventions GAT 2

:, ::	lengthening (0.2-0.5 sec.; 0.5-0.8 sec.)
(.)	micro pause of ca. 0.2 sec. duration
(-)	short pause of ca. 0.2-0.5 sec. duration
(2.2)	measured pause of 2.2 sec. duration
((giggles))	non-verbal actions and events
((laughs, ca. 1.5))	non-verbal actions and events of ca. 1.5 sec. duration
jus-	cut-off word
h°	audible inbreath
°h	audible outbreath
[xxx]	overlap and simultaneous talk
<<laughing> xxx>	descriptions and comments
<<:-)> okay>	smile voice
(why not)	assumed wording
(xxx)	one intelligible syllable
hm_mm	bi-syllabic token

Bibliography

Asmuß, Birte/Oshima, Sae, 2018: "Strategy Making as a Communicative Practice: The Multimodal Accomplishment of Strategy Roles". *M@n@gement* 21(2), 884–912.

Baraldi, Claudio/Joslyn, Erica/Farini, Federico, 2021: *Promoting Children's Rights in European Schools. Intercultural Dialogue and Facilitative Pedagogy*. London: Bloomsbury Academic.

Bolten, Jürgen, 2015a: *Megacities. Ein Planspiel für virtuelle Lernumgebungen*. Jena, retrieved 15.4.2022 from www.intercultural-campus.org.

Bolten, Jürgen, 2015b: *Einführung in die Interkulturelle Wirtschaftskommunikation*. Göttingen: V&R.

Castells, Manuel, 1996: *The Rise of the Network Society, The Information Age: Economy, Society and Culture*. Oxford: Blackwell.

Clark, Herbert H./Brennan, Susan E., 1991: "Grounding in Communication". In: Resnick, Lauren B./Levine, John M./Teasley, Stephanie D. (eds.): *Perspectives on Socially Shared Cognition*. American Psychological Association, 127–149.

Conti, Luisa, 2012: *Interkultureller Dialog im virtuellen Zeitalter. Neue Perspektiven für Theorie und Praxis* (Kommunikationswissenschaft 2). Münster: Lit Verlag.

Conti, Luisa, 2020: "Webinare dialogisch moderieren, Partizipation aller fördern". *Interculture Journal* 19(33), 45–65.

Conti, Luisa, 2021: "Caring and Power-Sharing: How Dialogue Influences Community Sustainability". *Journal of Dialogue Studies* 9(1), 34–52.

Conti, Luisa/Mendes de Oliveira, Milene/Nietzel, Barbara, 2022: "A Genuine 'Miteinander': On Becoming a Team in an International Virtual Simulation Game". *Interculture Journal* 36(21), 109–208.

Ehrhardt, Claus/Neuland, Eva, 2021: *Sprachliche Höflichkeit.* Tübingen: Narr Francke Attempto Verlag.

Goffman, Erving, 1967: "On face-work". In: Goffman, Erving (ed.): *Interaction Ritual.* New York: Routledge, 5–45.

Golato, Andrea/Betz, Emma, 2008: "German ach and achso in Repair Uptake: Resources to Sustain or Remove Epistemic Asymmetry". *Zeitschrift für Sprachwissenschaft* 27(1), 7–37, retrieved 13.6.2022 from DOI https://doi.org/10.1515/ZFSW.2008.002.

Grønkjær, Mette/Curtis, Tine/De Crespigny, Charlotte/Delmar, Charlotte, 2011: "Analysing Group Interaction in Focus Group Research: Impact on Content and the Role of the Moderator". *Qualitative Studies* 2(1), 16–30, retrieved 13.6.2022 from DOI https://doi.org/10.7146/qs.v2i1.4273.

Haugh, Michael/Chang, Wei-Lin M., 2015: "Understandingim/Politeness Across Cultures: an International Approach to Raising Sociopragmatic Awareness". *International Review of Applied Linguistics in Language Teaching* 53(4), 389–414, retrieved 13.6.2022 from DOI https://doi.org/10.1515/iral-2015-0018.

Heritage, John/Raymond, Geoffrey, 2005: "The Terms of Agreement: Indexing Epistemic Authority and Subordination in Talk-in-Interaction". *Social Psychology Quarterly* 68(1), 15–38, retrieved 13.6.2022 from DOI https://doi.org/10.1177/019027250506800103.

Imo, Wolfgang, 2016: "Dialogizität–eine Einführung". *Zeitschrift für germanistische Linguistik* 44(3), 337–356, retrieved 13.6.2022 from DOI https://doi.org/10.1515/zgl-2016-0019.

Mendes de Oliveira, Milene (2023). English as a Lingua Franca and Interculturality: Navigating Structure-and Process-oriented Perspectives in Intercultural Interactions. Language and Intercultural Communication, 1–13. https://doi.org/10.1080/14708477.2023.2254285

Mendes de Oliveira, Milene/Tuccillo, Mario Antonio, 2024: Intercultural Learning as an Interactional Achievement in a Digital Space. In: Conti, Luisa/Lenehan, Fergal: Lifewide Learning in Postdigital Society: Shedding Light on Emerging Culturalities. Transcript Verlag

Meyerson, Debra/Weick, Karl E./Kramer, Roderick Moreland, 1996: "Swift trust and temporary groups". In: Kramer, Roderick/Tyler, Tom R. (eds.): *Trust in Organizations: Frontiers of Theory and Research.* London: Sage Publications, 166–195, retrieved 13.6.2022 from DOI https://doi.org/10.4135/9781452243610.n9.

Robert, Lionel P./Dennis, Alan R./Hung, Yu-Ting Caisy, 2009: "Individual Swift Trust and Knowledge-based Trust in Face-to-Face and Virtual Team Members". *Journal of Management Information Systems* 26(2), 241–279, retrieved 13.6.2022 from DOI https://doi.org/10.2753/MIS0742-1222260210.

Schneider, Barbara, 2007: "Power as Interactional Accomplishment: An Ethnomethodological Perspective on the Regulation of Communicative Practice in Organizations". In: Zachry, Mark/Thralls, Charlotte (eds.): *Communicative Practices in Workplaces and the Professions: Cultural Perspectives on the Regulation of Discourse and Organizations.* New York: Baywood Publishing, 181–201.

Selting, Margaret/Auer, Peter/Barth-Weingarten, Dagmar/Bergmann, Jörg/Bergmann, Pia/Birkner, Karin/Couper-Kuhlen, Elizabeth/Deppermann, Arnulf/Gilles, Peter/Günthner, Susanne/Hartung, Martin/Kern, Friederike/Mertzlufft, Christine/Meyer, Christian/Morek, Miriam/Oberzaucher, Frank/Peters, Jörg/Quasthoff, Uta/Schütte, Wilfried/Uhmann, Susanne, 2011: "A System for Transcribing Talk-in-Interaction: GAT 2". *Gesprächsforschung: Online-Zeitschrift zur verbalen Interaktion* 12, 1–51.

Stang, Alexandra/Zhao, Qian, 2020: "Gestaltung virtueller kollaborativer Teamarbeit am Beispiel des Planspiels Megacities. Konsequenzen für die Moderation aus deutsch-chinesischer Perspektive". *Interculture Journal: Online-Zeitschrift für interkulturelle Studien* 19(33), 27–43.

Stegbauer, Christian, 2002: *Reziprozität: Einführung in soziale Formen der Gegenseitigkeit.* Wiesbaden: Westdeutscher Verlag.

Stevanovic, Melisa/Peräkylä, Anssi, 2012: "Deontic Authority in Interaction: The Right to Announce, Propose, and Decide". *Research on Language and Social Interaction* 45(3), 297–321, retrieved 13.6.2022 from DOI https://doi.org/10.1080/08351813.2012.699260.

Stivers, Tanya, 2005: "Modified Repeats: one Method for Asserting Primary Rights From Second Position". *Research on Language and Social Interaction* 38(2), 131–158, retrieved 13.6.2022 from DOI https://doi.org/10.1207/s15327973rlsi3802_1.

Stivers, Tanya/Mondada, Lorenza/Steensig, Jakob, 2011: "Knowledge, Morality and Affiliation in Social Interaction". In: Stivers, Tanya/Mondada, Lorenza/Steensig, Jakob (eds.): *The Morality of Knowledge in Conversation.* Cambridge: Cambridge University Press, 3–24.

van Dijk, Jan, 2006: *The Network Society* (Second Edition). London: Sage Publications.

Beatrix Kreß

„I definitely feel like I have become very germanized in a lot of ways": Zur Darstellung kultureller Erfahrung durch Expatriate Youtuber*innen

Abstract English: Numerous vloggers on YouTube have profiles that identify them as cultural, bi- or intercultural. Having immigrated from a different culture and/ or feeling a belonging to another cultural origin, they address experiences of difference with the current surrounding culture. Based on two comparable YouTube profiles, the article elaborates on essential linguistic means that the respective vloggers use to explain learning processes, but also to present themselves. With the help of pragmalinguistic procedures derived from speech action-oriented discourse analysis and functional pragmatics, linguistic practices and patterns are analytically presented that appear essential for the intentions pursued by the vloggers in their publicly shared profiles. It becomes apparent that difference as a fundamental condition of these public diaries must be adequately explained. In doing so, it is equally essential to position oneself as an expert who can treat these experiences of difference in a reflective way.

Abstract Deutsch: Zahlreiche Vloggerinnen und Vlogger auf YouTube verfügen über Profile, die sie als kulturell bzw. bi- oder interkulturell ausweisen. Zugewandert aus einer anderen Kultur bzw. sich einer anderen kulturellen Herkunft zugehörig fühlend thematisieren sie Differenzerfahrungen mit der jetzigen Umgebungskultur. Der Beitrag arbeitet anhand zweier vergleichbarer YouTube Profile wesentliche sprachlichen Mittel heraus, die die entsprechenden Vloggerinnen nutzen, um Lernprozesse darzulegen, aber auch, um sich darzustellen. Mit Hilfe pragmalinguistischer Verfahren, die sich aus der sprechhandlungsorientierten Gesprächsanalyse und der Funktionalen Pragmatik ableiten lassen, werden sprachliche Praktiken und Muster analytisch dargelegt, die wesentlich erscheinen für die von den Vloggerinnen verfolgten Intentionen ihrer öffentlich geteilten Profile. Es zeigt sich, dass Differenz als grundlegende Bedingung dieser öffentlichen Tagebücher hinreichend dargelegt werden muss. Dabei ist es ebenso wesentlich, sich

selbst als Expertin zu positionieren, die diese Differenzerfahrungen reflektiert behandeln kann.

Keywords: Vlogs, YouTube, Expatriates, Funktionale Pragmatik

1. Einleitung

Der digitale Raum gilt als ein Ort, eine Sphäre, in der interkulturelle Begegnungen ermöglicht bzw. erleichtert werden (vgl. z. B. Lüsebrink 2016: 2; Broszinksy-Schwabe 2017: 4). Andererseits erscheint das Internet von Anfang an auch als transkulturell, Marschall (1999: 151) beschreibt das Internet als „globalen Kommunikationsraum", fragt aber auch danach, ob diese Globalität und kulturelle Breite nicht in den Bereich der frühen Mythen des Netzes zu stellen ist.

Grundsätzlich ist der digitale Raum einer, der allen Personen offensteht, die über entsprechende technische Voraussetzungen verfügen. Technische Voraussetzungen bedeutet in diesem Falle, über die notwendigen Geräte und eine entsprechende Internetverbindung zu verfügen, man könnte aber auch die kommunikativen Kompetenzen, die die Teilhabe ermöglichen, also z. B. Lese- und Schreibfertigkeiten, ebenso wie eine digitale Kompetenz, als grundlegende Bedingung bestimmen.

Der digitale Raum, oft gleichgesetzt mit dem Internet, ist jedoch keine große, in sich ungestaltete Sphäre, in der Nutzerinnen und Nutzer – quasi unsortiert und völlig frei – zusammentreffen. Er ist – vielfach kommerziell – unterteilt in Plattformen und Netzwerke und dadurch ausgeformt. Insbesondere die wirtschaftlich arbeitenden sozialen Medien geben Gestaltungsmöglichkeiten vor, schränken Gestaltung aber auch durch ihre Nutzungsbedingen und durch rechtliche Vorgaben ein, etwa durch urheberrechtliche Restriktionen. In diesem Rahmen entstehen dennoch, u. a. durch kollaborative Prozesse, neue kommunikative Formen, die teilweise zwar auf außerhalb des digitalen Mediums oder Raums entwickelten oder diesem vorgängigen basieren, die aber hier eine spezifische Konturierung erfahren. Daneben lassen sich aber auch völlig neue Ausformungen des kommunikativen Austauschs finden, die die medienspezifischen Potenziale ausnutzen (vgl. Androutsopoulos 2005: 118). In der Sprachwissenschaft wird dies in der Gesprächs-, Text- und Medienlinguistik

verhandelt und der Frage nachgegangen, inwiefern prädigitale Text- und Gesprächsformen als Vorbilder für die im Netz geschaffenen kommunikativen Möglichkeiten dienen und wo tatsächlich Neues entsteht (vgl. z. B. Meier 2002, Meier 2012 zu Brief, E-Mail und SMS). Dabei stehen zwei zentrale Perspektiven im Vordergrund. Eine betrifft die Frage nach der Form bzw. den Formen der Kommunikation, ihren potentiellen Vorläufern und ihrer Musterhaftigkeit bzw. Reproduzierbarkeit. Begrifflich wird dies oft über Textsorten, Textarten, Texttypen oder auch kommunikative Gattungen und dazugehörige Muster erfasst. Die zweite Perspektive betrifft die „mediale"[1] Differenzierung zwischen Mündlichkeit und Schrift(lichkeit) sowie die oft mitverhandelte, aber nicht gleichzusetzende Grundunterscheidung zwischen Text und Diskurs (vgl. hierzu z. B. Androutsopoulos 2007). Hier geht es darum, inwieweit das mediale bzw. digitale Setting die beiden Realisierungsformen von Sprache – mündlich oder schriftlich – beeinflusst und wie die Zwecke von Texten und Diskursen umgesetzt werden.

Grundsätzlich nutzen Teilnehmerinnen und Teilnehmer den digitalen Raum, um miteinander oder über sich selbst zu sprechen und greifen dabei auf ihr sprachliches Wissen und ihre kommunikative Erfahrung zurück. Es bilden sich so wiederkehrende und wiedererkennbare Strukturen heraus, die als Ethnokategorien (vgl. z. B. Günthner/König 2016: 177) zumeist auch eine Bezeichnung finden, die diese Praxis beschreibt. *Hauls*, *Tutorials*, *Unboxing* Videos, *POVs* und *TrustTheProcess* sind nur einige Gattungen die sich auf unterschiedlichen Plattformen wie YouTube oder TikTok etablieren.

In Anbetracht dieses digitalen Dispositivs der Partizipation und der Emergenz unterschiedlicher, typischer kommunikativer Formen sind die bei YouTube verfügbaren Videos (und inzwischen auch zahlreichen

1 Die mündliche Face-to-Face-Interaktion gilt als einzige nicht mediale Kommunikationsform, die Schrift schon als technisch vermittelte und somit mediale Kommunikation (vgl. hierzu z. B. Metten 2014: 111). Im Rahmen dieses Beitrags soll allerdings nicht die linguistische Konzeption von Medialität (ebd.: 110) diskutiert werden. Im Vordergrund steht nicht die Medialität der diskutierten Beiträge, sondern die dort verwendeten Muster zur Bearbeitung kultureller Erfahrungen.

Shorts), die sich kulturellen Erfahrungen widmen, ein Zeichen für die
Relevanz des Themas im digitalen Raum. Dabei nutze ich im Folgenden
die Selbstzuschreibungen der von mir betrachteten Personen, die Kul-
tur als Kategorisierung und Deutungshorizont für ihre Erlebnisse und
Erzählungen nutzen und dabei letztlich auf eine nationale Zugehörig-
keit referieren. Interkulturalität wird im digitalen Raum also nicht nur
praktiziert (im oben angesprochenen Sinne der Begegnung und des Aus-
tauschs von Zugehörigen verschiedener Kulturen), sondern auch auf einer
Art Metaebene be- und verhandelt. Wenn ich also in diesem Beitrag von
Interkulturalität spreche, dann meine ich zwar einerseits die konkrete
interkulturelle Überschneidungssituation und das dabei Entstehende (vgl.
Földes 2009: 517), aber auch die bei Lüsebrink (2016: 8) angesprochene
„mediatisierte" interkulturelle Kommunikation als ein abstraktes Spre-
chen über Kultur und Interkulturalität. Gegenstand des folgenden Bei-
trags sollen die sprachlichen Formen von YouTuberinnen und YouTubern
sein, die eine ethnisch-national geformte kulturelle Identität nutzen, um
ihre von dieser Warte als kulturell andersartig eingeordneten Erfahrun-
gen zu thematisieren. Dies schließt an die Frage an, welche Rückschlüsse
aus der sprachlichen Darstellung auf das Bild von Kultur und Interkultur-
alität gezogen werden können, wie also die Tiefenstrukturen hinter der
sprachlichen Form aussehen könnten.

2. Expatriate Vlogs bei YouTube

Als Ethnokategorie, also als Alltagsbegrifflichkeit und -konzept, das für
die Zuordnung eines einzelnen Textes oder Diskursfragments zu einer
bestimmten Gruppe von Texten oder Diskursen steht (vgl. z. B. Gün-
thner/Knoblauch: 1997; Stehr 1998: 54) hat sich für die in Frage stehende
Konstellation unter anderem das Culture-Shock-Video und die dem nahe-
stehenden „Weird things" und „Don't do this in X"-Videos bei YouTube
etabliert. Bereits die Titel, die ich etwas verallgemeinern musste, machen
deutlich, dass es sich hier nicht um eine Gattung handelt, die ähnlich
eindeutig ist wie das „Unboxing"-Video. Darüber hinaus tangieren die
Videos zwar offensichtlich kulturelle Inhalte, sie sind aber mindestens
ebenso offensichtlich nicht völlig ernst gemeint. Auf die Spitze treiben die-
sen humoristischen Umgang mit kultureller Fremdheit inzwischen auch

einige Vlogger*innen, die in Kurzvideos kleine Serien etablieren, etwa der Influencer Liam Carps mit seinem Kanal *liamcarps* mit „In Germany we don't say..." oder Uyen Ninh, die in Kurzvideos vietnamesische oder deutsche „Kuriositäten" aufgreift und humoristisch übertreibt.

Hinter diesen Beiträgen stehen allerdings häufig Vloggerinnen und Vlogger, die als Expatriates, also als freiwillig und ggf. auf Zeit migrierte Personen (vgl. Moosmüller 2007: 480), ihre kulturellen Erfahrungen verarbeiten und das oft auch in längeren, durchaus ernsthaften Videos. Von diesen Videos als videografierte Tagebucheinträge zu sprechen, wie das Vloggen (analog zum Bloggen) definiert wird, wird ihnen insofern nicht ganz gerecht, als dass diese Videos oft nicht einfach ein wenig zweckgerichtetes Sprechen über das eigene Erleben dokumentieren (vgl. hierzu Runschke: 2020), sondern thematisch zentriert und vorkonzipiert sind. Auch kommen Schnitte zum Einsatz, so dass die Videos flüssig gesprochen und vorbereitet erscheinen, wenn auch nicht abgelesen.

Aus der Vielzahl der sich kulturell bzw. interkulturell verstehenden Vlogger*innen wurden für diesen Beitrag zwei in Deutschland lebende Expatriates ausgewählt, deren biographische Hintergründe – soweit bekannt – bis auf kleinere Unterschiede vergleichbar sind. Die Hintergründe sind teilweise der Kanalinformation entnehmbar, wurden aber auch aus den Videos rekonstruiert. Antoinette Emily[2] ist eine im südlichen Deutschland lebende Neuseeländerin, verheiratet und Mutter dreier Kinder. Hayley Alexis[3] ist eine aus Florida stammende US-Amerikanerin, die einen deutschen Partner hat und im Süden Deutschlands lebt.

Ich nutze den Expatriate-Begriff, da sich beide Vloggerinnen an unterschiedlichen Stellen als solche identifizieren. Er scheint mir auch dahingehend passend, dass es sich um eine Migration handelt, die nicht aus existenziellen Gründen erfolgt (vgl. Moosmüller 2007: 480), auch wenn offen ist, ob sie zeitlich begrenzt oder dauerhaft ist. Die Vloggerinnen beschreiben ihren Kanal als eine Dokumentation interkultureller Erfahrungen, so schreibt z. B. Antoinette Emily in der Kanalinfo: „Expat adventures/ramblings, German & New Zealand culture (...) Bi-cultural

2 https://www.youtube.com/@AntoinetteEmily/about; letzter Zugriff 30.11. 2022.
3 https://www.youtube.com/@HayleyAlexis/about; letzter Zugriff 30.11.2022.

relationships & marriage". Hayley Alexis wiederum charakterisiert ihren Kanal wie folgt „I upload videos to Youtube about comparisons, differences, funny stories and my everyday life in Germany." Beide zählen also unterschiedliche Themen und Facetten einer sich kulturell[4] identifizierenden Person auf, die in ihren Videos über – wieder kulturell eingeordnete – Erfahrungen von Andersartigkeit sprechen möchten.

Neben der Vergleichbarkeit der biographischen Hintergründe wurden die beiden Vloggerinnen vor allem ausgewählt, weil sie regelmäßig mit Videos bei YouTube in Erscheinung treten, nämlich ca. ein bis zwei Mal pro Woche. Sie haben zwischen 50.000 und 100.000[5] Abonnent*innen. Die Videos sind immer zwischen ca. zehn und 20 Minuten lang und haben einen thematisch zentrierten Titel. Die Konzentration auf zwei weibliche Vloggerinnen mit nur minimaler biographischer Varianz führt dazu, dass die in den Daten auftretenden sprachlichen Formen über eine gewisse Plausibilität verfügen, sie haben dadurch aber auch nur eine eingeschränkte Reichweite: Die Vloggerinnen stehen für eine Wohlstandsmigration, die beruflich oder durch persönliche Beziehungen motiviert ist. Zu beachten ist außerdem, dass die Daten institutionell beeinflusst werden, denn die Kommerzialität sozialer Medien spielt auch für die vorliegende Konstellation eine Rolle. Beide Vloggerinnen nutzen bzw. bieten in geringem Umfang *affiliate links* an und verweisen gelegentlich auf Sponsor*innen sowie Unterstützer (Sprachlernapps u.a.) der Videos. Wie inzwischen üblich sind diese Inhalte klar als werbend gekennzeichnet.

3. Fragestellung

Zwei Prämissen wurden einleitend vorausgeschickt: Zum einen, dass der digitale Raum ein Raum ist, der vergleichsweise leicht zugänglich ist und der daher in besonderer Weise das Zusammentreffen von Personen und

4 Kulturell ist hier immer im Wesentlichen national gedeutet, die Vloggerinnen sprechen von Neuseeland, den USA und Deutschland als Bezugspunkte. Ich übernehme hier also eine Kategorisierung, die sich aus dem Material ergibt. Auch wenn diese Deutung des Kulturbegriffs vielleicht zu kritisieren wäre, möchte ich den von den Vloggerinnen selbst gewählten Deutungshorizont hier akzeptieren und für die analytische Betrachtung übernehmen.

5 Am 30.11.2022.

Gruppen ermöglicht, die sich im nichtdigitalen Raum vielleicht nicht begegnen würden. Zum zweiten ist die Beobachtung festzuhalten, dass sich im digitalen Raum Kommunikationen manifestieren, die offenbar Kulturalität und interkulturelles Erleben thematisieren wollen. Diese wiederkehrenden Kommunikationen wurden zunächst als Gestaltungspraktiken des digitalen Raums verstanden und mit dem begrifflichen Komplex der Textsorten, Textarten, und kommunikativen Gattungen verbunden. Diese Begriffe sind Instrumente der Linguistik (und der Soziologie), um repetitive kommunikative Formen zu erfassen und zu klassifizieren. Dieser Zugang ist leicht zu verknüpfen mit der bereits erwähnten ethnotheoretischen Vorklassifikation (vgl. Ehlich 1986: 53–54), die auch als Ethnokategorien bezeichnet werden (s.o.). Was alltagssprachlich wie linguistisch gesehen wird, ist die Existenz wiederkehrender Formen, die „zur Lösung immer wiederkehrender kommunikativer Aufgaben eingesetzt werden" (Günthner/König 2016: 180).

Hinter den oben genannten Begriffen stehen teilweise unterschiedliche Auffassungen von Sprache und sprachlicher Interaktion, sie differieren beispielsweise hinsichtlich der Sicht auf Sprachbenutzer*innen als Individuen oder gesellschaftliche Akteur*innen (zu weiteren Unterschieden s. Redder 2016: 298–299). Was sie eint ist die Annahme, dass Muster (als Gattungen, Textsorten o. ä.) ein Indiz dafür sind, dass Sprecherinnen und Sprecher einer Herausforderung begegnen, die sie sprachlich bewältigen und dass sie im Zuge dieser Bearbeitung sprachliche Formen herausbilden, die sich manifestieren und tradieren und somit von weiteren Akteursgruppen aufgegriffen werden, um eben jener Herausforderung schneller, leichter, effizienter, also kommunikativ „entlastet" begegnen zu können.

Worin aber bestehen die Aufgaben der YouTube-Expatriate-Vlogs? Dies ist eine erste Frage, die an das Datenmaterial herangetragen werden kann. Aus der Literatur können zwei Vorannahmen quasi deduktiv in die Analyse mitgenommen werden. Dies sind einerseits die bereits ausgearbeiteten Funktionen der Selbstdarstellung und der Identitätskonstruktion (vgl. hierzu z. B. Hintz: 2018), die durch das Social Web ermöglicht werden, zum anderen ruft das Vloggen Zwecke auf, die mit dem Verfassen von Tagebucheinträgen verknüpft sind: Das Ordnen von Emotionen und die Verarbeitung sozialer Erfahrung (vgl. Runtschke 2020: 353) sind hier in erster Linie zu nennen. Für das Vloggen, also das Tagebuchschreiben

im digitalen Raum, zählt Wenz (2012: 161–162) auch noch die informie-
rende, die appellierende und die ästhetische Funktion auf.

Es stellt sich aber auch die Frage, welche Formen der sprachlichen
Be- und Verarbeitung die Vloggerinnen finden, um die jeweiligen Inten-
tionen zu verbalisieren. Damit einher geht die Frage nach dem Form-
Funktions-Zusammenhang, welche Tiefenstrukturen also zu welchen
sprachlichen Strukturen an der Oberfläche führen und inwiefern von
sprachlichen Formen auf zugrunde liegende Intentionen, Wissensbe-
stände und andere mentale Operationen geschlossen werden kann. Beide
Fragen – nach den Zwecken und nach der sprachlichen Form – kön-
nen nicht getrennt voneinander beantwortet werden, wenn man einen
Form-Funktions-Zusammenhang annehmen will (vgl. hierzu Ehlich
2017). Sprecherseitig werden sprachliche Mittel funktional eingesetzt, um
Zwecke zu erreichen, analysierendenseitig geben sprachliche Mittel Auf-
schluss über den mentalen Bereich der Sprechenden und die sprecherseitig
verfolgten Intentionen.

Im Folgenden sollen im Wesentlichen vier Videos der zuvor vorgestellten
YouTuberinnen exemplarisch analysiert werden, um den Fragen nach den
Zwecken der Vlogs und den gewählten sprachlichen Formen nachzugehen.
Die Erwartung ist, dass die Analyse auch Aufschluss über die Rolle von
Kultur und Interkulturalität für die Vloggerinnen wie auch über ihre Per-
formanz im digitalen Raum gibt. Zur Analyse nutze ich Kategorien der lin-
guistischen, insbesondere Funktionalen Pragmatik, die entwickelt wurden,
um die Handlungsqualität von Sprache erfassen zu können. Begriffe und
Kategorien werde ich entsprechend im analytischen Vollzug erläutern.

4. Zwecke und Formen des Expatriate-Vloggens

Die Beiträge wurden ausgewählt, weil sie prototypisch für die Vlogge-
rinnen erscheinen, sich daher die Zwecke des entsprechenden Vloggens
exemplifizieren lassen und sich andererseits musterhafte sprachliche For-
men manifestieren. Es handelt sich um Beiträge, die bereits durch ihre
Überschrift anzeigen, dass sie interkulturelle Themen fokussieren. Sie
sind von vergleichbarem Umfang, nehmen aber thematisch jeweils leicht
unterschiedliche Ausgangspunkte und Situationen in den Blick. Es handelt
sich nicht um reine Tagebucheinträge, die in den beiden Kanälen oft als

Updates oder Chats gehandhabt und teilweise in eine eigene Rubrik sortiert werden. Ausgeschlossen habe ich auch Beiträge, die sich vergleichsweise konkreten Themen widmen, also beispielsweise Nahrungsmitteln oder Konsumgütern, die in einer der beiden Bezugskulturen nicht erhältlich sind, sprachlichen Kuriositäten oder landeskundlichen bis politischen Überlegungen zum Gesundheits- und Bildungssystem. Die ausgewählten Beiträge beziehen sich auf jeweils unterschiedliche kulturelle Konstellationen – der Fokus liegt entweder auf der Herkunfts- oder der neuen Umgebungskultur. Daneben geht es um recht konkrete Situationen, aber auch um Selbstbeobachtungen im Hinblick auf längerfristige Veränderungen.

Ich möchte im Folgenden einige ausgewählte sprachliche Verfahren vorstellen, die Hinweise geben auf die mit den Beiträgen verfolgten Zwecke. Ich greife dabei auf die Videos und die automatisch erzeugten Transkripte zurück, die ich überarbeitet und korrigiert habe. Ich gebe das Transkript mit Zeitstempel[6] wieder und in ausgewählten Fällen auch einen Screenshot der entsprechenden Szene, wenn paraverbale Momente analytisch einzubeziehen sind.

4.1 Differenz beanspruchen

Wie bereits die Kanalinfo beider Kanäle vorgibt, ist die Existenz kultureller Differenz die *conditio sine qua non* für die Existenz der Vlogs. Umso wichtiger ist, dass die Differenz selbst bestätigt wird, indem sie durch eigene Erfahrung angereichert wird und dass diese Erfahrung gleichzeitig auch als nicht marginal hinsichtlich ihrer Folgen für die Betroffenen konstituiert wird. Begrifflich wird dies durch die Videoüberschriften in diesen konkreten Fällen von den Vloggerinnen unterschiedlich angegangen – Hayley Alexis zählt eine Reihe von „awkward situations" (AKWARD (sic!) situations I have in Germany because I'm American) auf, während Antoinette Emily von „REVERSE CULTURE SHOCKS" spricht, also eine Konstellation von deutlich größerer Brisanz aufruft. In beiden Videos werden dann Aufzählungen unterschiedlicher Situationen oder Momente vorgenommen, die sich aus Sicht der Autorinnen der Videos alle unter der jeweiligen Überschrift subsumieren lassen. Das aufzählende Verfahren

6 Um die Lesbarkeit zu verbessern, wurden gelegentlich Zeitstempel entfernt.

selbst ist recht verbreitet in dieser Art von Videos und ebenfalls funktio-
nal zu verstehen (im Sinne gleichrangiger Ereignisse oder Fakten, deren
übergreifende Bedeutung aus dem Zusammenspiel der scheinbar singulä-
ren Entitäten emergiert). Die sprachlichen Verfahren, die in diesen Videos
Differenz veranschaulichen, zeichnen sich aber ebenfalls durch einige
wiederkehrende Verfahren aus. Dies sei beispielhaft an zwei Auszügen
gezeigt:

Hayley Alexis zählt in ihrem Video „AWKWARD situations" unter-
schiedliche Situationen auf, die sie als unangenehm und peinlich bewer-
tet. Sie illustriert jede Situation mit einer relativ konkreten Erzählung, in
der sie kleinere Ausschnitte der Situation und der entsprechenden Dialoge
nachspielt. Abschließend zieht sie zwischen jede Erzählung eine kleine,
resümierend-bewertende Sequenz ein. Der folgende Abschnitt stammt
aus einer dieser Sequenzen, nachdem sie bereits zwei unangenehme Situ-
ationen geschildert hat, zunächst ihre Fehleinschätzung gegenüber einem
Kaminkehrer und nun der Umgang mit Pizza. Dieser bezieht sich einer-
seits auf den Verzehr (mit den Händen/mit Besteck) und andererseits auf
das Teilen einer Pizza. Die Vloggerin schildert den Moment, wie sie im
Restaurant eigentlich noch auf ihre Bestellung wartet und dann auf den
Teller einer anderen Person an ihrem Tisch greift, die gerade ein größeres
Stück Pizza abgeteilt hat:

(1)

I grabbed this person's pizza 7:32 like the little slice put it on my plate 7:35 and
they're looking at me and they're 7:36 like did you not order a pizza yourself
7:38 and I was like i mean 7:40 yeah 7:41 but I just thought that everyone like
7:43 shared a pizza like that's what you do 7:46 right you just take a slice and
they're 7:48 looking at me and they're like no and I 7:50 was like 7:51 you don't
do that here I mean it was a 7:53 good laugh it was a good you know funny 7:56
story to tell now but at the time it was 7:57 one of the most awkward situations
I`ve 7:59 ever been in in my life especially when 8:01 everyone's just sitting there
judging 8:02 you for the lack of manners and it's not 8:05 lack of manners it's
just the manners 8:07 that are 8:09 adequate in the united states are not 8:11
adequate in Germany the next point you 8:14 guys is
Video AWKWARD situations

Ich möchte den besonderen Fokus auf den Abschnitt von 7:41 bis 7:53 aus
Beispiel (1) lenken, den ich unterhalb der Abbildung noch einmal zitiere
und mit der nonverbalen Umsetzung, festgehalten im Screenshot, verbinde.

Abb. 1: It is quite common but I just thought that everyone like...

Abb. 2: ... you don't do that here

7:41 It is quite common but I just thought that everyone like
7:43 shared a pizza like that's what you do
7:46 right you just take a slice and they're
7:48 looking at me and they're like no and I
7:50 was like
7:51 you don't do that here

Die Sprecherin stellt hier durch unterschiedliche Mittel einen maximalen Kontrast her. Zunächst formuliert sie verbal eine Sentenz. Die Sentenz ist ein Umgang mit Wissen, den Ehlich/Rehbein (1977: 54) zuerst für Kommunikation in Bildungskontexten feststellen. Durch den Allquantor „everyone" wird aus dem partikularen Erleben zuvor allgemeingültiges Wissen abstrahiert, was mit „that's what you do" fast in Richtung einer Art – allerdings unterspezifischen – Maxime (ebd.: 58) abgebunden wird. Maximen zeichnen sich gegenüber Sentenzen durch eine explizite „Handlungsorientierung" (ebd.: 60) aus. Gestützt wird die etablierte Regelhaftigkeit durch eine weitere Sentenz, die als verschrifteter Text eingeblendet wird und die den „common sense" und die Allgemeingültigkeit für eine bestimmte Gruppe von Personen hervorhebt: „It is quite common in the USA" (vgl. Abbildung 1). Dies korreliert mit der Personaldeixis von „I just thought" zu „that's what you do". Die Sprecherin etabliert also ein Wissen, das für sie und für Angehörige der US-amerikanischen Kultur Gültigkeit besitzt. Dies wird kontrastiert mit einem „they", das sich auf die in der zuvor erzählten Geschichte anwesenden Anderen bezieht, damit aber auch auf eine nur implizit als Deutsch identifizierbare Menge (they're 7:48 looking at me and they're like no). Dann folgt in 7:50 wieder ein Perspektivwechsel „I was like you don't do that here", geäußert in hoher Stimmlage und mit fragender Intonation. Die Sprecherin zitiert sich selbst und gibt ihre Frage in der erzählten Situation wieder. Die Gegenüberstellung der Personaldeixis *I* (I was like) vs. *you* (you don't do that here) maximiert ebenfalls den Kontrast. Das Personalpronomen 2. Pers. Pl. referiert in diesem Fall auf die Personengruppe, die zuvor mit „they" angesprochen wurde. Hier wird quasi eine Sentenz erfragt, die im Kontrast zu dem zuvor als gültig Behaupteten steht. Damit erhält das „you" und rückwirkend auch das „they" in 7:46 eine Präzisierung des Geltungsbereichs, der schon angelegt ist, von der Gruppe der Anwesenden auf alle Angehörigen der deutschen Kultur. Gestützt wird der sprachlich etablierte Kontrast auch mimisch durch eine zurückgenommene Schrägstellung des Kopfes und ein leichtes Blecken der Zähne, das auch mit dem Ausdruck von Ekel assoziiert werden könnte.

Wissen in Form von Sentenzen zu äußern und dies in Verbindung mit entsprechender Personaldeixis oder anderen Mitteln, die zur Markierung von Zugehörigkeit genutzt werden, um dadurch Differenz oder gar maximalen Kontrast zu etablieren, ist ein sehr häufig genutztes Mittel der Vloggerinnen. Es findet sich beispielsweise auch in leicht abgewandelter Form in einem Szenario, das Antoinette Emily in einem Video zu Kulturschocks erzählt, die sie bei einer Reise mit ihrer Familie nach Neuseeland erlebt und die sie selbst als eine Rückkehr in ihre Herkunftskultur einordnet, indem sie dem Video den Titel NEW ZEALAND REVERSE CULTURE SHOCKS gibt. Sie berichtet von einer gesprächigen Zollbeamtin am Flughafen. Auch hier handelt es sich wieder um eine Episode in einer Aufzählung unterschiedlicher Kulturschocks. Der Bericht über das Erlebnis wird im folgenden Abschnitt (2) schrittweise abgeschlossen, um dann den nächsten Schock erzählen zu können:

(2)
5:54 family and all of that and I was like oh my goodness this is like a customs officer in Germany this would never 5:56 happen the customs officers are so 5:59 serious they barely even look at you let alone smile at you and 6:05 yeah you can imagine I was a little bit 6:07 taken back because i hadn't experienced 6:09 this kiwi hospitality and friendliness 6:12 for so long
Video NEW ZEALAND REVERSE CULTURE SHOCKS

Auch hier werden Sentenzen genutzt, um den Kontrast herzustellen. Das Zeitadverb „never" führt zu dem für Sentenzen notwendigen weiten Gültigkeitsanspruch, gestützt durch „in Germany". Auch die Folgeäußerung beansprucht Allgemeingültigkeit für alle Zollbeamt*innen, was Ehlich/Rehbein (1977: 56) als „diffuse Mundanisierung" bezeichnen: Das Behauptete kann sich durch partikulares Erlebniswissen/Einzelbeobachtungen als falsch erweisen, das schränkt die Gültigkeit jedoch nicht ein, denn diese speist sich aus einem Anspruch auf Verallgemeinerbarkeit des geäußerten Wissens. Dieses Wissen um den ernsten deutschen Zollbeamten wird nicht nur dem neuseeländischen Einzelfall der freundlichen Mitarbeiterin gegenübergestellt, sondern der Kontrast wird durch eine Phrase „kiwi hospitality and friendliness" in eben dieser Weise generalisiert. Auch hier geht die Äußerung mit einer markierten Mimik einher:

Abb. 3: I was like oh my goodness this is like a customs officer in Germany

4.2 Expertise zeigen

Die zuvor gezeigte sprachliche Strategie – das Formulieren eines deutlichen Kontrasts, der Allgemeingültigkeit beansprucht – geht einher mit einem ebenfalls relativ auffälligen und wiederkehrenden Verfahren, dem Beanspruchen von Expertise. Letztlich steckt natürlich bereits in den vorherigen Beispielen und dem darin gezeigten Anspruch auf Gültigkeit ein eben solcher auf das Verfügen über Expertenwissen, dies wird von den Vloggerinnen jedoch auch in unterschiedlicher Weise expliziert. Ein Verfahren ist das Verwenden terminologischer Lexik, die teilweise für die Zuschauer definiert wird.

(3)

1:03 I am going to be sharing some of my 1:05 (.) REVERSE culture shocks (.) so if you don't 1:07 know what reverse culture shock is I think the best way I can describe it is 1:11 if you spend a significant amount of 1:14 time away from your home country a 1:16 country where you maybe grew up where 1:19 you have spent many years of your life 1:21 and then you travel back to that country 1:25 after many years in my case over five 1:27 years and everything feels a little bit 1:30 weird you notice things that you didn't 1:32 notice when you were living there things 1:34 seem really familiar but at the same 1:36 time they don't you feel a little bit 1:38 foreign in your home country and it is 1:41 the weirdest

feeling also when you're 1:44 away for a long period of time things 1:46 change
little things evolve in that 1:48 country and you go back and you're like 1:51
I don't remember that or 1:53 things might stay the same and it's a 1:55 shock
to see that these things are still 1:58 the same for when you're a child so yeah
Video NEW ZEALAND REVERSE CULTURE SHOCKS

Antoinette Emily führt hier den Begriff „reverse culture shock" ein, den
sie bereits im Titel ihres Videos verwendet. Dieser kann als ein interkul-
tureller Fachterminus gelten, der vor allem in der psychologisch orientier-
ten Forschung verwendet wird und wurde (vgl. z. B. Adler 1975). Bevor
sie den Begriff in 1:05 einführt, pausiert die Sprecherin kurz (im Tran-
skript angezeigt durch den in Klammern gesetzten Punkt), ebenso wie
unmittelbar nach seiner Einführung. Sie setzt den Ausdruck damit quasi
in Anführungszeichen und hebt ihn hervor. Dazu trägt auch die deutliche
Emphase auf REVERSE bei, im Transkript angezeigt durch Großschrei-
bung. Damit nutzt Antoinette Emily Verfahren, die beispielsweise Jaki
(2018) für Expert*innen in Wissenssendungen zeigen kann. Im Anschluss
folgt dann die Definition durch die Expertin im Unterschied zu den unwis-
senden Zuschauer*innen („if *you* don't 1:07 know what reverse culture
shock is *I* think the best way *I* can describe it is", Hervorhebung B.K.).
Die dann folgende detaillierte Definition dient dazu, nicht nur Wissen
zu etablieren, sondern auch emotional angereicherte Erfahrung, die den
Expertenstatus der Sprecherin durch die Authentizität des Selbsterlebten,
dem das gesamte Video gewidmet ist, erhöht.

Diese Form der Expertise ist zwar sehr explizit und effizient im Hin-
blick auf den Expertenstatus der Sprecherinnen, weit häufiger sind jedoch
Strategien, die strukturell etwas tiefer angelegt sind. Eine solche ist das
Relativieren der eigenen Aussagen. Diese Strategie erscheint fast gegenläu-
fig zur zuvor beschriebenen Kontrastierung, ergänzt sie jedoch letztlich.
Denn wenn einmal die Differenz durch die Expertin etabliert ist, kann sie
natürlich selbst daran arbeiten, diese wieder zu relativieren. Dies kann
dadurch umgesetzt werden, dass der Geltungsbereich der Behauptung ein-
geschränkt oder erweitert wird:

(4)
10:16 throughout the sentence there's nothing more annoying than when some-
body is like 10:22 interrupting you when you were speaking 10:23 and I think

a lot of us native English 10:26 speakers do this I'm not saying all of 10:28 us
do but a lot of a lot of us do

Video 10 VERY GERMAN THINGS I DO, SINCE LIVING IN GERMANYᴅᴇ

In diesem Video, das Veränderungen der Sprecherin in recht unterschied-
lichem Ausmaß (Bevorzugung bestimmter Speisen, aber auch Kommuni-
kationsverhalten u.ä.) thematisiert, die sie auf einen kulturellen Einfluss
zurückführt, finden sich zahlreiche Relativierungen, wie die eben gezeigte,
oder auch Erweiterungen auf größere Zusammenhänge, z. B. in 3:11[7]
„that's like a very Kiwi[8] sort of English maybe American thing to do".
Interessant ist hier das schrittweise Verfahren („a lot of us, not all of us,
but a lot" und „Kiwi, sort of English, maybe American"), das eine Ein-
zelbeobachtung auf immer weitere kulturell-sprachlich bestimmte Kreise
überträgt. Ein derartig tentatives Vorgehen könnte den Expertenstatus
in Frage stellen, da es als unpräzise, zögerlich u. ä. interpretiert werden
könnte. Es entspricht jedoch einem kommunikativen Verfahren, das
zumindest in den Wissenschaften als Legitimierung und dem Experten-
status eher zuträglich etabliert ist. Das Zulassen von Zweifel, das offene
Kommunizieren des Geltungsbereichs der Erkenntnis sowie das Aufzeigen
der Lücke gilt als typische, vielleicht sogar notwendige Routine, um die
eigene Erkenntnis in der Wissenschaftscommunity adäquat platzieren zu
können und Anerkennung zu erhalten (vgl. z. B. Gloning 2018: 315). Die-
sem folgen hier auch die interkulturellen Vloggerinnen.

Bei Hayley Alexis findet sich ein analoges Verfahren, angereichert noch
durch eine Metakommentierung:

(5)

8:03 it is their duty to go out 8:05 and vote as long as they cast their 8:07 ballot
as long as they throw in their 8:09 vote then they are seen as a good GERMAN
8:11 (.) umbrella term as long as they're doing 8:13 everything that you're sup-
posed to be 8:14 doing to be a good citizen

Video HOW I HAVE CHANGED SINCE LIVING IN GERMANY (update)

7 Der zitierte Abschnitt liegt zwischen den in (3) und (4) zitierten längeren Pas-
 sagen.
8 Der Ausdruck *Kiwi/Kiwiana* wird genutzt, um prototypische neuseeländi-
 sche („iconic New Zealand elements") Gegenstände und Verhaltensweisen zu
 bezeichnen (vgl. https://en.wikipedia.org/wiki/Kiwiana).

Auch in diesem Video geht es um die Veränderungen der Sprecherin. An dieser Stelle spricht sie über Patriotismus und den Verfassungspatriotismus der Deutschen im Vergleich zum US-amerikanischen Patriotismus. Sie beurteilt im Verlaufe des Videos viele ihrer deutschen Eigenschaften – die im Titel dieses Beitrags angesprochene „Germanization" – als positiv. Insofern ist der „good German", über den sie an der zitierten Stelle spricht und der seinen Patriotismus auslebt, indem er zur Wahlurne geht, sprecherseitig positiv evaluiert. Dennoch schiebt sie, durch eine kurze Pause und die vorherige Emphase auf GERMAN leicht hervorgehoben, den Metakommentar „umbrella term" ein, der die von ihr gewählte sprachliche Form beurteilt, aber auch deren Geltung.

In den hier genutzten Videos, aber auch in weiteren Vlogs, finden sich zahlreiche analoge Verfahren, aber auch solche, die die Expertise noch in anderer Weise stärken. So werden beispielsweise historische Daten und Ereignisse als Belege des Gesagten ergänzt, auf externe Quellen zurückgegriffen, aber auch Expertinnen und Experten zitiert oder gar interviewt. Die sprachliche Beanspruchung von Differenz wie auch von Expertise sind somit zentrale Verfahren der vorliegenden Gattung bzw. Textart interkultureller Vlogs.

5. Einordnung und Fazit

Es finden sich zweifellos noch zahlreiche weitere sprachliche Verfahren in Vlogs von Expatriates, die als musterhaft und damit gattungsbestimmend gelten können. Klar ist auch, dass die Videos ebenso den für andere Darstellungsformen im Netz ausgearbeiteten wie auch dem privaten Tagebuch entsprechenden Zwecken dienen. Die Vloggerinnen informieren über die Kulturen, auf die sie sich beziehen. Sie nutzen die Beiträge weiterhin, um Erfahrungen zu verarbeiten und sich selbst zu präsentieren. Auch ästhetische Funktionen lassen sich finden, so vage die Bestimmung dieser Funktion sein mag. Der Einsatz von Musik, Bildern und die explizite Referenz der Sprecherinnen auf die Räumlichkeiten, in denen sie die Videos drehen, verbunden mit der Frage, welche Hintergründe die Zuschauer präferieren, deutet darauf hin, dass die Vloggerinnen hier etwas inszenieren, was auch unterhaltsam und ansprechend sein soll. Einer intensiveren Betrachtung wäre auch das Potential appellierenden Sprechhandelns in diesem

Kontext wert. So geht es den Expatriates auch darum zu beraten und zu unterstützen. Antoinette Emily postet beispielsweise ein Video mit dem Titel SIMPLE WAYS TO IMPROVE YOUR LIFE IN GERMANY AND FEEL HAPPIER[9].

Mir ging es in diesem Beitrag aber darum, zunächst einmal zwei ganz wesentliche Verfahren aufzuzeigen, die das Expatriate-Vloggen und damit in Teilen auch das interkulturelle Vloggen kennzeichnen. Die Inanspruchnahme von Differenz durch das Herstellen eines möglichst deutlichen Kontrasts ist letztlich der Ausgangspunkt dieser Art des Vloggens. Gäbe es keinen kulturellen Kontrast bzw. wäre dieser in Zweifel zu ziehen, verlöre sich wohl Vieles von dem, was den Vloggerinnen am Herzen liegt. Die Differenz ist somit der Ausgangspunkt, aber auch der rechtfertigende Hintergrund und sie muss daher immer reklamiert werden; vermutlich auch deshalb, weil alternative Konzepte von Kulturalität und kultureller Differenz, die den Fokus von der Differenz weglenken – Multioder Transkulturalität bspw. – inzwischen in das alltägliche Bewusstsein diffundieren. Es ist dabei durchaus interessant, dass hierfür sprachliche Verfahren gewählt werden – Sentenzen – die aus Bildungskontexten, und zwar vor allem aus schulischer Kommunikation, bekannt sind.

Ist die Differenz etabliert, können die Vloggerinnen aber auch auf alternative Sichtweisen referieren, indem sie den Geltungsanspruch wieder relativieren bzw. ihn ausdifferenzieren: „Nicht für alle X gilt" oder aber „Was für X gilt, gilt auch für Y". Mit diesen Verfahren differenziert sich die Selbstdarstellung hinsichtlich des Expertenstatus der Vloggerinnen weiter aus, sie reflektieren implizit Konzepte kultureller Diversität und nutzen dabei sprachliche Mittel, die wiederum in der Wissenschaftskommunikation etabliert sind.

Sowohl das Etablieren von Differenz als auch die Inanspruchnahme von Expertise sind musterbildend für die vorliegenden Kommunikate. Angesichts der Platzierung im digitalen Raum, in einem sozialen Medium, sind sie auch deshalb elementar, weil sie großes Immunisierungspotential bieten gegen die potentiell in diesem Raum immer zu erwartende Kritik.

9 SIMPLE WAYS TO IMPROVE YOUR LIFE IN GERMANY AND FEEL HAPPIER DE Tips from a New Zealand Expat. https://www.youtube.com/watch?v=_AvGSa4xOuo; letzter Zugriff 30.11.2022

Ein Blick in die Kommentare, die in diesem Beitrag nicht berücksichtigt wurden, zeigt, dass es durchaus zu vereinzeltem Widerspruch kommt. Die Differenz zunächst als gültig zu etablieren und sie dann gewissermaßen selbst wieder zu relativieren erscheint vor diesem Hintergrund wie eine Art Doppelstrategie, um sich antizipierend gegen Kritik zu immunisieren.

Bibliografie

Adler, Peter S., 1975: „The Transitional Experience: An Alternative View of Cultureshock." *Journal of Humanistic Psychology* 15 (4),13–23. Retrieved from https://doi.org/10.1177/002216787501500403.

Androutsopoulos, Jannis K., 2005: „Online-Magazine und Co. Publizistische Nischenangebote im Internet." In: Runkehl, Jens/Schlobinski, Peter/Siever, Thorsten (Hrsg.): *Websprache.net. Sprache und Kommunikation im Internet*. Berlin: De Gruyter, 98–131.

Androutsopoulos, Jannis K., 2007: „Neue Medien – Neue Schriftlichkeit?" *Mitteilungen des Deutschen Germanistenverbandes*, 72–97.

Broszinksy-Schwabe, Edith, 2017: *Interkulturelle Kommunikation. Missverständnisse und Verständigung* (2. Auflage). Wiesbaden: Springer VS.

Ehlich, Konrad, 1986: „Die Entwicklung von Kommunikationstypologien und die Formbestimmtheit des sprachlichen Handelns." In: Kallmeyer, Werner (Hrsg.): *Kommunikationstypologie*. (Jahrbuch des Instituts für deutsche Sprache 1985). Düsseldorf: Schwann, 47–72.

Ehlich, Konrad, 2017: „Zur Funktionalität von Form. Versuch." In: Krause, Arne/Lehmann, Gesa/Thielmann, Winfried/Trautmann, Caroline (Hrsg.): *Form und Funktion*. Festschrift für Angelika Redder zum 65. Geburtstag. Berlin: De Gruyter.

Ehlich, Konrad/Rehbein, Jochen, 1977: „Wissen, kommunikatives Handeln und die Schule." In: Goeppert, Herma C. (Hrsg.): *Sprachverhalten im Unterricht. Zur Kommunikation von Lehrer und Schüler in der Unterrichtssituation*. München: Wilhelm Fink Verlag, 36–114.

Földes, Czaba, 2009: „Black Box ‚Interkulturalität'. Die unbekannte Bekannte (nicht nur) für Deutsch als Fremd-/Zweitsprache Rückblick, Kontexte und Ausblick." *Wirkendes Wort* 59 (3), 503–525.

Gloning, Thomas, 2018: „Wissensorganisation und Kommunikation in den Wissenschaften". In: Birkner, Karin/Janich, Nina (Hrsg.): *Handbuch Text und Gespräch*. Berlin: De Gruyter, 344–371.

Günthner, Susanne/Knoblauch, Hubert, 1997: „Gattungsanalyse". In: Hitzler, Ronald/Honer, Anne (Hrsg.): *Sozialwissenschaftliche Hermeneutik: eine Einführung*. Wiesbaden: VS Verlag für Sozialwissenschaften, 281–307.

Günthner, Susanne/König, Katharina, 2016: „Kommunikative Gattungen in der Interaktion: Kulturelle und grammatische Praktiken im Gebrauch". In: Deppermann, Arnulf/Feilke, Helmuth/Linke, Angelika (Hrsg.): *Sprachliche und kommunikative Praktiken*. (Jahrbuch des Instituts für Deutsche Sprache 2015), Berlin/Boston: De Gruyter, 177–203. Retrieved from https://doi.org/10.1515/9783110451542-008.

Hintz, Elisabeth, 2018: *Kommunikationsarbeit im Social Web. Die Social Community als Schauplatz kommunikativ erbrachter Identitätsarbeit*. Weinheim: Beltz.

Jaki, Sylvia, 2018: „Terms in Popular Science Communication: The Case of TV Documentaries". *HERMES – Journal of Language and Communication in Business 58*, 257–272. Retrieved from https://doi.org/10.7146/hjlcb.v0i58.111689.

Lüsebrink, Hans-Jürgen, 2016: *Interkulturelle Kommunikation. Interaktion, Fremdwahrnehmung, Kulturtransfer* (4. Auflage). J.B. Stuttgart: Metzler.

Marschall, Stefan, 1999: „Das Internet als globaler Raum öffentlicher medialer Kommunikation?" In: Donges, Patrick/Jarren, Otfried/Schatz, Heribert (Hrsg.): *Globalisierung der Medien? Medienpolitik in der Informationsgesellschaft*. Wiesbaden: VS Verlag für Sozialwissenschaften, 151–169, retrieved from https://doi.org/10.1007/978-3-322-83329-7_10.

Meier, Jörg, 2002: „Vom Brief zur E-Mail. Kontinuität und Wandel". In: Ziegler, Arne/Dürscheid, Christa (Hrsg.): *Kommunikationsform E-Mail*. Tübingen: Stauffenburg, 9–32.

Meier, Jörg, 2012: „Kommunikationsformen im Wandel. Brief – E-Mail – SMS". *WerkstattGeschichte 60*, 58–75.

Metten, Thomas, 2014: *Kulturwissenschaftliche Linguistik. Entwurf einer Medientheorie der Verständigung*. Berlin/Boston: De Gruyter.

Moosmüller, Alois, 2007: „Lebenswelten von Expatriates". In: Straub, Jürgen/Weidemann, Arne/Weidemann, Doris (Hrsg.): *Handbuch Interkulturelle Kommunikation und Kompetenz: Grundbegriffe – Theorien – Anwendungsfelder*. Stuttgart/Weimar: Metzler, 480–488.

Redder, Angelika, 2016: „Theoretische Grundlagen der Wissenskonstruktion im Diskurs". In: Killian, Jörg/Brouër, Brigt/Lüttenberg, Dina (Hrsg.): *Handbuch Sprache in der Bildung*. Berlin: De Gruyter, 297–318.

Runschke, Kerstin, 2020: *Das private Tagebuch Jugendlicher: Textualität und Stil von Tagebucheinträgen. Eine mikroanalytische Untersuchung*. Berlin: Peter Lang.

Stehr, Johannes, 1998: *Sagenhafter Alltag: über die private Aneignung herrschender Moral*. Frankfurt/New York: Campus Verlag.

Wenz, Kathrin, 2012: „Entstehung neuer Textsorten im Internet – Überlegungen am Beispiel des Webblogs". In: Bedijs, Kristina/Heyder, Karoline H. (Hrsg.): *Sprache und Person im Web 2.0. Linguistische Perspektiven auf YouTube, SchülerVZ & Co.* (Hildesheimer Beiträge zur Medienforschung, Bd. 1). Berlin: LIT Verlag, 153–170.

Quellen

Antoinette Emily:

NEW ZEALAND REVERSE CULTURE SHOCKSnz | Finally returning back after 5 years in GermanyDE
https://www.youtube.com/watch?v=36iqSaLKwjA; retrieved 30.11.2022.
10 VERY GERMAN THINGS I DO, SINCE LIVING IN GERMANYde
https://www.youtube.com/watch?v=H5uhDiAe9P0; retrieved 30.11.2022.

Hayley Alexis:

AKWARD situations I have in Germany because I'm American
https://www.youtube.com/watch?v=q4XjimNXm2U; retrieved 30.11.2022.
HOW I HAVE CHANGED SINCE LIVING IN GERMANY (update)
https://www.youtube.com/watch?v=NPYy-iTgpBQ&t=641s; retrieved 30.11.2022.

Adriana Fernandes Barbosa

Positioning in Digital Interactions: Representations of the German Language and its "Culture" on YouTube Text-Based Polylogues

Abstract English: In this paper, I report on how YouTube users react in comment sections to videos on the Goethe Institute's channel that teaches *Landeskunde* in the context of German as a Foreign Language (DaF). I aim to identify how these users position themselves in relation to emergent categories such as "Germans" and "German culture". Based on the analysis of comment threads, I intend to demonstrate how participants of YouTube text-based polylogues (Bou-Franch/Lorenzo-Dus/Blitvich 2012) co-construct their personal and social identities and position themselves in relation to this kind of digital content (Liebscher/Dailey-O'Cain 2008). The results reveal that claims of knowledge about a particular culture are mostly grounded in personal experiences with that culture, even when participants position themselves as not being members of that cultural collective. On the other hand, participants who had no personal experience with the topic discussed in the threads tend to endorse the knowledge shared by the videos and automatically position the institution as the specialist in German culture and language. This helps us reflect on how DaF-teachers and teaching materials should consider learners' personal experiences, including their perceptions of the target language and culture, in order to develop intercultural competence.

Abstract Deutsch: In diesem Beitrag analysiere ich Kommentare zu Videos mit landeskundlichen Inhalten auf dem YouTube-Kanal des Goethe-Instituts, um herauszufinden, wie sich die Nutzer*innen in Bezug auf Kategorien wie „Deutsche" und „deutsche Kultur" positionieren. Anhand einer interaktionalen Analyse von Kommentarthreads möchte ich zeigen, wie die Teilnehmer*innen eines textbasierten YouTube-Polylogues (Bou-Franch/Lorenzo-Dus/Blitvich 2012) ihre persönlichen und sozialen Identitäten ko-konstruieren und sich in Bezug auf diese speziellen digitalen Inhalte positionieren (Liebscher/Dailey-O'Cain 2008). Die Ergebnisse deuten darauf hin, dass die Teilnehmer*innen ihr Wissen über eine bestimmte Kultur meist auf ihren persönlichen Erfahrungen basieren, selbst wenn sie sich als Nichtmitglieder dieser Kultur positionieren. Auf der anderen Seite tendieren

Teilnehmer*innen, die keine persönlichen Erfahrungen mit dem besprochenen Thema haben, dazu, das in den Videos vermittelte Wissen zu akzeptieren und somit die Institution automatisch als die Expertin für die deutsche Kultur und Sprache zu positionieren. Aus diesem Grund bietet es sich an, darüber nachzudenken, wie DaF-Lehrkräfte und Unterrichtsmaterialien die persönlichen Erfahrungen der Lernenden, einschließlich ihrer Wahrnehmung der Zielsprache und -kultur, berücksichtigen sollten, um interkulturelle Kompetenz zu entwickeln.

Keywords: Deutsch als Fremdsprache (DaF), Landeskunde, Positionierung, YouTube Polylogues, Interkulturelle digitale Kommunikation.

1. Introduction

In my work teaching German as a Foreign Language (*Deutsch als Fremdsprache*, hereafter DaF), both in language schools and in a university context, I feel constantly challenged by the topic *Landeskunde*. The challenge always begins by defining "German culture," for this word is polysemic, and the concept is fluid. Most textbooks usually offer the traditional and communicative approaches to *Landeskunde*: teaching facts about geography, history, the political system, social topics, and customs and traditions as well as teaching country- or culture-specific communicative standards such as speech acts, prosody, and gestures through modeling dialogues, role-playing, texts, videos, and the like.

On the other hand, students also understand the term *culture* to include its more abstract elements, such as behaviors and attitudes that would be typical of the "native speaker of German" (usually understood as a person who was born in Germany). Moreover, students who have had the opportunity to visit German-speaking countries, or have interacted with native speakers, tend to conceive "German culture" based on their personal experiences. Therefore, teaching *Landeskunde* becomes a task beyond teaching factual and linguistic information. It is necessary to discuss what culture is, how it is related to language, and how we can deal with cultural differences if there are any.

In this sense, research on the teaching and learning of Foreign Languages (L2) has developed different views on how to approach *interculturality* and even on how to develop L2 learners' intercultural competence. Although research on DaF contemplates other models of interculturality, I will focus

on an intercultural approach[1] that understands culture as complex and diverse, and that considers the heterogeneity, hybridities, and interconnectedness of culture, which shapes people extensively but mostly unconsciously, as in acting, perceiving, thinking, feeling, and evaluating people (Ros 2016: 98). According to Ros (2016: 98), "Kulturen haben einerseits eine statische, konservierende Tendenz, andererseits sind sie dynamisch und entwickeln sich ständig weiter" [On the one hand, cultures have a static, conserving tendency; on the other hand, they are dynamic and constantly evolving].[2] An intercultural approach to DaF should thus consider culture in its ambiguities.

In addition, I will also consider a model of interculturality "that emphasizes the context in which the interaction takes place or rather the interdependencies between participants involved in a particular intercultural communication episode" (Rathje 2007: 255). As Dervin and Jacobsson (2021) state:

> Interculturality can be regarded, from this perspective, as moving beyond stable cultural categorisations as explanations for social behaviour, to analyse and clarify how diversity and difference in the form of, for example, 'cultural' and linguistic background is brought into contexts and made meaningful by those involved in the encounters (Dervin/Jacobsson 2021: 16).

In this view, the participants of an intercultural interaction can position themselves as members (or not) of a particular culture and validate themselves as experts of that culture based on their own perceptions and the interactional context. As Liebscher and Dailey-O'Cain (2008: 248)

1 Such an intercultural approach is already considered in the Common European Framework of Reference (CEFR), which states that building a pluricultural repertoire involves (1) "the need to deal with ambiguity when faced with cultural diversity, adjusting reactions, modifying language, etc. (2) the need for understanding that different cultures may have different practices and norms, and that actions may be perceived differently by people belonging to other cultures; (3) the need to take into consideration differences in behaviours (including gestures, tones and attitudes), discussing over-generalisations and stereotypes; (4) the need to recognise similarities and use them as a basis to improve communication; (5) willingness to show sensitivity to differences; (6) readiness to offer and ask for clarification, anticipating possible risks of misunderstanding" (Council of Europe 2020: 124).

2 All translations are my own unless otherwise noted.

explain, such perceptions function as "construction material" of an identity that serves an interactional purpose.

Therefore, I intend to show how participants of a YouTube text-based polylogue (Bou-Franch, Lorenzo-Dus/Blitvich 2012), namely two comment threads posted on the Goethe Institute's channel, react to the content of two educational videos that address topics on German language and culture. I intend to demonstrate how these participants draw on videos' content and their own experiences to construct their identities, whether as learners or as native speakers of German, while positioning themselves and the other participants (in the comment section and in the videos) as being (non-)specialists in German language and culture.

2. Building identities and positioning in text-based digital polylogues

In order to investigate how participants of YouTube comment threads position themselves as experts or non-experts with respect to German language and culture, we use Liebscher and Dailey-O'Cain's (2008) understandings of identity and positioning, as well as some analytical categories for YouTube text-based polylogues developed by Bou-Franch, Lorenzo-Dus, and Blitvich (2012).

Different research areas, such as ethnomethodology, conversation analysis, and interactional linguistics, have focused on social interaction to explain how people communicate. They are interested, for instance, in the actions organized by individuals concerning the interactional context, seeking to understand how people co-construct their actions sequentially and how they mobilize the resources available during the conversation. In this sense, researchers focus primarily on analyzing oral language-based interactions.

Computer-mediated communication (CMC) analyses have been conducted in both spoken and text-based exchange. Although the word 'conversation' may be primarily related to the spoken word, Herring (2010) points out that textual interactions in media sharing and social network sites are typical examples of computer-mediated "conversations".

> There is much prima facie implicit evidence that text-based CMC is conversation-
> like. In casual parlance, Internet users often refer to textual exchanges as

conversations, using verbs such as 'talked,' 'said,' and 'heard' rather than 'typed,' 'wrote,' or 'read' to describe their CMC activities. Even published authors sometimes refer, unconsciously, it seems, to 'speakers' rather than online 'writers', 'talk' rather than 'typed exchanges', 'turns' rather than 'messages,' and so forth, when reporting on CMC. This linguistic usage attests to the fact that users experience CMC in fundamentally similar ways to spoken conversation, despite CMC being produced and received by written means (Herring 2010: 2).

On the other hand, research (Garcia/Jacobs 1998, Herring 1999) has demonstrated that text-based CMC may function differently from spoken conversations, especially in relation to patterns of turn-taking, such as turn adjacency and overlapping exchanges. The reason for this is that 'communicators' access to a persistent textual record of the interaction enables a different strategy of discourse processing" (Herring 2010: 2).

The data analyzed in this paper, however, involves a particular type of interaction defined by Kerbrat-Orecchioni (2004: 3) as *polylogues* or *multi-participant interactions* (in contrast to dyadic interaction such as dialogues), which includes all types of communicative situations that "gather together several participants, that is, real live individuals." The YouTube text-based interaction, in turn, is a

> sui generis case of polylogal communication – one, furthermore, which is open to public, largely anonymous, multiparticipation for as long as the YouTube video clips that trigger the interaction remains posted. Because of its open, public nature and the highly persistent textual record it generates, YouTube interaction not only tends to involve a sizeable number of participants but also to do so over a prolonged period of time (Bou-Franch, Lorenzo-Dus and Blitvich 2012: 503).

Therefore, YouTube polylogues are a combination of typical dyadic conversation patterns (conversation organized turn by turn) with networked sequences formed by adjacent and non-adjacent turns, as seen in asynchronous interactions.

Based on Bou-Franch, Lorenzo-Dus, and Blitvich's (2012) study of digital, text-based polylogal conversations, I will consider the interactional concepts of participation and adjacencies to demonstrate how a YouTube comment thread can be described as a type of conversation and how its participants use linguistic elements to position themselves in relation to the content of the video that generated the thread.

Bou-Franch, Lorenzo-Dus, and Blitvich (2012) understand participation as comprising the main characteristics that describe the participants

of an interaction, such as the number of participants and the way they interact in the platform (being active or non-active as well as anonymous participants). In a YouTube comment section polylogue, all viewers of a video are considered to be participants in the interaction, even when they are non-active, unknown users. A user will only be regarded as an active participant when posting a comment.[3] This distinction is important because the number of comments posted by these active (message-sending) users provides "a tangible, though admittedly partial, view of the configuration of the participation structure of YouTube polylogues" (Bou-Franch/Lorenzo-Dus/Blitvich 2012: 505). Moreover, it is essential to remember that these active users are aware of the non-active participation of other users (only viewers), and many comments (especially the ones that originate a thread) are, therefore, directed at this more extensive viewership.

The concept of adjacency, in its turn, refers to the sequential organization of the interaction, and its analysis allows us to understand cohesive elements that connect the turns. Bou-Franch, Lorenzo-Dus, and Blitvich (2012: 505) developed a coding system for their YouTube corpus "according to a taxonomy of turn relations which included five categories: adjacent turn, nonadjacent turn, video turn, multiple reference turn, and mixed turn," as follows:

- Video Turn (VT): turn referring to triggering video clip,
- Adjacent Turn (AT): turn referring to immediately prior turn,
- Nonadjacent Turn (NAT): turn that refers to a turn other than the immediately prior one,
- Multiple Turn (MT): turn referring to multiple prior turns,
- Mixed Turn (MXT): turn combining two or more of the above turn-types.

I also applied the following code system for some turn-management devices (Bou-Franch, Lorenzo-Dus and Blitvich 2012, Herring 1999):

3 One can also argue that a viewer is actively participating in the polylogue since they can like or share the video even without posting any comments. But I will consider the concept of active participation only within the comment section.

- Backchannels (BC): short reactions to prior comments and/or to the triggering video clip,
- Cross-Turn Addressivity (CTA): explicitly using a username to select the addressee,
- Cross-Turn Linking (CTL): use of explicit expressions that link a turn to another turn,
- Video Addressivity (VA): turns addressing the video or organizations that host it.

Based on these categories, I scanned the comment sections of two educational videos from the Goethe Institute's YouTube channel, looking for threads that could be analyzed as a short interactional sequence by establishing each comment as a turn and verifying how these turns relate to each other. Once I determined how the comment thread functions regarding their turn-taking system, I could comprehend how the users, being active participants of that polylogue, interactionally co-construct their personal and social identities as well as position themselves (and their interlocutors) in relation to the video content.

The distinction between personal and social identities is based on Liebscher and Dailey-O'Cain's (2008) framework, which considers the relationship between identity, knowledge asymmetries, and positioning in face-to-face interactions. This relationship is important in that speakers may or may not claim authority to certain knowledge based on how they position themselves as someone who is entitled to that knowledge. To put it differently, there are cases "where speakers use some piece of knowledge, but simultaneously display their asymmetrical position of non-entitlement to – or of not being an authoritative source of – that knowledge." (Drew 1991 cited by Liebscher/Dailey-O'Cain's 2008: 247).

Personal identity is related to the accumulation of experiences in life and one's own interpretations of such experiences. These interpretations are made available through interactional and linguistic elements, which help us understand how speakers claim authority over specific knowledge. Some of these elements are direct (e.g., affirmative or negative sentences) and non-direct forms (hedging elements such as "I think", probably, rhetorical questions, etc.) that indicate the relationship of the speaker to that piece of information and their interlocutors.

> These forms correspond, in turn, to the notion of locating the information inside or outside a particular territory, which is analogous to a physical space that can be claimed by a person or animal [...] When a given piece of information falls into the speaker's territory but not the hearer's, the speaker will tend to use the direct form; when a given piece of information falls into the hearer's territory but not the speaker's, the speaker will tend to use an indirect form (Liebscher/Dailey-O'Cain 2008: 250).

The accumulation of speakers' personal experiences, which can be understood as first-hand knowledge, leads them to become aware of their own experience, as well as of the other's, during interaction, co-constructing contextual knowledge. As a result, the speaker builds their social identity by combining the "I" in interaction with social and cultural context since "the cultural context in which conversation participants live makes them aware of such social categories, and this awareness enables them to use these categories as 'construction materials' of social identities for themselves and others, making such information relevant in interaction" (Liebscher/Dailey-O'Cain's 2008: 248).

These identities are made relevant by the speaker through different processes of positioning during interaction. According to Liebscher and Dailey-O'Cain (2008: 248), positioning is "the ways in which interactants index their own and others' relationships to roles and social categories by means of interactive resources. [...] And far from being permanent category memberships, these positionings are always highly context-dependent and often quite temporary." As we will see in the following analysis, social categories like "being a native speaker of German" and "being a learner of German" as well as "having some/lots of immersive cultural experience" and "having no immersive cultural experience" emerge during the interaction among users in the comment threads of the Goethe Institute's YouTube channel. These categories are more or less complementary and are used by the participants to claim authority in terms of knowledge about German culture and language and to validate or contest information presented by the videos that generated the comment thread. Furthermore, the use of direct or indirect forms in the comment threads helps participants to create epistemic or affective stances to position themselves and others in relation to the categories of specialist or non-specialist with respect to German language and culture.

In the following sections, I will describe the data and show how these categories help demonstrate how the participants co-construct their identities as native speakers or learners of German and how they position themselves and their interlocutors as (non-)experts on German language and culture.

3. The Dataset

As set out in section 2, the data for this study were taken from the comments section of two educational videos from the Goethe Institute's channel on YouTube. The selection of these videos was based on three criteria, namely, the topic of the video, its popularity (viewership size) within the channel, and the type of participation in the comment section. With respect to the topic, only videos related to *Landeskunde* (specific cultural content regarding Germany, German language, or German people) were chosen, not those focused on teaching grammar or specific vocabulary.[4] The video's popularity, in turn, was defined by the number of views and comments registered by YouTube. These numbers allowed the participation structure of the polylogue to be determined and active and non-active participation within that specific community to be identified.[5] As for participation, videos were selected in which both proficient/native speakers and beginning learners of German were active participants in the comment section. As we will see in the analysis, these categories emerged in the interaction and are the result of participants' identity-building process and their positioning.

In order to have a mixed sample with respect to language proficiency, I selected one video whose comment section engaged mostly proficient/native speakers and another video that attracted comments from mostly beginning learners of German. The first video *Burgenländisch* is part of the series *Dialekte Hotline* [Dialect Hotline] whose aim is to present the dialects

4 By focusing on grammar/vocabulary, I mean videos whose main purpose is to explain grammar topics or videos to practice thematic vocabulary, such as food, professions, colors, etc.
5 Community is here understood as the users who visit the Goethe Institute's channel.

spoken within German-speaking countries.[6] The video was posted on June 2022 and had by January 2023 over 27,700 views and 59 comments. By YouTube standards, this is not a particularly popular video, but its content engaged lots of proficient/native speakers – given the numerous comments written in German – in comparison to other educational videos from the same channel.[7] Although the video aims at "teaching" German dialects, such content is rather more comprehensible for proficient speakers who are probably the minority of the viewership of the Goethe Institute's channel, which can also explain the discrepancy between the large number of views and the small number of comments with respect to other videos on the same channel. Nevertheless, the relevance of this video lies in the number of participants who position themselves as native speakers, which seemed to be an important aspect when claiming authority to knowledge about German language and culture.

The other video *Im Bus* [On the bus] is the first episode of the series *Mein Weg nach Deutschland* [My path to Germany], which tells the fictional story of Nevin, an immigrant who recently arrived in Germany and is having difficulties with the language and the "German culture."[8] The video was posted in 2013 and is the most popular video within Goethe Institute's Channel, with over 4,6 million views and 1,812 comments by January 2023. It was selected due to its popularity among beginning learners, as evidenced by the large number of comments written in languages other than German, especially in English. Details about the content of the videos will be given in the analysis section.

6 This series is part of the project Deutschland #NoFilter, a website designed "for German learners, German teachers and everyone who is interested in Germany with information from and about German". The idea is to offer "stories about everyday life, career and studies" as well as other content related to "German cities, trends and much more." (Goethe Institute. Available at https://www.goe the.de/prj/ger/en/kon.html).

7 Given the nature of YouTube polylogues, older videos tend to have more views and comments since they have been available for longer. The series *Dialekte Hotline* is rather new in the channel with only four videos, all posted in 2022. So, although they have not reached thousands of comments yet, I consider them relatively popular for this specific community.

8 A typical example of communicative approach to *Landeskunde*.

After selecting the videos, I examined the comment section looking for comments or comment threads that somehow reflected the viewers' opinions regarding the cultural aspects of German language displayed in the videos. Once I identified such content, I narrowed down to those comments that generated a thread, since my main concern was to describe identity and positioning in interaction. The next step was to transcribe the threads into a text editor and edit them to a more reader-friendly version: any pictures used as avatars by the users[9] were removed, and the number of likes the comments received was kept below but without the original icon, which was replaced by the word "like." The time when the comment was posted appears next to the username. The comments were transcribed without correcting grammatical or spelling mistakes. In addition, as some comments were written in German, the translation in English is presented between brackets just after the original text.

4. Analysis

In this section, I will present the analysis of threads posted in the comment section of two different videos from the Goethe Institute's channel on YouTube. The first comments analyzed below refer to the video *Dialekte Hotline: Burgenländisch*,[10] in which the presenter Rahel learns how to speak/pronounce words and short sentences as well as some factual information about Burgenländisch, a dialect spoken in the region of Burgenland in eastern Austria. As mentioned above, the video had by January 2023 over 27,700 views and 59 comments. During the clip, the guest Michi Buchinger, who is from Burgenland, mentioned the word *Pogatscherl*, a typical dish made with potatoes. While he explains the dish as a small *Gebäck*, the video displays the picture of a *Knödel*, a very popular dish in Germany, also made with potatoes. This excerpt ((5:24–5:44)) from the video generates the comment thread shown in Example 1:

9　I preserved the real usernames since the video and its comments were already made public on the YouTube platform.

10　Available at https://youtu.be/6OCen-xuxLg, assessed on 06 January 2023.

Example 1 – *Pogatscherl* is not a *Knödel*

Ádám Perjési | 2 months ago

Oh no, Pogatscherl sind keine Knödel☻ Pogatscherl kommt aus dem Ungarischen (Pogácsa), und ist ein Salzgebäck mit Grammeln oder nur mit Käse Ober drauf☺

[Oh no, *Pogatscherl* aren't *Knödel*. *Pogatscherl* comes from the Hungarian (*Pogácsa*) and is a salty pastry with greaves or only with cheese on the top].

Like: 6

Irene Adler | 2 months ago

Das Burgenland ist auch direkt an der ungarischen Grenze:) da überlappt sich viel. Ich glaub mit Knödel meinte er einfach, dass sie rund und etwas kugelig sind.

[Burgenland is also located right on the Hungarian border:) there's a lot of overlap. I think that, with Knödel, he just meant they are round and somewhat spherical].

Savaş Özdemir | 1 month ago (edited)

Es ist auch "poğaça" auf Türkisch. Sie sagen, dass es kommt aus italienischen Wort focaccia und das Wort kommt aus lateinischen Wort focus (hearth/fireplace)

[It is also "*poğaça*" in Turkish. They say that it comes from Italian word *focaccia* and the word comes from Latin word *focus* (hearth/fireplace)]

Zendra Gallhauser | 1 month ago

@Savaş Özdemir *das burgenländische Wort ist auch mit dem türkischen verwandt*

[the word in Burgenländisch is also related to the Turkish one]

Zendra Gallhauser | 1 month ago

@Irene Adler *nicht nur deswegen das Burgenland gehörte lange zu Ungarn*

[not only because of that, Burgenland belonged to Hungary for a long time]

Savaş Özdemir | 1 month ago

@Zendra Gallhauser *wow, ich wusste das nicht. Danke schön :)*

[wow, I didn't know that. Thank you]

Zendra Gallhauser | 1 month ago

@Savaş Özdemir *hängt mit dem osmanischen Reich zusammen* ☺

[it's connected with the Ottoman Empire]

Example 1 Continued

Zendra Gallhauser | 1 month ago

Die ganze Folge ist irgendwie falsch

So reden eher Wiener und nicht Burgenländer!

Ich sag nicht Heisl sondern Aburt

Ich sag nicht Spritzer sondern Mischung

Ich sag auch nicht Gschissener sondern „hearst knorrata"

Einfach schlecht gemacht das ganze

[The whole episode is somehow wrong

That's how Viennese people talk, not *Burgenlanders*!

I don't say *Heisl* but *Aburt*

I don't say *Spritzer* but *Mischung*

I also don't say *Gschissener* but "*hearst knorrata*"

Simply badly done the whole thing]

The first comment is a Video Turn (VT), which refers directly to the triggering video clip. The user Ádám Perjési mentions the word *Pogatscherl* (Video Addressivity – VA) to explain its Hungarian origin (*Pogácsa*) and to advise that this dish has nothing to do with the German *Knödel*. They[11] first claim that *Pogatscherl* is not a *Knödel*, a statement followed by the See-No-Evil Monkey emoji, whose meaning varies depending on the context but is "often used as a playful way to convey a laughing, disbelieving, cringing I can't believe what I'm seeing! or I can't bear to look!".[12] Next, they describe the origin of the word and what the dish is made of, followed by the Face Savoring Food emoji, implying that he finds the dish tasty. The direct forms used by Ádám Perjési ("*Pogatscherl sind keine Knödel*" [*Pogatscherl* aren't *Knödel*], "*Pogatscherl kommt aus dem Ungarischen*" [*Pogatscherl* comes from the Hungarian]) suggest that this knowledge falls into their information territory, and therefore they position themselves as someone who knows this region and possibly also speaks Hungarian, while positioning the participants of the polylogue, including the ones

11 I use "they" here as a neutral pronoun for all users.

12 All names and definitions of emojis were based on Emojipedia, available at: https://emojipedia.org/

in the video, as not experts of Burgenländisch culture (Liebscher/Dailey-O'Cain's 2008).

Next, we see a sequence of adjacent (AT) and nonadjacent (NAT) turns, all related to Ádám Perjési's comment. The first response is an AT in which the user Irene Adler says that the Burgenland region is directly on the border with Hungary and because of that "there's a lot of overlap" ("*da überlappt sich viel*"), that is, cultural elements of both countries, Austria and Hungary, may be similar due to geographic proximity. Furthermore, they ponder whether the interviewee compared a *Pogatscherl* to a *Knödel* because both are round and spherical. However, Irene Adler used indirect forms, like the expression "*ich glaube*" [I think] and the smiley emoji after the information about the border, which indicates that they do not identify themselves as a native of Burgenländisch. Therefore, Irene Adler positions themselves as someone who is not a specialist in the local culture and chooses to corroborate the information given by the video.

The following response is a NAT posted a month later by the user Savaş Özdemir, who seems to identify themselves as a Turkish speaker. In this Cross-Link Turn (CLT), Savaş Özdemir states that the Hungarian *Pogácsa* corresponds to Turkish *poğaça*, implying that these are similar dishes. Furthermore, they do it so by sharing second-hand knowledge: "*Sie sagen, dass...*" [they say that]. They also added more linguistic information, claiming that the Turkish word comes from the Italian *focaccia*, which in turn comes from the Latin word *focus*. Savaş Özdemir engages actively in the discussion using both direct ("*Es ist auch 'poğaça' auf Türkisch*" [It is also "poğaça" in Turkish]) and indirect forms ("*Sie sagen, dass*"). Although using a direct form, Savaş Özdemir does not claim authority over knowledge about Burgenländisch. They keep themselves in their own information territory, namely the Turkish language.

The next two responses come from the same user Zendra Gallhauser and they are both examples of Cross-Turn Addressivity (CTA), in which Zendra Gallhauser uses the @ to directly address specific users (probably because these responses are NAT). The first CTA is addressed to Savaş Özdemir, in which Zendra Gallhauser states that the Turkish word *poğaça* also bears some resemblance to the Burgenländisch word *Pogatscherl*. The second CTA is addressed to Irene Adler, saying that the linguistic-cultural similarities between Burgenland and Hungary are not only due to their

geographical proximity but also to the fact that this Austrian region once belonged to Hungary. Savaş Özdemir then directly responds to Zendra Gallhauser (CTA), thanking them for the information and saying that they didn't know about these similarities between Turkish and Burgenländisch, reaffirming their positioning as non-specialists in this dialect. Zendra Gallhauser again responds directly (CTA) to Savaş Özdemir, claiming that the linguistic similarities between the Burgenländisch and Turkish go back to the time of the Ottoman Empire.

It is worth noting the use of linguistic signs in combination with emojis in this thread. On one hand, the predominant use of direct forms to communicate facts about geography, history, and linguistics (second-hand knowledge) helps users to create an epistemic stance. On the other hand, the use of emojis reveals that participants are also interested in creating affective stances. The use of emojis, allied with the extensive use of direct forms to share second-hand knowledge, may be interpreted as a form of politeness that preserves the other user's face: Ádám Perjési uses the See-No-Evil Monkey 🙈 after refuting information shared in the video. Irene Adler uses the smiley :) after telling Ádám Perjési that Burgenland is on the Hungary border, and Zendra Gallhauser uses the Grinning Face with Sweat emoji 😅 after telling user Savaş Özdemir about the linguistic connection between Turkish and Burgenländisch. It seems clear that these users are claiming to have knowledge about Burgenland culture/language and that they want the other participants to acknowledge that. Nevertheless, it appears that they also understand that taking an epistemic stance might be perceived as a face-threatening act. Therefore, the use of these emojis functions as softeners (Thaler 2012, Skovholt/Grønning/Kankaanranta 2014) as well as locates text-based communication within an informal context. "By including emojis in a post, the author assures his or her counterpart that he considers the interactional situation as a situation at eye level – even when the counterpart is criticized" (Beißwenger/Pappert 2019).

Nevertheless, just below the thread, we see another comment by user Zendra Gallhauser that is a VT dedicated to criticizing the video. Zendra states that the whole sequence is wrong (*"Die ganze Folge ist irgendwie falsch"* [The whole episode is somehow wrong]), and that the guest Michi does not speak like a native from Burgenland but as someone from Vienna, even if the video introduces Michi as the expert in Burgenländisch, since

he comes from that area and speaks the dialect. Zendra Gallhauser then compares the words used by the interviewee in the video with their own vocabulary, like the following examples:

> Ich sag nicht Heisl sondern Aburt
> *Ich sag nicht Spritzer sondern Mischung*
> *Ich sag auch nicht Gschissener sondern „hearst knorrata"*
> [I don't say Heisl but *Aburt*
> I don't say *Spritzer* but *Mischung*
> I also don't say *Gschissener* but "hearst knorrata"]

The comment ends with a statement of how bad the video was made ("Einfach schlecht gemacht das ganze" [Simply badly done the whole thing]). Once more, the direct form is used to claim knowledge but this time no softeners were used to mitigate face-threating. Based on the dates of Zendra Gallhauser's posts, one can see that this last comment was made at the same time as the responses to user Irene Adler and user Savaş Özdemir. While Zendra Gallhauser chooses politeness strategies in the CTA responses, they assume a rather impolite (face-threatening) tone to criticize the content of the video in the VA comment, using adjectives like "falsch" [wrong] and "schlecht" [bad] to question the Michi's status as a native speaker of Burgenländisch. It may be so due to Michi's commentaries about Burgenländisch compared to Vienna's German. Right in the beginning of the video (00:28-00:41)), the presenter Rahel asks Michi whether Burgenländisch is different from Wienerisch (German spoken in the capital Vienna). Michi answers: "Yes, naturally, because it's from a rural area." and also adds: "The Viennese tend to think of it as being a bit rustic."[13] One might imagine Zendra Gallhauser to have been offended by such comparison and as such chosen to react negatively to the video content.

This last comment positions Zendra Gallhauser as a "true" *Burgenländer* (native of Burgenland) while positioning Michi as a "Wiener" (native of Vienna). By the time the data were collected, there were no responses to this second post. It could be argued that Zendra Gallhauser, when addressing an institutional video, appears not to mind face-threatening

13 I am citing the official English translation from YouTube's video transcript. The word used by Michi was "bäuerlich".

acts and draws on personal experiences (first-hand knowledge) to claim the authority over cultural knowledge, positioning themselves as a true specialist in the Burgenländisch dialect. Conversely, second-hand knowledge and politeness strategies were preferred when interacting directly with other participants.

The next thread refers to the video *Im Bus* [On the bus].[14] As mentioned above, it was posted in February 2013 and had by January 2023 over 4.6 million views and 1,812 comments. This is the first episode of the series *Mein Weg nach Deutschland* [My path to Germany] that was designed as support material for DaF-lessons.[15] The thread I selected refers to some passages in the video, in which Nevin needs the assistance of German citizens who kindly help her to cope with the singularities of public transportation in Germany. The first comment is a VT written by the user *R.B.* It is a sarcastic comment about how friendly everybody in the clip sounds, implying that it is not how strangers would behave in reality.

This comment has had until January 2023 38 responses, two in Russian, one in Spanish, one in Italian, and one that is illegible, probably due to a language-setting problem in the browser. I considered for analysis only the 33 responses written in English and those using non-verbal communication. I will first show the whole thread as it appears on the YouTube page with all the comments organized in a linear and chronological fashion, in which the oldest ones are located above, and the more recent ones are below. Then, I will analyze only the most relevant examples, organized according to the turn-management devices discussed in section 2, namely Backchannels and Addressivity devices.

14 Available at https://youtu.be/PMj9kUPrnBk, assessed on 06 January 2023.

15 The series can be used autonomously or as support material for DaF-lessons. For learners registered in Goethe Institute's learning platforms, it is possible to do exercises related to each episode.

Example 2 – (un)friendly Germans:

R.B. | 4 years ago (edited)

In a magical world where strangers both speak slowly and clearly, AND have time for you!…

Likes: 2.3K

Ana Maria Borges Honorato | 3 years ago

Likes: 22

Fivepointsgang | 3 years ago (edited)

It's not magical mate, my own experience

Likes: 30

hend kohlef | 3 years ago

Likes: 2

Sirli Amalia | 2 years ago

It's not magical, in Indonesia you can do that often

Likes: 10

Luis Gaxiola | 2 years ago

@fivepointsgang good point. That was my experience in Germany as well. Maybe one of the best living experiences of my life, if I could I would go back to live there again.

Likes: 26

Amir Sb | 2 years ago

In iran you can see it every where it depends on country! Persian always are available for helping foreigners!

Likes: 9

Ruslan Magerramov | 2 years ago

That is not really true, the German people are really polite and they don't speak too fast even between each other. It's a typical situation which might happen on the daily basis.

Likes: 13

Игорь Чувашов | 2 years ago

Фашисти привет!

Example 2 Continued

Likes: 1

Jasmin Kwok (Deutsch lernen) | 2 years ago

Ja 😊this is super slow compared to all other German videos I watched before

Likes: 10

Simony Ribeiro | 2 years ago

pretend is real

Likes: 2

Ivan Hrytsenko | 2 years ago

@Игорь Чувашов Привет дурик

Shivin Unitholi | 2 years ago

@S Ewing well I've spoken with Germans, Brits and Americans but I've found Germans to be the best of em all

Likes: 7

Haregweyni Measho | 2 years ago

@Sirli Amalia

33333333333333333333³3333333333333433333333333³3333³3³3³3³3333³³3333333333³ 3333³³³³³³³³³³3³³3333³³3³3³³³³3³³³3³³3333³³³³³3³³³³3333³³³³³³³3³³³3³³³3³³³³³³³3³³³³³³3³33³³³³³³³³³³3³³³³³³3³³³³³³³³³³³³³3³³³³³3 3333³³33³³3333³³3w (sic)

PEXMA | 2 years ago

@fivepointsgang you mean it's real and good right?

Likes: 1

Alexandra Emj | 2 years ago

They always. Doing this with me they're so sweet I swear 😒CH

Likes: 1

Abel | 2 years ago

The Best in what way???

Likes: 1

Herr Rotkäppchen | 2 years ago

Weil das für die Leute ist, welche Deutsch lernen, mein Freund;-)

[Because this is for the people who are learning German, my friend.]

Likes: 2

memoli parvizi | 2 years ago

Ja. really A magical World.

Example 2 Continued

Likes: 1

Camilo Icaza Santacruz | 2 years ago

applies 4 germany tho

Likes: 1

Carolina Abalo | 2 years ago

And politely...

PEDACITOS DE ALMA | 2 years ago

Es muy difícil irte de tu país a otro en el que el idioma es totalmente diferente.....
Es la primera barrera que nos encontramos..... POR SUERTE HAY GENTE
BUENA EN TODAS PARTES!!!.... ☺☺☺

Likes: 2

Bluyellow | 1 year ago

:/

Hosna Mortazavi | 1 year ago

The real world is better, most of them speak English and are more helpful than in
this video!

Terry | 1 year ago

Nel mondo dei sogni ☺

Whostot | 1 year ago

Exactly. It is useless.

Athina Tsakiropoulou | 1 year ago

and are nice enough to care....

Dave Darius | 1 year ago

@Hosna Mortazavi Lol English isn't everything mate! It's better to speak their
own Language than the whole world learning English!!

Likes: 2

Pacificprospector | 1 year ago

German folks in Berlin were helpful to me and showed patience. I think it depends
on your approach and what mood they are in.

w Osborne | 10 months ago

That is not magical, that is Canada. I am Canadian......and now I am in
Germany.......I know what you mean ☹.

Example 2 Continued

Ivan Ivan | 7 months ago

Absolutely...sometimes itsn't your language suck, but you need some sorta coperation of the fascist who hates immigrants and do everything's possible for you to be clueless.

Vicky Lewis | 6 months ago

@fivepointsgang Do teens really take their feet off the seat after disapproving looks from their elders where you come from?! We need a bit of that here in the UK!

David L | 4 months ago

and they are weird too

Deutsch mit Purple | 1 month ago

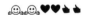

With regard to Backchannels devices (BC), we noticed the consistent use of emojis, especially those illustrating smiles and laughs, as we see below:

Ana Maria Borges Honorato | 3 years ago

😂😂😂😂

Likes: 21

hend kohlef | 3 years ago

😂😂😂😂

Likes: 2

Jasmin Kwok (Deutsch lernen) | 2 years ago

Ja 🐌 [this is super slow compared to all other German videos I watched before]

Likes: 10

Bluyellow | 1 year ago

:/

Deutsch mit Purple | 1 month ago

Beißwenger et al. (2012: 18) state that emojis often "portray facial expressions, and [that] typically serve as emotion, illocution, or irony markers." Since these responses are NAT addressed to R.B.'s comment, I consider these emojis as a sort of multimodal BC devices that functions as short emotional reactions to the original comment. The laugh emojis in the first three responses – Face with Tears of Joy 😂, Rolling on the Floor Laughing 🤣 – may indicate that these users understood R.B.'s irony but chose simply to react playfully as a way of diminishing a sensitive topic (Kelly/Watts 2015) implicit in R.B.'s comment: if friendly and helpful strangers only exist in a magical world, then real-world people might not count on them. Bluyellow's comment, however, has a negative reaction evidenced by the Confused Face emoji ":/ ", which is "is also commonly used for slight sadness, disappointment, and frustration". This may indicate that user inferred the irony implied by R.B. but reacted negatively toward the implicit meaning. The last comment is a sequence of positive emojis, but one cannot affirm whether the user agrees or not to R.B.'s original comment. The user *Deutsch mit Purple* only inserts two emojis of Smiling Face with Open Hands (🤗), followed by two hearts (♥) and two Thumbs Up emojis. In addition, Jasmin's response is initiated by a BC ("*ja*" and Rolling on the Floor Laughing emoji) but is followed by a CLT device: they endorse R.B.'s commentary about how slow people speak in the video ("this is super slow") based on their previous experiences with "German videos".

There are other responses that are not reactions per se but I consider them as BCs since they are short and were giving some sort of feedback to R.B.'s comment, as we see below:

Carolina Abalo | 2 years ago
And politely...

Athina Tsakiropoulou | 1 year ago
and are nice enough to care....

David L | 4 months ago
and they are weird too

In these nonadjacent turns (NAT), users begin their comments with the conjunction "and" to point out other features they noticed in the characters from the video. Therefore, these users not only agree that the video depicts

Germans as being (unrealistically) friendly and helpful but also as people that are "nice enough to care", "weird" and speak "politely". Although these comments are NATs to R.B.'s, the use of the conjunction "and" creates a cohesive chain, which adopts the rhetorical speech of R.B. and emphasizes the irony in their comment.

Another type of BC device that I consider to be relevant for YouTube polylogal interactions is the number of likes or dislikes that a video or comment receives. It is usually the simplest way to react to digital content and also functions as evidence of active but anonymous participation in a polylogal digital interaction.[16] R.B.'s original comment registered over 2,300 likes January 2023. It is also the case for some responses within the thread. As we can observe in the examples above, Ana Maria Borges Honorato's response has 21 likes while Jasmin's has 10. Therefore, even when R.B.'s original comment has only generated 38 written responses, one may claim that a much larger number of users agree with or at least enjoyed the comment.

Regarding the Addressivity devices, I highlight those that tend to disagree with or criticize R.B.'s original comment. Interestingly, R.B. never mentioned the categories "German" or "foreign", or any other term that could refer to nationalities or national cultural groups. They just used the word "strangers", which might evoke complementary social categories such as "strangers" vs. "acquaintances" and/or "friends". The comment clearly states that it is rather improbable ("in a magical world") that strangers would speak in a friendly manner ("where strangers both speak slowly and clearly") and offer their time to help other strangers ("AND have time for you"). In addition, by writing the conjunction "and" in capital letters, R.B. not only highlights those unrealistic behaviors but also the fact that they would not occur together, which makes the role-played situation in the clip even more implausible.

Although R.B. did not explicitly refer to any specific nationalities or cultural groups, these categories emerged in several responses in the thread. Mostly, these categories were used to refute the original comment, as we can see in the examples below.

16 One cannot identify who has liked or unliked videos or comments on YouTube.

Sirli Amalia | 2 years ago
It's not magical, in Indonesia you can do that often
Likes: 10

Amir Sb | 2 years ago
In iran you can see it every where it depends on country! Persian always are available for helping foreigners!
Likes: 9

Ruslan Magerramov | 2 years ago
That is not really true, the German people are really polite and they don't speak too fast even between each other. It's a typical situation which might happen on the daily basis.
Likes: 13

Pacificprospector | 1 year ago
German folks in Berlin were helpful to me and showed patience. I think it depends on your approach and what mood they are in.

w Osborne | 10 months ago
That is not magical, that is Canada. I am Canadian......and now I am in Germany.......I know what you mean ☺.

Some users state that the situation roleplayed by the characters in the video, which was ironized in R.B.'s original comment, is not only possible but also common in some countries, including Germany. These NTA responses use CLT devices to contradict R.B.'s comment: Sirli wrote "It's not magical" while Osborne wrote "That is not magical". Ruslan refutes R.B. by saying "That is not really true". Except for Pacificprospector, who ponders their views by using the indirect form "I think it depends," all other participants use direct forms: Amir wrote "In iran you can see it everywhere (sic)." Ruslan, in their turn, claimed that "German people are really polite and they don't speak too fast" and that "It's a typical situation which might happen on the daily basis", in an attempt to ensure the plausibility of the video clip. It is also worth mentioning the use of generalization words like "everywhere" and "on a daily basis" to emphasize these assertions. This direct style indicates that the users' knowledge about these nationalities falls into their own territory of information (Liebscher/ Dailey-O'Cain's 2008). Therefore, they position themselves as specialists in those topics.

Furthermore, the term "strangers" in R.B.'s comment appears to invoke the categories "foreigners" and "nationals": Amir wrote "Persian always are

available for helping foreigners!" while Pacificprospector wrote "German folks in Berlin were helpful to me and showed patience." The words "available", "helping" and "helpful" are cohesively linked to R.B.'s sentence "AND have time for you". Thus, when R.B. reasons that strangers would only be friendly and helpful in a magical world, the other participants not only consider it false but do so by comparing the specific situation shown in the video to their own reality: the "strangers" are actually "Germans" (or any other nationality) that casually meet "foreigners" in the streets and the "magical world" is Germany, Canada, Indonesia, or Iran.

Hence, it seems clear that the narrative in the video, namely the story of an immigrant in Germany, motivates the emergence of complementary categories such as "Germans" (or other nationalities) and "foreigners". According to Adami (2023: 17–18), national categories tend to appear in conversations about language and this thread is an example of how discussions around language might lead participants to draw on such stereotypes. Ruslan asserts that Germans are "really polite", while Pacificprospector affirms that "German folks in Berlin were helpful". Osborne's comment, despite assuring that such friendly behavior is possible in Canada ("That is not magical, that is Canada. I am Canadian"), suggests this is not the case in Germany: the final part of the response "and now I am in Germany… I know what you mean" is followed by the Crying Face emoji, implying that they might have already witnessed unfriendly behavior in Germany and that is sad. Anyhow, Ruslan, Pacificprospector, and Osborne position themselves as non-Germans and hence as foreigners in that particular interactional context but, at the same time, they claim expertise regarding Germany and German people, on the basis of their own experiences in that country.

This is also the case of this specific thread of responses addressed to user Fivepointsgang. In their response to R.B.'s comment, Fivepointsgang wrote:

Fivepointsgang | 3 years ago (edited)
It's not magical mate, my own experience
Likes: 31

The user is also refuting the ironic comment by R.B. and basing their refutation on their own experience. This response received 31 likes and three written CTA responses, as shown below:

Luis Gaxiola | 2 years ago
@fivepointsgang good point. That was my experience in Germany as well. Maybe one of the best living experiences of my life, if I could I would go back to live there again.
Likes: 25

PEXMA | 2 years ago
@fivepointsgang you mean it's real and good right?
Likes: 1

Vicky Lewis | 6 months ago
@fivepointsgang Do teens really take their feet off the seat after disapproving looks from their elders where you come from?! We need a bit of that here in the UK!

The user Luis Gaxiola endorses Fivepointsgang's comments and reinforces it by saying that this was "one of the best living experiences" of their life and confessing they want to go back to Germany. This response has received 25 likes. Pexma, in their turn, seeks for confirmation, asking if Fivepointsgang meant that the situation in the video is "real and good". Vicky Lewis, on the other hand, appears to distrust not only Fivepointsgang's account but also a specific situation roleplayed in the video regarding disturbing teenagers on the bus. By asking the question "Do teens really take their feet off the seat after disapproving looks from their elders where you come from?!", Vicky Lewis does not want to know what Fivepointsgang actually thinks but wonders whether it would really happen in reality. The irony in Vicky Lewis' rhetorical question, indicated by the use of an exclamation mark after the question mark, is reinforced by the sentence that comes next: "We need a bit of that here in the UK!". Again, Vicky Lewis is supposedly not wishing to have disciplined teenagers in the UK but is ironizing the situations roleplayed in the video, which Fivepointsgang claims to be real. In addition, it is interesting how national categories are opposed in Vicky Lewis' comment when they write "where you come from" and "We ... here in UK". These expressions are linguistic evidence of how they position themselves as well as Fivepointsgang as non-Germans.

5. Concluding remarks

The analysis above corroborates research that shows text-based CMC can be analyzed as "conversations" (Garcia and Jacobs 1998, Herring 1999,

Herring 2010, Bou-Franch, Lorenzo-Dus/Blitvich 2012), despite having significant differences regarding the turn-taking system. In the case of YouTube text-based polylogal interaction, the linear and chronological organization of the posts requires participants to use polylogue-specific cohesion features to organize and correlate turns. In only a few cases it was not possible to determine which turn a particular comment refers to, due to the lack of explicit cohesive elements.

Nevertheless, in most examples, the participants applied cohesion elements (like Backchannels, Cross-Turn-Addressivity, Cross-Turn Linking and Video Addressivity) to address their interlocutors, and this was essential for the analysis of identity construction and positioning processes. Based on the analysis, it was possible to determine that positioning works similarly in both YouTube text-based polylogues and face-to-face interactions. The direct forms were extensively used to display and claim authority with respect to knowledge about the German language and culture (Liebscher/ Dailey-O'Cain 2008). Moreover, it was demonstrated that claiming knowledge about a certain culture mostly occurs on the basis of one's own personal experiences (first-hand knowledge) with the culture. In the comment section of the video *Dialekte Hotline: Burgenländisch* (examples 1), users who position themselves as native speakers of this dialect tend to confront the information displayed in the clip, despite the fact that the person in the video was introduced as native speaker, therefore, positioned in the video as an expert in the subject. Conversely, as shown in the comment section of the video *Im Bus* (example 2), when the polylogue's participants position themselves as learners of German, they would claim authority to knowledge about the dynamics of intercultural encounters in Germany based solely on their personal experiences when living in or visiting Germany. They also considered the content of the video as realistic by ensuring that these situations usually happen in their own country too.

Only when there was no mention of personal experience with a particular language or culture have participants relied on second-hand knowledge. In the case of comments analyzed above, participants who revealed no experience with the topic tended to endorse the knowledge shared by the videos. That was the case in example 1, when the user Irene Adler tries to justify the association of the Austrian pastry *Pogatscherl* with the German *Knödel*. In these situations, participants tend to position themselves as a

non-expert in German language or culture and, automatically, position the institutional video as the specialist.

This analysis is an example of how first-hand knowledge (personal experience) often overlaps with second-hand knowledge (e.g., information shared or acquired formally through institutional means). Therefore, it could be argued that personal experience serves as a counterpoint to theoretically acquired knowledge, which leads us to reflect on how DaF-teachers and teaching materials approach topics such as *Landeskunde*. As mentioned above, the participants in intercultural interactions can validate themselves or their interlocutors as experts of a culture based on their own perceptions within the interactional context. Likewise, learners rely on their previous practices and observations, not only when interacting with classmates and teachers, but also when interacting with teaching resources. In the case of developing intercultural competence, one may consider learners' personal experiences, including their perceptions of the target language and culture, as means of deconstructing stereotypes as well as raising awareness of cultural differences (Ros 2016). Taking a subjective, dialogic learning process into consideration, instead of focusing on objective, unidirectional teaching, might lead DaF-teachers towards a complex but more realistic intercultural approach to *Landeskunde*.

Bibliography

Adami, Elisabetta, 2023: "Multimodality and the Issue of Culture: A Social Semiotic Perspective onto the Interculturality of Communication". In: Schröder, Ulrike/Adami, Elisabetta/Dailey-O' Cain, Jennifer (eds.): *Multimodal Communication in Intercultural Interaction.* (Studies in Language and Intercultural Communication). London, New York: Routledge, 17–40.

Beißwenger, Michael/Ermakova, Maria/Geyken, Alexander/Lemnitzer, Lothar/Storrer, Angelika, 2012: "A TEI Schema for the Representation of Computer-mediated Communication". *Journal of the Text Encoding Initiative* [Online] 3, retrieved 16.10.2022 from https://doi.org/10.4000/jtei.476.

Beißwenger, Michael/Pappert, Stefan, 2019: "How to be Polite with Emojis: a Pragmatic Analysis of Face Work Strategies in an Online Learning

Environment". *European Journal of Applied Linguistics* 7(2), 225–254, retrieved 16.10.2022 from https://doi.org/10.1515/eujal-2019-0003.

Bou-Franch, Patricia/Lorenzo-Dus, Nuria/Blitvich, Pilar Garces-Conejos, 2012: "Social Interaction in YouTube Text-Based Polylogues: A Study of Coherence". *Journal of Computer-Mediated Communication*, 17, 501–521, retrieved 16.10.2022 from https://doi.org/10.1111/j.1083-6101.2012.01579.x.

Council of Europe, 2020: *Common European Framework of Reference for Languages: Learning, Teaching, Assessment* – Companion Volume. Strasbourg: Council of Europe Publishing, retrieved 16.10.2022 from www.coe.int/lang-cefr.

Dervin, Fred/Jacobsson, Andreas, 2021: *Teacher Education for Critical and Reflexive Interculturality*. Cham: Palgrave Macmillan.

Garcia, Angela/Jacobs, Jennifer Baker, 1998: "The Interactional Organization of Computer Mediated Communication in the College Classroom". *Qualitative Sociology* 21(3), 299–317, retrieved 16.10.2022 from https://doi.org/10.1023/A:1022146620473.

Herring, Susan. C., 1999: "Interactional Coherence in CMC". *Journal of Computer-Mediated Communication* 4(4), retrieved 16.10.2022 from http://jcmc.indiana.edu/vol4/issue4/herring.html.

Herring, Susan. C., 2010: "Computer-mediated Conversation Part I: Introduction and Overview". *Language@Internet* 7(2), retrieved 16.10.2022 from https://www.languageatinternet.org/articles/2010/2801.

Kelly, Ryan/Watts, Leon, 2015: *Characterising the Inventive Appropriation of Emoji as Relationally Meaningful in Mediated Close Personal Relationships*. Paper presented at Experiences of Technology Appropriation: Unanticipated Users, Usage, Circumstances, and Design, Oslo, Norway, retrieved 16.10.2022 from https://projects.hci.sbg.ac.at/ecscw2015/wp-content/uploads/sites/31/2015/08/Kelly_Watts.pdf.

Kerbrat-Orecchioni, Catherine, 2004: "Introducing Polylogue". *Journal of Pragmatics* 36(1), 1–24, retrieved 16.10.2022 from https://doi.org/10.1016/S0378-2166(03)00034-1.

Liebscher, Grit/Dailey-O'Cain, Jennifer, 2008: "Identity and Positioning in Interactive Knowledge Displays". In: Auer, Peter (Ed.): *Style and Social Identities: Alternative Approaches to Linguistic Heterogeneity*. Berlin, New York: De Gruyter Mouton, 247–278.

Rathje, Stefanie, 2007: "Intercultural Competence: The Status and Future of a Controversial Concept". *Language and Intercultural Communication* 7(4), 254–266, retrieved 16.10.2022 from https://doi.org/10.2167/laic285.0.

Ros, Lourdes, 2016: "Landeskunde und Interkulturelles Lernen". In: Brinitzer, Michaela/Hantschel, Hans-Jürgen/Kroemer, Sandra/Möller-Frorath, Monika/Ros, Lourdes (eds.): *DaF unterrichten: Basiswissen Didaktik – Deutsch als Fremd- und Zweitsprache*. Stuttgart: Ernst Klett Sprachen, 96–106.

Skovholt, Karianne/Grønning, Anette/Kankaanranta, Anne, 2014: "The Communicative Functions of Emoticons in Workplace E-Mails: :-)". *Journal of Computer-Mediated Communication* 19, 780–797, retrieved 16.10.2022 from https://doi.org/10.1111/jcc4.12063.

Thaler, Verena, 2012: *Sprachliche Höflichkeit in computervermittelter Kommunikation*. Tübingen: Stauffenburg.

2 Digitale Interkulturalität in Institutionellen Kontexten

Digital Interculturality in Institutional Contexts

Jennifer Schluer / Yarong Liu

Peer Feedback in Intercultural Online Communication
Theoretical and Practical Considerations for English Language Teaching

Abstract English: In recent years, intercultural online communication (IOC) as well as peer feedback (PF) have attracted increased attention by scholars and practitioners. However, there is hardly any research or theoretical model available that strives to combine these two fields. The present contribution critically reviews the previous literature and raises awareness of the many interrelated and dynamically shifting factors that affect PF processes in intercultural online environments. These include (trans-)linguistic and multimodal communicative strategies, awareness of sociocultural and interpersonal skills, affective and other individual factors, as well as a critical and purposeful utilization of digital tools. PF literacies in IOC thus require critical language awareness, critical cultural awareness, interpersonal (collaborative) skills as well as critical digital literacy. The proposed model is meant to provide pedagogical guidance for teachers of English as a foreign language to enable successful feedback exchanges among the learners. At the same time, it can be re-shaped and re-negotiated continuously for specific learning goals and learner needs. The chapter closes with recommendations for future research and teaching practice to meet these dynamic demands.

Abstract Deutsch: In den letzten Jahren haben sowohl die interkulturelle Online-Kommunikation als auch das Peer-Feedback eine gestiegene Aufmerksamkeit unter Forschenden und Lehrenden erfahren. Allerdings gibt es kaum Forschungsarbeiten oder theoretische Modelle, die diese beiden Bereiche miteinander verknüpfen. Der vorliegende Beitrag gibt einen kritischen Überblick über den Forschungsstand und schärft das Bewusstsein für die zahlreichen eng miteinander verknüpften und sich zugleich dynamisch verändernden Faktoren, die Peer-Feedback-Prozesse in interkulturellen Online-Umgebungen beeinflussen. Dazu gehören (trans-)linguale und multimodale kommunikative Strategien, soziokulturelle und interpersonelle

Faktoren, affektive Aspekte und andere individuelle Variablen, sowie die kritische und zielgerichtete Nutzung digitaler Werkzeuge. Peer-Feedback in interkultureller Online-Kommunikation erfordert daher ein kritisches Sprach- und Kulturbewusstsein, zwischenmenschliche (kollaborative) Fähigkeiten sowie eine kritisch-reflexive digitale Kompetenz. Das vorgeschlagene Modell soll eine pädagogische Hilfestellung für Englisch-Lehrkräfte darstellen, um einen erfolgreichen Austausch von Feedback zwischen Lernenden zu ermöglichen. Gleichzeitig kann es für spezifische Lernziele und -bedürfnisse immer wieder neu ausgestaltet und ausgehandelt werden. Das Kapitel schließt mit Empfehlungen für zukünftige Forschungsarbeiten und für die Unterrichtspraxis, um diesen dynamischen Anforderungen zu begegnen.

Keywords: Peer-Feedback, Online-Lernen, interkulturelle Kommunikation, digitales Feedback, Feedback-Kompetenz

1. Introduction

Intercultural communication (IC) requires multifaceted skills from all participants. When exchanges take place in an online space, additional skills become important, which vary with the specific digital environment (cf. Chong 2022; Schluer 2022a). These skills can be fostered and practiced through interpersonal interaction with peers. In this way, learners develop cooperative skills that are essential not only for the job market, but also for daily life. Moreover, in these interactions, peer feedback (PF) plays a fundamental role, as it helps learners to clarify and co-construct meanings as well as to improve learning strategies and results.

For this reason, peer feedback literacies should be cultivated in the classroom. They help to challenge traditional learner roles due to a change from passive knowledge receivers to active knowledge co-creators that seek, produce, and discuss feedback (cf. Carless/Boud 2018; Nieminen et al. 2022). This also necessitates a shift in mindset regarding culturally-shaped roles and expectations, which can pique learners' interests in exploring cultures and negotiating meanings. Through cooperation and inquiry, learners can develop cultural empathy and demonstrate mutual respect. Especially in foreign language learning contexts, awareness of variation in pragmatic norms as well as trans- and multilingual communicative strategies are additionally required (Ishikawa 2020; 2021).

Furthermore, a critical and conscious use of digital tools is crucial. Not only can peers' perceptions of digital tools vary for personal and cultural reasons, but also due to the specific affordances that they attribute to them (Kern/Develotte 2018; Thorne 2016). Indeed, the characteristics of tools and users' perceptions of them can enable or constrain interactions in numerous ways (cf. Tai et al. 2021).

Given this variety of factors, it is obvious that the successful implementation of PF exchanges in intercultural online environments requires pedagogical guidance by teachers as the facilitators of students' learning. This chapter therefore focuses on PF in intercultural online communication (IOC) and aims to develop a comprehensive model for practical use. It should guide English language teachers and learners in becoming aware of the dynamic interactions and interrelations as well as of the complexity of factors in intercultural online peer feedback (OPF).

To establish a foundation for the development of this model, the next section discusses the key notions of IOC and OPF by juxtaposing prevalent theoretical positions. Afterwards, the chapter reviews several factors that can have an impact on intercultural OPF, including linguistic/communicative, sociocultural/interpersonal, collaborative, affective and further individual variables as well as technological factors. On that basis, a model for peer feedback literacies in IOC will be sketched. Adopting a meta-perspective of culture and an interactional feedback approach, it stresses the importance of communicative strategies during OPF exchanges in IOC. They are meant to help learners manage affect and interpersonal relations, (re-)negotiate and co-construct meanings as well as advance their learning by strategically seizing the affordances of different digital communication modes and their cultural and linguistic resources. The chapter will close with practical suggestions for pedagogical design as well as with recommendations for future research in the field of intercultural OPF.

2. Terminology

2.1 Intercultural online communication (IOC)

Intercultural online communication (IOC) is a relatively young concept as compared to IC. The online space differs from analog settings in numerous

ways, which can influence the processes and results of IOC substantially. However, when reviewing the literature, we notice that many studies jump directly into discussing the affordances and downsides of the virtual environment (VE) without clarifying the notions of culture, IC, and IOC sufficiently (e.g. Çağıltay/Bichelmeyer/Kaplan Akilli 2015; Marcoccia 2012; Prieto-Arranz/Juan-Garau/Jacob 2013; Shuter 2017; Zorn 2005). Notably, the major advantages cited for IOC are the anonymity and freedom from constraints (e.g. Marcoccia 2012; Zorn 2005). According to several works (e.g. Marcoccia 2012; Zorn 2005), the VE allows for interactions regardless of social status, gender, ethnicity, and occupation. It can make the impact of appearances on interaction less relevant and therefore help individuals create a new (cultural) identity. They might take on a role that differs from the one that they would normally assume in face-to-face interactions. On the one hand, this can catalyze communication (Marcoccia 2012), but on the other it can diminish mutual trust and hinder intercultural dialogue (Shuter 2017).

On the macro-level, it is argued that the online space contributes to the formation of a common culture which adheres to certain forms of netiquette, including principles of politeness and cooperation (Marcoccia 2012: 361; Prieto-Arranz et al. 2013). Some of these rules are also associated with conflict management in studies of IC (e.g., Hammer 2005). However, the politeness construct differs starkly in its verbal, para- and non-verbal realizations across languages and cultures. Thus, these netiquette codes and rules are not culture-neutral, but emerge from the specific orientations and repertoires of the interlocutors. Nonetheless, there appears to be an inclination towards North American standards in the published literature and teaching practice (cf. Marcoccia 2012).

Conversely, IOC processes can also be conceptualized from the perspective of a third space on the micro-level of individuals' interaction (Kramsch 1993; Prieto-Arranz et al. 2013; Shuter 2017). Regretfully, many studies merely examined external stimuli, such as the anonymity and freedom of VEs, while not paying due attention to participants' internal motivation for co-constructing a third culture and the communicative strategies they use for achieving this. Also, the potential of VEs as a constantly transculturally and multilingually co-constructed and renegotiated space for successful OPF has not been sufficiently recognized (cf. Ishikawa/Baker 2021).

In IC, individuals "move through and across [...] cultural and linguistic boundaries", making the notion of borders a blurry one (Baker/ Sangiamchit 2019: 472). In IOC, they also transcend boundaries of space and time and can resort to a wide modal repertoire. Accordingly, a transcultural, translingual, transpatial and transmodal approach to researching and fostering OPF dialogues seems to be needed (cf. Hawkins/Mori 2018). While earlier research adopted an essentialist paradigm or "container" approach focusing on the form and "structure" of culture (Bolten 2020), more recent work puts a stronger emphasis on the "process" of communication (cf. Jenkins 2015). At the interactional micro-level, individual profiles and strategies utilized in particular social and material environments (cf. Ishikawa 2021) are the key to interpreting the processes of meaning negotiation in intercultural OPF. In that regard, "digital access" (Dooly/Darvin 2022: 356) to cultural resources in the VE becomes relevant as well. Hence, it is not just about (unequal) access to technologies, but also about recognizing the impact of algorithms that distribute cultural information and constrain the supposed freedom of VEs (Dooly/ Darvin 2022: 357). Neither the participants nor the technology are thus culture-neutral, but they affect communication in various ways (Darvin 2017: 10; Thorne 2016: 185).

Many studies, however, were based on a specific conceptualization of (oftentimes text-heavy) VEs (e.g. Zorn 2005), even though there is a rich diversity of possible interaction modes in the digital space. To exemplify, learners can engage in various communicative activities, such as emailing, chatting, blogging, podcasting (Çağıltay/Bichelmeyer/Kaplan Akilli 2015; Maroccia 2012; Prieto-Arranz et al. 2013; Shuter 2017) and videoconferencing (cf. Kern/Develotte 2018). Likewise, feedback exchanges can take place in numerous ways, from unimodal (often text-based) to multimodal in cloud applications, e-portfolios and videoconferences (cf. Schluer 2022a) as well as on social media platforms, e.g. Instagram, Facebook, Twitter, and TikTok.

According to current sociomaterial perspectives on learning (e.g. Chong 2022), the particularities of the specific digital spaces and resources need to be taken into account more thoroughly, as well as their interactions with individual, sociocultural and further situational factors. These include, for example, linguistic and communicative, social and cooperative as well as

affective factors. The complex interrelations have recently been highlighted in the feedback literature (Chong 2022; Gravett 2022) to which we will turn next.

2.2 Feedback and peer feedback (PF)

Feedback is a complex construct that has been re-conceptualized in various ways over time. Frequently, it is defined as the information which is needed to close the gap between the learners' current level (performance) and the reference level (learning goal) (Sadler 1989: 120–121). For a long time, research focused on the transmission of information from the feedback giver (usually teacher) to the feedback recipient (typically student) (as reviewed by Ajjawi/Boud 2015: 253). This one-sided view did not sufficiently consider the active processing of feedback on the part of learners (cf. Nicol/Thomson/Breslin 2014: 103) and overlooked linguistic (and communicative), sociocultural/interpersonal (as well as collaborative), individual, affective, and technological factors when giving and receiving feedback (Chong 2022).

However, it is necessary to understand feedback practices and processes in the specific contexts in which they occur, as "contexts [enable] and constrain" the ways in which individuals can act (Tai et al. 2021: 2). In addition, contexts are changing dynamically and can be (re-)configured to a certain extent by the people partaking in them. It is therefore worthwhile to examine the ways in which participants draw on available linguistic, cultural, and modal repertoires in feedback exchanges. At the same time, this requires a constant rethinking of suitable pedagogies that help learners engage in OPF successfully.

During the Covid-19 pandemic and the abrupt shift to online teaching, the impact of changing contextual conditions became conspicuously clear. Therein, a simple transfer of pedagogies from analog to digital modes turned out to be neither feasible nor effective. Feedback processes in particular were neglected, as teachers and learners felt unprepared for virtual exchanges (cf. Schluer 2022b). Therefore, it is necessary to create suitable pedagogies that help develop their digital feedback literacies while acknowledging the dynamic reconfigurations of various contextual and individual factors. All of them can foster but also constrain learners'

agency in the feedback process, including the active processing of feedback messages, feedback-seeking, feedback-giving, and feedback use (Nieminen et al. 2022: 95). According to Nicol/Thomson/Breslin (2014: 103), PF is an approach to facilitate learners' active engagement in these processes.

In PF, learners reciprocally provide and receive comments on each other's work (Nicol 2014: 208; Nicol/McCallum 2022: 424; Zhu/Carless 2018: 883). By receiving feedback, students become aware of the reader perspective and of the aspects that need further clarification or revision (Nicol/Thomson/Breslin 2014: 112, 116). As compared to limited teacher feedback (cf. e.g. Irwin 2019: 44), PF is likely to improve the perception of the trustworthiness of the comments: If several peer reviewers adduce similar points, it gives the impression of a "collective consensus" (DiPardo/Freedman 1988: 123 cited by Cho/MacArthur 2010: 330) and "a sense of assurance" (Lee 2015: 6 quoted by Chang 2016: 97). Depending on the quality of the peer comments, learners may ultimately be able to improve their own work (Cho/Cho 2011: 636, 639).

The greater learning gain, however, appears to come from feedback production (Nicol/Thomson/Breslin 2014). To give feedback, active engagement with the relevant assessment criteria is required (ibid.: 116). It also helps learners to become critical readers, not only of others' but also of their own work (Cho/Cho 2011; Nicol 2010: 509). They discover different ways of solving a task, which provides them with new perspectives (Nicol/Thomson/Breslin 2014). Additionally, when they review a work of higher quality, they are likely to generate possible improvements to their own work, while comparisons with lower-quality work alert them to mistakes that they should avoid as well (Nicol/McCallum 2022; cf. Cho/Cho 2011: 639). Overall, it has therefore been argued that reviewing fosters critical thinking (Nicol/Thomson/Breslin 2014) and may ultimately enhance students' self-regulated learning (Nicol 2014: 197; Nicol/McCallum 2022: 427). By explaining their feedback, "students become teachers of others" (Hattie 2012: 79) and gain a clearer understanding themselves (cf. Sadler 1989: 140). This phenomenon has been termed the "explanation effect" (Nicol/Thomson/Breslin 2014: 105). It presupposes communicative skills from the peers and is an important part of the linguistic dimension that will be elaborated in the next section.

3. Dynamic dimensions of online peer feedback (OPF)

Current conceptualizations of feedback stress the learner's active role as well as the multiple interrelations between different dimensions: linguistic/ communicative, collaborative, sociocultural/interpersonal, individual, affective, and technological (material). All of these are part of a complex dynamic system (cf. Chong 2022; Ishikawa 2020; Larsen-Freeman 2018), so it is difficult to clearly separate them from one another (Tai et al. 2021: 6). Thus, unpacking the complexities of PF interactions in IOC into single components certainly does not do justice to the manifold interrelations between these different dimensions. However, it helps to raise awareness of the multitude of factors that influence PF in IOC. Due to this complex interplay, the results from empirical studies may contradict each other if background variables are not sufficiently considered. It is therefore crucial to gain clarity about the concrete contexts in which PF interactions take place in online spaces.

3.1 Linguistic (& communicative) dimension

Feedback is a communicative process (Nicol 2021: 771), which means that the interlocutors' linguistic resources and communicative skills play a predominant role in intercultural OPF. For example, when they utilize English as a foreign language or lingua franca, their language proficiency and differing pragmatic norms (esp. hedging/indirectness) can have an impact on the success of PF (e.g. Marcoccia 2012). A low level of language proficiency might lead to frustration or very shallow comments (e.g. about formatting or mechanics), whereas learners with higher L2 expertise tend to make more higher-order comments about contents and argumentation (cf. the review by Chang 2016: 99).

Regarding pragmatics, Nguyen (2008), for example, compared Vietnamese learners' and Australian native speakers' language choices in PF. It was found that the Vietnamese learners of English utilized fewer modifiers, expressed bold disagreements, and utilized imperatives, such as "you must" and "you have to" (Nguyen 2008: 61–62). In turn, they might take indirect suggestions by the Australian speakers at face value, i.e. as a suggestion, not as a must, even though they were meant that way (as in "It might be a good idea to check your tense use again before re-submitting").

To resolve potential misunderstandings, awareness of pragmalinguistic variation and communicative strategies to address them would be crucial. In that respect, teachers could also guide learners to become more literate in comprehending verbal, paraverbal, nonverbal, and extraverbal components of communication.

Thus, the linguistic dimension not only relates to comments on rhetorical and linguistic improvements to the papers of their peers (Sun/Doman 2018: 1), but also to their own communicative skills that are required for successful interaction and cooperation during PF (Hyland/Hyland 2006: 92; cf. Brereton/Dunne 2016: 29411; Irwin 2019: 44). Drawing on a translingual perspective, the interlocutors should see discrepancies in English language use as an opportunity to initiate a discussion and/or negotiation about their language usage and about what counts as the standard in their concrete communicative situation (cf. Kohn 2018). Clearly, the linguistic norms of a supposed target variety of English do not necessarily determine learners' language use in IC (Baker 2015). Rather, English language use varies with particular communicative contexts, which in turn are affected by the interpersonal relationships between the interlocutors, situational variables, and topics discussed (Baker 2015; Kohn 2018; Piller 2012; Risager 2006; see next sections). In that respect, learners should be made aware of negotiable communicative norms and continuously (re-) assess their own practices critically regarding communicative efficiency as well as speaker satisfaction and peer needs (cf. Kohn 2018). Depending on the linguistic profiles of the interlocutors, there can thus be a wide spectrum of multilingualism and translanguaging, which complies with current views of English as a multilingua franca (Ishikawa 2020; Jenkins 2015).

3.2 Sociocultural/Interpersonal (& collaborative) dimension

Feedback is "an interpersonal process" (Chong 2021: 8) or "social practice" (Evans 2013: 103) and consequently requires collaborative skills from students (Nicol 2014: 210, 215; Schluer 2022a: 242; Zhan/Wan/ Sun 2022: 3). Through PF, they learn to take responsibility not only for their own but also for other's learning (Sun/Doman 2018: 6). Importantly, peers with different strengths can scaffold each other's learning process (Min 2005: 294, 305; see also Hyland/Hyland 2006: 90). This mutual

support can motivate students so that they may even start engaging in PF on their own in future assignments, which will strengthen "interpersonal relationships and class bonding" (Brereton/Dunne 2016: 29414). In that regard, online environments could add an extra dimension to the development of wider learning communities and "feedback networks" (Evans 2013: 103, emphasis omitted).

Apart from technological aspects (see below), cultural factors can influence this interpersonal dimension. So far, research on intercultural OPF (Guardado/Shi 2007; Liu/Sadler 2003; Pham et al. 2020; Swierczek/ Bechter 2010; Zhan 2022) often relied on structural views of culture, noticeably by focusing on three cultural dimensions: individualism and collectivism (Hofstede 2001); power distance (Hofstede 2001); and high and low context (Hall/Hall 1990). To be clear, we acknowledge that the cultural dimensions applied in these studies overlook the fluidity and complexity of cultures, which we have discussed above. For instance, from the perspective of power distance, it is claimed that Asian learners traditionally prefer instructor- or authority-based learning approaches (Swierczek/ Bechter 2010: 294). Consequently, they might not ask for corrective feedback (Liou/Peng 2009: 516) and doubt the credibility of the received feedback, especially when it comes from a peer (Adiguzel et al. 2017: 238; cf. Sadler 1989: 140–141). Another factor is that especially Asian learners might not dare to provide criticism to others because relationships are valued to a high extent in collectivist societies. Instead of honest feedback, they would rather offer praise and suggestions to maintain social harmony (Pham et al. 2020; cf. the review by Zhan/Wan/Sun 2022: 8). In addition, chain effects were observed: when a peer only gave surface-level comments and did not deeply "engage in critical thinking, their partner would do so neither" (Schluer 2022a: 120 with reference to Xie et al. 2008: 23).

However, also contrasting findings were obtained in prior studies. For instance, Pham et al. (2020: 15) showed that Vietnamese students actively engaged in OPF and held positive attitudes towards giving and receiving critiques. Furthermore, Zhang et al. (2014: 678) observed that Chinese students worked harder on their essays in order to gain positive PF so that their positive face could be saved. Liu/Sadler (2003: 218) presumed that the perceived anonymity of the VE increased Asian participants' engagement. Others argued that Asian students eagerly engaged in OPF owing

to the impact of the "examination culture" they found themselves in (e.g. Zhan 2021 quoted by Zhan/Wan/Sun 2022: 8).

The cultural ascriptions in these studies should be discussed critically (Hawkins/Mori 2018: 6; cf. Baker/Sangiamchit 2019: 471), e.g. by using them as pedagogical materials to remind learners of the perils of stereotyping. At the same time, the review has shown that culture is a multilayered notion referring to different kinds of context, from the macro-level of the sociocultural and sociomaterial environment, to the educational, institutional and classroom culture, as well as the individual agents' cultural profiles, resources and expectations regarding feedback provision and reception.

3.3 Individual dimension

Apart from the social dimension, culture is also an individual variable that shapes PF exchanges. Beyond that, there is a variety of further individual factors. According to Chong,

> the individual dimension relates to individual differences of learners including beliefs and goals (about feedback, about learning, and about self), learners' feedback experiences (e.g., the types of feedback experienced by learners, learners' experiences in responding to feedback), learners' abilities (e.g., academic skills, academic literacies, subject knowledge, metacognitive knowledge) (2022: 5–6).

Clearly, these features are not fixed, but develop over time based on the knowledge and experiences the individuals have gained (Nieminen et al. 2022: 99). Moreover, they vary situationally, e.g. with the specific tasks the learners engage in (ibid.). Indeed, the design of the pedagogical context (see below) is likely to have an impact on the peers' attitudes and actions (cf. Han 2019 cited by Chong 2021: 8–9).

In addition, learner factors evolve dynamically during task engagement and peer interaction. In that respect, students' beliefs about the usefulness of feedback in general and the specific feedback they exchange with their peers can be influential (cf. Chong 2021: 5). At the same time, the feedback experiences students gain are likely to influence their future practices, expectations, and attitudes towards PF (ibid.: 9). The effects of motivation in learning as well as learners' confidence and self-efficacy also need closer scrutiny (Zhan/Wan/Sun 2022: 9–10). For instance, a learner in Chang's (2012) study concentrated on grammar issues because he felt confident

in this area, but not so in others, especially regarding more global issues of content and argumentation. On the other hand, if learners feel confident in their abilities and in the impact their feedback could have on their peers, they will probably be more motivated. This directs us to the affective dimension, discussed next.

3.4 Affective dimension

PF can invoke many different kinds of emotions among learners (as reviewed by Yang/Carless 2013: 289). Often, positive emotions and attitudes are cited for PF (Nicol/Thomson/Breslin 2014: 108) and OPF in particular (Zhan/Wan/Sun 2022: 7). For example, when learners feel motivated, proud and satisfied with PF, they feel a greater bonding within the learning community and are able to regulate their own learning (Pekrun et al. 2002 cited by Yang/Carless 2013: 289; Zhan/Wan/Sun 2022: 7).

However, also negative emotions are discussed in the literature. First of all, some students might be embarrassed to share their work or even fear plagiarism by their peers (Nicol 2014: 210). They could also be afraid of comments that others might make (Hattie 2012: 131). Certainly, the remarks of peers could be overly critical on the one hand (Amores 1997 cited in Hyland/Hyland 2006: 91) or "sugar-coated" on the other (Cuthrell et al. 2013: 16–17). Some peers might refrain from providing critical comments at all (Sun/Doman 2018: 3) because they do not feel confident or competent enough to give feedback to a peer (Evans 2013: 101; Nicol 2010: 514; Zhu/Carless 2018: 885). They could have difficulties in error detection and feedback provision (as reviewed by Hyland/Hyland 2006: 90–91), which may also affect the focus of their feedback comments (Chang 2012: 71, 73). Cognitive and affective aspects thus closely interact.

Culturally and interpersonally, it has been reported that Chinese students avoid criticizing others in public to save their peers' face instead of risking their potential embarrassment (Lin/Yang 2011 cited by Zhan/Wan/Sun 2022: 8; see above). Some might even give negative self-appraisals of their own work in order to save positive face (Priego 2011: 142) or they already invest extra efforts before submitting their work for peer review (Zhang

et al. 2014 quoted by Zhan/Wan/Sun 2022: 8). When giving and receiving PF, Asian learners could be afraid of hurting friendships or relationships (Chiu 2009; Yu/Lee/Mak 2016). By contrast, it is claimed in the literature that Western learners pursue results in PF and tend to argue from "facts and specific details" (Swierczek/Bechter 2010: 294). It becomes clear that these cited findings rest on or even reinforce cultural stereotypes. Instead, it would be advisable for research and practice to put a stronger focus on interactional strategies that could be conducive to intercultural OPF, including multi- and transcultural, transpatial, transmodal and translingual communication (Baker/Sangiamchit 2019; Hawkins/Mori 2018). In addition, much depends on the beliefs and roles peers ascribe to themselves and to others as feedback givers and feedback recipients.

Furthermore, the characteristics of the online environment deserve closer scrutiny. For example, Shuter (2017: 6) argued that online communication diminished "fears of making interpersonal errors" compared to face-to-face interactions. The VE seems to reduce psychological burdens when giving feedback (Guardado/Shi 2007: 444; Liou/Peng 2009: 516). In terms of individual factors, shy learners might specifically benefit from asynchronous or text-based PF. Similarly, receiving anonymous comments could prevent writers from feeling personally attacked and may therefore heighten the acceptance rate of corrections and suggestions. It allows them to think about the comments independently of the person who has provided them.

The issue of anonymity in OPF is a controversial one, though. Students could feel awkward when providing feedback to an anonymous peer (cf. Guardado/Shi 2007 cited by Chang 2016: 101). Conversely, if the identity of the peer was known, the reviewers might be less critical in their evaluative judgments (see the reviews by Chang 2016: 100 and Cho/Cho 2011: 633). Crucially, though, the possibilities for interactions and asking questions for clarification are limited in anonymous constellations (Chang 2016: 100–101). This could have detrimental effects on the construction of feedback dialogues and learning partnerships (see interpersonal dimension). However, this might also vary with the characteristics and affordances of the specific digital environment they find themselves in. These aspects will therefore be addressed next.

3.5 Technological (material) dimension

Overall, there are many different kinds of digital environments in which (intercultural) PF can occur, such as in chats, cloud applications and/ or videoconferences (cf. Schluer 2022a), and their number is likely to increase further in the future (e.g. Instagram, TikTok etc.). As Kern and Develotte (2018: 8) problematize, IOC practices "are often influenced by the infrastructure of the digital medium (i.e., 'chat' culture is different from 'e-mail' culture is different from 'forum' culture is different from 'game' culture)."

Frequently, a distinction is made between the affordances and limitations of synchronous and asynchronous OPF. With asynchronous modes, e.g. email writing, students are not pressured to respond immediately, but they can take the time they need in order to provide and process PF. This often results in deeper reflections as well as more detailed (Zhan/ Wan/Sun 2022: 6) and structured feedback. However, these modes are likely to reduce interactivity due to the lack of nonverbal cues and the delay of interaction (Guardado/Shi 2007: 444; Liou/Peng 2009: 516; Liu/Sadler 2003).

With synchronous modes, by contrast, students can exchange immediate feedback, e.g. via videoconferencing or quasi-synchronous chats (Schluer 2022a). Videoconferencing may additionally improve students' listening (Martin 2005: 402) and speaking skills, especially in foreign language learning settings. Moreover, as opposed to face-to-face communication, sociocultural questions about keeping an appropriate physical distance have become obsolete (Schluer 2022a: 211). However, video communication is challenging since the interlocutors need to shift their gaze between looking straight into the camera on the one hand and looking at the screen containing the interlocutor's video image on the other hand (Schluer 2022a: 211).

Concerning chatting, scholars found that it can encourage greater participation as compared to live interactions because it is perceived as less face-threatening (cf. AbuSeileek/Rabab'ah 2013: 55). Also, it makes a difference whether public (classroom) or private chats (individuals, small groups) are used (Schluer 2022a: 126–127). With public chats, "learners

may feel that they have a voice in the classroom. They can contribute in the chat whenever they want to and do not have to wait until the teacher allows them to speak" (Schluer 2022a: 126). This can help to break down power hierarchies and traditional student-teacher roles (see interpersonal dimension above).

In total, the majority of studies rather mentions advantages than challenges of OPF (Zhan/Wan/Sun 2022: 8 on Chinese students). The VE can be beneficial for learners, not the least due to the technological affordances of communicating across time and space (Tai et al. 2021: 6). It also appears to be advantageous for personal and cultural reasons (cf. the review by Schluer 2022a: 138), as it can accommodate to different learning preferences and facilitate communication. Learners may resort to a rich variety of tools, such as chats, wikis, video conferences, cloud documents and social media apps, to engage in authentic communication.

Overall, scholars advocate a combination of different modes due to their complementary affordances (Chang 2012: 73–74). However, pedagogical advice is still scarce with regard to suitable combinations (Schluer 2022a). Particularly, the cultural and affective aspects of the utilization of digital tools among learners have gained little attention. Thorne (2016) revealed that the engagement, perception of the functions, and preference for digital tools can be socioculturally influenced and thus encourage or demotivate learners' practices. Taking language learning through email as an example, he found that an American student was initially demotivated by her French key-pal who slowly replied to her emails, but that their learning engagement increased after they had switched to instant messaging instead (Thorne 2003: 47–49). It thus appears that the tool features have an impact on exchange structures and frequencies (Thorne 2003: 40). Dooly and Darvin (2022: 356) further explained that learners' perceptions of digital tools are also socialized regarding their educational values, i.e. for entertaining or for learning. Moreover, Liaw and Ware (2018) observed different preferences concerning uni- (e.g. text) or multimodal communication (video) between Taiwanese and US American pre- and in-service teachers, which was driven by several reasons. The next sections therefore strive to bring together recommendations for PF in IOC by considering the variety of interwoven dimensions.

4. Towards peer feedback literacies in intercultural online communication

Successful PF in IOC depends on a multiplicity of factors that pertain to the peers as agents in the feedback process as well as to the contextual conditions that enable or constrain their actions (Tai et al. 2021: 3). Individual variables comprise their personal characteristics, linguistic/communicative skills, interpersonal/collaborative aspects, affective/motivational factors as well as cultural orientations and technological expertise. At the same time, culture and technology are not only individual resources, but also contextual factors that influence the feedback process, its contents and outcomes. A brief sketch of this array of factors and their interrelations is shown in Figure 1.

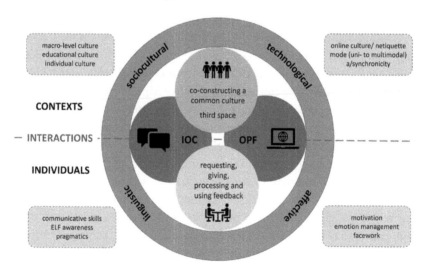

Figure 1: Dynamic dimensions of peer feedback in intercultural online communication

Linguistic: Overall, dialogue seems the key to improve the success of OPF. First of all, communicative norms need to be discussed, including differing conceptualizations of politeness. In accordance with the translingual perspective, awareness of English as a lingua franca (ELF) should be raised (cf. Kohn 2018), which refers to the capacity to not blindly follow the supposed norms of native speakers but to negotiate an appropriate set

of practices that complies with the situation, interpersonal aspects, and the VE. For this, students need strategies to explain the semantic and pragmatic meanings of their language use and to negotiate with their peers to achieve successful communication. Sharifian's (2018) concept of metacultural competence can be conducive in that respect. It comprises variation awareness, explication strategies, and negotiation strategies. It is not restricted to features of verbal language, but also includes sensitivity to paraverbal and nonverbal aspects (cf. Schluer 2021). Especially in OPF, multimodal communication deserves closer scrutiny, i.e. the use of different semiotic resources (Ishikawa/Baker 2021: 24). Crucially, learners should be equipped with communicative strategies to engage in transpatial, translingual, transmodal, and transcultural OPF dialogues. The following principles might help to improve the quality of IOC experiences: 1) ask peers whether they feel comfortable with the language used in the feedback; 2) request clarification and confirmation; 3) use synonyms or paraphrases to increase comprehensibility; 4) show linguistic and cultural sensitivity; 5) demonstrate empathy and open-mindedness (cf. Pietikäinen 2018 cited by Ishikawa 2021; Zaltsman 2008: 110). From the sociolinguistic perspective, students should also consider the same issue from a variety of perspectives and appreciate a diversity of opinions (Dimitrov et al. 2014: 89).

Sociocultural: Intercultural skills in OPF are closely related to communicative skills. Culture influences the ways in which PF is exchanged; it can be a communicative resource as well as be re-negotiated and co-constructed through communication. For effective PF in IOC, students should inquire about each other's cultural perspectives as well as be able to co-construct a new culture. For that purpose, intercultural skills can be developed and practiced in at least three interconnected ways: 1) by openly discussing sociolinguistic beliefs and behaviors, e.g. to inquire about and negotiate pragmatic conventions; 2) by deconstructing teachers' roles as the sole authorities of providing feedback and students' roles as passive feedback receivers (especially for students who expect high power distance), while re-considering the benefits of multiple feedback sources and reaching consensus about individual responsibilities in the PF process; 3) by critically inspecting existing communicative structures while creating new interactional norms, which could also make critiques more acceptable. This

way, rules can be established as a common ground to ensure smooth OPF interactions.

Affective: During these interactions and re-negotiations, affective skills play a central role. They are vital for managing emotions as well as for activating and accelerating learning processes (cf. Carless/Boud 2018). In the entire process of OPF, students will have to deal with perceptions towards themselves (e.g. self-confidence, embarrassment) and others (e.g. their perceived qualifications when giving feedback). Peers should therefore be prepared for the emotional discrepancy between their expectations and the reality of PF processes. For that purpose, students should learn to share their concerns and uncertainties by applying communicative and intercultural skills. Moreover, students should demonstrate digital skills to facilitate the exchange of information, e.g. while evaluating others' work, engaging with the received feedback, assessing its quality, and clarifying their understanding with peers (cf. the review by Schluer 2022a: 35–44). They need to develop confidence and competence in selecting suitable communication modes to convey their meanings. For example, to compensate for a lack of language proficiency, visual aids can be beneficial, such as "emoticons and smileys" (Zaltsman 2008: 107) in written communication. However, these icons might also be confusing for some learners, e.g. when a laughing smiley is used to tone down the negative force of a critical remark.

Technological: Depending on the kind of VE, OPF can be challenging. If it is unimodal and largely relies on (written) language without further visual and social cues, the difficulty of decoding pragmatic meanings increases (cf. Marcoccia 2012: 359). In videoconferences, in turn, interlocutors can negotiate meanings more easily due to the richness of available communicative resources and modalities, for instance through audiovisual channels, chats, text pads, screen sharing and file sharing (Schluer 2022a: 212). On the other hand, sophisticated digital tools, as in videoconferencing, can cause insecurities about their usage. It is therefore crucial to familiarize students with the particularities of specific communication modes and tools in OPF (cf. Schluer 2022a). Otherwise, learners can become confused, overwhelmed, or even frustrated by the various multimodal functionalities. The peers might also lack relevant equipment or have slow internet connections (cf. Nieminen et al. 2022: 102). Furthermore, they

may not know how to turn on the camera or microphone and how to switch on the screensharing (Schluer 2022a: 214). These and further conditions can inhibit their active participation in OPF (cf. Nieminen et al. 2022: 102; Zhan/Wan/Sun 2022: 8). To make appropriate usage of these affordances for intercultural OPF purposes, a breadth of interrelated skills is needed that should be fostered through an adequate pedagogical design (see next section).

5. Implications for pedagogical design

Pedagogical design is crucial for the success of PF. Each learning scenario is shaped by the educational system in which it takes place, including the curriculum, specific institutional regulations, the discipline or subject, the particularities of the instructional context as well as the classroom climate. In this section, aspects of the pedagogical design will be foregrounded, i.e. those that can be influenced by the teacher as the facilitator of the learning event. Teacher feedback literacy is thus important, i.e. the understandings and capacities that educators need to possess in order to design feedback processes which support student engagement and uptake (Carless/Winstone 2020; Winstone/Carless 2020). In fact, teachers need to be literate on the same dimensions that they intend to foster among their learners:

- Critical language awareness, including awareness of different communicative norms and English as a multilingua franca (Ishikawa 2020; Jenkins 2015);
- Multiliteracy: using different media and modes to communicate effectively, also to compensate for the limitations of single modes, e.g. to clarify linguistic mis- or nonunderstanding (cf. Kress 2004; Liaw/ Ware 2018);
- Critical cultural awareness: cultural reflexivity as well as metacultural explication and negotiation strategies (Sharifian 2018);
- Collaborative skills: discussing roles and responsibilities as well as managing emotions in OPF (cf. Carless/Boud 2018);
- Feedback literacy: awareness of the purposes of feedback as well as suitable task design and in-process support to enable dialogic feedback processes and foster learner engagement (Carless/Winstone 2020; Winstone/Carless 2020);

- Critical digital literacy: awareness of the impact of tools as well as choosing suitable ones for specific communicative intentions, also to challenge existing power structures (Darvin 2017; Dooly/Darvin 2022; Thorne 2003).

Clearly, these multifaceted and interrelated dimensions can only be developed in a stepwise manner and with continuous opportunities for intercultural OPF practice.

As a first step, a common ground should be established through an open discussion of feedback perceptions and understandings (Yang/Carless 2013: 293). Notably, it is necessary to encourage and ensure a positive atmosphere of mutual trust and respect (Nicol 2014: 210) so that PF processes will not be impaired by feelings of fear, reluctance, resentment, or even humiliation (Sadler 1989: 140). Learners could be insecure "about what it involves and why teachers are implementing it" (Nicol 2014: 210). Therefore, the goals of OPF and relevant assessment criteria as well as the roles and responsibilities of the students in the PF process need to be clarified (Zhan/Wan/Sun 2022: 5, 9). In that respect, also students' concerns about their own abilities regarding feedback provision, (foreign) language use, power structures as well as the use of technology should be discussed (see above). All this should not occur in a teacher-centered way, but rather in a teacher-mediated one, so that students can recognize their active role from the outset (as reviewed by Schluer 2022a: 36; Zhan/Wan/Sun 2022: 11). This sensitizes them to the importance of negotiating understandings and co-constructing meanings, which will be a core part of collaborative and dialogic PF processes. Furthermore, teachers should encourage learners to take responsibility for improving their strategies for 1) seeking feedback for their own development; 2) managing affect; 3) giving high-quality feedback; 4) negotiating understandings; and 5) utilizing feedback for their further learning (cf. Carless/Boud 2018; Schluer 2022a: 36–44).

To enable such engagement, the design of OPF tasks and the choice of appropriate communication tools are crucial, which is the second step. For example, when PF is given in a text editor, students can utilize the "Track Changes" feature to indicate detailed sentence-level corrections (Chang 2012: 73). By contrast, synchronous modes, e.g. via screensharing

in videoconferences, seem to invite more elaborate discussions of higher-order aspects (e.g. argumentation) and explanations. Further, Chang (2012: 74) argued that synchronous modes might be particularly beneficial for the early stages of the drafting process, whereas the deepened reflection and concern for surface-level issues could be more suitable for later stages in the writing process. In fact, some tools allow for both synchronous and asynchronous feedback exchanges (cf. Schluer 2022a). To exemplify, in online editors, such as Google Docs, learners do not need to work simultaneously, but they can also proceed at their own pace. They may reflect about the acceptance or rejection of edits and suggestions before continuing their work (Zhang et al. 2022: 5). On the other hand, the wait time in asynchronous OPF can slow down the negotiation of meanings (O'Shea/Fawns 2014: 234) and thus hinder a smooth progression (Ho 2015 cited in Zhan/Wan/Sun 2022: 8). Especially in collaborative tasks (such as PF in wikis), however, regular social interaction is essential.

As a precondition, the students would need interaction strategies (cf. O'Shea/Fawns 2014: 234) and be aware of potential differences regarding learning preferences (individual work, group work) and communicative styles. It might be necessary, then, to change the communication mode and tool. For example, when peers exchange feedback in an online document (e.g. Google Docs), they may utilize the chat or a videoconference to discuss the feedback in more detail (Schluer 2022a: 134). The document could also be displayed via screensharing while talking about it and editing it simultaneously (for further suggestions see Schluer 2022a: 231–238). Moreover, learners can be invited to share their perceptions of digital tools beforehand to eliminate interactional obstacles, such as doubts about the tool's educational values and communicative functions (cf. Thorne 2016: 188). This helps teachers guide learners in choosing a suitable digital tool so that they can comfortably interact with their peers. In addition, learners can also discuss and negotiate the use of semiotic resources afforded by the digital tools and disclose their preferences. In this vein, the dynamic variables in IOC become discernible for learners to help them decide with which peer to interact in what way and to select appropriate modes and resources for the contents they want to negotiate. The guidance ensures a safe space for learners to co-construct interactive norms for the purpose of exchanging OPF.

Furthermore, learners' awareness of unequal access to cultural resources in the VE needs to be acknowledged. They should be made aware of the ways in which information is prioritized by algorithms based on individual preferences and sociocultural constraints (Dooly/Darvin 2022; Thorne 2003). Moreover, it appears that cultural factors can influence students' use of digital tools in terms of engagement, perception of their functions, and preference (cf. Thorne 2003; 2016). Crucially, however, cultural factors need to be addressed without evoking cultural stereotyping. For example, it was claimed that IOC may cause problems since preferences for processing information can differ across cultures (Çağıltay/Bichelmeyer/Kaplan Akilli 2015: 6) or because the VE can reinforce ambiguity and uncertainty. At the same time, it was argued that the VE could enable members in collectivist cultures to speak out, owing to its anonymity (ibid.: 6–7). In the special context of intercultural VEs, OPF might therefore have the potential to break down hierarchical power relations and to strengthen more balanced social relations (cf. Nicol 2014: 210; Yang/Carless 2013: 290). These culturally comparative descriptions in the literature must be read with caution, though, as not everyone adheres to supposed cultural norms (Zhan/Wan/Sun 2022: 10) that are in a constant flux, especially in the digital world. Shuter (2017), for instance, reported that VEs can reduce stereotypes because people are provided with more exposure to other cultures. In that regard, cultural characteristics could be seen as communicative resources in intercultural OPF, not as determinants of possible difficulties (Piller 2012; cf. Canagarajah 2013). Greater emphasis should therefore be placed on intercultural OPF as arenas for transcultural and multilingual negotiation and/or meaning-making processes in which spaces of interaction are transcended and/or newly established. In the end, then, intercultural OPF "could lead to a widening of horizons and 'greater tolerance of other perspectives'" (Martin 2005: 401–402 cited by Schluer 2022a: 213). It may also result in the creation of new communities of OPF practice.

To accomplish this, teachers should also guide students to see the positive side of frictions or disruptions in dialogue because they offer chances to discover unknown perspectives (O'Shea/Fawns 2014: 231). By emphasizing OPF as a dialogue, students might come to comprehend OPF as a way to bridge "the gap between confusions and uncertainties, on the one

hand, and a sense of clarity and shared purpose, on the other" (ibid.: 231). For this, communicative skills are needed that empower learners to address and negotiate differing understandings and expectations.

Likewise, pedagogical designs should be re-shaped, re-aligned and re-negotiated continuously to meet specific learning objectives and learner needs. Due to the emergent and situated nature of feedback processes, also feedback literacies need to be developed dynamically (cf. Schluer 2022a: 238–250 on "dynamic digital feedback literacies") and practiced continuously (Tai et al. 2021: 10).

6. Conclusion and future avenues

For this chapter, the literature on PF in IOC was reviewed from several perspectives. In the PF literature, scholars frequently investigated students' emotions, practices, and learning gains. In studies about OPF, in turn, researchers quite often cited many advantages and disadvantages for single digital feedback methods that did not necessarily arise from the digital tools and modes themselves, but from the advantages and challenges associated with PF (cf. Schluer 2022a). Moreover, many studies about online learning and digital feedback resorted to static, essentialist ascriptions that risk stereotyping certain groups while ignoring the fluidity of cultures. By taking it for granted that culture refers to national culture or constitutes a rather static construct, several studies ascribed mixed results to cultural differences but failed to pay attention to communicative processes and contextual factors. Conversely, many papers about IOC emphasized the features of anonymity and accessibility in VEs. The focus appeared to be more on online communication rather than on culture-related considerations.

As we have seen above, cultural facets can be (re-)negotiated in intercultural encounters, for which individual factors, interpersonal variables, and interactional skills are decisive. Inevitably, students engage in OPF by using cultural resources that are shaped and reshaped through interaction in specific (digital) contexts. It was argued that linguistic, cultural, affective, cooperative, and technological skills are relevant for peers to conduct effective OPF in a co-created third space. In that regard, this review has shown not only that culture is a multifaceted construct, but also that online environments can be of many different kinds. Consequently, the particular

affordances and limitations of single communication modes and tools need closer examination. This can be achieved through detailed analyses from a sociomaterial perspective (Chong 2022; Gravett 2022). It strives to account for complexity and a multitude of factors while considering OPF processes "as being situated in the complex relationships between, and assemblages of, humans and their contexts including objects, places, systems, space and time" (Nieminen et al. 2022: 101). Thus, essentialist and static conceptualizations can neither be presumed for culture nor for VEs. Accordingly, researchers should make transparent the pedagogical design that serves as the foundation of their interventions. This clarity about contextual variables can help to account for seemingly contradictory findings in the intercultural OPF literature.

Overall, however, only a few studies have been conducted on OPF so far (e.g. Irwin 2019: 45), and most of them have not systematically examined the impact of different VEs, especially in IOC (Zhan/Wan/Sun 2022: 10). In fact, digital tools permit or restrict OPF in several ways, which means that peers need to

- be capable of making purposeful choices regarding suitable communication modes (Thorne 2016: 188) while recognizing that each tool has different affordances (Kern/Develotte 2018: 11) and "can shape [their] semiotic work" (Dooly/Darvin 2022: 358);
- become aware of the constraints of VEs and consider discrepancies in peers' perceptions of digital tools;
- possess communicative strategies to exchange feedback as well as to discuss the impact of (inter-)personal, cultural, and technological factors;
- be able to switch between communicative resources (modes, tools, language etc.) if they consider one more appropriate than another for a particular purpose.

This chapter has reviewed linguistic/communicative, sociocultural/interpersonal, collaborative, affective and other individual factors as well as the material (technological) dimension. It has shown that there are manifold interrelations between them, which deserve further investigation (Chong 2021: 9; 2022: 7; Schluer 2022a: 245; Zhan/Wan/Sun 2022: 11). In that respect, research should also re-examine the role of culture by foregrounding communicative strategies and digital resources that are seized to conduct

intercultural OPF successfully – instead of assuming beneficial effects of VEs in a very generalized manner. It would therefore be important to explore these processes, practices, and strategies as well as the motivations peers pursue in intercultural OPF (cf. Lee/Canagarajah 2018: 12): In what ways do intercultural OPF exchanges take place? What verbal, paraverbal, and nonverbal strategies and what modes of communication do learners use for what purposes? How are challenges in intercultural OPF handled productively? What (trans)linguistic, (trans)cultural, and (trans)modal resources do they utilize? With these exploratory questions in mind, research can gain a more nuanced understanding of PF in IOC and of the intricate interplay of a variety of dynamically shifting variables.

In the end, intercultural OPF may offer a chance for language learners to not only improve their work and their competences, but also to engage constructively with linguistic and cultural variation, to question power imbalances and to re-negotiate roles and meanings while using digital tools in a responsible, purposeful, and critical manner.

Bibliography

AbuSeileek, Ali Farhan/Rabab'ah, Ghaleb, 2013: "Discourse Functions and Vocabulary Use in English Language Learners' Synchronous Computer-Mediated Communication". *Teaching English with Technology* 13(1), 42–61.

Adiguzel, Tufan/Varank, İlhan/Erkoç, Mehmet Fatih/Koskeroglu Buyukimdat, Meryem, 2017: "Examining a Web-Based Peer Feedback System in an Introductory Computer Literacy Course". *EURASIA Journal of Mathematics, Science and Technology Education* 13(1), 237–251, retrieved 19.8.2022 from DOI https://doi.org/10.12973/eurasia.2017.00614a.

Ajjawi, Rola/Boud, David, 2015: "Researching Feedback Dialogue. An Interactional Analysis Approach". *Assessment & Evaluation in Higher Education* 42(2), 252–265, retrieved 10.11.2022 from DOI https://doi.org/10.1080/02602938.2015.1102863.

Baker, Will, 2015: *Culture and Identity through English as a Lingua Franca. Rethinking Concepts and Goals in Intercultural Communication.* Berlin: De Gruyter.

Baker, Will/Sangiamchit, Chittima, 2019: "Transcultural Communication: Language, Communication and Culture through English as a Lingua Franca in a Social Network Community". *Language and Intercultural Communication* 19(6), 471–487, retrieved 19.8.2022 from DOI https://doi.org/10.1080/14708477.2019.1606230.

Bolten, Jürgen, 2020: "Rethinking Interculturality: Structure-process Perspectives". Research proposal, retrieved 7.10.2022 from https://www.researchgate.net/publication/339726754.

Brereton, Bernadette/Dunne, Karen, 2016: "An Analysis of the Impact of Formative Peer Assessment and Screencast Tutor Feedback on Veterinary Nursing Students' Learning". *All Ireland Journal of Teaching and Learning in Higher Education (AISHE-J)* 8(3), 29401–29424.

Brück-Hübner, Annika/Schluer, Jennifer, 2023: "Was meinst du eigentlich, wenn du von 'Feedback' sprichst? Chancen und Grenzen qualitativ-inhaltsanalytischer Scope-Reviews zur Herausarbeitung von Taxonomien zur Beschreibung didaktischer Szenarien am Beispiel 'Feedback'. MedienPädagogik 54 (Research Syntheses), 125–166, retrieved 15.1.2024 from DOI https://doi.org/10.21240/mpaed/54/2023.11.29.X.

Çağıltay, Kürşat/Bichelmeyer, Barbara/Kaplan Akilli, Goknur, 2015: "Working with Multicultural Virtual Teams. Critical Factors for Facilitation, Satisfaction and Success". *Smart Learning Environments* 2(11), 1–16, retrieved 19.8.2022 from DOI https://doi.org/10.1186/s40561-015-0018-7.

Canagarajah, Suresh, 2013: "Agency and Power in Intercultural Communication. Negotiating English in Translocal Spaces". *Language and Intercultural Communication* 13(2), 202–224, retrieved 12.11.2022 from DOI https://doi.org/10.1080/14708477.2013.770867.

Carless, David/Boud, David, 2018: "The Development of Student Feedback Literacy. Enabling Uptake of Feedback". *Assessment & Evaluation in Higher Education* 43(8), 1315–1325, retrieved 12.11.2022 from DOI https://doi.org/10.1080/02602938.2018.1463354.

Carless, David/Winstone, Naomi, 2020: "Teacher Feedback Literacy and its Interplay with Student Feedback Literacy". *Teaching in Higher Education* 3(69), 1–14, retrieved 10.11.2022 from DOI https://doi.org/10.1080/13562517.2020.1782372.

Chang, Carrie Yea-huey, 2016: "Two Decades of Research in L2 Peer Review". *Journal of Writing Research* 8(1), 81–117.

Chang, Ching-Fen, 2012: "Peer Review via Three Modes in an EFL Writing Course". *Computers and Composition* 29(1), 63–78, retrieved 10.11.2022 from DOI https://doi.org/10.1016/j.compcom.2012.01.001.

Chiu, Yi-Ching Jean, 2009: "Facilitating Asian Students' Critical Thinking in Online Discussions". *British Journal of Educational Technology* 40(1), 42–57, retrieved 19.8.2022 from DOI https://doi.org/10.1111/j.1467-8535.2008.00898.x.

Cho, Kwangsu/MacArthur, Charles, 2010: "Student Revision with Peer and Expert Reviewing". *Learning and Instruction* 20(4), 328–338, retrieved 10.11.2022 from DOI https://doi.org/10.1016/j.learninstruc.2009.08.006.

Cho, Young Hoan/Cho, Kwangsu, 2011: "Peer Reviewers learn from giving Comments". *Instructional Science* 39(5), 629–643, retrieved 10.11.2022 from DOI https://doi.org/10.1007/s11251-010-9146-1.

Chong, Sin Wang, 2021: "Reconsidering Student Feedback Literacy from an Ecological Perspective". *Assessment & Evaluation in Higher Education* 46(1), 92–104, retrieved 10.11.2022 from DOI https://doi.org/10.1080/02602938.2020.1730765.

Chong, Sin Wang, 2022: "The Role of Feedback Literacy in Written Corrective Feedback Research. From Feedback Information to Feedback Ecology". *Cogent Education* 9(1), 1–13, retrieved 10.11.2022 from DOI https://doi.org/10.1080/2331186X.2022.2082120.

Cuthrell, Kristen/Fogarty, Elizabeth/Smith, Judy/Ledford, Carolyn, 2013: "Implications of using Peer Audio Feedback for the College Learner. Enhancing Instruction". *The Delta Kappa Gamma Bulletin*, 13–21.

Darvin, Ron, 2017: "Language, Ideology, and Critical Digital Literacy". In: Thorne, Steven L./May, Stephen (eds.), *Language, Education and Technology*. Cham: Springer, 17–30.

Dimitrov, Nanda/Dawson, Debra/Olsen, Karyn/Meadows, Ken, 2014: "Developing the Intercultural Competence of Graduate Students". *Canadian Journal of Higher Education* 44(3), 86–103, retrieved 19.8.2022 from DOI https://doi.org/10.47678/cjhe.v44i3.186040.

Dooly, Melinda/Darvin, Ron, 2022: "Intercultural Communicative Competence in the Digital Age: Critical Digital Literacy and Inquiry-based Pedagogy". *Language and Intercultural Communication* 22(3), 1–13.

Evans, Carol, 2013: "Making Sense of Assessment Feedback in Higher Education". *Review of Educational Research* 83(1), 70–120, retrieved from DOI https://doi.org/10.3102/0034654312474350.

Gravett, Karen, 2022: "Feedback Literacies as Sociomaterial Practice". *Critical Studies in Education* 63(2), 261–274, retrieved 12.11.2022 from DOI https://doi.org/10.1080/17508487.2020.1747099.

Guardado, Martin/Shi, Ling, 2007: "ESL Students' Experiences of Online Peer Feedback". *Computers and Composition* 24(4), 443–461, retrieved 19.8.2022 from DOI https://doi.org/10.1016/j.compcom.2007.03.002.

Hall, Edward T./Hall, Mildred Reed, 1990: *Understanding Cultural Differences. Germans, French and Americans.* Boston/Mass: Intercultural Press.

Hammer, Mitchell R., 2005: "The Intercultural Conflict Style Inventory. A Conceptual Framework and Measure of Intercultural Conflict Resolution Approaches". *International Journal of Intercultural Relations* 29(6), 675–695, retrieved 19.8.2022 from DOI https://doi.org/10.1016/j.ijintrel.2005.08.010.

Hattie, John, 2012: *Visible Learning for Teachers. Maximizing Impact on Learning.* London: Routledge.

Hawkins, Margaret R./Mori, Junko, 2018: "Considering 'Trans-' Perspectives in Language Theories and Practices". *Applied Linguistics* 39(1), 1–8, retrieved 7.10.2022 from DOI https://doi.org/10.1093/applin/amx056.

Hofstede, Geert, 2001: *Culture's Consequences. Comparing Values, Behaviors, Institutions, and Organizations across Nations.* Thousand Oaks: Sage.

Hyland, Ken/Hyland, Fiona, 2006: "Feedback on Second Language Students' Writing". *Language Teaching* 39(2), 83–101, retrieved 10.11.2022 from DOI https://doi.org/10.1017/S0261444806003399.

Irwin, Bradley, 2019: "Enhancing Peer Feedback Practices through Screencasts in Blended Academic Writing Courses". *The JALT CALL Journal* (15), 43–59.

Ishikawa, Tomokazu, 2020: "Complexity of English as a Multilingua Franca. Place of Monolingual Standard English". In: Konakahara, Mayu/Tsuchiya, Keiko (eds.), *English as a Lingua Franca in Japan.* Cham: Springer, 91–109.

Ishikawa, Tomokazu, 2021: "Translanguaging and English-within-multilingualism in the Japanese EMI Context". In: Tsou, Wenli/Baker, Will (eds.): *English-medium Instruction Translanguaging Practices in Asia: Theories, frameworks and Implementation in Higher Education.* Cham: Springer, 1–16.

Ishikawa, Tomokazu/Baker, Will, 2021: "Multi-, Inter-, and Trans-'Confusing' Terms for ELF Researchers". Retrieved 10.11.2022 from DOI https://doi.org/10.15045/00001564.

Jenkins, Jennifer, 2015: "Repositioning English and Multilingualism in English as a Lingua Franca". *Englishes in Practice* 2(3), 49–85, retrieved 12.1.2022 from DOI https://doi.org/10.1515/eip-2015-0003.

Kern, Richard/Develotte, Christine, 2018: "Introduction. Intercultural Exchange in the Age of Online Multimodal Communication". In: Kern, Richard/Develotte, Christine (eds.), *Screens and Scenes. Multimodal Communication in Online Intercultural Encounters.* New York: Routledge, 1–21.

Kohn, Kurt, 2018: "Towards the Reconciliation of ELF and EFL: Theoretical Issues and Pedagogical Challenges". In: Sifakis, Nicos C./ Tsantila, Natasha (eds.): *English as a Lingua Franca for EFL Contexts.* Bristol: Multilingual Matters, 1–17.

Kramsch, Claire, 1993: *Context and Culture in Language Teaching.* Oxford: Oxford University Press.

Kress, Gunther, 2004: *Literacy in the New Media Age.* London: Routledge.

Larsen-Freeman, Diane, 2018: "Complexity and ELF". In: Jenkins, Jennifer/Baker, Will/Dewey, Martin (eds.): *The Routledge Handbook of English as a Lingua Franca.* Abingdon: Routledge, 51–60.

Lee, Eunjeong/Canagarajah, A. Suresh, 2018: "The Connection Between Transcultural Dispositions and Translingual Practices in Academic Writing". *Journal of Multicultural Discourses* 1–15, retrieved 16.10.2022 from DOI https://doi.org/10.1080/17447143.2018.1501375.

Lee, Eunjeong/Canagarajah, A. Suresh, 2019: "Beyond Native and Non-native: Translingual Dispositions for More Inclusive Teacher Identity in Language and Literacy Education". *Journal of Language, Identity & Education* 18(6), 352–363, retrieved 7.10.2022 from DOI https://doi.org/10.1080/15348458.2019.1674148.

Liaw, Meei-Ling/Ware, Paige, 2018: "Multimodality and Social Presence in an Intercultural Exchange Setting". In: Kern, Richard/Develotte, Christine (eds.): *Screens and Scenes. Multimodal Communication in Online Intercultural Encounters*. New York: Routledge, 256–278.

Liou, Hsien-Chin/Peng, Zhong-Yan, 2009: "Training Effects on Computer-mediated Peer Review". *System* 37(3), 514–525, retrieved 19.8.2022 from DOI https://doi.org/10.1016/j.system.2009.01.005.

Liu, Jun/Sadler, Randall W., 2003: "The Effect and Affect of Peer Review in Electronic Versus Traditional Modes on L2 Writing". *Journal of English for Academic Purposes* 2(3), 193–227, retrieved 19.8.2022 from DOI https://doi.org/10.1016/S1475-1585(03)00025-0.

Marcoccia, Michel, 2012: "The Internet, Intercultural Communication and Cultural Variation". *Language and Intercultural Communication* 12(4), 353–368, retrieved 19.8.2022 from DOI https://doi.org/10.1080/14708477.2012.722101.

Martin, Marie, 2005: "Seeing is Believing. The Role of Videoconferencing in Distance Learning". *British Journal of Educational Technology* 36(3), 397–405, retrieved 18.10.2021, from DOI https://doi.org/10.1111/j.1467-8535.2005.00471.x.

Min, Hui-Tzu, 2005: "Training Students to Become Successful Peer Reviewers". *System* 33(2), 293–308, retrieved 10.11.2022 from DOI https://doi.org/10.1016/j.system.2004.11.003.

Nguyen, Thi Thuy Minh, 2008: "Criticizing in an L2. Pragmatic Strategies Used by Vietnamese EFL Learners". *Intercultural Pragmatics* 5(1), retrieved 19.8.2022 from DOI https://doi.org/10.1515/IP.2008.003.

Nicol, David, 2010: "From Monologue to Dialogue. Improving Written Feedback Processes in Mass Higher Education". *Assessment & Evaluation in Higher Education* 35(5), 501–517, retrieved from DOI https://doi.org/10.1080/02602931003786559.

Nicol, David, 2014: "Guiding Principles for Peer Review. Unlocking Learners' Evaluative Skills". In: Kreber, Carolin/Anderson, Charles/Entwistle, Noel/McArthur, Jan (eds.): *Advances and Innovations in University Assessment and Feedback. A Festschrift in Honour of Professor Dai Hounsell*. Edinburgh: Edinburgh University Press, 197–224.

Nicol, David, 2021: "The Power of Internal Feedback: Exploiting Natural Comparison Processes". *Assessment & Evaluation in Higher Education* 46(5), 756–778, retrieved 22.8.2022 from DOI https://doi.org/10.1080 /02602938.2020.1823314.

Nicol, David/McCallum, Suzanne, 2022: "Making Internal Feedback Explicit. Exploiting the Multiple Comparisons that Occur During Peer Review". *Assessment & Evaluation in Higher Education* 47(3), 424–443, retrieved 12.11.2022 from DOI https://doi.org/10.1080/02602 938.2021.1924620.

Nicol, David/Thomson, Avril/Breslin, Caroline, 2014: "Rethinking Feedback Practices in Higher Education. A Peer Review Perspective". *Assessment & Evaluation in Higher Education* 39(1), 102–122, retrieved 12.11.2022 from DOI https://doi.org/10.1080/02602 938.2013.795518.

Nieminen, Juuso H./Tai, Joanna/Boud, David/Henderson, Michael, 2022: "Student Agency in Feedback. Beyond the Individual". *Assessment & Evaluation in Higher Education* 47(1), 95–108, retrieved from DOI https://doi.org/10.1080/02602938.2021.1887080.

O'Shea, Clara/Fawns, Tim, 2014: "Disruptions and Dialogues. Supporting Collaborative Connoisseurship in Digital Environments". In: Kreber, Carolin/Anderson, Charles/Entwistle, Noel/McArthur, Jan (eds.): *Advances and Innovations in University Assessment and Feedback. A Festschrift in Honour of Professor Dai Hounsell*. Edinburgh: Edinburgh University Press, 225–245.

Pham, Thinh Ngoc/Lin, Mei/Trinh, Vu Quang/Phuong Bui, Lien Thi, 2020: "Electronic Peer Feedback, EFL Academic Writing and Reflective Thinking. Evidence from a Confucian Context". *SAGE Open* 10(1), 215824402091455, retrieved 19.8.2022 from DOI https://doi.org/ 10.1177/2158244020914554.

Piller, Ingrid, 2012: "Intercultural Communication. An Overview". In: Paulston, Christina Bratt/Kiesling, Scott F./Rangel, Elizabeth S. (eds.): *The Handbook of Intercultural Discourse and Communication*. Wiley, 3–18.

Priego, Sabrina, 2011: "Helping Each Other. Scaffolding in Electronic Tandem Language Learning". *The International Journal of Technology, Knowledge, and Society* 7(2), 133–152, retrieved 23.8.2022 from DOI https://doi.org/10.18848/1832-3669/CGP/v07i02/56191.

Prieto-Arranz, José Igor/Juan-Garau, Maria/Jacob, Karen Lesley, 2013: "Re-imagining Cultural Identity. Transcultural and Translingual Communication in Virtual Third-space Environments". *Language, Culture and Curriculum* 26(1), 19–35, retrieved 19.8.2022 from DOI https://doi.org/10.1080/07908318.2012.759585.

Risager, Karen, 2006: *Language and Culture: Global Flows and Local Complexit.* Clevedon: Multilingual Matters.

Sadler, D. Royce, 1989: "Formative Assessment and the Design of Instructional Systems". *Instructional Science* 18(2), 119–144, retrieved 10.11.2022 from DOI https://doi.org/10.1007/BF00117714.

Schluer, Jennifer, 2021: "Exploring L2 Readers' Metacultural Competence Through a Video- based Cooperative Approach". In: Peters, Arne/ Mundt, Neele F. (eds.): *Cultural linguistics Applied. Trends, Directions and Implications.* Berlin: Peter Lang, 205–234.

Schluer, Jennifer, 2022a: *Digital Feedback Methods.* Tübingen: Narr Francke Attempto.

Schluer, Jennifer, 2022b: "Pre-service Teachers' Perceptions of Their Digital Feedback Literacy Development Before and During the Pandemic". *International Journal of TESOL Studies* 4(3), 15–32, retrieved 10.11.2022 from DOI https://doi.org/10.46451/ijts.2022.03.03.

Sharifian, Farzad, 2018: "Metacultural Competence in English Language Teaching (ELT)". In: Liontas, John I. (ed.): *The TESOL Encyclopedia of English Language Teeaching.* Hoboken: John Wiley & Sons, Inc., NJ, 1–6.

Shuter, Robert, 2017: "New Media and Intercultural Communication". In: Kim, Young Y. (ed.): *The Encyclopedia of Intercultural Communication.* Hoboken: Wiley, NJ, 1–9.

Sun, Yilin/Doman, Evelyn, 2018: "Peer Assessment". In: Liontas, John I. (ed.): *The TESOL Encyclopedia of English Language Teaching.* Hoboken: Wiley-Blackwell, NJ, 1–7.

Swierczek, Fredric William/Bechter, Clemens, 2010: "Cultural Features of E-Learning". In: Spector, J. Michael et al. (eds.): *Learning and Instruction in the Digital Age.* Boston: Springer US, MA, 291–308.

Tai, Joanna/Bearman, Margaret/Gravett, Karen/Molloy, Elizabeth, 2021: "Exploring the Notion of Teacher Feedback literacies Through the Theory of Practice Architectures". *Assessment & Evaluation in Higher*

Education 62(1), 1–13, retrieved from DOI https://doi.org/10.1080/02602938.2021.1948967.

Thorne, Steven L., 2003: "Artifacts and Cultures-of-use in Intercultural Communication". *Language Learning & Technology* 7(2), 38–67.

Thorne, Steven L., 2016: "Cultures-of-use and Morphologies of Communicative Action". *Language Learning & Technology* 20(2), 185–191, Retrieved 7.10.2022 from http://llt.msu.edu/issues/june2016/thorne.pdf.

Winstone, Naomi/Carless, David, 2020: *Designing Effective Feedback Processes in Higher Education. A Learning-focused Approach.* Abingdon: Oxon: Routledge.

Yang, Min/Carless, David, 2013: "The Feedback Triangle and the Enhancement of Dialogic Feedback Processes". *Teaching in Higher Education* 18(3), 285–297, retrieved from DOI https://doi.org/10.1080/13562517.2012.719154.

Yu, Shulin/Lee, Icy/Mak, Pauline, 2016: "Revisiting Chinese Cultural Issues in Peer Feedback in EFL Writing. Insights from a Multiple Case Study". *The Asia-Pacific Education Researcher* 25(2), 295–304, retrieved 19.8.2022 from DOI https://doi.org/10.1007/s40299-015-0262-1.

Zaltsman, Rita Ricardo, 2008: "The Challenge of Intercultural Electronic Learning: English as Lingua Franca". In: Ricardo, Francisco J. (ed.): *Cyberculture and New Media.* Leiden: Brill, 99–113.

Zhan, Ying/Wan, Zhi Hong/Sun, Daner, 2022: "Online Formative Peer Feedback in Chinese Contexts at the Tertiary Level. A Critical Review on its Design, Impacts and Influencing Factors". *Computers & Education* 176, retrieved 19.8.2022 from DOI https://doi.org/10.1016/j.compedu.2021.104341.

Zhang, Haisen/Song, Wei/Shen, Suping/Huang,Ronghua, 2014: "The Effects of Blog-Mediated Peer Feedback on Learners' Motivation, Collaboration, and Course Satisfaction in a Second Language Writing Course". *Australasian Journal Of Educational Technology* 30(6).

Zhang, Han/Shulgina, Galina/Fanguy, Mik/Costley, Jamie, 2022: "Online Peer Editing. Effects of Comments and Edits on Academic Writing Skills". *Heliyon* 8(7), retrieved 10.11.2022 from DOI https://doi.org/10.1016/j.heliyon.2022.e09822.

Zhu, Qiyun/Carless, David, 2018: "Dialogue Within Peer Feedback Processes. Clarification and Negotiation of Meaning". *Higher Education Research & Development* 37(4), 883–897, retrieved 10.11.2022 from DOI https://doi.org/10.1080/07294360.2018.1446417.

Zorn, Isabel, 2005: "Do Culture and Technology Interact? Overcoming Technological Barriers to Intercultural Communication in Virtual Communities". *ACM SIGGROUP Bulletin* 25(2), 8–13, retrieved 19.8.2022 from DOI https://doi.org/10.1145/1067721.1067723.

Tilman Schröder

Online Consumer Reviews and Management Responses: Intercultural Service Encounters in the Digital World

Abstract English: Service encounters between customers and staff members with different cultural backgrounds are susceptible to misunderstandings and dissatisfaction on both sides. After problematic encounters, some customers vent their frustration by publishing complaints in online review portals. Such negative online reviews can thus be considered written records of intercultural conflict between customers and staff members. In review portals, service providers can publicly respond to negative reviews, with the objective of clarifying the complaint, repairing the relationship with the customer, or conveying a positive public image. The present paper analyzes culture-related complaints written by hotel guests in online review portals and management responses to these complaints. First, the study identifies the reasons for intercultural conflict that become apparent in the reviews. Next, it discusses speech act structures in the management responses to negative culture-related reviews. Based on the analysis, an initial typology of steps in management responses to culture-related complaints is developed. The paper finishes with a summary and implications for future research.

Abstract Deutsch: Interaktionssituationen zwischen Kund*innen und Mitarbeiten-den mit unterschiedlicher kultureller Herkunft sind in besonderem Maße anfäl-lig für Missverständnisse und Unzufriedenheit auf beiden Seiten. Im Anschluss an konfliktbehaftete Interaktionssituationen veröffentlichen manche Kund*in-nen negative Online-Bewertungen, um ihrer Frustration Luft zu machen. Solche Online-Beschwerden können als schriftliche Zeugnisse interkultureller Konfliktsi-tuationen betrachtet werden. Unternehmen haben die Möglichkeit, negative Bewer-tungen öffentlich zu kommentieren, um Beschwerden aufzuklären, die Beziehung zur Kundin/zum Kunden wiederherzustellen oder ein positives Bild von sich zu ver-mitteln. Der vorliegende Beitrag analysiert negative Bewertungen mit kulturellem Bezug, die von Hotelgästen online veröffentlicht und vom jeweiligen Unternehmen kommentiert wurden. Zunächst werden jeweils die Gründe für den interkulturel-len Konflikt ermittelt, bevor anschließend typische Sprechaktstrukturen in den

Reaktionen der Unternehmen identifiziert werden. Basierend auf der Analyse wird eine erste Typologie von Sprechakten in Unternehmensreaktionen auf kulturspezifische Beschwerden entwickelt. Der Beitrag schließt mit einer Zusammenfassung und Implikationen für weitere Forschung.

Keywords: Intercultural communication, tourism, service encounter, online reviews, complaints, genre analysis

1. Introduction

Mutual interactions between customers and service employees with different cultural backgrounds have been described as intercultural service encounters (ICSEs) (Paparoidamis/Tran/Leonidou 2019: 56; Sharma 2019: 1). These interaction situations are often susceptible to misunderstandings or a lack of mutual comprehension as a result of cultural and linguistic differences between the participants (Holmqvist 2011: 179). In view of this, ICSEs are an intriguing object of research for the fields of business, linguistics, and intercultural studies. Following Schroll-Machl (2011: 26), culture is understood here as national culture, i.e., as a set of meaningful practices and values that the members of a society establish through mutual interactions over extended periods of time, and that serve as a framework for orientation in everyday life. It must be recognized, however, that national affiliation is but one factor among many others that can influence individual behavior, and that cultures can be "multidimensional, open-ended, and dynamic" (Delanoy 2020: 30).

Over the past decade, the opportunities for ICSEs have increased considerably (Sharma 2019: 2), mostly in the international tourism industry, which saw annual growth of four to seven percent leading up to the COVID-19 pandemic (UNWTO 2022). The expansion of the tourism sector was largely facilitated by the development of digital information and communication technologies (Mariani/Borghi/Okumus 2020: 1). With the help of digital technologies, tourists can easily arrange travel, communicate with fellow travelers, and interact with tourism service providers such as airlines, tour operators, and hotel owners across different countries (ibid.). During and after their trips, tourists tend to share their experiences on social media, e.g., by posting pictures on social networking

sites or by leaving reviews on online portals such as HolidayCheck, Tripadvisor, or Google (Sparks/Bradley 2017: 720). Positive reviews are composed with the objective of enjoyment, positive self-enhancement, or helping the company. Negative reviews, in contrast, are written to vent negative feelings, to leverage collective power, or to warn other customers (Yoo/Gretzel 2008: 291).

Before departing on a trip, prospective travelers use online reviews to gather information about service providers, and to help with their booking decisions (Godnov/Redek 2019: 2456). In the tourism sector, with its intangible service products, information from other travelers is particularly relevant for future customers, as it helps reduce uncertainties about product quality (Buzova/Sanz-Blas/Cervera-Taulet 2019: 155; Zhang et al. 2020: 1). Online reviews in tourism are perceived to be an objective source of information, and they are believed to be more credible than marketing and advertising (Sparks/Bradley 2017: 720). As such, reviews shape travelers' expectations and influence hotel and destination choices (Buzova/Sanz-Blas/Cervera-Taulet 2019: 155). While considerable research has been conducted about online reviews in tourism, there is a lack of studies regarding the impact of cultural differences between tourists and service providers in the context of online travel reviews (Mariani/Borghi/Okumus 2020: 1).

From a linguistics viewpoint, online reviews posted by consumers can be conceptualized as digital genres. Genres are conventionalized sequences of speech acts that are used to realize a specific communicative purpose. They tend to show recurring features regarding form, content, and style (Swales 1990: 58; Yates et al. 1999: 84). Genres in digital media, such as online reviews, can additionally be dynamic and dialogical: many review portals enable the management of service providers to respond to consumer reviews (Zhang et al. 2020: 1). A consumer review with a subsequent management response constitutes a short conversation that is limited to two turns, since further turns cannot be added to the thread (Cenni/Goethals 2021: 40). If the review author and the service provider do not share the same cultural background, their conversation can be interpreted as a written digital record of an intercultural service encounter.

Such conversations are particularly interesting in intercultural research if the traveler review and the corresponding management response reflect a culture- or language-based conflict situation. The reasons for such conflict situations can be different expectations, norms, and rules, or differences in verbal and nonverbal communication. Additionally, low levels of intercultural competence among travelers and service providers, i.e., the inability to negotiate a mutually acceptable solution for the situation, as well as specific incidents can contribute to these conflicts (Kenesei/Stier 2017: 313).

To date, no research has been conducted regarding the interconnection between ICSEs, culture-related online reviews, and management responses. Yet, research in this area is needed to raise awareness among service providers regarding the importance of intercultural issues when handling online reviews. In particular, inappropriate or incomplete management responses to culture-related online complaints can pose threats to an organization's online reputation. The present study aims to close this gap by combining research frameworks from linguistics and intercultural studies to analyze written records of problematic intercultural encounters between tourists and hotel staff on the review platforms HolidayCheck and Tripadvisor. The main research interest concerns the manner in which service providers respond to culture-related complaints that originate from tourists with a different cultural background. The study has two specific objectives: (1) illustrate different types of problematic ICSEs in review portals based on various culture-related conflicts, (2) identify typical linguistic moves that hoteliers use in their responses to culture-related complaints. The findings can be used to advance this relatively recent field of research, and as an initial point of orientation for hotel staff dealing with online reviews.

The paper begins by reviewing relevant literature from the fields of business, intercultural studies, and linguistics, with the objective of identifying parameters for analyzing ICSEs in review portals. As a second step, the identified parameters are used to qualitatively analyze a sample of 12 culture-related guest reviews with the corresponding management responses in online portals. The paper closes with a summary and some concluding remarks.

2. Literature Review and Theoretical Background

2.1 Business Perspectives on Online Reviews

Online reviews can be characterized as electronic word of mouth (eWOM) interactions, which fall into the broader category of user-generated content on the Internet. Online reviews can strongly influence the public image of a hotel (Godnov/Redek 2019: 2456) since they have countless potential recipients (Sparks/Bradley 2017: 720). While positive reviews can increase a hotel's reputation and business success, negative reviews can threaten its reputation and lead to a decline in bookings (Cenni/Goethals 2021: 39). Consequently, many service providers in the hospitality sector actively monitor and manage online reviews, for instance by publishing management responses on review portals (ibid.: 721). Previous research from the fields of marketing and hospitality has explored business strategies for handling reviews (Park/Allen 2013), the effect of different contents in responses (Li/Ma/Bai 2020), and best practices for responding to negative reviews (Sparks/Bradley 2017). These studies, however, do not include cross-cultural or linguistic perspectives.

While responding to positive reviews is relatively easy, composing appropriate responses to negative reviews is considerably more challenging (Sparks/Bradley 2017: 721). With responses to negative reviews (RNRs), businesses aim to repair or consolidate the relationship with the customer who wrote the review (Cenni/Goethals 2021: 39). Moreover, appropriate RNRs can convey positive images to prospective customers who may be reading along (Zhang et al. 2020: 3). Research shows that customized RNRs with specific references to the original review are perceived to be helpful by potential guests, whereas copying and pasting identical RNRs below each review should be avoided (ibid.), since such generic RNRs will lead readers to question the company's seriousness (Napolitano 2018: 141). This implies that the responsibility for RNRs should not lie with low-level staff such as student interns or apprentices. Instead, customized RNRs should be composed by experienced high-level staff members (Zhang et al. 2020: 13).

Several marketing and hospitality researchers have explored the link between traveler reviews, management responses, and culture.

Previous research has compared online reviews across cultures in terms of expressiveness and emotionality (Buzova/Sanz-Blas/Cervera-Taulet 2019), directness and perceived helpfulness (Nakayama/Wan 2021), and perceived credibility (Brand/Reith 2021). Litvin (2019) and Mariani/Borghi/Okumus (2020) show that cultural dimensions can influence the content and style of online reviews, whereas Ayeh/Au/ Law (2016) compare tourists' intentions for reading online reviews across cultures. In a study about RNRs, Zbikowska (2020) compares the frequency of publishing RNRs among business owners across different countries. An overview of the existing literature in this field can be found in Brand/Reith (2021). Nonetheless, Buzova/Sanz-Blas/Cervera-Taulet (2019: 155) highlight the general need for more research about culture and eWOM.

2.2 Intercultural Service Encounters

In the present paper, online reviews are considered as written accounts of intercultural service encounters (ICSEs). Service encounters are task-oriented interactions between customers and service providers, during which both participants use their culture-specific norms, values, behaviors, and communication styles (Barker/Härtel 2004: 4; Sharma 2019: 34–35). In ICSEs, cultural and linguistic differences can hinder the interaction and lead to frustration and dissatisfaction (Paparoidamis/Tran/ Leonidou 2019: 56), because protagonists may use their culture-specific norms, values, and service quality expectations to evaluate an ICSE (Kenesei/Stier 2017: 308). However, intercultural competence among customers and service providers can reduce the risk of misunderstanding or frustration in ICSEs (ibid.: 310). According to Bolten (2020: 59), intercultural competence "consists of identifying possible appropriate rules in contexts with less familiar and less obviously determinable rules in order to generate plausibility and security among the actors involved." In particular, international travelers tend to be more proficient in identifying such rules during an ICSE, and may have more realistic expectations regarding the outcomes of the ICSE (Kenesei/Stier 2017: 310). Along these lines, research has shown that, in ICSEs, customers lower their expectations if they expect the service to be worse than in their country of origin (ibid.: 309).

ICSEs have been the subject of diverse scholarly publications. Of these, the seminal work by Sharma (2019), who studies the phenomenon from a variety of theoretical angles, deserves special mention. Holmqvist (2011), Wang/Miao/Mattila (2015), and Zolfagharian/Hasan/Iyer (2018) specifically address language use in ICSEs and agree that using the customer's first or preferred language is a factor for success. Additionally, intercultural competence among service staff and customers contributes to positive results of ICSEs (Paparoidamis/Tran/Leonidou 2019). Kenesei/Stier (2017) propose the following factors that can influence the outcome of ICSEs in the hospitality sector:

> (1) Intercultural competence of frontline staff, (2) Intercultural competence of guests, (3) Differences in culture and communication, (4) Situational difficulties during the ICSE, (5) Efforts made by staff members and customers to overcome the difficulties.

The outcome of the ICSE depends on whether the guests' expectations could be met or not (ibid.: 313). This framework provides important insights for the present study, as it can help identify the reasons for failure of the written ICSE records analyzed here.

3. Linguistic Analysis of Online Reviews and Management Responses

Online reviews and management responses have also received attention from researchers in the field of linguistics who have conceptualized these texts in terms of speech act and genre theory. Negative reviews reflect the speech act of complaining, whereas positive reviews are analogous to the speech act of complimenting (Cenni/Goethals 2021: 39). Vásquez (2011) identifies speech act patterns in negative reviews on Tripadvisor, while De Ascaniis/Cantoni (2018) analyze argumentative structures in online reviews. Several studies have also conducted linguistic analyses of management responses to online reviews. Zhang/Vásquez (2014), Panseeta/Todd (2014), Napolitano (2018), and Thumvichit/Gampper (2019) study typical moves in management responses to negative reviews (RNRs). Cenni/Goethals (2021), in contrast, provide a genre analysis of management responses to positive reviews and identify typical move structures in such texts. Aside from the genre-based approaches, other studies have

investigated forms of address and self-reference in management responses (Sanmartín Sáez 2018) as well as linguistic style matches between reviews and responses (Zhang et al. 2020).

From a genre perspective, the purpose of an RNR is either to achieve service recovery or to protect the business's image (Thumvichit/Gampper 2019: 3). An RNR tends to be the final turn in the short conversation between reviewer and management since review portals do not allow for further replies; however, RNRs can be referenced in subsequent reviews. An RNR consists of several moves and steps which can be obligatory, conventional, or optional (ibid.: 4). Zhang/Vásquez (2014: 60) propose the following 10 moves for RNRs in the Chinese hotel sector:

> (1) Opening pleasantries, (2) Express gratitude, (3) Apologize for sources of trouble, (4) Proof of corrective or investigative action, (5) Acknowledge complaints/feedback, (6) Refer to customer reviews, (7) Intention to avoid reoccurring problems, (8) Invitation for a second visit, (9) Solicit response, (10) Closing pleasantries.

While the positions of moves (1) and (2) are fixed, the position of the other moves can vary. Moves (1), (2), (3), (4), and (8) appeared in more than 60 percent of the analyzed RNRs. The other moves were included less frequently (ibid.: 58).

Napolitano (2018) applies Zhang/Vásquez's model to British and Italian RNRs and identifies seven additional moves:

> (1) Reasons for answering, (2) Reference to specific interaction, (3) Justification, (4) Making a point, (5) Criticism towards review, (6) Declaring the review untrue, (7) Offence.

Based on Panseeta/Todd (2014: 6), Thumvichit/Gampper (2019: 5) establish a model of six typical RNR moves and steps:

> (1) Salutation
> (2) Feedback: (2a) Expressing gratitude, (2b) Valuing feedback, (2c) Expressing regret/concern/apology
> (3) Brand positioning: (3a) Stating hotel's commitment, (3b) Confirming hotel's standard
> (4) Dealing with complaints: (4a) Explaining causes of the incident, (4b) Reporting action taken, (4c) Admitting mistakes

(5) Concluding remarks: (5a) Expressing gratitude (II), (5b) Expressing regret/concern/apology (II), (5c) Asking for a return visit, (5d) Soliciting direct contact, (5e) Promising to improve service
(6) Closing: (6a) Sign off, (6b) Signature, (6c) Job titles, (6d) Contact information, (6e) Affiliation

When applying the model to a corpus of RNRs from British hotels, Thumvichit/Gampper (2019) found that moves (2), (4), (5) appear in more than 90 percent of the RNRs, whereas (1), (3), and (6) were used considerably less frequently.

The analysis of RNRs to culture-related reviews will be based on Thumvichit/Gampper's (2019) model, with a special focus on move (4) "Dealing with complaints". The model will be expanded with steps that were found in the RNRs of the present study.

4. Management Responses to Culture-Related Reviews

4.1 Sample and Methodology

For this exploratory study, hotel reviews published on HolidayCheck and Tripadvisor were searched for written records of problematic ICSEs, i.e., negative reviews that included a culture-related reference and that had received an RNR from the hotel management. Reviews were classified as neutral to negative if the overall rating for the hotel was not better than 3/5 on Tripadvisor or 4/6 on HolidayCheck. Reviews were only considered if the author's profile in the review portal disclosed their country of residence. Reviews that received generic RNRs and machine-translated reviews were excluded from the analysis. All reviews and RNRs were analyzed in their original language. It is not possible, however, to verify the residency, nationality, or cultural identity of the review authors. The same holds true regarding the identities of hotel staff members who composed the RNRs, as the workforce in the tourism industry tends to be international. The national and linguistic affiliations of the review authors are among the few parameters that are visible on Tripadvisor and were thus used for practical reasons to narrow down the sample when searching for written records of ICSEs. Yet, the content and style of reviews and RNRs may be influenced by further individual and context-specific factors which cannot be ascertained in this study.

Within both review portals, 184 hotels of diverse star categories across five countries were manually searched, and a total of 115 negative reviews with RNRs documenting ICSEs were found. Following the notion of purposeful sampling (Marshall 1996)[1], 12 examples of reviews and RNRs were considered as particularly meaningful for this paper's research interest and thus selected for detailed analysis. These examples refer to three, four, and five-star hotels from the Dominican Republic, Egypt, Germany, Spain, and Turkey.

For each example, the model proposed by Kenesei/Stier (2017) was used to describe the nature and the circumstances surrounding the underlying ICSE. Thumvichit/Gampper's (2019) model of RNR move structures was adapted for analyzing the hotels' reactions to culture-related complaints. For practical purposes, the analysis focuses solely on Thumvichit/Gampper's (2019) move (4) "Dealing with complaints".

The analysis of culture-related negative reviews and the corresponding RNRs is structured according to the nature of the underlying intercultural conflicts. Due to space constraints, only the culture-related sections of the reviews and the RNRs are excerpted. The original texts are quoted without modifications of grammar, spelling, and typography. Translations are provided for reviews and RNRs written in a language other than English. In view of the exploratory nature of this study, and the small sample of reviews and RNRs, the findings reported here are of limited scope and require further empirical validation.

5. Analysis

Following Kenesei/Stier (2017), the analysis of customer reviews and management responses exhibited three main areas of culture-related conflict:

- Differences in culture: time orientation, mealtimes, food options, religion, clothing

1 Purposeful sampling refers to the intentional selection of cases that are considered most relevant for answering a given research question (Marshall 1996: 523).

- Differences in communication: speaking volume, politeness, language
- Difficulties during ICSE (specific situation at the hotel): dominant nationalities, misunderstanding, behavior of staff or fellow guests

Within the management responses, the move "Dealing with complaints" (Thumvichit/Gampper 2019) was found to have the following steps:

(a) Explain local culture/habits/language
(b) Use humor
(c) Show polycentrism
(d) Show empathy
(e) Mention positive aspects of local culture
(f) Show indifference towards complaint
(g) Point to misunderstanding
(h) Quote guest review
(i) Reference specific interactions
(j) Lecture guest about local culture
(k) Accuse guest of misbehavior
(l) Accuse guest of ethnocentrism or erroneous expectations
(m) Declare allegations incomprehensible
(n) Ignore culture-related complaint
(o) Report action taken

In the following, each of the 12 examples will be described regarding the underlying intercultural conflict and the steps used in the respective RNR.

Review/RNR (1)

Area of conflict: differences in culture (time orientation)

Review (1) was posted on Tripadvisor in January 2015 by an Italian tourist about a three-star hotel in Munich, Germany (overall rating: 2/5). The review suggests that the guest and the hotel owner have differing views concerning time orientation and following plans and schedules.

> Review (1)
>
> (...) The owner isn't that nice: we requested to leave our luggage for a couple of hours and she refused. She's not very flexible with breakfast hours either, and she pressured us to check out in the morning. (...)

RNR (1)

(...) This are guests (...) starting with breakfast half an hour after breakfast time (I was waiting on them), checking out after check-out time. What should I say? Hopefully they'll find a cheaper hotel suiting their needs next time. (...)

The German hotel owner explains her view on the incident by referencing specific interaction situations for which the guests are accused of misbehavior: (i), (k): "starting with breakfast half an hour after breakfast time [...] checking out after check-out time". The exact sequence of events is impossible to trace; however, both participants of this ICSE show some level of inflexibility and fail to negotiate a mutually acceptable solution for dealing with their different expectations. It is worth noting that, of all RNRs analyzed in this paper, this is the only case where the hotel owner does not specifically address the review author, but the general public instead. Most review authors, on the other hand, do not address the hotels directly.

Review/RNR (2)

Area of conflict: differences in culture (meal times)

Review (2) was written by a British guest on Tripadvisor in July 2017 about their stay at a four-star hotel at the Spanish Costa Brava (overall rating: 3/5). The review exhibits the guest's discontent with evening dinner schedules, which, in the United Kingdom, tend to be earlier than in Spain.

Review (2)

(...) however, main criticism was evening mealtimes, dining hall supposed to open at 7.30pm (which is too late when you have kids), sometimes didn't open until nearer 7.45PM. This was a nightmare especially for families. (...)

RNR (2)

(...) About the evening mealtimes we catch this point. The thing is that in Spain our dinner hour are, in general, about "20:00–22:00" but we understand that the other countries have different hours and for that reason is difficult to decide the perfect hour for everyone. However, we can assure you that we will take note about this because all the opinions are important and we want to improve for make happy our guest. (...)

In this RNR, the Spanish hotel reacts to the criticism by explaining Spanish dinner times (a): "in Spain our dinner hour are"; however, without

lecturing or accusing the guest of erroneous expectations. In contrast, the RNR shows polycentrism (c): "we understand that the other countries have different hours" and a certain degree of empathy (d): "we catch this point"; "is difficult to decide the perfect hour for everyone", both of which can be seen as expressions of the staff member's intercultural competence.

Review/RNR (3)

Area of conflict: differences in culture (food options)

Review (3) was published on Tripadvisor in April 2019 by a British tourist about a four-star hotel at the Costa Blanca in Spain (overall rating: 1/5). The review author expresses dissatisfaction with the lack of non-Spanish food options at the hotel and accuses the hotel of limiting their offer to Spanish nationals.

> Review (3)
>
> Food was awful, they only cater for Spanish, they don't like young people more like a retirement home full of old people everyone so rude the staff are just ignorant the all inclusive is terrible. (...)

> RNR (3)
>
> (...) We regret that we have not met your expectations in the gastronomic area, we understand that it may not have been to your expectation, however we focussed gastronomic offer to the different nationalities housed in the hotel. Remember that you are in Spain and we will try you enjoying the benefits of our mediterranean cuisine. (...)

In the RNR, the hotel initially expresses regret about the guest's complaint. As a next step, however, the hotel manager lectures the guest about local culture (j): "remember that you are in Spain". With this move, the hotel also points to erroneous expectations on behalf of the guest (l), which are assumed to be the reason for this ICSE's failure. The hotel's statement about "the benefits of our mediterranean cuisine" can be categorized as move (e) ("Mention positive aspects of local culture").

Review/RNR (4)

Area of conflict: differences in culture (food options, religion)

Review (4) was posted on Tripadvisor in October 2018 by a British tourist concerning a three-star hotel in Side, Turkey (overall rating: 2/5). The

review author complains about the noise caused by a nearby mosque and the food options available for breakfast at the hotel.

Review (4)

(...) hotel is situated in a run down area close to the market and the mosque which is very noisy at 3.30 and 5.00 am during call to pray (...) the breakfast was terrible but ok if you like hard boiled eggs and watered down juice. (...)

RNR (4)

(...) The next thing you complain is mosque. Welcome to 99% muslim country. If you dont know how to respect religion why you go to holiday to other countries. and If you know about writing review on Tripadvisor why you didint take attention to our hotel reviews before you came and you booked our hotel. Many people like you mention about the mosque. (...) Breakfast is what you paid. I hope you are not waiting us to serve you English breakfast. Thomas Cook and all other companies approved our breakfast buffet so I really dont care what you ra thinking about our breakfast buffet. (...)

The guest's dissatisfaction appears to be related to a mismatch in expectations towards their vacation in Turkey, presumably due to a lack of awareness and tolerance as well as a certain degree of ethnocentrism. In the RNR, the hotel counters the complaint about noise coming from a mosque by lecturing the guest about local culture (j): "Welcome to 99 % muslim country". Additionally, the hotel accuses the guest of ethnocentrism and erroneous expectations (l): "I hope you are not waiting us to serve you English breakfast"; "If you dont know how to respect religion why you go to holiday to other countries". The hotel also disparages the review by showing their indifference towards the complaint (f) "all other companies approved our breakfast buffet so I really dont care what you ra thinking". Compared with other examples, the tone of this RNR is considerably more aggressive and emotional.

Review/RNR (5) and (6)

Area of conflict: differences in culture (clothing)

Review (5) was composed by a German tourist on Holidaycheck in May 2017 regarding a five-star hotel in Side, Turkey (overall rating: 3/6). The author expresses their discontent with fellow guests wearing a full-body swimsuit in the swimming pool.

Review (5)

(...) Ich mag es nicht wenn Menschen in Ganzkörperkondomen in den Pool gehen. (...)

[I don't like people entering the pool in full-body condoms.]²

RNR (5)

(...) Es tut uns sehr leid ‚dass (...) wir Ihre Erwartungen nicht erfüllt haben . (...)

[We are very sorry that we did not meet your expectations.]

Based on the review, the ICSE failed due to ethnocentrism and a lack of tolerance among the German guest. Aside from the complaint about female swimwear, the review author mentions several other areas of concern which the hotel addresses in the RNR; however, these other complaints are not connected to culture. The swimwear complaint is ignored by the hotel (n). It is worth noting that this conversation has more than just two participants and two turns: shortly afterwards, review 5) is referenced by another German guest (6) who reviews the same hotel on HolidayCheck (overall rating: 6/6).

Review (6)

(...) Da fahren Sie doch tatsächlich in die Türkei und beschweren sich darüber, dass in Ihrem selbst gewählten Gastland türkische Badegäste sind. Hut ab! (...) Meine Empfehlung für Sie und Ihre weitere urlaubsbedingte Karriere: Bleiben sich sicherheitshalber zukünftig in Ihrem germanischen Schrebergarten und malen Sie weiterhin Ihre Gartenzwerge hübsch bunt an. Vorzugsweise in Bikinis statt Burkinis. Niemand wird Sie ernsthaft vermissen. (...)

[You actually travel to Turkey and complain about Turkish bathers being present in the country of your choice. Kudos to you! (...) My recommendation for you and your future travels: as a precaution, stay in your Germanic small garden plot and continue to paint your garden gnomes in beautiful colors. Preferably in bikinis instead of burkinis. No one is seriously going to miss you.]

Reviewer (6) sides with the hotel and sarcastically points out the ethnocentric attitude of review author (5). The hotel also responds to review 6) and expresses their gratitude:

2 All translations are my own unless otherwise noted.

Hotel response to (6)

EINE TOLLE BEWERTUNG VON IHNEN RECHT HERZLICHEN DANK
(...) Sie sind ein guter Mensch und ein grosses Herz haben Sie (...)

[A GREAT REVIEW FROM YOU THANK YOU VERY MUCH. (...) You are
a good person and have a big heart.]

Review/RNR (7)

*Area of conflict: differences in culture (speaking volume, politeness) and
difficulties during ICSE (dominant nationalities, behavior of staff or fel-
low guests)*

Review (7) comes from a British guest and concerns the same three-star
hotel in Side as review (4). Review (7) was published on Tripadvisor in
September 2016 (overall rating: 3/5) and documents the guest's frustration
with the quantity of local guests and their behavior at the hotel premises.

Review (7)

(...) last week was a local holiday,the place full of Turkish speaking rude n
no mannered children,I was battered with balls in the face as was a few
other guests,they were awful noisy and spoilt the idyllic setting gazipasa
offered!!!!! (...)

RNR (7)

Thank you very much for your review. I hope next time your holiday does not
coincide same time with Turkish Eid holiday:) I agrre with you, you will enjoy
your stay more than last time. (...)

The failure of this ICSE can be ascribed to intercultural differences regard-
ing acceptable speaking volumes between the British and the Turkish
guests at the hotel. It should be noted that in the RNR, the hotel does not
deny the allegations made by the guest. The actual basis for the complaint
is not addressed (n); instead, the hotel deflects the negative review with
humor (b): "I hope next time your holiday does not coincide same time
with Turkish Eid holiday :)."

Review/RNR (8)

*Area of conflict: differences in culture (diverse aspects) and difficulties
during ICSE (behavior of staff or fellow guests)*

Review (8) was composed by a Swiss guest about a four-star hotel in Hurghada, Egypt (overall rating: 2/5). The review was published on Trip-advisor in December 2017 and suggests that the tourist's dissatisfaction was caused by diverse aspects of local culture and staff or guest behavior.

Review (8)

(...) Ansonsten sind die Ägypter leider immernoch eine Katastrophe! (...) Gut wegen der Sauberkeit kann man ihnen nicht viel vorhalten, wie sollten denn rostige Zimmer und Hoteleinrichtungen geputzt werden (...) zeitlich sind sie hier einfach stehen geblieben! So wird in den grossen Hotelaufenthaltsräumen und teils leider auch in den Zimmern weiterhin ordentlich geraucht wie in den besten 90er Jahren! (...) [das ergibt] eine neue kulinarische Geschmacksreise, welche nur kurz durch einen überparfumierten Ägypter unterbrochen werden kann... (...) Links und rechts stehen zur „Sicherheit" der Gäste Securitytrottels welche einem nicht mehr weiterlassen.... Tourist und Terrorist können die leider nicht unterscheiden... (...)

[Other than that, the Egyptians are still a disaster! (...) OK, you can't really blame them for the cleanliness, how are they supposed to clean rusty rooms and hotel installations. (...) They are just stuck in the past here! In the communal areas and, unfortunately, in some rooms as well, people are still smoking like in the best 90s! (...) This generates a whole new flavor which is only briefly interrupted by an excessively perfumed Egyptian. (...) To ensure guest "safety", security idiots are lined up to the left and to the right who won't let you pass. Sadly, they are unable to tell apart tourists from terrorists.]

RNR (8)

(...) ihre Beschreibung dass "Ägypter leider immernoch eine Katastrophe" sind, "zur „Sicherheit" der Gäste Securitytrottels " stehen (...), können wir leider nicht nachvollziehen. (...)

[Unfortunately, we can't understand your description that "the Egyptians are still a disaster" and that "to ensure guest safety, security idiots are lined up".]

This review suggests that the ICSE failed due to ethnocentrism and stereotypical thinking among the guest. While the hotel's RNR ignores some of the culture-related complaints (n), it reacts to other allegations by quoting offensive statements from the original review (h) (see above) and declaring them to be incomprehensible (m): "we can't understand your description."

Review/RNR (9)

Area of conflict: differences in communication (politeness) and difficulties during ICSE (dominant nationalities, behavior of staff or fellow guests)

Review (9) was posted on Tripadvisor in 2019 by a British tourist about the same Spanish four-star hotel as in review (3) (overall rating: 1/5). This guest complains about impolite and discriminatory behavior from fellow Spanish guests at the hotel.

Review (9)

(…) The lobby looks like deaths waiting room with every seat taken up my Spanish pensioners sleeping and god forbid you should try and sit in a seat, they stand and stare at you until you get off it. (…) Elderly Spanish people just take your sunbeds and throw your stuff on the ground whenever they feel like it. (…) This place is not for young families or British people in general. If you are ok with being spoken to like an idiot and constantly snarled at, shoved out of and into lifts or even shoved out the way of them altogether, (…) then yeah book here.

RNR (9)

(…) We regret the situations you have suffered during your vacations, we understand that part of the incidents that you describe were a misunderstanding. (…) In Spain we give the possibility to our elderly people a low cost vacation, we understand, this is an sample of help for the most needy people, there are also in the UK, we understand that the elderly people of all countries are priority, it is true they can occupy a lot of space, not only the Spanish seniors, all the hotel guests who use the facilities in a way perhaps a bit possessive, but we understand that most of them have not had a great time in their lives and they still have the remnants of the past. we also understand the mix of nationalities is wonderful, there is usually a tolerance and a sample of the Mediterranean warmth. (…)

This ICSE may have failed due to different politeness standards or as a result of specific behaviors of staff members and fellow guests. Neither the details of the incident, nor the actual behavior of the involved protagonists, however, can be ascertained. Nonetheless, among the contributing factors for failure of this ICSE may have been a lack of knowledge about Spanish IMSERSO tourism among the British guests. As part of the Spanish social security system, the *Instituto de Mayores y Servicios Sociales* (IMSERSO) offers subsidized vacations for pensioners in the off-peak season. The objective of the program is to improve the quality of life for elderly Spanish retirees, while helping to maintain the service

sector in periods of low-utilization (Cisneros-Martínez/Fernández-Morales 2020: 72–73). For the British guest, the large presence of Spanish senior citizens was presumably unexpected and could be the reason for the reported discomfort and frustration.

In the RNR, the hotel points to a potential misunderstanding (g): "part of the incidents that you describe were a misunderstanding" to explain what happened. Next, the hotel extends considerable effort to explain local culture (a): "In Spain we give the possibility to our elderly people a low cost vacation" and justifies IMSERSO tourism in general ("most of them have not had a great time in their lives and they still have the remnants of the past"). The RNR also attempts to rationalize the locals' behavior ("it is true they can occupy a lot of space, not only the Spanish seniors, all the hotel guests who use the facilities in a way perhaps a bit possessive"); however, without apologizing for said behavior. Finally, the RNR closes with positive aspects of the local culture (e): "there is usually a tolerance and a sample of the Mediterranean warmth."

Review/RNR (10)

Area of conflict: differences in communication (language) and difficulties during ICSE (behavior of staff or fellow guests)

Review (10) was published on Tripadvisor in September 2021 by a tourist from the United States about their stay at a five-star hotel in Punta Cana, Dominican Republic (overall rating: 1/5). As per this review, the hotel staff declined to use the guest's preferred language. Moreover, the hotel is accused of language-based discrimination.

Review (10)

(...) All the staff are totally disrespectful, and they dont want to speak English. In lunch and dinner we waited for water about 20 minutes EVERY DAY. If you don't speak Spanish you can't get drinks. So poor. (...)

RNR (10)

(...) Allow us, please, to inform you that we provide english lessons to our team. Moreover, our team in direct contact with our guests speaks English. We will review in detail your remarks about our service with our team and work to prevent similar reports from our future guests (...).

It cannot be discerned if the ICSE failed due to the language choices of staff members (and guests), or due to differing levels of English proficiency

between both parties. In the RNR, the hotel does not directly react to the complaint, but instead confirms existing standards ("we provide english lessons to our team; our team in direct contact with our guests speaks English") and reports the action taken (o): "We will review in detail your remarks; we will work to prevent similar reports". The core allegations of the complaint, i.e., the staff's unwillingness to communicate in the guest's preferred language and language-based discrimination, remain unanswered (n).

Review/RNR (11)

Area of conflict: differences in communication (language) and difficulties during ICSE (misunderstanding)

Review (11) concerns the same Dominican hotel as review (10). It was written by a guest from the United States on Tripadvisor in November 2019 (overall rating: 1/5). This guest interpreted an exchange with a hotel staff member as sexual harassment.

Review (11)

(...) My wife and her friends received inappropriate sexual advances from a staff member, specifically a golf cart driver who refused to start driving until one of them "sat next to him". He asked them if they were the type to "meter mano", which literally means "stick your hand in there". (...)

RNR (11)

(...) We think there was a misunderstanding in the expression "meter mano" (get hands on) because this is a colloquial expression is frequently used for the Dominicans to say we are goin to do something. Example a person says to another: "Hay que llevar a los huéspedes a su habitación, vamos a meter mano". (We have to take the guests to their room, let's get hands."). (...)

The review and the RNR suggest that the sexual harassment allegations are based on a language-related misunderstanding between guest and staff member, presumably because the guest is unaware of the meaning of "meter mano" in Dominican Spanish. In their RNR, the hotel frames the incident as jumping to conclusions based on a misunderstanding (g): "We think there was a misunderstanding" and attempts to clarify the incident by neutrally explaining local vernacular without being condescending (a): "this is a colloquial expression is frequently used for the Dominicans to say we are goin to do something."

Review/RNR (12)

Area of conflict: difficulties during ICSE (behavior of staff or fellow guests)

Review (12) shows the feedback of a German tourist for a five-star hotel in the Punta Cana region in Dominican Republic. It was posted on Tripadvisor in May 2017 (overall rating: 1/5).

Review (12)

(...) Ich kann Punta Cana und dieses Hotel leider niemandem mit gutem Gewissen weiterempfehlen. Die Menschen dort sind gegenüber den westlichen Leuten sehr rassistisch eingestellt. (...)

[Unfortunately, I cannot in good conscience recommend Punta Cana and this hotel to anyone. The people there are very racist towards Westerners.]

RNR (12)

(...) Concerning the treatment you received by of our staff member, we sincerely apologize for it. As you may know, the Dominicans are always friendly and helpful people, and thanks to these characteristics our hotel is considered one of the best in the Punta Cana area because of the sympathy of the people who works here; we will look into this matter to take corrective actions and several measures if necessary. (...)

Neither the guest nor the hotel provides concrete details or explanations regarding the alleged racism. It is thus difficult to determine the reason for failure of this ICSE. In their RNR, the Dominican hotel apologizes for the alleged discrimination and replies by illustrating the positive aspects of the culture (e): "As you may know, the Dominicans are always friendly and helpful people." Moreover, the RNR discusses action that will be taken as a result of the review (o): "we will look into this matter to take corrective actions and several measures if necessary."

6. Summary and Conclusions

The analysis of culture-related hotel reviews and RNRs has yielded several meaningful results.

First, the exploratory study has highlighted that conflict in ICSEs can be caused by differences in culture and communication, but also by difficulties of the specific situation at the hotel. Some of the reviews studied in this paper allow for identifying ethnocentrism, stereotypes, or a lack

of tolerance and flexibility not only among guests, but also among service providers. It is useful to note that the analysis shows several examples of erroneous expectations: apparently, not all customers temper their expectations when travelling outside of their own culture (Kenesei/Stier 2017: 309). Some examples also document guests' frustration if the hotel fails to address them in their preferred language. This confirms the findings presented by Holmqvist (2011), Wang/Miao/Mattila (2015), and Zolfagharian/Hasan/Iyer (2018). It is important to note, however, that the reviews and RNRs studied here may have been influenced by factors beyond the presumed national and linguistic affiliation of the authors.

Second, in functional terms, most review authors in the sample appear to vent negative feelings (Yoo/Gretzel 2008: 291). The functions of the hotels' RNRs, in contrast, are more diverse: while some RNRs are clearly directed at consolidating the relationship with the customer after a failed ICSE (Cenni/Goethals 2021: 39), other hotel managers express individual frustration with the service encounter, the complaint, or the review author.

Third, regarding the pragmatic structure of the RNRs, this study has suggested an initial typology of moves used by hoteliers when dealing with culture-related complaints. It is worth noting that, in the management responses to culture-related reviews, the move "Admitting mistakes", identified by Thumvichit/Gampper (2019: 5), was not found in the 12 examples studied here. Moreover, most RNR moves described by Napolitano (2018: 143) were not found in the present study, with the exception of "Reference specific interactions". Specifically, hoteliers did not openly offend or insult guests in the culture-related RNRs. This may be due to the fact that most of the examples studied here refer to larger hotels, and not to small family-run accommodations. Napolitano (2018: 150) explains that family business owners are more likely to perceive negative reviews as personal attacks. In contrast, staff members of larger organizations may be able to respond more objectively since they feel less personally involved, and the overall business responsibility lies further up the hierarchy. Some hoteliers in the sample also ignored culture-related complaints. In some cases, this could be interpreted as a way to avoid an open and public conflict with the guests. With the exception of RNR (1), all RNRs in the sample addressed the authors of the negative reviews directly.

As a conclusion, hotel staff should receive intercultural training to increase their ability to successfully handle ICSEs (Litvin 2019: 715). Additionally, responding to negative reviews should be the responsibility of experienced staff members who, ideally, are also prepared for this task. The findings of the present study show that culture-related complaints can be complex and thus pose additional challenges for composing RNRs. Due to space constraints, this paper has only analyzed a sample of 12 reviews and RNRs. The set of pragmatic steps for dealing with culture-related complaints developed here remains to be determined, and can be investigated using further data samples. If necessary, the set of steps should be expanded accordingly. The same is true for the typology of ICSEs reflected in online reviews and RNRs. Moreover, future analyses should include reviews and RNRs that reflect additional cultural and linguistic backgrounds. It must be highlighted, however, that descriptive analyses of RNRs should not be used without critical reflection for establishing manuals or guidelines for dealing with online complaints. Nonetheless, the findings presented in this paper are an initial step towards establishing a systematic way of handling culture-related online complaints. Written records of problematic ICSEs in review portals are permanent. They can be read by any potential customer and pose threats to the organization's reputation. It is thus important to raise awareness for the importance of intercultural aspects in online reputation management among business practitioners. Specifically, hoteliers can use the results presented here to review existing standards for responding to online customer feedback, and to establish guidelines for a more mindful handling of culture-related online reviews in the future.

Bibliography

Ayeh, Julian K./Au, Norman/Law, Rob, 2016: "Investigating Cross-National Heterogeneity in the Adoption of Online Hotel Reviews". *International Journal of Hospitality Management* 55, 142–153, retrieved 5.6.2022 from http://dx.doi.org/10.1016/j.ijhm.2016.04.003.

Barker, Sunita/Härtel, Charmine E. J., 2004: "Intercultural Service Encounters: An Exploratory Study of Customer Experiences". *Cross Cultural Management. An International Journal* 11(1), 3–14, retrieved 5.6.2022 from http://dx.doi.org/10.1108/13527600410797710.

Bolten, Jürgen, 2020: "Rethinking Intercultural Competence". In: Rings, Guido/Rasinger, Sebastian (eds.): *The Cambridge Handbook of Intercultural Communication*. Cambridge: Cambridge University Press, 56–67.

Brand, Benedikt/Reith, Riccardo, 2021: "Cultural Differences in the Perception of Credible Online Reviews – The Influence of Presentation Format". *Decision Support Systems* 154, 113710, retrieved 5.6.2022 from https://doi.org/10.1016/j.dss.2021.113710.

Buzova, Daniela/Sanz-Blas, Silvia/Cervera-Taulet, Amparo, 2019: "Does Culture Affect Sentiments Expressed in Cruise Tours' eWOM?". *The Service Industries Journal* 39(2), 154–173, retrieved 5.6.2022 from https://doi.org/10.1080/02642069.2018.1476497.

Cenni, Irene/Goethals, Patrick, 2021: "Business Responses to Positive Reviews Online: Face-work on TripAdvisor". *Journal of Pragmatics* 180, 38–50, retrieved 5.6.2022 from https://doi.org/10.1016/j.pragma.2021.04.008.

Cisneros-Martínez, José David/Fernández-Morales, Antonio, 2020: "The Social Tourism Programmes in Spain". In: Diekmann, Anya/McCabe, Scott (eds.): *Handbook of Social Tourism*. Cheltenham: Edward Elgar, 72–82.

De Ascaniis, Silvia/Cantoni, Lorenzo, 2018: "Social Media from a Communication Perspective. The Case of the Argumentative Analysis of Online Travel Reviews". In: Sigala, Marianna/Gretzel, Ulrike (eds.): *Advances in Social Media for Travel, Tourism and Hospitality. New Perspectives, Practice and Cases*. Milton Park: Routledge, 262–276.

Delanoy, Werner, 2020: "What is Culture?". In: Rings, Guido/Rasinger, Sebastian (eds.): *The Cambridge Handbook of Intercultural Communication*. Cambridge: Cambridge University Press, 17–34.

Godnov, Uroš/Redek, Tjaša, 2019: "The Use of User-generated Content for Business Intelligence in Tourism: Insights from an Analysis of Croatian Hotels". *Economic Research- Ekonomska Istraživanja* 32(1), 2455–2480, retrieved 5.6.2022 from https://doi.org/10.1080/1331677X.2019.1633372.

Holmqvist, Jonas, 2011: "Consumer Language Preferences in Service Encounters: A Cross-cultural Perspective". *Managing Service*

Quality: An International Journal 21(2), 178–191, retrieved 5.6.2022 from https://doi.org/10.1108/09604521111113456.

Kenesei, Zsofia/Stier, Zsofia, 2017: "Managing Communication and Cultural Barriers in Intercultural Service Encounters: Strategies from Both Sides of the Counter". *Journal of Vacation Marketing* 23(4), 307–321, retrieved 5.6.2022 from https://doi.org/10.1177/1356766716676299.

Li, Xiaofei/Ma, Baolong/Bai, Rubing, 2020: "Do you Respond Sincerely? How Sellers' Responses to Online Reviews Affect Customer Relationship and Repurchase Intention". *Frontiers of Business Research in China* 14, 18, retrieved 5.6.2022 from https://doi.org/10.1186/s11782-020-00086-2.

Litvin, Stephen, 2019: "Hofstede, Cultural Differences, and TripAdvisor Hotel Reviews". *International Journal of Tourism Research* 21, 712–717, retrieved 5.6.2022 from https://doi.org/10.1002/jtr.2298.

Mariani, Marcello/Borghi, Matteo/Okumus, Fevzi, 2020: "Unravelling the Effects of Cultural Differences in the Online Appraisal of Hospitality and Tourism Services". *International Journal of Hospitality Management* 90, 102606, retrieved 5.6.2022 from https://doi.org/10.1016/j.ijhm.2020.102606.

Marshall, Martin, 1996: "Sampling for Qualitative Research". *Family Practice* 13(6), 522–526, retrieved 5.6.2022 from https://doi.org/10.1093/fampra/13.6.522.

Nakayama, Makoto/Wan, Yun, 2021: "Textual Analysis of Online Reviews as a Lens for Cross-Cultural Assessment". *International Journal of Culture, Tourism and Hospitality Research* 15(2), 125–130, retrieved 5.6.2022 from https://doi.org/10.1108/IJCTHR-04-2020-0086.

Napolitano, Antonella, 2018: "Image Repair or Self-Destruction? A Genre and Corpus-assisted Discourse Analysis of Restaurants' Responses to Online Complaints". *Critical Approaches to Discourse Analysis Across Disciplines* 10(1), 135–153.

Panseeta, Sayamol/Todd, Richard Watson, 2014: "A Genre Analysis of 5-star Hotels' Responses to Negative Reviews on TripAdvisor". *rEFLections* 18, 1–13.

Paparoidamis, Nicholas G./Tran, Huong Thi Thanh/Leonidou, Constantinos N., 2019: "Building Customer Loyalty in Intercultural Service Encounters: The Role of Service Employees' Cultural Intelligence".

Journal of International Marketing 27(2), 56–75, retrieved 5.6.2022 from https://doi.org/10.1177/1069031X19837950.

Park, Sun-Young/Allen, Jonathan P., 2013: "Responding to Online Reviews: Problem Solving and Engagement in Hotels". *Cornell Hospitality Quarterly* 54(1), 64–73, retrieved 5.6.2022 from https://doi.org/10.1177/1938965512463118.

Sanmartín Sáez, Julia, 2018: "Interacción discursiva y fórmulas de tratamiento en las respuestas de los hoteles a las opiniones de viajeros". *Onomázein*, NE IV, 119–141, retrieved 5.6.2022 from https://doi.org/10.7764/onomazein.add.01.

Schroll-Machl, Sylvia, 2011: *Doing Business with Germans. Their Perception, Our Perception*. Göttingen: Vandenhoeck & Ruprecht.

Sharma, Piyush, 2019: *Intercultural Service Encounters. Cross-cultural Interactions and Service Quality*. Cham: Palgrave McMillan.

Sparks, Beverley A./Bradley, Graham L., 2017: "A 'Triple A' Typology of Responding to Negative Consumer-Generated Online Reviews". *Journal of Hospitality & Tourism Research* 41(6), 719–745, retrieved 5.6.2022 from https://doi.org/10.1177/1096348014538052.

Swales, John, 1990: *Genre Analysis – English in Academic and Research Settings*. Cambridge: Cambridge University Press.

Thumvichit, Athip/Gampper, Chanika, 2019: "Composing Responses to Negative Hotel Reviews: A Genre Analysis". *Cogent Arts & Humanities* 6(1), 1629154, retrieved 5.6.2022 from https://doi.org/10.1080/23311983.2019.1629154.

UNWTO, 2022: "Country Profile – Inbound Tourism", retrieved 5.6.2022 from https://www.unwto.org/tourism-data/country-profile-inbound-tourism.

Vásquez, Camilla, 2011: "Complaints Online: The Case of TripAdvisor". *Journal of Pragmatics* (43)6, 1707–1717, retrieved 5.6.2022 from https://doi.org/10.1016/j.pragma.2010.11.007.

Wang, Chen-Ya/Miao, Li/Mattila, Anna S., 2015: "Customer Responses to Intercultural Communication Accommodation Strategies in Hospitality Service Encounters". *International Journal of Hospitality Management* 51, 96–104, retrieved 5.6.2022 from https://doi.org/10.1016/j.ijhm.2015.09.001.

Yates, Joanne/Orlikowski, Wanda/Okamura, Kazuo, 1999: "Explicit and Implicit Structuring of Genres in Electronic Communication: Reinforcement and Change in Social Interaction". *Organisation Science* 10(1), 83–117, retrieved 5.6.2022 from https://doi.org/10.1287/orsc.10.1.83.

Yoo, Kyung-Hyan/Gretzel, Ulrike, 2008: "What Motivates Consumers to Write Online Travel Reviews?". *Information Technology & Tourism* 10, 283–295, retrieved 5.6.2022 from https://doi.org/10.3727/109830508788403114.

Żbikowska, Agnieszka, 2020: "Cultural Differences in a Restaurant's Communication with Unsatisfied Customers – The Case of _Tripadvisor". *Folia Oeconomica Stetinensia* 20, 485–493, retrieved 5.6.2022 from https://doi.org/10.2478/foli-2020-0061.

Zhang, Yi/Vásquez, Camilla, 2014: "Hotels' Responses to Online Reviews: Managing Consumer Dissatisfaction". *Discourse, Context & Media* 6, 54–64, retrieved 5.6.2022 from https://doi.org/10.1016/j.dcm.2014.08.004.

Zhang, Xiaowei/Yang, Yang/Qiao Shuchen/Zhang, Ziqiong, 2020: "Responsive and Responsible: Customizing Management Responses to Online Traveler Reviews". *Journal of Travel Research* 61(1), 120–135, retrieved 5.6.2022 from https://doi.org/10.1177/0047287520971046.

Zolfagharian, Mohammadali/Hasan, Fuad/Iyer, Pramod, 2018: "Customer Response to Service Encounter Linguistics". *Journal of Services Marketing* 32(5), 530–546, retrieved 5.6.2022 from https://doi.org/10.1108/JSM-06-2017-0209.

All reviews retrieved from www.tripadvisor.com and www.holidaycheck.de

Bernd Meyer / Annalena Kolloch

Mehrsprachigkeit in der polizeilichen Einsatzausbildung – analog und digital[1]

Abstract English: Language barriers have become part of police everyday life. But what happens when police officers notice that their so-called counterpart has only limited or no command of the official language? Starting from the concept of "inclusive multilingualism" (Backus et al. 2013) and based on observations of five experimental operational trainings, each of which with six teams at a German police school, this article analyses the different linguistic practices of individual police officers when dealing with language barriers, especially the use of different languages and translation aids. Fictitious settings vary from interventions because of noise disturbance in refugee accommodation to a student dormitory and during traffic control. The crucial differences in solving these situations lie in the means of communication used by police officers, which can be communication-oriented, inclusive, or non-inclusive. In particular, the article outlines the impact of digital translation aids when dealing with language barriers in daily interactions between police and citizens. The use of these tools is problematic. However, overcoming language barriers seems for both sides to be more important than, for instance, cultural differentiation.

Abstract Deutsch: Sprachbarrieren sind Teil des Polizeialltags geworden. Was passiert jedoch, wenn Polizeibeamt*innen bemerken, dass ihr so genanntes Gegenüber die Amtssprache nur eingeschränkt oder gar nicht beherrscht? Ausgehend vom Konzept der „inklusiven Mehrsprachigkeit" (Backus et al. 2013) und basierend auf Beobachtungen von fünf experimentellen Einsatztrainings mit je sechs Teams an einer deutschen Polizeischule analysiert dieser Beitrag die unterschiedlichen sprachlichen Praktiken einzelner Polizeibeamter beim Umgang mit

1 Dieser Beitrag wurde gefördert durch die Deutsche Forschungsgemeinschaft/ DFG, im Projekt *Polizei-Translationen: Mehrsprachigkeit und die Konstruktion kultureller Differenz im polizeilichen Alltag* (BE 6695/1-1). Wir danken Jan Beek, Thomas Bierschenk, Theresa Radermacher und Marcel Müller für ihre kritischen Kommentare. Teile des Beitrags basieren auf Kolloch/Meyer 2023.

Sprachbarrieren, v.a. jedoch die Verwendung verschiedener Sprachen und Übersetzungshilfen. Die Settings variieren zwischen fiktiven Einsätzen bei Lärmbelästigung in Flüchtlingsunterkünften und in einem Studentenwohnheim sowie während einer Verkehrskontrolle. Die entscheidenden Unterschiede bei der Lösung der Situationen liegen in den Kommunikationsformen der Polizeibeamt*innen, die verständigungsorientiert bzw. inklusiv oder auch nicht-inklusiv sein können. Der Beitrag skizziert insbesondere, wie sich digitale Übersetzungshilfen auf den Umgang mit Sprachbarrieren im täglichen Umgang zwischen Polizei und Bürger*innen auswirken können. Der Einsatz dieser Hilfsmittel ist problembehaftet, die Überwindung von Sprachbarrieren scheint jedoch für beide Seiten wichtiger zu sein als beispielsweise eine kulturelle Differenzierung.

Keywords: Polizeiarbeit, Übersetzungsapps, inklusive Mehrsprachigkeit, experimentelle Ethnographie, Einsatzausbildung

1. Einleitung: mehrsprachige Kommunikation im Polizeialltag

Im Folgenden präsentieren wir eine erste Vignette aus einem Teil der Feldforschung im Projekt *Polizei-Translationen*. Im Rahmen der Untersuchung hatten wir die Gelegenheit, an einer Polizeiakademie reguläre Szenarien der Einsatzausbildung zu beobachten und mitzugestalten. Normalerweise stehen in diesen Szenarien die korrekte Durchführung einer Maßnahme und die Eigensicherung im Vordergrund. Im Rahmen der partizipativen Forschung konnten wir sprachliche und kulturelle Differenz thematisch und organisatorisch einbringen. Durch die Beteiligung von mehrsprachigen Studierenden anderer Studiengänge wurden Sprachbarrieren in realistischen Situationen inszeniert. Das Ziel war, den Umgang der Polizistinnen und Polizisten mit dieser im Rahmen der Ausbildung neuen Herausforderung zu beobachten.

Die Einsatzausbildung fand in den Schulungshallen auf dem Gelände der Polizeiakademie statt. Die Szenerie ähnelte einer Filmkulisse. Die Ruhestörung durch Musik fand in einer Zweizimmerwohnung (mit Flur) eines Studentenwohnheims statt.

Vignette 1, „Polizei ist da"
Zwei Bewohner streiten sich – Konstaninos hört laute Musik, die Denise sehr stört. Konstaninos versteht nur Griechisch und ein wenig Englisch,

Denise versteht nur Französisch und Douala. Sie klopft heftig an seine Tür und fängt an, ihn zu beschimpfen und anzuschreien. Die beiden schreien sich an und streiten, als das Polizeiteam (eine Frau und ein Mann) das Setting betritt. Außerdem läuft die Musik und es gibt viel Verwirrung und starken Lärm. Die Situation scheint sehr aggressiv zu sein.[2]

POLIZIST: *„Hey! Polizei ist da! Ruhe!"* und während er das sagt, schiebt er Denise an der Schulter zur Seite, zu seiner Kollegin. Die Kollegin übernimmt und schiebt Denise ebenfalls an der Schulter zur Seite, weg von Konstaninos Tür in den Flur. Das stört die beiden nicht und Denise ruft Konstaninos auf Französisch zu: *„Putain! Idiot!"* Die Polizistin schubst sie zur Seite und der zweite Polizist betritt Konstaninos Zimmer.

POLIZIST (zu Konstaninos, mit langsamer, lauter Stimme und mit beruhigenden Handbewegungen nach unten): *„Beruhigen Sie sich jetzt mal! Kommissariat Frankfurt. Parlez-vous allemand? Allemand?* " Konstaninos schaut ihn mit offenem Mund an und sagt: *„I don't under... What? The language?"*

Der Polizist wirkt sichtlich verwirrt, wahrscheinlich, weil er gerade gehört hat, wie sein Gegenüber sich lautstark mit Denise auf Französisch streitet. Er scheint sich zu fragen, warum sein Gegenüber ihn nicht versteht. Konstaninos hingegen versteht nicht, warum der Polizist Französisch mit ihm spricht.

POLIZIST: *„Allemand? Parlez-vous allemand?* "

KONSTANINOS: *„No... Why? What do you speak? I don't understand."*

(Denise ruft der Polizistin aus dem Flur zu: *„Je veux dormir! Et moi, je n'ai pu!).*"

Nun wendet sich der Polizist auf Deutsch an Konstaninos: *„Sprechen Sie Deutsch?"*

KONSTANINOS: *„No, I speak English."*

POLIZIST: *„English. French?"*

KONSTANINOS: *„No. At all."*

POLIZIST: *„Ok."*

POLIZIST: *„My partner can speak better Englisch als I."*

KONSTANINOS: *„Ok."*

2 Aus Datenschutzgründen sind alle Namen und Orte in diesem Artikel pseudonymisiert.

POLIZIST: *„One moment, please."* (Polizist tritt aus dem Raum und beobachtet die Situation im Flur.)

DENISE (ZUR POLIZISTIN IM FLUR): *„Je ne parle que français!"*

POLIZISTIN (IM FLUR): *„Ok. Dann gehen wir erstmal kurz, am besten gehen wir kurz raus, oder kommen Sie grade. Ok."* Sie spricht weiterhin Deutsch mit ihrem Gegenüber, das anscheinend nur Französisch spricht. Dann funkt sie die Zentrale an, um einen Dolmetscher für das Studentenwohnheim zu bekommen. Interessanterweise gibt es keine vorherige Kommunikation zwischen den beiden Polizeischülern darüber, ob der männliche Kollege Französisch sprechen könnte. Doch er belauscht den Anruf und bietet dann an zu wechseln.

POLIZIST ZU POLIZISTIN: *„Anne, sollen wir wechseln? Bisschen Französisch kann ich!"*

POLIZISTIN: *„Ok, ja, dann lass' wechseln."* (zu Denise): *„Stay here, my colleague is coming and he will speak to you. Ok? I am not able to speak Français very well."*

DENISE: *„Je ne comprends pas."*

POLIZISTIN: *„Ok, Willy!"*

POLIZIST: *„Ja."* (an die Kollegin): *„Er versteht nur Englisch."* (Die beiden tauschen die Rollen, die Polizistin geht nun zu Konstaninos): *„Hallo!"*

(Überarbeitete Feldnotizen, Dezember 2019)

Der Umgang mit Sprachbarrieren gehört in Europa zunehmend zum Polizeialltag, da europäische Länder sprachlich und ethnisch immer heterogener werden (Jacobsen 2009: 91). Was ist, wenn die Polizei feststellt, dass ihr Gegenüber keine der Amtssprachen beherrscht? Wie reagieren einzelne Polizeiteams auf eine Lärmbelästigung, zu der sie gerufen werden, wenn Personen mit eingeschränkten Deutschkenntnissen beteiligt sind? Das Verstehen und Sprechen der Amtssprache scheint für eine erfolgreiche Kommunikation mit Polizeibeamt*innen besonders wichtig zu sein (Sauerbaum 2009: 85). Verhöre, Verdächtigungen und Anschuldigungen sind für die meisten Bürger*innen nicht alltäglich und sehr herausfordernd, insbesondere wenn sie wenig Kenntnisse der Amtssprache haben (Bornewasser 2009: 28–29). Wir wollten daher wissen, mit welchen Methoden Polizistinnen und Polizisten im Alltag Sprachbarrieren überbrücken und wie sie ihren Einsatz unter schwierigen sprachlichen Bedingungen bewältigen. Insbesondere stellte sich die Frage, inwieweit und mit welchen

Effekten digitale Sprachtechnologien wie Google translate oder DeepL in alltäglichen Einsatzszenarien verwendet werden, da diese Technologien ja in herkömmlichen Smartphones im Prinzip allgemein zugänglich sind.

Die beschriebene Vignette verdeutlicht, dass sich die Polizistin und der Polizist zunächst nicht nur einen Überblick über die Situation verschaffen (die zu Beginn aggressiv belastet zu sein scheint) und die Akteur*innen kategorisieren und sortieren. Im zweiten Schritt müssen sie jedoch auch herausfinden, welche Sprachen gesprochen werden, um ihren institutionellen Plan umsetzen zu können, d.h. die ihnen gestellte Aufgabe zu lösen und das Szenario mit einem Ergebnis oder einer Entscheidung verlassen zu können. Das Szenario dieses Einsatztrainings offenbart bereits verschiedene Sprachpraktiken, die anschließend von beiden Polizist*innen ausprobiert wurden. Zuerst sprechen sie weiterhin konsequent Deutsch, dann versuchen sie, die Situation durch nonverbale Kommunikation und sogar körperliches Engagement leicht zu deeskalieren, indem sie die streitende Frau an der Schulter zur Seite schieben und sie wieder auf Deutsch ansprechen. Zu Beginn stritten Konstaninos und Denise sehr laut und aggressiv. Die Beamt*innen reagierten darauf, indem sie körperlichen Zwang anwandten und die beiden mit den Händen kräftig auseinanderstießen. Gegenüber Frauen hielten sich die Polizeischüler*innen in allen 32 Durchläufen mit verschiedenen Szenarien mit körperlichem Zwang zurück. Normalerweise lösen sie die Situation, indem sie sich auf jeweils eine Person konzentrieren und sich um sie „kümmern". Sehr oft übernahm der männliche Polizist das männliche Gegenüber und die weibliche Polizistin übernahm das weibliche Gegenüber. Weitere sprachliche Praktiken waren die Verwendung von begrenzten Fremdsprachenkompetenzen, der Versuch, Dolmetscher zu bekommen, spontanes Dolmetschen durch Anwesende oder eben auch der Einsatz digitaler Hilfsmittel.

Interessanterweise gab es in Vignette 1 zunächst nicht viel Kommunikation innerhalb des Teams. Das führte dazu, dass der beauftragte Dolmetscher abgesagt werden musste, als sich herausstellte, dass der Kollege selbst Französisch verstand. Schließlich löste das Team die Situation durch einen Rollentausch – der Polizist sprach mit Denise, die Polizistin mit Konstaninos. Zwar erkannten die Polizeischüler*innen die Notwendigkeit einer Unterstützung in der mehrsprachigen Situation und holten sich die Handlungsmacht zurück, indem sie einen Dolmetscher anforderten,

nicht in Betracht gezogen wurde in diesem Fall jedoch die Verwendung
von digitalen Hilfsmitteln. Über die Gründe lässt sich nur spekulieren.

Die Vignette 1 zeigt auch, dass die Polizist*innen viel Zeit brauchen, um
die Situation zu filtern, sich einen Überblick zu verschaffen und Zugänge
zu finden. Erst dann konnten sie sich mit dem eigentlichen Inhalt des
Streits zwischen den beiden Bewohnern auseinandersetzen. In unserem
Beitrag wollen wir die Notwendigkeit einer erfolgreichen mehrsprachi-
gen Kommunikation für die Polizeiarbeit verdeutlichen. Schließlich zeigt
sich, dass unterschiedliche sprachliche Repertoires und begrenzte sprach-
liche Gemeinsamkeiten gegenüber möglichen kulturellen Differenzierun-
gen in der inszenierten Situation im Vordergrund standen. Die Sprache
(und nicht etwaige kulturelle Zuschreibungen) stand an erster Stelle – es
spielt in der Vignette 1 keine erkennbare Rolle, dass Konstaninos einen
griechischen Pass hat und Denise Kamerunerin ist. Obwohl wissenschaft-
liche und mediale Diskurse „kulturelle Differenz" oftmals als Problem
hervorheben, konzentrierten sich die angehenden Polizeibeamt*innen in
unseren Daten vielmehr darauf, die Kommunikation zu erleichtern. Kom-
munikationsprobleme werden nur sehr selten als Ergebnis kultureller
Unterschiede interpretiert. Darüber hinaus sind die Sprachpraktiken der
Polizeischüler*innen meist inklusiv und darauf ausgerichtet, die Kommu-
nikation zu erleichtern sowie von institutionellen Notwendigkeiten domi-
niert. Die Analyse basiert auf qualitativen Methoden und inszenierten
(wenn auch realitätsnahen) Einsatzsituationen und sagt insofern nichts
über die deutsche Polizei im Allgemeinen aus. Der mikroanalytische
Ansatz bietet jedoch Einblicke in die Dynamik von Situationen, in denen
Sprachbarrieren eine wichtige Rolle spielen.

Der Moment, in dem die Sprachbarriere sichtbar wird, wirft zentrale
Fragen auf: Wie bemerken die Beamt*innen sie und wie gehen sie fortan
mit der Situation um? Unsere Ergebnisse zeigen, dass angehende Polizei-
beamt*innen auf unterschiedliche Weise mit Sprachbarrieren umgehen,
um die ihnen gestellte Aufgabe zu lösen. Wir können diese Praktiken
grob in zwei verschiedene Kommunikationsmodi unterteilen: inklusive
und nicht-inklusive (siehe Kapitel 4). Zu den nicht-inklusiven Kommu-
nikationsformen gehören Praktiken wie das Beharren auf der deutschen
Sprache und die Anwendung physischen Zwangs zur Durchsetzung

des institutionellen Plans, ohne sich um die Kommunikation mit ihren Gegenstücken zu kümmern, z.b. eine Leibesvisitation, eine räumliche Trennung der streitenden Personen, körperliche Berührung oder energisches „Schieben" der Person.

2. Experimentelle Ethnographie und inszenierte Realitäten

In diesem Abschnitt geben wir zunächst einen Einblick in unsere Methoden, dann gehen wir auf die Literatur ein und veranschaulichen abschließend unsere Erkenntnisse über unterschiedliche Kommunikationsformen im Umgang mit Sprachbarrieren im Feld.

In der Anthropologie sind Experimente und inszenierte Realitäten eher ungewöhnliche Methoden der Datenerhebung. Daten werden üblicherweise über mehrere Monate in Feldforschung und durch teilnehmende Beobachtung gewonnen und gelten aufgrund des langen Feldaufenthaltes als authentisch. Ethnographie als Methode untersucht die unerwarteten und tatsächlichen Praktiken im Alltag (Bierschenk/Olivier de Sardan 2019: 249). Da solche alltäglichen Interaktionen zwischen Polizist*innen und Personen mit begrenzten Deutschkenntnissen schwer zugänglich und zu erfassen sind, mussten wir Alternativen in Betracht ziehen. In Kooperation mit einer Polizeiakademie in einem Bundesland ergab sich für unser Projektteam die Möglichkeit, Einsatztrainings mit Polizeischüler*innen zu begleiten. Wir entwickelten in Absprache mit den Ausbildern eigene Szenarien, die die angehenden Polizist*innen vor Herausforderungen stellten, die bisher nicht Teil des Trainings waren. In der Einsatzausbildung trainieren angehende Polizeibeamt*innen regelmäßig den Umgang mit Polizeieinsätzen, was auch bedeutet, dass wir als Ethnologen auszubildende Polizeibeamt*innen in ihrer Ausbildung begleiten und beobachten konnten. In Anlehnung an Stahlke (2001: 58) verstanden wir die Übungseinheiten als Rollenspiele, mittels derer Interaktionsdaten elizitiert wurden. Der Schwerpunkt der Einsatzausbildung liegt üblicherweise auf Selbstschutz, Taktik, Recht, Techniken, Ausübung von Zwang, aber auch Kommunikation (Müller 2021: 26). Die inszenierte Realität in den Einsatztrainings erlaubte es uns jedoch, Situationen zu beobachten, aus denen wir Rückschlüsse auf den Praxisalltag von Polizeibeamt*innen und ihren Umgang mit Mehrsprachigkeit im Feld ziehen können.

Während ihres Studiums durchlaufen Polizeibeamt*innen regelmäßig Einsatzszenarien und sind an diese Form der Ausbildung gewöhnt; in gewisser Weise ist es Teil ihrer beruflichen Sozialisation (Beek/Kecke/Müller 2022: 2; Staller/Körner 2019). Alle Projektbeteiligten nahmen die Szenarien sehr ernst. Die Treue zur Rolle zeigte sich z. B. daran, dass sie die Möglichkeit des Funkkontakts mit der Polizeistation nutzten, die von einem Polizisten gespielt wurde. Die Teilnehmenden des Szenarios riefen dort „per Funk" an, obwohl sie den in unmittelbarer Nähe des Geschehens anwesenden Polizisten direkt hätten ansprechen können (Müller 2021: 10–11). Müller (2021: 13–16) untersucht eingehend die methodischen Implikationen unserer inszenierten Szenarien und der fokussierten Ethnographie, die es uns ermöglicht, uns auf ein bestimmtes Fragment des polizeilichen Alltags zu konzentrieren. Die Methode der fokussierten Anthropologie erlaubt es uns auch, das gleiche Setting mit einem neuen Team von Polizist*innen gezielt zu wiederholen und ermöglicht so einen Vergleich.[3]

Insgesamt 32 Streifenteams nahmen an fünftägigen Einsatztrainings in der Polizeiakademie teil. Alle 32 Teams wurden aufgezeichnet, 28 der 32 Teams auch auf Video. Alle waren im sechsten Semester ihres Studiums für den höheren Polizeidienst und hatten bereits neun Monate Praktikumserfahrung absolviert. Im Durchschnitt waren sie Mitte zwanzig. Von den 64 Auszubildenden, die an unserer Studie teilnahmen, waren 52 Polizist*innen und 12 Beamt*innen der Kriminalpolizei. 39 Teilnehmer waren männlich und es gab 25 weibliche Teilnehmer*innen (siehe auch Beek/Kecke/Müller 2021; Müller 2021).

Unser Projektteam entwickelte zwei unterschiedliche Szenarien, die jeweils von angehenden Polizeianwärter*innen in Zweierteams gelöst werden sollten. An drei Tagen wurde das Szenario *Verkehrskontrolle* durchgespielt, an zwei Tagen das Szenario *Ruhestörung*. Die übergeordnete Herausforderung dieser Szenarien war die Kommunikationshürde: Die Kontrollierten wurden angewiesen, kein Deutsch zu sprechen. Wir engagierten Austauschstudenten aus Russland, Griechenland, Kamerun und Nigeria mit unterschiedlichen Muttersprachen wie

3 Siehe auch Beek, Kecke/Müller 2021.

Griechisch, Französisch, Englisch, Russisch und Igbo. Wir haben auch zwei deutschsprachige Studierende als polizeiliches Gegenüber eingesetzt, die Französisch sprachen, da sie seit einigen Jahren in Frankreich lebten. Während der ersten beiden Trainingstage wurden die von uns eingesetzten Akteur*innen angewiesen, nur ihre Muttersprache (Russisch, Griechisch, Französisch, Igbo) zu sprechen und auf Anfragen der Polizeibeamt*innen in anderen Sprachen (z. B. Deutsch oder Englisch) nur dann zu reagieren, wenn sie ihre Worte mit verständlichen und begleitenden Gesten oder anderen Hilfsmitteln untermauerten. So haben wir in diesen ersten beiden Trainingstagen eine erhebliche – vielleicht sogar übertriebene – Sprachbarriere geschaffen. Durch die Beobachtung und Überwachung der Einsatztrainings konnten wir zeigen, dass Polizeibeamt*innen jeweils unterschiedliche Mittel einsetzen, um mit diesem Stolperstein umzugehen. Zu beachten ist dabei, dass solche Verstehenshindernisse im täglichen Leben allgegenwärtig sind, selbst innerhalb einer relativ homogenen Sprachgruppe, da das sprachliche Repertoire von Individuen in der Regel nicht vollständig übereinstimmt. So ist die Situation, dass etwas nicht verstanden wird oder ein Wort unbekannt ist (oder auf ungewohnte Weise verwendet wird), im Prinzip jedem bekannt.

Sprachbarrieren unterscheiden sich jedoch dadurch, dass sie mehr oder weniger geschlossen (d. h. unüberbrückbar) sein können (Müller 1989). Müller (1989) beschreibt mehrsprachige Konstellationen als ein Kontinuum zwischen „transparenten" und „opaken" sprachlichen Mitteln, wobei „opak" bedeutet, dass sprachliche Mittel für Gesprächspartner*innen überhaupt nicht verständlich sind. In seiner Analyse ethnographischer Interviews mit italienischen Arbeitsmigranten in Deutschland zeigt er, wie Interviewende und Interviewte aufgrund einer teilweise transparenten Sprachbarriere ständig zwischen verschiedenen Kommunikationsformen wechselten. Wie Meyer (2012) argumentiert, könnte dies für viele Konstellationen der Fall sein, in denen Sprecher*innen von Amtssprachen mit Sprecher*innen einer Herkunftssprache kommunizieren, da letztere in der Regel ein gewisses Maß an Kompetenz in der Amtssprache aufweisen.

Infolgedessen können sich Teilnehmende in relativ transparenten mehrsprachigen Konstellationen sofort auf ihr gemeinsames sprachliches Wissen beziehen, eine Art „Translanguaging" (Vogel/García 2017) oder „Polylanguaging" (Ag/Jørgensen 2013) oder eine andere Art der mehrsprachigen Kommunikation (Meyer/Apfelbaum 2010) praktizieren, während in opaken Konstellationen in erster Linie ein Kommunikationsmodus gefunden und etabliert werden muss. Wenn also die Teilnehmer*innen einer Interaktion kein sprachliches Repertoire teilen, wird es eine opake Sprachbarriere geben, und der erste kommunikative Schritt muss darin bestehen, nach gemeinsamen Repertoires oder alternativen Kommunikationsformen zu suchen.

Die Polizist*innen hingegen wussten nicht, dass ihre Gegenüber kein Deutsch sprechen konnten und gingen daher zunächst von einer „normalen", einsprachigen Verkehrskontrolle oder Ruhestörung aus. Die Auflösung der einzelnen Szenarien dauerte je nach Polizeistreifenteam zwischen neun und zwanzig Minuten. Anschließend führten wir mit jedem Polizeibeamt*innen einzeln kurze Interviews über die Einsatzausbildung und ihre Erfahrungen mit ähnlichen Situationen im realen Leben. Diese Interviews dauerten zwischen fünf und 25 Minuten. In den Post-hoc-Interviews der beiden Erstausbildungen erklärten viele der angehenden Polizeibeamt*innen, dass zumindest grundlegende Begriffe wie „Pass", „ID", „Identität" von den meisten Menschen auf Englisch oder Französisch im wirklichen Leben verstanden würden und dass es auch logisch sei, dass die eigenen Dokumente bei einer polizeilichen Identitätskontrolle gezeigt werden müssen. Deshalb haben wir unsere Methode geändert: An den anderen drei Trainingstagen wiesen wir die Kolleg*innen an, neben ihrer Muttersprache auch fragmentarisches Englisch zu verwenden und zumindest einige Schlüsselwörter auf Deutsch zu verstehen, was eine realistischere Konstellation zu sein schien. Diese ständige Reflexion und Anpassung während unserer Forschung verdeutlicht die Agilität und Flexibilität unserer Methodik, die sich vorteilhaft an die Forschungssituation und die Interaktionspartner*innen selbst anpasst.

Im Szenario einer Verkehrskontrolle hatte das Gegenüber keinen Führerschein zur Hand und die Herausforderung bestand darin, herauszufinden, ob der Fahrer berechtigt war, Autos zu fahren oder nicht, d.h. ob der Führerschein irgendwo im Auto oder in einer Tasche usw. war. Im

Szenario *Ruhestörung* gab es Ärger in einer Flüchtlingsunterkunft oder einem Studentenwohnheim und eine Anruferin hat gerade die Polizeistation angerufen, um zu sagen, dass sie polizeiliche Unterstützung benötigt. Aufgrund von Kommunikationsschwierigkeiten konnte der Grund für den Anruf nicht zweifelsfrei festgestellt werden. Die Herausforderung bestand darin, die Situation zu klären, die Anruferin zu kontaktieren und notwendige Maßnahmen zu ergreifen. Während der Szenarien konnten sich die meisten Polizeiazubis gut auf die Situation einlassen und sie überzeugend spielen – was wohl auch daran liegt, dass sie diese Art der Ausbildung gewohnt sind (Staller/Körner 2019).

Inszenierte Realitäten sind keine hundertprozentige Darstellung der Realität, sondern zielen darauf ab, der Realität so nah wie möglich zu sein. Die Anwesenheit von Beobachter*innen kann die Dynamik der Situation grundlegend ändern und das ist ein viel diskutiertes Thema in den Sozialwissenschaften. Das Forschungsteam war nah am Einsatzgeschehen, beobachtete es und führte Post-hoc-Interviews durch, was eine Art „Beobachterparadoxon" (Labov 1972) schuf. Es gibt jedoch einige Aspekte, die auf eine Realitätsnähe schließen lassen, wie zum Beispiel, dass die angehenden Polizist*innen bereits neun Monate Praktika im Feld absolviert hatten und in den anschließenden Interviews von ähnlichen Erfahrungen aus dem Feld berichteten.

Eine Besonderheit der gewählten Methode ist die Erzeugung vergleichbarer Daten durch die Steuerung der einzelnen Praktiken der Teams mit Video- und Audioaufnahmen der gleichen Grundsituation. Ein weiterer Vorteil ist die gleichzeitige Anwesenheit mehrerer Forschenden – die Auswertung von Daten im Team ist eine eher außergewöhnliche Methode in der anthropologischen Feldforschung. Diese Methode ermöglicht es uns, unsere Ergebnisse aus interdisziplinären Perspektiven zu interpretieren (Müller 2021: 14–16).

3. Kulturalisierungen

In den meisten der 32 beobachteten Fälle verrichteten die Polizeibeamt*innen ihre Arbeit, ohne zu versuchen, kulturelle Unterschiede als mögliche Ressource für das Verständnis der Situation zu produzieren. Nur selten wurden kulturelle Aspekte von den Polizist*innen thematisiert, besonders

wenn wir unsere Szene in einer Flüchtlingsunterkunft (und nicht im Studentenwohnheim) spielen ließen.

Vignette 2 „Überall gibt es Regeln"

Konstaninos ist weiterhin verärgert und wirft ein, dass seine Zimmernachbarin ihn einfach selbst hätte informieren können, anstatt sofort die Polizei zu rufen. Die Polizistin erklärt ihm noch einmal die Situation und droht, ihm das Handy (das die Musik spielt) wegzunehmen, wenn sie wegen der Lautstärke zurückkommen muss. Schließlich sagt die Polizistin mit Nachdruck: *„We don't want to come again, okay? If we come again, then we are not speak friendly, okay?"* Konstaninos antwortet: *„Why you don't speak friendly? Are you not supposed to speak friendly to the people?"* Polizistin: *„We are. We are supposed to speak friendly, but when we say one time to turn the music a bit lower, then you have to do it. But when we have to come again and again..."* Konstaninos: *„Okay, it will not happen again."* Polizistin: *„Okay, then everything is okay. After 7 a.m., till 10 p.m. you can hear music loudly again, okay?"* Konstaninos: *„Okay. But she could have told me."* Polizistin: *„Yes, I Know, but she wants to sleep. We have rules in Germany."* Konstaninos: *„Everywhere are rules."* Polizistin: *„You know."* Konstaninos: *„Okay."* (Team 2, 17. Dezember 2019)

Als die Polizistin eines der Teams im Szenario *Ruhestörung* mit Konstaninos, der sich in Rage redet, nicht zurechtkommt, erklärt sie ihm zunächst auf Englisch, dass er nach zehn Uhr nachts leise sein muss und laute Musik nicht hören darf. Sie droht auch, ihm sein Handy wegzunehmen, wenn sie wiederkommen muss. Solche Warnungen gehören zum üblichen Instrumentarium von Polizeibeamt*innen (Shon 2005). Wie Luhmann schreibt, bleibt das Gesetz im Hintergrund zitierfähig, bei Bedarf einsatzbereit (Beek 2016: 103). Nachdem sie Konstaninos gewarnt hat, erklärt sie die gesetzlichen Regelungen zu Lärm und lauter Musik. Konstaninos zeigt, dass er versteht und bestätigt, dass „es nicht wieder passieren wird". Die Situation scheint gelöst zu sein, aber die Polizistin verweist erneut auf die Verordnung und Konstaninos antwortet, dass die Nachbarin ihn darüber hätte informieren können, anstatt die Polizei zu rufen. Anstatt dem einfach zuzustimmen und die Situation zu beenden, behauptet die angehende Polizistin, dass „wir Regeln in Deutschland haben", und wechselt damit von der zwischenmenschlichen Ebene („sie hätte es mir sagen können") zu einer abstrakten kulturellen („deutsche Regeln"), um zu rechtfertigen, warum die andere Studentin sofort die Polizei gerufen hat. Konstaninos' trockene Antwort: „Überall gibt es Regeln."

Im gleichen Szenario rechtfertigt ein anderes Team den Eingriff auch damit, dass die Regeln „hier in Deutschland" einfach so seien.

Vignette 3 „Es ist nicht wie in Syrien"

Fawad sagt, er sei verärgert, dass sein Nachbar sofort die Polizei gerufen habe, anstatt die Situation direkt mit ihm zu klären. Der Polizist antwortet: *„How do you react in Syria? If you have a problem, you can call the police. In Germany it is not bad if the police comes. It is not like in Syria."*

Nachdem der Beamte (der selbst arabische Wurzeln hat) zunächst versuchte, ein Gespräch mit Fawad zu beginnen und ihn nach seinem Aufenthalt in Griechenland und seinem Fluchtweg in Europa fragte, wird Fawad wieder aufgeregt. Er fängt an zu schreien und fragt erneut, warum sein Nachbar direkt die Polizei rufen musste. Mit Bezug auf die Herkunft von Fawad erklärt der Beamte, dass man in Syrien auch die Polizei rufen kann, wenn man ein Problem hat, aber in Deutschland ist es kein Problem, wenn die Polizei vor Ort erscheint. Anstatt mit Fawad über die aktuelle Situation zu sprechen, improvisiert der Polizist einen Vortrag über den Charakter der Polizei in der deutschen Gesellschaft. Während Fawad sich darüber beschwert, dass die andere Person nicht direkt mit ihm gesprochen hat, beantwortet der Beamte seine Frage nicht deutlich, sondern verweist auf die syrische Polizei; und gibt ihm im Prinzip eine kurze Lektion, als jemand, der aufgrund seines eigenen arabischen Hintergrunds Syrien besser kennt als andere Polizist*innen.

Kulturelle Unterschiede hervorzuheben oder „Kultur" als Wissensressource für die Interpretation der Handlungen anderer Menschen zu nutzen, erscheint daher in unseren Daten als untergeordnetes Phänomen, als situativer Zug, der keinen besonderen Einfluss auf die Situation hat. Der essentialistische Kulturbegriff scheint kurz durch, hat aber keine große Bedeutung für den Verlauf der Interaktion. Die Antwort „Überall gibt es Regeln" macht sich auch deshalb über die kulturelle Referenz lustig, weil sie den Satz „Wir haben Regeln in Deutschland" als Binsenweisheit entlarvt. Diese seltenen kulturellen Differenzierungen zeigen, dass die Sprachbarriere die dominierende Herausforderung in unseren Daten ist. Die Zuschreibung kultureller Unterschiede entfaltete sich nicht und blieb eher die Ausnahme. Die meisten Szenarien waren durch die Etablierung inklusiver Kommunikationsformen gekennzeichnet.

4. Inklusive und nicht-inklusive Kommunikationsformen

In den Einsatztrainings beobachteten wir unterschiedliche Sprachprakti-
ken im Umgang der angehenden Polizeibeamt*innen mit Sprachbarrieren.
Die verschiedenen Praktiken wiederum können in zwei übergeordnete
Kategorien eingeteilt werden: inklusiv und nicht-inklusiv. Backus et al.
(2013) prägten den Begriff „inklusive Mehrsprachigkeit" als Kritik an der
EU-Politik „Muttersprache plus 2" für das Sprachenlernen an Schulen.
Gleichzeitig lehnen sie den Ansatz „English as a lingua franca" (De Swaan
2013) als Alternative ab. Stattdessen schlagen die Autoren eine flexible
und situationsbezogene Nutzung unterschiedlicher sprachlicher Ressour-
cen vor, um der bestehenden sprachlichen Vielfalt in der EU zu begegnen.
Dieser Bottom-up-Vorschlag erkennt an, dass trotz aller Bemühungen zur
Förderung der sprachlichen Vielfalt innerhalb der EU die sprachlichen
Kompetenzen niemals gleichmäßig unter den Bürger*innen verteilt sein
werden und mögliche sprachliche Konstellationen vielfältig sein werden.
Die Dynamik der Migration innerhalb und außerhalb der Europäischen
Union macht es nahezu unmöglich, relevante sprachliche Kompetenzen
für bestimmte Berufe oder Situationen zu beschreiben. Anstatt ein hohes
Niveau an Sprachkenntnissen in einer kleinen Gruppe von Sprachen zu
erreichen, sollten alle Europäer*innen ihre Fähigkeit verbessern, auf ver-
schiedene Arten zu kommunizieren, wie zum Beispiel: (1) Verwendung
einer Lingua franca (Englisch oder regional), (2) Lingua Receptiva üben
(eine Sprache sprechen und in einer anderen hören, wie es beispielsweise
von mehrsprachigen Teams in der Schweiz praktiziert wird), (3) Code-
Switching (d.h. Verwendung einzelner Wörter aus anderen Sprachen, um
das Verständnis zu verbessern), oder (4) unter Bezugnahme auf sprachli-
che Mediation (d.h. Übersetzungshilfen, Dolmetscher*innen etc., Backus
et al 2013).

Inklusive Kommunikationsformen sind also solche, die anerkennen,
dass es eine Sprachbarriere gibt, und darüber hinaus Praktiken einer „lin-
guistischen Bricolage" (Galliker 2014) auf der Grundlage dessen stimu-
lieren, worauf die Teilnehmer*innen von Interaktionen vor Ort zugreifen
können. Solche Praktiken führen vielleicht nicht zu einem ausgefeilten
Sprachgebrauch und dem Austausch subtiler Bedeutungen, aber sie wer-
den es Sprecher*innen verschiedener Sprachen zumindest ermöglichen,

wiederkehrende Situationen zu lösen, ohne einen Zusammenbruch der Kommunikation zu provozieren. In unseren Daten aus der professionellen Polizeiausbildung ist es diese Haltung der Improvisation, die wir in den meisten, wenn auch nicht allen, Teams gefunden haben. Darüber hinaus stellten wir fest, dass die Sprachbarriere, anstatt eine unangemessene Anwendung direkter Gewalt zu provozieren, in den meisten Fällen die Notwendigkeit der Kontaktaufnahme durch Kommunikation als einen wichtigen Aspekt der Polizeiarbeit in den Vordergrund stellte. Dennoch ist es wichtig zu beachten, dass inklusive Kommunikationsformen auch mit Momenten der Unbeholfenheit, Anspannung oder sogar körperlicher Gewalt verbunden sein können. Solche Situationen scheinen jedoch schnell vorüberzugehen, eher lokal zu sein und mit spezifischen situativen Bedürfnissen verbunden zu sein.

Auf der anderen Seite beobachteten wir auch nicht-inklusive Kommunikationsformen. In einigen Fällen kommunizierten die Teams ausschließlich auf Deutsch (oder Englisch), obwohl ihre Gegenüber offensichtlich kein Wort verstanden. Darüber hinaus zeigten die nicht-inklusiven Teams oder Einzelpersonen negative Einstellungen gegenüber ihren Gegenübern, beschuldigten sie, kein Deutsch zu sprechen oder zeigten ihre Ablehnung offen durch Mimik, laute Stimme usw.

In den meisten Fällen änderten jedoch selbst die Teams, die nicht-inklusiv begannen, ihren Kommunikationsstil, als sie herausfanden, wie sie die Kommunikation über Sprachbarrieren hinweg bewältigen können. Wir haben solche Situationen als „gemischt" bezeichnet, da sie Elemente inklusiver und nicht-inklusiver Kommunikationsformen aufweisen. Von den 28 auf Video aufgezeichneten Teams agierten drei Teams nicht-inklusiv, sechs Trainingsduos waren gemischt (d. h. wechselten von nicht-inklusiv zu inklusiv) und 19 Teams übten von Anfang an inklusive Kommunikationsformen.

Tab. 1: Sprachliche Praktiken und Kommunikationsformen, die in den beobachteten Trainings verwendet werden

Praktiken	Kommunikationsmittel	
	Inklusiv	Nicht inklusiv
Auf Deutsch bestehen		X
Auf Englisch bestehen		X
Physischer Zwang		X
Englisch als Lingua franca verwenden	X	
Verwendung einer anderen Fremdsprache	X	
Verhandlung der Sprachwahl	X	
Einfache Sprache verwenden	X	
Übersetzungshilfen: ad hoc Dolmetscher*innen, Apps	X	
Gestik / nonverbale Kommunikation	X	

4.1 Aushandeln des Kommunikationsmodus

Der erste Schritt in allen Trainings könnte als Suche nach einer Sprache beschrieben werden, die das Gegenüber spricht. Hier gibt es unterschiedliche Prozesse und Muster. Die Auszubildenden begannen in der Regel mit Deutsch und unterstellten, das Szenario wäre im üblichen einsprachigen Format. Als sie merkten, dass Deutsch nicht funktionierte, wechselten die inklusiven Teams meist auf Englisch. Abhängig von den Akteur*innen und dem Szenario war die Verwendung von Englisch in vielen Fällen die inklusive Art der Kommunikation. Englisch wurde manchmal absichtlich in einem vereinfachten „Ausländer"-Stil verwendet, ohne jedoch die rassistischen Implikationen, die solche Praktiken auch haben können (Ferguson 1975; Alim 2016).

> **Vignette 4, „Musik nein"**
>
> Der Beamte sagt zum Ruhestörer: „Musik ausmachen!" und zieht mit den Händen in der Luft eine symbolische Linie. Unmittelbar danach sagt er zusätzlich: „Turn off!". Am Ende sagt er, wieder mit unterstützender Geste: „Music no!" Im anschließenden Interview erklärt der Beamte, dass seine Strategie in diesem Fall darin bestand, „extra schlechtes Englisch zu sprechen, damit du verstanden wirst" (6. Dezember 2019, Gruppe 5).

Mehrere Teams verwendeten konsequent weiterhin Deutsch, in vereinfachter Form, oft unterstützt durch Mimik und Gestik, basierend auf

der zugrunde liegenden Annahme, dass diese Kombination aus Stimme, Ausdruckskraft und grundlegender Grammatik Verständnis ermöglicht, auch wenn es offensichtlich war, dass Deutsch keine gemeinsame Sprache ist.

Vignette 5, „Einfaches Deutsch"

Bereits nach sechs Minuten schafften es die angehenden Polizisten, die Musik aufgrund einer zunächst kaum zu überbrückenden Sprachbarriere leiser zu stellen. Der Polizist bedankt sich bei Denise auf Deutsch: *„Dankeschön!"* Denise jedoch nutzt die Gelegenheit der offenen Zimmertür, um Konstaninos zuzurufen, für was für einen Idioten sie ihn hält: *„Tu es un idiot toi!"* Konstaninos beleidigt zurück. Der zweite Polizist, der bei Konstaninos ist, packt ihn an der Schulter und stößt ihn zurück in sein Zimmer, so dass er den Blickkontakt zu Denise verliert. Der Polizist bei Denise schaut sie nun an und sagt in langsamem, einfachem und lautem Deutsch: *„Jetzt hier! Du! Mit mir reden! Okay?"* Denise beleidigt Konstaninos weiterhin: *„Fignon!"* Der Polizist sagt dann wieder und sehr nachdrücklich in einfachem Deutsch zu ihr: *„Nicht reden! Nicht hören! Einfach, okay? Mit mir reden. Okay?"*

Die beiden Ruhestörer beeindruckt das nicht, Konstaninos ruft auf Englisch: *„Stop, please! Take her out of here. Please. Leave!"* Denise antwortet auf Französisch, dass er selbst in sein Land zurückkehren solle. Der Polizist versucht, die Lage zu beruhigen und spricht weiterhin konsequent Deutsch. Ganz laut sagt er: *„Hey! Was habe ich gerade gesagt? Mit mir reden!"*

Erst jetzt deutet er ihr mit einer deutlichen Geste an, dass sie das Kissen, das sie vor ihren Bauch drückt, weglegen soll. Jetzt mischt er zum ersten Mal Englisch mit seinem Deutschen: *„Can you put the Kissen somewhere like over the desk? Das dahin?"* Denise scheint zu verstehen und antwortet fragend: *„Là?"* Der Polizist bejaht auf Deutsch und Denise räumt das Kissen weg. (Team 6, 17. Dezember 2019)

Ein weiteres Beispiel für die zunächst durchgängige Verwendung des Englischen als Lingua franca zeigt das folgende Beispiel.

Vignette 6, „Kleines Französisch"

Denise hört laute Musik und tanzt durch den Raum. Plötzlich, ohne vorher anzuklopfen, betritt ein Team von zwei Polizisten den Raum. Der Polizist sagt laut: *„Hallo!"* Denise fragt auf Französisch: *„Qu'est-ce se passe?"* Der Polizist tritt etwas näher und sagt: *„Äh, music! The music!"* Denise antwortet auf Französisch und fragt: *„Musique?"* Der Polizist spricht weiterhin besonders einfaches Englisch: *„Music! Stop the music!"* Die Polizistin fragt nun: *„Is someone else in this room? Are you alone?"* Sie unterstreicht ihre Frage mit einer Geste. Denise scheint zu verstehen und antwortet auf Französisch, dass sie

allein ist: *„Je suis seule.*" Sie schaltet auch die Musik komplett aus, ohne zu antworten. Die Polizistin fragt sie auf Englisch: *„So, you know why we are here? Or? Do you understand what we are saying?*" Denise versteht offensichtlich nicht und antwortet fragend: *"Pardon?"* Die Polizistin seufzt, es gibt eine kurze Pause und sie sagt: *„Okay. Ähm..."* Sie tritt nun ein und fragt: *„You speak English? Or?"* Denise antwortet fragend: *„Français?"* Der Polizist wiederholt und seufzt dann auch: *„Français? Oh. Okay. Ähm."* Er scheint darüber nachzudenken, was er jetzt fragen soll, als seine Kollegin wieder das Wort ergreift, diesmal wagt sie es, Französisch zu sprechen: *„Äh. Petit Français. Tu sais pourquoi nous avons ici? C'est parce que la musique est tout, eh, trop.... laut, was heißt laut... est trop, trop... Plus, en volume, et à cause de ça, les autre personnes ne peut... ähm... Schlafen..."*

Jetzt mischt sie Englisch, Deutsch und Französisch. Denise scheint sie dennoch zu verstehen und antwortet auf Französisch, dass ihre Musik sehr angenehm sei: *„Non, mais la musique est douce!"* Die Polizistin versteht und antwortet ihr wieder auf Französisch: *„Non, ce n'est pas douce, ici, n'était pas douce, tu n'es pas aller haut. Tu compris?"* Denise sagt, dass sie es nicht versteht. So geht es eine Weile hin und her, als durch die offenen Türen wieder Sichtkontakt zwischen Konstaninos und Denise hergestellt wird und sich die beiden trotz der Anwesenheit der Polizisten anschreien. (Team 4, 17. Dezember 2019)

Zu Beginn schienen die Polizist*innen nicht in der Lage zu sein, mit der Situation umzugehen. Mehrmals seufzten sie, verdrehten die Augen oder stammelten ein paar Worte. Erst nach wenigen Augenblicken des Seufzens, der Sprachlosigkeit und des Augenrollens benutzte die Polizistin in diesem Fall ihr Grundfranzösisch, das sie in der Schule gelernt hatte. Zuerst mischte sie Englisch, Deutsch und Französisch, sie versuchte, sich mit allen Sprachen auszudrücken, die sie beherrschte, und das führte zu Verständnis seitens der Bewohnerin Denise. Sie schaltete die Musik aus. Das Polizeiteam versuchte auch, die Situation durch nonverbale Kommunikation weiter zu beruhigen, indem es die Türen für den anderen Bewohner schloss, der sich in seinem Frieden gestört fühlte.

Wir betrachten dies als Beispiel für eine inklusive Art der Kommunikation: Die Sprachbarriere wurde als gemeinsames Problem von Polizei und Gegenüber angesprochen, Denise wurde nicht vorgeworfen, die „falsche" Sprache zu sprechen, und die angehenden Beamt*innen versuchten, sich mit ihren Sprachkenntnissen zu begnügen, sie zögerten nicht, ihre begrenzten Kompetenzen offenzulegen.

4.2 Übersetzungshilfen und Dolmetscher

Die zweite Praxisform, die wir in den Trainings zum Umgang mit sprachlichen Unterschieden beobachtet haben, ist der Einsatz von Ad-hoc-Dolmetschern (Bührig/Meyer 2004). Eine naive Wahrnehmung der Rolle von Dolmetscher*innen ist in der Regel die eines bloßen Kanals. Bedeutung wird unverändert vermittelt, und Dolmetscher*innen tun nichts darüber hinaus. Diese irreführende Vorstellung entstand im Kontext des Simultandolmetschens in stark fixierten und ritualisierten Umgebungen wie internationalen Konferenzen, politischen Treffen oder bei Gericht, wo Dolmetscher*innen buchstäblich unsichtbar sein sollen und die Kommunikation geplant und oft nicht sehr dynamisch ist. In anderen Umgebungen, in denen Dolmetscher*innen im konsekutiven Modus agieren oder Umstehende spontan die Dolmetscherrolle übernehmen, sind die aktiven und komplexen Beteiligungsmuster von Dolmetscher*innen viel offensichtlicher (Pöchhacker 2012). Ad-hoc-Dolmetscher*innen werden aufgrund ihrer möglichen Beziehungen zu anderen Teilnehmenden, ihrer unklaren Sprachkenntnisse und ihrer unterschiedlichen Einstellungen zu Treue und Neutralität oft als problematisch angesehen (Pöllabauer 2005: 184; siehe auch Kolloch 2021: 113). Dennoch werden viele Alltagssituationen von jemandem gelöst, der kurzerhand spontan die Dolmetscherrolle übernimmt. Dies geschieht auch in unseren Daten, wenn in einigen Fällen andere Bewohner*innen zur Interpretation hinzugezogen werden.

Interessanterweise werden sie, sobald sie endlich gefunden wurden, oft mit Informationen bombardiert. In manchen Fällen beobachteten wir, dass die angehenden Polizeibeamt*innen eine Dolmetscherin mit Informationen überschütteten, wenn sie ankam. Sie hatte keine Zeit, auf die Situation zu reagieren oder einzelne Wendungen zu interpretieren. Manchmal wirkten die Beamt*innen auch so erleichtert, dass endlich ein Dolmetscher da ist, dass sie fast verzweifelt versuchten, so viele Informationen wie möglich loszuwerden. Dies deutet darauf hin, dass die Auszubildenden und die anderen Teilnehmer*innen in den Szenarien einfach nicht an die dolmetschervermittelte Kommunikation gewöhnt sind, bei der das übliche einsprachige Format des schnellen Sprecherwechsels und des direkten Zugriffs auf die Beiträge anderer Teilnehmer*innen durch

eine viel langsamere und indirektere Art der Kommunikation ersetzt wird. Dolmetschen ermöglicht gegenseitiges Verständnis und ist jedoch gleichzeitig eine zeitraubende Art der Kommunikation, die Anpassungsfähigkeit und Konzentration von allen Beteiligten erfordert.

Interessant ist auch die Positionierung der Dolmetscher*innen im Setting – einige sind aus Sicherheitsgründen vor der Tür, im Flur, positioniert, was bei einer Dolmetscherin das Gefühl hervorrief, dass sie „nur herumstand". Sobald Dolmetscher*innen vor Ort erscheinen, werden sie behandelt, als wären sie zum Dienst verpflichtet und nicht hilfsbereite Bürger*innen, die der Polizei einen Gefallen tun. Solch instrumenteller Umgang mit mehr oder weniger zufällig anwesenden Personen war aus Sicht der Einsatzkräfte nachvollziehbar, da für sie die Bewältigung der ihnen gestellten Aufgabe im Vordergrund stand. Dabei wurde in manchen Fällen jedoch übersehen, dass die ad hoc-Dolmetschenden zufällig und freiwillig zu dieser Bewältigung beitrugen und dafür andere Verpflichtungen oder Vorhaben hintenanstellten. Außerdem waren sie den Konfliktparteien oftmals irgendwie verbunden, wie etwa der Onkel, der bei einer Verkehrskontrolle per Telefon für seinen Neffen dolmetschte oder die Mitbewohnerin, die im Szenario *Ruhestörung* spontan vor Ort dolmetschte und gleichzeitig mit Denise befreundet war. Die möglichen Auswirkungen solcher Beziehungsaspekte auf die Interaktion und potenziell auch auf die Qualität der Dolmetschleistung schienen für die Polizist*innen gegenüber ihrem institutionellen Plan, ihrer Aufgabe im Szenario keine Rolle zu spielen.

Technische Hilfsmittel wie Übersetzungs-Apps auf mobilen Endgeräten, die unterstützend bzw. augmentiert eingesetzt werden, sind stattdessen allzeit bereit und keiner sozialen Beziehung oder kulturellen Prägung unterworfen (Fantinuoli/Dastyar 2022). Diese Maschinen übersetzen auf der Basis statistischer Verfahren und sind damit sprachlich-kulturell nicht sensibilisiert. Gesprochene Sprache wird zunächst erkannt und in schriftlichen Text umgewandelt, dann maschinell übersetzt und schließlich als Text (auf dem Bildschirm) und als Sprachausgabe per Lautsprecher wiedergegeben. Typische Phänomene der Mündlichkeit, wie etwa Stockungen, Stottern oder auch Hörersignale werden dabei weitgehend eliminiert. Da die vorgeschaltete Spracherkennung die Basis für die Übersetzung bildet und diese nicht immer zuverlässig funktioniert (z. B. aufgrund undeutlicher Aussprache oder Nebengeräuschen), ergeben sich in der Zielsprache

mehr oder weniger starke Abweichungen vom Ausgangstext, bis hin zu sinnlosen Beiträgen.

Trotzdem wurden solche Apps von den Trainees mehrfach eingesetzt, um Sprachbarrieren zu überbrücken, mal einfach als Wörterbuch, mal auch mit Sprachausgabe und ganzen Sätzen. Laut unseren Schauspieler*innen, die in Wirklichkeit Deutsch sprechen konnten, es aber nicht im Setting anwenden durften, funktionierten diese Tools manchmal überhaupt nicht, da Übersetzungen oft nicht verständlich waren. Offensichtlich war die Technik für alle Teilnehmenden neu und sie waren nicht mit der richtigen Verwendung der Apps vertraut, insbesondere auch mit den Grenzen und Stärken dieser Technologie. Dennoch wirkte sich der Einsatz von Übersetzungs-Apps auch moderierend auf die Teilnehmer*innen und die Situation als solche aus.

Zum Beispiel hatte das Team in einem Verkehrssteuerungsszenario (Training 2, Team 01) den Fahrer gezwungen, mit den Händen auf dem Dach neben seinem Auto zu stehen und begann, ihn zu durchsuchen, nur um seinen Führerschein zu finden. Dann begann ein Teammitglied, seine Smartwatch für die Übersetzung zu verwenden, während seine Kollegin per Funk nach einem Dolmetscher fragte. Nach einigen Fehlern bei der Nutzung der Smartwatch bat die Polizistin ihren Kollegen, das Smartphone zu benutzen, weil die App auf seiner Uhr nicht gut funktionierte. Am Ende stand der Beamte mit dem Fahrer zusammen, übergab das Smartphone und schaute gemeinsam mit dem Fahrer auf die Übersetzungen der App oder lauschte der Stimme aus dem Telefon. Wie die modifizierten Screenshots aus dem Video in Abbildung 1 zeigen, verschiebt sich die Szene von einer Situation, in der der Fahrer lediglich Gegenstand einer körperlichen Kontrollprozedur ist, hin zu einer kommunikativeren Situation, in der sich die Teilnehmer gegenseitig anschauen und kommunizieren.

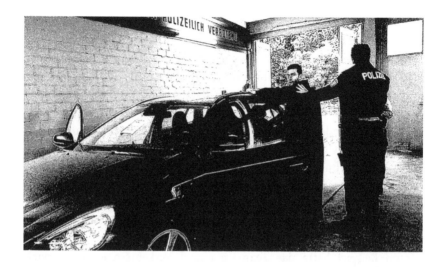

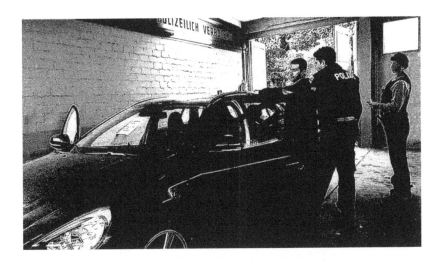

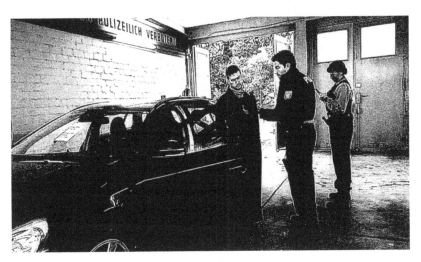

Abb. 1–4: Wechsel vom Zwangs- zum moderaten Kontrolltyp aufgrund der Verwendung einer Übersetzungs-App.[4]

4 Die beteiligten Beamt*innen wurden grafisch verfremdet. Nur die Körperhaltungen sind gleich.

Auch hier führt die inklusive Art der Kommunikation nicht nur zu einer allgemeinen Kommunikationsorientierung. Vielmehr bringt es das Team auch dazu, von einer übermäßig repressiven Praxis zu einer moderaten und angemesseneren Art der Kontrolle überzugehen. Und es zeigt, dass organisatorische Rationalitäten letztlich das Zusammenspiel prägten – in dem hier angesprochenen Szenario geht es den Polizisten nur um eine ordnungsgemäße Verkehrskontrolle und das Auffinden der Fahrerlaubnis. Dafür wurde nach erfolglosen Kommunikationsversuchen das Mittel der körperlichen Durchsuchung eingesetzt – eine Weiterfahrt ohne Vorzeigen der Fahrerlaubnis wäre unzulässig gewesen. Das Dokument musste also gefunden werden. In anderen Fällen mit ähnlich scheiternden Kommunikationsversuchen haben Teams gemeinsam entschieden, dass die Kontrolle eigentlich „nicht erforderlich" gewesen sei und daher auch keine Überprüfung der Fahrerlaubnis stattfinden müsse – diese „Lösung" des Kommunikationsproblems ist jedoch rechtlich bedenklich.

In anderen Fällen werden Übersetzungs-Apps lediglich zur Vervollständigung der eigenen begrenzten Sprachkompetenzen eingesetzt. So verständigt sich ein Team bei der Verkehrskontrolle zunächst in gebrochenem Französisch mit der Fahrerin. Den Ausdruck für „Erste-Hilfe-Kasten" kennen sie jedoch nicht. Daraufhin schaut ein Teammitglied in der App nach, die Fahrerin versteht, zeigt den Kasten vor und die Kontrolle kann beendet werden.

Bei einer Kontrolle mit Russisch wird zunächst versucht, über Funk einen russischsprechenden Kollegen oder eine Kollegin zu finden. Nachdem dies nicht gelingt, wird sofort eine App eingesetzt. Das Smartphone wird zwischen Fahrer und kontrollierenden Teammitgliedern hin und her gereicht, sodass eine präzisere Eingabe von Schlüsselwörtern über die Tastatur stattfinden kann. Die fehlerträchtige Spracherkennung wird so umgangen. Dieses Verfahren, bei dem jeweils zentrale Begriffe („Führerschein?", „Fahrzeugschein?", usw.) von den Beteiligten über die Tastatur des Smartphones direkt eingegeben werden, taucht mehrfach auf und scheint beim jetzigen Stand der Spracherkennung am besten geeignet zu sein, um stark standardisierte Interaktionen, wie etwa eine Verkehrskontrolle, zu unterstützen.

Auch in dem komplexeren und dynamischeren Szenario *Ruhestörung*, in dem beide Kontrahenten lautstark im Streit liegen, können Apps jedoch

hilfreich sein, sofern alle Beteiligten sich auf dieses Hilfsmittel einlassen. In diesem Szenario gelingt es dem Team in einem Fall, mit Hilfe einer App einzelne Aspekte der Rechtslage den Beteiligten zu erläutern und damit zu einer Klärung bzw. Befriedung beizutragen. Allerdings kommen Apps in diesem Szenario nur einmal zum Einsatz, weil andere Möglichkeiten, wie etwa anwesende ad hoc-Dolmetscher und rudimentäre Englischkenntnisse der Streitenden, gezielt eingebaut wurden, um das Setting realitätsnäher zu gestalten.

5. Schlussfolgerungen

In unserem Beitrag zeigen wir, wie Polizeibeamt*innen mit Sprachbarrieren umgehen und welche Funktion analoge und digitale Übersetzungshilfen dabei spielen. In unterschiedlichen Settings, dem fiktiven Einsatz einer Lärmbelästigung in einer Flüchtlingsunterkunft oder einem Studentenwohnheim und einer Verkehrskontrolle, nutzten insgesamt 32 Teams von Polizist*innen unterschiedliche Verfahren, um Sprachbarrieren zu überbrücken, neben Übersetzungshilfen und Lingua-franca-Gebrauch auch nonverbale Kommunikation und Gestik oder physischen Zwang. Die entscheidenden Unterschiede bei der Lösung der Situationen liegen in den differenzierten Kommunikationsformen der Polizeibeamt*innen, die wir als inklusiv oder als nicht-inklusiv bezeichnet haben. Durch die Nutzung verschiedener sprachlicher Strategien schließen Polizeibeamt*innen in unseren Daten Kommunikationslücken weitgehend durch inklusive Kommunikationsformen, d.h. „inklusive Mehrsprachigkeit".

Während sich Müller (2021) auf Missverständnisse als Folge von Unverständnis konzentriert, die zu Gewalt in der Interaktion zwischen Bürger*innen und Polizei führen können, konzentrieren wir uns auf die kommunikativen Praktiken von angehenden Polizist*innen, mit denen diese mehrsprachige Konstellationen ohne direkte Gewalt auflösen. Unsere Daten deuten darauf hin, dass die von uns beobachteten Polizeischüler*innen sehr kreativ sind, wenn es darum geht, alternative Methoden zur Verbesserung des gegenseitigen Verständnisses einzusetzen. In keinem der beobachteten 32 operativen Trainings wurde das Szenario abgebrochen oder übermäßige Gewalt angewendet. Fast alle eingesetzten Teams lieferten ein Ergebnis und konnten die Verkehrskontrolle oder die Ruhestörung bewältigen.

Interessanterweise entfaltet sich ein Szenario umso friedlicher und gewaltfreier, je mehr Sprache verstanden oder Sprachbarrieren überbrückt werden können. Das heißt, dass die verwendeten inklusiven Kommunikationsmittel dazu führen, dass die Lösung der polizeilichen Aufgabe weniger durch Konfrontation und Zwang geprägt ist. Das zeigten auch die Szenarien, in denen wir die Möglichkeit, einen informellen Dolmetscher einzusetzen, integriert haben. Diese Situationen wurden meist kommunikativer und mit mehr Verständnis für beide Seiten gelöst als einige der Szenarien, in denen es bis zum Schluss keinen Dolmetscher gab und in denen für das polizeiliche Gegenüber teilweise völlig unklar war, worum es bei dem Polizeieinsatz eigentlich ging. Unsere Ergebnisse zeigen also, dass die Trainees in unseren Daten im Gegensatz zu dem, was aktuelle wissenschaftliche Diskurse teilweise vermuten lassen, nicht sofort begonnen haben, kulturelle Differenz ausgehend von Sprachbarrieren zu konstruieren.

Digitale Übersetzungstools kamen, obwohl mittlerweile für alle Polizeibeamt*innen ohne großen Ressourceneinsatz und jederzeit verfügbar, nur in einer kleinen Zahl der Durchläufe zum Einsatz. Dabei waren die in Bezug auf kulturelle und sprachliche Besonderheiten ignoranten Apps jedoch als Übersetzungshilfen teilweise sogar besonders effektiv, weil ihre fehlerhaften oder nur fragmentarisch verständlichen Übersetzungen für alle Beteiligten die Notwendigkeit erfolgreicher Kommunikation deutlich machten. Die Beteiligten wurden durch die App dazu gebracht, die Herausforderungen der Sprachbarriere genauer zu beachten und nicht vorschnell von einem Verständnis oder auch einer mangelnden Kooperationsbereitschaft des jeweiligen Gegenübers auszugehen, etwa wenn Anweisungen nicht befolgt wurden oder Fragen nicht beantwortet wurden.

Vielmehr suchten die polizeilichen Teams nach Wegen, die Kommunikationslücken zu überbrücken und als sie es geschafft hatten, boten sie teilweise auch nachhaltigere Lösungen an (meist im Szenario der Ruhestörung). Sie schlugen vor, den Eigentümer anzurufen, die Verwaltung des Wohnheims zu kontaktieren, möglicherweise Zimmer zu wechseln, ein Störungsprotokoll zu führen oder sogar das Ordnungsamt zu kontaktieren, falls es erneut Lärm gibt. Die Apps zeigten sich hier also als echte Alternative für den Polizeieinsatz zur Überbrückung von Sprachbarrieren. Gegenüber Dolmetscher*innen als „Hilfsmittel" haben sie Nachteile in

der zwischenmenschlichen Kommunikation und aufgrund von Fehleranfälligkeit, jedoch auch Vorteile (Schnelligkeit, Förderung von Kreativität, Fokus auf Verständigung).

Diese nachhaltigen Lösungen vorzuschlagen, ist nicht unbedingt Teil ihrer gesetzlichen Pflicht – im Gegenteil, die Lösungen gehen darüber hinaus. Je weniger sich die angehenden Polizist*innen jedoch auf die Ermöglichung von Kommunikation und gegenseitige Verständigung konzentrierten, desto mehr begannen sie, Zwangsmittel und auch körperliche Gewalt anzuwenden. Diese Beobachtungen zeigen das enorme Potenzial inklusiver Kommunikationsformen für die Schaffung von Gemeinsamkeit und Verständnis in Begegnungen zwischen Polizei und Bürger*innen. Die Polizist*innen können in dieser Hinsicht weiter speziell geschult werden, um die Potentiale verschiedener Mittel zur Überbrückung von Sprachbarrieren für ihren Dienstalltag besser bewerten und nutzen zu können.

Anstatt die offensichtlichen Grenzen kommunikativer Ressourcen wie etwa der Übersetzungs-Apps oder auch die von menschlichen ad hoc-Dolmetscher*innen hervorzuheben, sollte in Einsatztrainings das konfliktbegrenzende Potenzial betont werden, dass diesen Verfahren und Kommunikationsmodi innewohnt. Dabei geht es nicht darum, die offensichtlichen Grenzen von digitalen Translationstechnologien zu bagatellisieren. Gerade die defizitären, dekontextualisierten und sprachlich-kulturell unsensiblen Formen der Übersetzung, die diese Maschinen praktizieren, bieten jedoch offensichtlich die Möglichkeit, Polizist*innen und ihre Gegenüber auf die Notwendigkeit einer gemeinsamen Verständigung zu fokussieren und damit Eskalationsdynamiken zu bremsen.

Bibliografie

Ag, Astrid/Jørgensen, Jens N., 2013: „Ideologies, Norms, and Practices in Youth Poly-Languaging." *International Journal of Bilingualism* 17(4), 525–539.

Alim, H. Salim, 2016: „Introducing Raciolinguistics." In: Alim, Salim/Rickford, John/Ball, Arnetha (Hrsg.): *Raciolinguistics: How Language Shapes our Ideas About Race.* Oxford University Press, 1–30.

Backus, Ad/Gorter, Durk/Knapp, Karlfried/Schjerve-Rindler, Rosita/Swanenberg, Jos/ten Thije, Jan/Vetter, Eva, 2013: „Inclusive Multilingualism: Concept, Modes and Implications." *European Journal of Applied Linguistics* 1(2), 179–215, retrieved from DOI https://doi.org/10.1515/eujal-2013-0010.

Beek, Jan/Bierschenk, Thomas, 2020: „Bureaucrats as Para-Ethnologists: The Use of Culture in State Practices." *Sociologus* 70 (1), 1–17.

Beek, Jan, 2016: *Producing Stateness: Police Work in Ghana.* Leiden/Boston: Brill.

Beek, Jan/Kecke, André/Müller, Marcel, 2022: „Sprach-und Gewaltkompetenz im Einsatztraining." *Handbuch polizeiliches Einsatztraining.* Wiesbaden: Springer Gabler, 713–731.

Bierschenk, Thomas/de Sardan/Jean-Pierre Olivier, 2019: „How to Study Bureaucracies Ethnographically." *Critique of Anthropology* 39 (2), 243–57.

Bornewasser, Manfred, 2009: „Ethnische Vielfalt im eigenen Land: Eine nicht nur sprachliche Herausforderung im Innen-und Außenverhältnis der Polizei." In: Liebl, Karlhans (Hrsg.): *Polizei Und Fremde – Fremde in der Polizei.* Wiesbaden: VS Verlag für Sozialwissenschaften, 13–44.

Bührig, Kristin/Meyer, Bernd, 2004: „Ad-hoc-interpreting and the Achievement of Communicative Purposes in Doctor-patient-communication." In: Rehbein, Jochen/House, Juliane (Hrsg.): *Multilingual Communication.* Amsterdam: Benjamins, 43–62.

De Swaan, Abram, 2013: *Words of the World: The Global Language System.* Hoboken: John Wiley & Sons.

Fantinuoli, Claudio/Dastyar, Vorya, 2022: „Interpreting and the Emerging Augmented Paradigm." *Interpreting and Society* 2(2), 185–194.

Ferguson, Charles A., 1975: „Toward a Characterization of English Foreigner Talk". *Anthropological Linguistics* 17(1), 1–14.

Galliker, Esther, 2014: *Bricolage: ein Kommunikatives Genre im Sprachgebrauch Jugendlicher aus der Deutschschweiz.* Berlin: Peter Lang.

Jacobsen, Astrid, 2009: „Was mach ich denn, wenn so'n Türke vor mir steht? Zur interkulturellen Qualifizierung der Polizei", in Liebl, Karlhans (Hrsg.): *Polizei und Fremde – Fremde in der Polizei.* Wiesbaden: VS Verlag für Sozialwissenschaften, 91–103.

Kolloch, Annalena (2021). „Ich verstehe die Kultur. So verstehe ich, wer lügt' – Sprach- und Kulturvermittler als Vermittler und Para-Ethnologen". In: Dombrowsky-Hahn, Klaudia/Littig, Sabine (Hrsg.): *Migration, Sprache, Integration. (Der Mund. Kritische Studien zu Sprache, Kultur und* Gesellschaft 8(1)), 110–129. Retrieved from https://themouthjournal.com/migration-language-integration-issue-no-8/

Labov, William, 1972: *Language in the Inner City: Studies in the Black English Vernacular* (No. 3). University of Pennsylvania Press.

Lücking, Andy, 2013: *Ikonische Gesten: Grundzüge einer linguistischen Theorie.* Berlin: De Gruyter.

Meyer, Bernd, 2012: „Ad hoc Interpreting for Partially Language Proficient Patients: Participitation in Multilingual Constellations." In: Baraldi, Claudio/Gavioli, Laura (Hrsg.): *Coordinating Participation in Dialogue Interpreting*, Amsterdam: Benjamins, 99–113.

Meyer, Bernd/Apfelbaum, Birgit (Hrsg), 2010: *Multilingualism at Work: From Policies to Practices in Public, Medical, and Business Settings.* Amsterdam: Benjamins.

Müller, Frank E., 1989: „Übersetzung in zweisprachigen Konversationen: Pragmatische Aspekte der translatorischen Interaktion." *Zeitschrift für Pragmatik 13* (5), 713–739.

Müller, Marcel, 2021: *Umgang mit Differenz am Beispiel von Verkehrskontrollen. Eine auto-ethnografische Forschung im Rahmen der Ausbildung von Kommissar-Anwärter/innen.* Frankfurt am Main: Verlag für Polizeiwissenschaft.

Pöchhacker, Franz, 2012: „Interpreting Participation. Conceptual Analysis and Illustration of the Interpreter's Role in Interaction. In: Baraldi, Claudio/Gavioli, Laura (Hrsg.) Coordinating Participation in Dialogue Interpreting, edited by Claudio Baraldi/Laura Gavioli (Hrsg.): *Coordinating Participation in Dialogue Interpreting*, Amsterdam: Benjamins, 45–70.

Pöllabauer, Sonja, 2005: *„I don't understand your English, Miss." Dolmetschen bei Asylanhörungen.* Tübingen: Narr.

Sauerbaum, Anke, 2009: „Interaktion und Kommunikation zwischen Polizei und Migranten. Die Polizeiausbildung in Baden-Württemberg auf dem Prüfstand", in Liebl, Karlhans (Hrsg.): *Polizei Und*

Fremde – Fremde in der Polizei. Wiesbaden: VS Verlag für Sozialwissenschaften, 77–90.

Shon, Philipp Chong Ho, 2005: „'I'd grab the S-O-B by his hair and yank him out the window'. The Fraternal Order of Warnings and Threats in Police-citizen Encounters." *Discourse & Society* 16 (6), 829–845.

Stahlke, Iris, 2001: *Das Rollenspiel als Methode der qualitativen Sozialforschung: Möglichkeiten und Grenzen.* Münster: Waxmann.

Staller, Mario/Körner, Swen, 2019: „Quo vadis Einsatztraining?" In Kühne, Eberhard (Hrsg.): *Die Zukunft der Polizeiarbeit – die Polizeiarbeit der Zukunft*, Teil 2, Rothenburger Beiträge, Band 101, 321–363.

Vogel, Sara/García, Ofelia, 2017: *Translanguaging.* New York: Cuny Graduate Center.

3 (Sozio-)Kulturelle Reflexionen und Fallstudien zu Digitaler Interkulturalität

(Socio-)Cultural Reflections and Case Studies on Digital Intercultural Phenomena

Roman Lietz

Diskursive Herstellung von Identität und sozialer Kohäsion im virtuellen Raum

Abstract English: The internet offers diverse – often unconscious – possibilities to position oneself and to talk about oneself. This article reports on some of these identity constructions. It deals with how internet users in virtual communities make their identity visible and communicate it, and how communality and social cohesion are created in this context. In this context, the creation of community also plays an important role, which ultimately leads to a social cohesion between people who form an internet community. Narrations of identity in social media are linguistic manifestations that perform the balancing act between the formation of a distinctive *I-identity* and an integrative, cohesive *we-identity*. Examples from discourse processes and narrative practices on different platforms such as Twitter, Facebook, in weblogs, in fan forums and especially on YouTube are presented and explained. These processes and practices are identity-forming for the interactants in online communities, and thus ultimately underpin the social cohesion within these groups.

Abstract Deutsch: Das Internet bietet mannigfaltige – oft auch unbewusst ablaufende – Möglichkeiten, sich zu positionieren und von sich selbst zu berichten. Von einigen dieser Identitätskonstruktionen erzählt dieser Artikel. Er befasst sich damit, wie Internet-Nutzer*innen in virtuellen Gemeinschaften ihre Identität sichtbar machen und diese kommunizieren. In diesem Zusammenhang kommt auch der Herstellung von Gemeinschaftlichkeit eine wichtige Rolle zu, die letztendlich zu einer sozialen Kohäsion zwischen den Menschen, die eine Internet-Community bilden, führt. Identitätsnarrationen in den sozialen Medien sind sprachliche Manifestationen, die den Spagat zwischen der Ausgestaltung einer eigenen, unverwechselbaren *Ich-Identität* und einer integrativen, kohäsiven *Wir-Identität* leisten. Es werden Beispiele aus Diskursverläufen und narrative Praktiken auf unterschiedlichen Plattformen wie Twitter, Facebook, in Weblogs, in Fan-Foren und vor allem auf YouTube gezeigt und erläutert. Diese sind für die Akteure in Online-Communitys identitätsstiftend und fundieren damit letztendlich die soziale Kohäsion innerhalb dieser Gruppen.

Keywords: Identität, soziale Kohäsion, Social Media, Multikollektivität, Sprach-register, Ingroup & Outgroup, Reziprozität

1. Einleitung

Identität. Das ist heute vor allem die Antwort auf die Frage „Wer bin ich?" (Keupp et al. 2008: 29; Watzlawick et al. 2021: 3). Im digitalen Raum wird sie millionenfach beantwortet. Zumindest wird millionenfach diese Antwort gesucht, denn sie zu finden ist nicht trivial. Identität wird kontinuierlich gebildet und ist veränderlich (Hall 1994: 183). Die Weise, sie zu kommunizieren, ist mitunter so veränderlich wie das persönliche WhatsApp-Profilbild oder die aktuelle Facebook-Statusmeldung. Identität ist nicht statisch oder determiniert und sie gibt Auskunft darüber, „wer ich im Augenblick" bin (Keupp et al. 2008: 32). Wobei das Augenblick-liche zumindest im Sinne von Lebensphasen bzw. „Lebenssituationen" gefasst werden muss (Keupp et al 2008: 32). Problemlos und nahezu spie-lerisch nimmt man überlappende, hybride, fragmentierte, uneinheitliche Identitäten an (cf. Bhabha 1994, Hall 1999:180 u. 396). Davon zeugen exemplarisch drei von unzähligen Beispielen aus dem sozialen Medium Twitter (Abb. 1): Man markiert die eigene Identität als „Gutmensch", „Nazi-Hasser" und „Harley"-Fan. Man gibt sich als „Pferdefreundin", als „Jungsmama", und „gelegentliche Star-Wars-Cosplayerin" zu erken-nen, und man identifiziert sich als „Abba-Fan" und „gleichgeschlechtlich Liebende". Und diese Statements sind nur ein Bruchteil der Antworten auf die Frage: „Wer bin ich?". Gleichzeitig geben sie vor allem auch nicht nur Auskunft über eine selbstbezogene Ich-Identität, sondern verorten die Personen auch in einem übergeordneten Wir, wie später im Artikel gezeigt wird.

FCKAFD
@ODDO60

Moin, Links/Grün, Gutmensch, gerechtigkeitsliebend, sozial, Frau und Kinder, AfD und Nazi-Hasser! Hin und wieder vulgär, bzw. liebe die deutsche Sprache! Harley

Pferdefreundin
@Thie2111

Architektur, Pferde, 'leben und leben lassen', Jungsmama, Nordsee, Niederlande, 'mehr Meer bitte', manchmal ein Abstecher in die Welt von StarWars Cosplay...

zoë (ABBA fan account)
@krabrat

bissi müde trotzdem da 🖤

Abb. 1: Zusammenschnitt von Identitätsnarrationen auf Twitter (am 15.09.2021); https://twitter.com/Thie2111, https://twitter.com/krabrat, https://twitter.com/ODDO60

Man kann davon ausgehen, dass jede dieser Selbstzuschreibungen nicht zufällig erfolgt ist, sondern im Sinne Boltens Fuzzy-Cultures-Ansatzes die beschriebenen Positionierungen *Zugehörigkeitsgrade* zu – über die Akteure miteinander interagierenden – Kollektiven reflektieren (Bolten 2011). Für eine öffentlich selbsterklärte „Pferdefreundin" ist beispielsweise die *kulturelle* Zugehörigkeit zum Pferdeliebhaber*innen-Kollektiv besonders relevant.

Um darzustellen, wie sich Identität und soziale Kohäsion im virtuellen Raum manifestieren und wie sie sich erkennen lassen, stellt der Artikel im Folgenden den Identitätsbegriff vor allem vor dem Hintergrund digitaler Räume vor. Zudem wird anhand einer YouTube-Kommentarsektion beispielhaft gezeigt, wie Identität und soziale Kohäsion in einem diskursiven Austauschprozess mit anderen Internetuser*innen hergestellt werden.

2. Online-Identitätskonstruktion

2.1 Kurze (eurozentrische) Geschichte der Identität

Der Begriff *Identität* wurde soeben als die Antwort auf die Frage „Wer bin ich?" eingeführt. Historisch gesehen stand jedoch nicht immer diese Frage im Mittelpunkt der Identitätssuche und Identitätskonstruktionen sind nicht immer so verlaufen, wie es uns heutzutage selbstverständlich erscheint. Das macht eine kurze Geschichte der Identität (wohlgemerkt aus europäischer Sicht) deutlich. Auch wenn menschliche Gemeinschaft schon relativ alt ist – oder Menschheit ohne Gemeinschaft möglicherweise gar nicht denkbar ist – ist die bewusste Auseinandersetzung mit Identität eine relativ neue Facette der Menschheitsgeschichte. Vor der Moderne bzw. vor der Aufklärung spielten bewusste Identitätsfragen kaum eine Rolle, mal abgesehen von intellektuellen Leuchttürmen wie den altgriechischen Kosmopoliten. In tribalen Gesellschaften stellte sich die Identitätsfrage schlichtweg nicht. Bamberg/Dege verweisen darauf, dass es auch aus der Antike und dem Mittelalter so gut wie keine Überlieferungen über Identitätsdiskurse vor allem betreffs der einfachen Bevölkerungsschichten, Frauen und Sklav*innen gibt (Bamberg/Dege 2021: 37). Erst mit der Aufklärung, Immanuel Kant sei hier hervorgehoben, lösten sich die Menschen aus der „selbstverschuldeten Unmündigkeit" (Kant) bzw. „schicksalhaften Ergebenheit" (Schiller) und stellten zunehmend Fragen

nach einer nicht göttlichen, sondern weltlichen Ordnung (Keupp et al. 2008: 19). Bis dato weniger privilegierte Gruppen, die sich den Traditionen und Strukturen und ihrer vorgegebenen „Position in der Großen Kette des Seins" (Hall 1994: 188–189) gefügt hatten, forderten etablierte Machtverhältnisse heraus. Es blieb nicht aus, sich damit auch selbst infrage zu stellen, erinnert sei an René Descartes' fast schon verzweifelte Selbstversicherung „Cogito ergo sum" (Die einzige Gewissheit, dass ich überhaupt existiere, ist, dass ich in der Lage bin, zu zweifeln). Dieses neue Selbst-Bewusstsein gipfelte auch in einer erstmaligen ernsthaften Auseinandersetzung mit Identitätsfragen (Keupp et al. 2008: 19; Bamberg/Dege 2021: 37). In der Praxis liefen sie jedoch zumeist auf lokale und auf Dauer angelegte Zugehörigkeiten hinaus. Beantwortet wurde nicht die Frage „Wer bin ich?", sondern: „Wo komme ich her?" und „Wo gehöre ich hin?" Die Fragen waren relativ einfach und lieferten überschaubare Antworten: Die Zugehörigkeitsmarkierung zu einem sozialen Stand oder Beruf (Magd, Handwerker, Krämer, Seefahrer, …) sowie zu einer Region, später dann Nation, gaben Sicherheit und Identitätskonkretheit, auch weil die Neuzeit wegen zunehmender Mechanisierung an Berufszweigen und wegen zunehmender Urbanisierung an Wohntraditionen rüttelte. Wachstum bzw. Expansion in jeglicher Hinsicht (Wissen, Macht, Kapital, Einfluss, Erfahrungshorizonte …) als Leitlinie der Moderne führte natürlich nicht ganz zufällig auch zu Nationalismus und Kolonialismus: Aus regionaler Identifikation wurde eine konstruierte, nationale Identität, und mit der imperialistischen Attitüde wurde auch jenseits Europas die Welt mit einem eurozentrischen Identitätsnarrativ überzogen (cf. Bhabha 1986, zitiert nach Bamberg/Dege 2021: 39): Aus der blinden Annahme, dass sich die ganze Welt am Beispiel Europas zu entwickeln habe, wurden den Menschen in den Kolonien Identitätskonstrukte unter rassistischen Gesichtspunkten übergestülpt. Jene Identitätskonstrukte waren keine Selbst-, sondern Fremdverortungen.

Keupp et al. (2008: 30) folgend fehlt jedoch noch ein wesentlicher Schritt bei der Herausbildung der Identität in der Spätmoderne: Identität, wie sie auch von Erik Erikson (u. a. in *Identität und Lebenszyklus*, 1966) konzipiert wurde, setzt auch in der Moderne ein „Ordnungsmodell regelhaft-linearer Entwicklungsverläufe" (ibid.) voraus. Mit eigenen Worten: In den Vorstellungen der Moderne blieb es bei einem Determinismus

von Nationen und v. a. soziodemografischen Zugehörigkeiten, die für das Gros der Bevölkerung nahezu festgeschrieben waren. Für die Söhne von Landwirten war es klar, Landwirt zu werden, so wie der Vater, der Großvater, die eigenen Kinder und deren Kinder. Für individuelle Lebensentwürfe blieb weiterhin kein Platz, noch weniger für Frauen, deren Zugehörigkeit sich häufig nicht mal über den eigenen Lebensentwurf, sondern über die Identität ihres Mannes definierte (vgl. Thon 2012: 28). Erst mit der Individualisierung kam es unter anderem zur „Freisetzung des Individuums aus sozialen Klassenbindungen und aus Geschlechtslagen von Frauen und Männern" (Beck 1986: 116; zitiert nach Thon 2012: 27). Ihr Katalysator waren die großen Post-2.-Weltkrieg-Umbrüche: Der Feminismus, Post-Kolonialismus, Cultural Turn, Anti-Autoritarismus und weitere post-moderne Erscheinungen forderten die Menschen neu heraus, auch hinsichtlich ihrer Identitätsfragen. Ein selbstbestimmtes Leben ohne Standes-, Herkunfts- und regionaler Schranken wurde immer möglicher und wurde immer mehr eingefordert (cf. Bamberg/Dege 2021: 38). Keupp et al. (2008: 30) nennen es die „Dekonstruktion grundlegender Koordinaten modernen Selbstverständnisses". Soziale und quasi vorgegebene identifikationsstiftende Prozesse wurden immer weiter hinterfragt und modifiziert (Beck 2004: 42). Dazu gehört insbesondere auch die Infragestellung von vermeintlich determinierenden (nationalen, ethnischen oder religiösen) Identitätszugehörigkeiten (Sen 2006: 34–35). Die Identitätsfrage in der Post-Moderne, nach und angesichts der Individualisierung, lautet nicht mehr rückwärtsgewandt „Wo komme ich her?" / „Wo gehöre ich hin?". Sie ist allenfalls, „Wie bin ich so geworden?". Die Frage lautet: „Wer bin ich?", und vor allem prospektiv: „Wer will ich sein?" („Which identity to choose", Bauman 2009: 5–9).

2.2 Dynamik der Identitätsbegriffe und deren diskursive Ablehnung

Aus *Monokollektivität* wird dabei *Multikollektivität* des Individuums. Sen (2006: 24) spricht von „plural affiliations". Das Bewusstsein für die eigene Identifikation mit einer Vielzahl unterschiedlicher Gruppen steigt (siehe Beispiele oben: „Pferdefreundin", „Jungsmama", „Star Wars-Cosplayerin"). Diese Mehrfachidentitäten wirken dabei additiv und komplementär

(Hansen 2009: 20). Die Individualisierung hat eine Dynamik und Fragmentierung der Identitäten bewirkt, die sich von homogenen und normativen Identitätsvorstellungen löst. Gerade für Personen, die sich bis dato mit einer oder mehreren ihrer Identitäten in einer Nische wiederfanden, möglicherweise gesellschaftlich sogar marginalisiert waren, bedeutet dies eine unbekannte, lang ersehnte Freiheit und Selbstverwirklichung. *Mann* oder *Frau,* *hetero* oder *homo, deutsch* oder *türkisch*, diese Identitäten sind heute nicht mehr zwangsläufig dichotome Selbstverständlichkeiten, also unterliegen nicht unbedingt einer *Entweder-Oder-Logik,* sondern manchmal auch einer *Sowohl-Als-Auch-Logik.* Veränderung wird jedoch für nicht wenige Menschen als Bedrohung empfunden, und diese unvorhersehbaren gesellschaftlichen Dynamiken verunsichern diese Menschen. Tradiertes Wissen über das eigene Kollektiv liefert schließlich, so Assmann (1988: 13 f.), „Identitätskonkretheit", „Rekonstruktivität" und „Verbindlichkeit". Die Furcht vor der Ungewissheit, die die Veränderung mit sich bringt, ist mit Kontrollverlust und der Angst, dass die bekannten Selbstverständlichkeiten nicht mehr wirksam sein könnten, verbunden. Das führt natürlich auch zu Ablehnung. Die virtuelle Umgebung ist aufgrund von Anonymität bzw. Pseudonymität und medialer Reichweite nahezu prädestiniert, um diese Arten von Ablehnungen im Sinne von Gegenöffentlichkeiten kundtun zu können und um Gleichgesinnte und affektive Bestärkung zu finden (Strick 2021: 15–19). Auf der ganzen Welt haben sich Autoritarismus und Nationalismus – im Sinne einer Opposition zum Kosmopolitismus – ihren Platz erkämpft und gesichert. Die Abbildungen 2–4 geben nur einen winzigen Ausschnitt dessen wieder. Strick (2021: 34) stellt ernüchtert fest, dass die „Alternative Rechte verwoben mit dem digitalen Zeitalter [ist]." Die hier vorgelegten Beispiele zeigen erstens eine Metapher (Abb. 2) als rassistisches Narrativ, welches sich innerhalb der neuen Rechten seit einiger Zeit einer gewissen Beliebtheit erfreut, hier repetiert im Forum *Allmystery.de.* Zweitens (Abb. 3) ein Statement aus einer öffentlich einsehbaren Diskussion zwischen Wikipedia-Autor*innen, welches gendergerechte Sprache bzw. ihre Befürworter*innen delegitimieren soll („Chaddy" und „Informationswiedergutmachung" sind hier übrigens selbstgewählte und teilweise auch schon sprechende Pseudonyme von Wikipedia-Autor*innen); und schließlich (Abb. 4) eine Facebook-Gruppe mit immerhin mehr als 1.000 Followern (Stand Juni 2022), die nicht nur persönlich gleichgeschlechtliche Ehen

ablehnen, sondern sich in dieser Opposition auch öffentlich positionieren und vernetzen.

Abb. 2: Reaktanz auf dynamische Identitätsbegriffe, https://www.allmystery.de/themen/pr32302

> Sofern Chaddy mal eine progressive Idee hat, darf er sich mal gerne melden. Gendergerechte Sprache ist jedenfalls keine progressive Idee, sondern nur eine aggresive. --Informationswiedergutmachung (Diskussion) 23:21, 7. Jun. 2019 (CEST) [Beantworten]

Abb. 3: Delegitimation von gendergerechter Sprache, https://de.wikipedia.org/wiki/Wikipedia_Diskussion:Meinungsbilder/Geschlechtergerechte_Sprache#Die_Vernunft ; (Hervorhebung durch Autor)

Abb. 4: Aktivismus gegen gleichgeschlechtliche Ehe, https://www.facebook.com/Deutschland-gegen-Homoehe-633422250018020

Der Kampf um kulturelle Hegemonie, um Aufmerksamkeit und um Deutungshoheit ist auch ein Kampf um die Grenzen von Identitätsfragen und er wird virtuell und verbal ausgetragen, bleibt aber natürlich nicht in der virtuellen Welt und auf das verbale Instrumentarium beschränkt (Strick 2021: 37–43).

Letztendlich ist natürlich auch die Positionierung *gegen* eine Identitätskonstruktion (z. B. *gegen* das dritte Geschlecht, *gegen* queere Lebensentwürfe oder *gegen* Ausländer*innen) eine Manifestation bzw. eine Erzählung der eigenen Identität. Sowohl sich als Befürworter als auch als Gegner eines Lebensentwurfs auszusprechen, zeugt von einer persönlichen Positionierung. Diese schöpft ihre Relevanz nicht nur aus Affirmation zu der Position, die man einnimmt, sondern oft auch aus der Abgrenzung zur Position, die man *nicht* einnimmt: Eine nicht unwesentliche Rolle für die eigene Identität spielt die Konstruktion des von einem selbst abweichenden *Anderen*, von Gayatri Spivak (1985) als „Othering" in den Diskurs eingeführt (Jensen 2011: 64).

2.3 Die narrative Konstruktion von Identität

Dass Identität narrativ konstruiert wird, ist kein Geheimnis, wie wir u. a. bei Lucius-Höhne und Depperman (2002) sowie bei Keupp et al. (2008) nachlesen können. Bamberg/Georgakopoulou (2008: 378) vermerken, dass der sogenannte „narrative turn" etwa seit den 1990er-Jahren viele Geisteswissenschaften erfasst hat und damit auch einen direkten Einfluss auf die Identitätsforschung hatte. Die eher sozialwissenschaftlich und psychologisch angelegte Identitätsforschung erringt damit auch das Interesse der linguistischen Forschung: „Recent post-structuralist and post-modern theory has closely associated identity with discourse, and identity is often said to be an effect of discourse, constructed in discourse." (Fairclough 2003: 160).

Bei der narrativen Konstruktion von Identität geht es um konkrete Äußerungen, etwa zu Themen, Merkmalen, Eigenschaften, Gefühlen oder Handlungen, über die eine unverwechselbare Eigenart der Sprecher*innen offenbart wird (Keupp et al. 2008: 32). Im Zentrum steht dabei die Narration, eine Selbsterzählung. Drei Zitate verdeutlichen dieses noch einmal (Hervorhebungen durch den Autor des Artikels): Aus „**sprachlich-kommunikativen Leistungen** lässt sich die narrative Identität abbilden."

(Lucius-Höhne/Deppermann 2002: 11). Deppermann (2013: 67) erkennt grundsätzlich Identität in „**auto-biographischen Selbst-Präsentationen**." Und Röll (2020: 122) bezeichnet Identität als ein „**narratives Projekt im ständigen Wandel**". Diese sich mit Identität auseinandersetzenden Zitate eröffnen die Tür zu Narrationen in der Online-Welt, insbesondere im Web-2.0 (De Fina/Perrino 2017): Denn ist ein Tweet nicht auch eine „sprachlich-kommunikative Leistung" über die eigene Identität? Finden wir „auto-biografische Selbstpräsentationen" nicht allenthalben in Selfies und Foodporn auf Facebook und Instagram? Und ist letztendlich ein Weblog nicht auch ein „narratives Projekt im ständigen Wandel"?

2.3.1 Weblogs

Ohnehin waren Weblogs (Blogs) eines der zentralen Elemente des Web-2.0, also des Internets, welches in den frühen 2000er-Jahren aus Konsument*innen Produzent*innen (oder *Prosument*innen* (gleichzeitig *Produzent* und *Konsument*, cf. Kelly 2005)) von Webinhalten gemacht hat (Thelwall 2013: 81). Mittlerweile verdienen Video-Blogs (Vlogs), die anstelle schriftlicher eine audio-visuelle Narration verwenden, mindestens eine genauso große Aufmerksamkeit für die Identitätsnarration (Lanza 2020). In Weblogs und Vlogs erzählen Menschen ihren Alltag. Erzählungen und Geschichten bilden dabei die „einzigartige menschliche Form, das eigene Erleben zu ordnen, zu bearbeiten und zu begreifen" (Kraus 1996: 202). Erst in dieser geordneten Sequenz und deren Interpretation gewinnt das Chaos von Eindrücken, dem jeder Mensch täglich unterworfen ist, eine Struktur, vielleicht sogar einen Sinn (ebd.).

In Selbstdarstellungen lassen sich Geschichten und unser Erleben wiedergeben, letztendlich die gesamte Beziehung zur Welt (Mancuso 1986, zitiert nach Keupp et al. 2008: 101) und ihre leitende Frage: „Wer bin ich?", und „Warum bin ich so geworden". Durch diese Kundgaben machen wir uns verstehbar für andere, wobei man die Selbsterzählung „aufbauschen oder sparsam gestalten kann", und sie möglicherweise wie „formloses Geplapper" wirkt, jedoch an sich (unbewusst) strategisch abläuft (Keupp et al. 2008: 208–209); Feststellungen, die sich problemlos auf Blogs wie diesen Reiseblog (Abb. 5) einer nicht näher bekannten Maria übertragen lassen.

Jeden Morgen zu Sonnenaufgang standen wir auf und machten uns auf den Weg zum Caffee, was so 40 Minuten Fußweg hieß. Dort haben wir dann die ersten Gäste in Empfang genommen und es ging den ganzen Tag so weiter. Ich hatte sehr das Gefühl dort viel Zeit zu verschwenden, weil auch teilweise sehr wenig los war, aber nach und nach spielte sich das ein. So um 20 Uhr ging es dann meistens mit einen Taxi nach Hause. In der ganzen „Stadt" habe ich auch nur 10 Privatautos gesehen und sonst gab es nur Taxen. Die Familie war auch ein bisschen ernst und nicht ganz so herzlich wie ich die Art aus Lima kenne.

Abb. 5: Weblog Marias Reise; https://mariasreise627924318.wordpress.com/2020/ 03/08/chachapoyas-peru/

2.4 Ich-vs-Wir-Identität

Identitätsziele sind einerseits emotional und produktionsorientiert begründet und liefern Selbstachtung, Selbstwirksamkeit, Selbstbewusstsein und Originalität; andererseits sind sie sozial begründet und sorgen für Anerkennung, Akzeptanz und Zugehörigkeit (Keupp et al. 2008: 261–262). Identität leistet also den Spagat zwischen zwei beinahe konkurrierenden Konzepten. Zum einen möchte man ein „unverwechselbares Individuum sein", ein *Ich als Ich selbst* und so wie niemand sonst auf der Welt; zum anderen möchte man ein *Ich als Teil eines Wirs* sein, also verlässlich zu einer Gruppe zugehörig. Um nochmal Keupp et al. (2008: 28) aufzugreifen, ist Identität „ein selbstreflexives Scharnier" zwischen der inneren und der äußeren Welt, der Kompromiss zwischen „Eigensinn" (Ich-Identität) und „Anpassung" (Wir-Identität). Es geht also um die Aushandlung zwischen Selbstbewusstsein, Individualität und vor allem Unverwechselbarkeit auf der einen Seite sowie der Gewissheit, in einer Gruppe integriert zu sein, auf der anderen Seite (Keupp et al. 2008: 28; auch Bamberg/Dege 2021: 25).

Kaum verwunderlich ist es, dass diese Aushandlung auch bei online manifestierter Identitätsnarration deutlich sichtbar wird. Sicherlich

bekannt ist die Eigenheit des Web-2.0, nach der man online spielerisch eine von der tatsächlichen Identität abweichende oder damit experimentierende Identität annehmen kann. Dies wurde umfangreich behandelt (u. a. Döring 2003; Ganguin/Sander 2008) und weltberühmt durch den bereits 1993 erschienenen und später zum Meme gewordenen Cartoon von Peter Steiner: „On the Internet, nobody knows you're a dog." (Abb. 6; Fleishman 2000).

"On the Internet, nobody knows you're a dog."

Abb. 6: Peter Steiner Cartoon; The New Yorker, 1993.

Nicht selten wird im Internet jedoch auch Authentizität als Identitätsnarration gesucht. Ganguin und Sander (2008: 425) unterscheiden beim virtuellen Identitätsverhalten zwischen einer „experimentellen Selbstdarstellung", wenn man sich mit seiner virtuellen Identität anders verhält als im physischen Raum, und einer „authentischen Selbstdarstellung", wenn

die Identitätsdarstellung im Internet der aus der analogen Welt entspricht.
Für die Erörterung der Aspekte diskursiver Herstellung von Identität und
sozialer Kohäsion sind die authentischen Identitätsexpressionen selbstver-
ständlich von größerer Bedeutung. In weiteren Studien konnte nachgewie-
sen werden, dass auch in den sozialen Medien, insbesondere Twitter, eine
authentische Selbstdarstellung von wachsender Bedeutung ist (Marshall/
Barbour 2015: 6; Lietz/Lenehan 2023).

Abb. 7: Authentische Selbstpräsentation im Spiel The Sims; https://www.red
dit.com/r/thesims/comments/brpz1i/my_cousin_made_her_simself_i_think_its
_spoton/

In Abbildung 7 hat eine Spielerin des Online-Rollenspiels *The Sims* einen
Avatar nach ihrem eigenen Ebenbild erschaffen und mit persönlichen,
unverwechselbaren Details versehen, bis hin zur Frisur, der Halskette,
den Ohrringen und der kleinen Kuhle unter dem Kehlkopf. Ein unver-
wechselbares *Ich* als Online-Identität. Gerade das „Nicht-Identische" ist
das, was hier die Identität ausmacht (Keupp et al. 2008: 172). Auf der
anderen Seite zeigt die Abbildung 8 Repräsentationen aus einem Star-
Wars-Online-Forum.

Abb. 8: Stormtrooper-Avatare in einem Star Wars-Forum; https://www.whitear
mor.net/forum/forum/24-forum-help-support/

Hier wählen die Nutzer*innen Avatare, die sie eindeutig als Stormtrooper – die Sturmtruppen des Imperiums im Star-Wars-Universum – erkennen lassen. Wer Star Wars kennt, weiß, dass sich Stormtrooper nicht gerade durch Individualität auszeichnen. Dadurch identifizieren sich die Forumsteilnehmer*innen als Teil einer homogenen Gruppe und auch innerhalb des Star-Wars-Kollektivs als Angehörige einer Subkultur. Wir erkennen hier Identität als eine „spezifische Erfahrung, die einen von vielen anderen unterscheidet, aber auch mit einigen wenigen anderen verbindet." (Keupp et al. 2008: 172). Die Konstruktion dieser und vergleichbarer Subkulturen ist überhaupt erst durch das Web-2.0 möglich. Zuvor waren „Gleichgesinnte", die irgendwo auf diesem Planeten leben und ihre spezielle Identitätsnarration nicht alltäglich exponieren konnten oder wollten, schwer ausfindig zu machen, und die Begegnung mit ihnen war unter Umständen sehr voraussetzungsvoll.

3. Identitäts- und Kohäsionskonstruktion: ein Fallbeispiel

Identität ist also das Zusammenspiel aus Individualität („Eigensinn") und Zusammenhalt („Anpassung"). Was nun besonders interessieren soll, ist die Konstruktion des Zusammenhalts in Diskursen im digitalen Raum, die *soziale Kohäsion*. Identität bildet und verändert sich als soziale Konstruktion (Lucius-Höhne/Deppermann 2002: 49), also durch eine Wechselwirkung von sozialen Erwartungen, sozialisatorischen Erfahrungen und der individuellen Antwort darauf (ebd.). Passenderweise untersucht die kulturelle Linguistik (Sharifian 2017: 1) genau jene Beziehungen zwischen Sprache und soziokulturellen Konstruktionen und betrachtet die Wirkweise von Sprache auf eben jene Konstruktionen.

Welche Elemente Online-Diskurse mit dem dahinterliegenden Ziel der sozialen Kohäsion enthalten können, zeigt das nachfolgende Fallbeispiel. Es handelt sich dabei um ein beeindruckendes Fundstück aus dem Internet, welches einmal mehr offenbart, dass Identität „ein empirisch zugängliches Phänomen" ist: Das Konstrukt der narrativen Identität ist „in den empirischen Handlungen des Subjekts fundiert." (Lucius-Höhne/Deppermann 2002: 11).

Nachdem am 24. März 2021 die türkische Fußballnationalmannschaft in der Fußballweltmeisterschafts-Qualifikation 4:2 gegen die favorisierten Niederländer gewonnen hatte, gelang am Tag darauf auch dem Nachbarn Griechenland ein respektables 1:1 gegen Spanien. Wie üblich ist auf YouTube eine kurze Zusammenfassung des Spiels auf Deutsch zu finden,[1] und es gibt eine zugehörige YouTube-Kommentarsektion, die von allen angemeldeten Nutzer*innen editiert werden kann. Da das Video der Spielzusammenfassung auf Deutsch ist, ist auch die große Mehrzahl der Kommentare in dieser Sprache verfasst. Ein Gros der Kommentator*innen kann aufgrund von Selbstzuschreibungen als Anhänger*innen der griechischen bzw. türkischen Fußballnationalmannschaft bzw. als griechisch- oder türkisch-stämmige Person in Deutschland gelesen werden. Damit haben wir es hier mit einem interessanten Aspekt interkultureller Kommunikation zu tun, bei dem vordergründig Kultur im Sinne einer Nationalkultur als etwas Trennendes (türkische Kultur vs. griechische Kultur) angenommen werden könnte, gleichzeitig sich die Personen jedoch auf Basis eines großen Zugehörigkeitsgrades zu einem (Teil-)Kollektiv (Bolten 2011: 59–62), nämlich der Fußball-Fan-Kultur oder der YouTube-Kultur weniger stark voneinander unterscheiden, als man aus kulturkontrastiver Sicht annehmen könnte. Diese Kommentarsektion sprudelt über vor Respekt, Anerkennung und enthält Diskurse zur sozialen Kohäsion auf mehreren Ebenen. Die in Abbildung 9 einführend gezeigten Beispiele sind nicht geschnitten.

1 https://www.youtube.com/watch?v=JuCNvY8G1CA

Abb. 9: YouTube-Kommentarsektion „Spanien schwach zum WM-Quali-Start".

Im Folgenden wird die Kommentarsektion dieses YouTube-Videos genauer analysiert: In den drei Monaten nach Veröffentlichung des Videos wurden 859 Kommentare abgegeben. Diese wurden mittels der Funktion „Sortieren nach Top-Kommentaren" systematisiert, um die für die diskursive Interaktion relevantesten Einträge zu priorisieren. Es wurden, angelehnt an die Qualitative Inhaltsanalyse (Mayring 2015: 69–72), bis zur theoretischen Sättigung Fallbeispiele kodiert, an denen sich Diskurse zur sozialen Kohäsion zwischen den YouTube-Kommentierenden verdeutlichen lassen. Diese Codes wurden anschließend in Kategorien zusammengeführt, welche nachfolgend präsentiert werden.

3.1 Register Bolzplatzsprache

Der auf Thomas Bertram Wallace Reid (1956, zitiert nach Lukin et al. 2008:
190) zurückgehende und u. a. von Michael Halliday weiter spezifizierte
Begriff *Sprachregister* wird zur Beschreibung von Sprachvarietäten ver-
wendet, die spezifisch für bestimmte Settings sind (Lukin et al. 2008: 190).
Man geht davon aus, dass je nach Kontext, also zum Beispiel *Örtlichkeit*,
soziale Rolle der Interagierenden, *Medium* etc., eine bestimmte Sprach-
varietät gewählt wird (Shore 2015: 61). Die Verwendung einer „gemeinsa-
men Sprache" stärkt den sozialen Zusammenhalt der Gruppe. Mithilfe der
Sprache kann die Position der Interaktionspartner*innen eingenommen
werden oder zumindest implizit eine Gemeinsamkeit und ein gemeinsames
Verständnis verdeutlicht werden (Petzold 2013: 62).

Im vorliegenden Beispiel (Abb. 10) wird eine Varietät verwendet, die
man als „Bolzplatzsprache" bezeichnen kann. Charakteristisch sind
Emphase („VAMOS GRIECHENLAND"), Authentizität des Fußball-
platzes („Jungs sind heiß auf mehr") und Umgangs- bis zur Vulgärsprache
(„verkackt").

Paralytic Angel 1 year ago

Knaller Defensive und die Jungs sind heiß auf mehr.

Berke Demircan 1 year ago

VAMOS GRIECHENLAND, Grüße ausm Nachbarstaat! :)

Fifa_ Pro402 1 year ago

Jawoll junge GRGRGRGRGR

ch36799 vor 4 Monaten (bearbeitet)

Niederlande verkackt, Kroatien verkackt, Frankreich verkackt,
Spanien verkackt

Abb. 10: Zusammenschnitt von Beispielen zum Sprachregister.

Durch diese gemeinsame Sprache stellen die Kommentator*innen einen
gemeinsamen Deutungsraum her und verständigen sich auf einem kum-
pelhaften und authentischen Level, welches den Umgang entkompliziert
und der sozialen Kohäsion in der Community zuträglich ist.

3.2 Ingroup-Bildung

Wie oben dargestellt, ist ein fundamentaler Aspekt der Identität, der sich selbstverständlich auch sprachlich zeigt, das Erzeugen eines Wir-Gefühls und die Integration in eine Gruppe. Die Tatsache, dass hier aus dem Sprachregister das in der analogen Welt als freundschaftlich markierte „Du" gewählt wird, ist dabei sogar eher unspektakulär, da dieses weitestgehend auch zwischen einander Unbekannten zum üblichen YouTube-Jargon gehört. Der bekannte und einflussreiche YouTuber Rezo schreibt dazu für die Wochenzeitung *Die Zeit*: „In sozialen Medien ist das Du die Standard-Anrede. Doch erschreckend viele User respektieren das nicht. Das ist mehr als nur etwas weird. Es ist grob unhöflich." (Zeit 2020). So ist das „Du" auch im gewählten Fallbeispiel der Standard (Abb. 11), aber hier geht die sprachliche „Verbrüderung" noch weiter. Man zollt einander größten Respekt und bringt sich Zuneigung entgegen.

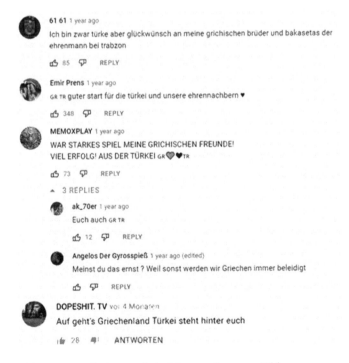

Abb. 11: Zusammenschnitt von Beispielen zur Ingroup-Bildung.

Das geschieht verbal durch klare Markierungen wie „ehrennachbern"
(sic) – wohlgemerkt, nicht nur Nachbarn, sondern mit der symbolisch auf-
geladenen und grundwertbasierten Qualifizierung „Ehren"-Nachbarn –
„Freunde", „Brüder". Fast die ganze Palette der intimen Bindungen wird
bespielt. Auch die paraverbale und nonverbale schriftliche Kommunika-
tion gibt diesem zum Beispiel durch die Verwendung von Großbuchstaben
(mit der impliziten Bedeutung besonderer Lautstärke) oder des Herzsym-
bols seinen Ausdruck. Es wird ein gemeinsames „Wir" konstruiert. Und
das, obwohl es wichtig zu sein scheint, dass es ein auf den ersten Blick
trennendes Element in der Beziehungsebene gibt: Mehrfach identifizieren
sich die Kommentator*innen explizit als Türk*innen, dies ist so augen-
scheinlich, dass es sogar ein Teil des Kohäsionsnarrativs zu sein scheint,
als würde es die soziale Kohäsion sogar noch verstärken. Gerade in der
türkisch-griechischen Konstellation überrascht das sogar viele User*in-
nen, und das Thema wird nicht nur über in konzessiver Verbindung ste-
hende Parataxen („Ich bin zwar Türke, aber …") eingeflochten, sondern
es wird sogar auf die Meta-Ebene gehoben („Meinst du das ernst? Weil
sonst werden wir Griechen immer beleidigt"). Möglicherweise spielt hier
eine gemeinsame Erfahrung als Migrant*innen in Deutschland eine Rolle,
was die sinnbildliche „Nachbarschaft" nicht nur auf die gemeinsame
Anrainerschaft im östlichen Mittelmeer bezieht, sondern ganz banal auch
auf die konkret vorliegende Nachbarschaft in deutschen Städten.

3.3 Abwertung der Fremdgruppe

Gießen wir aber doch noch etwas Wasser in den völkerverbindenden
Wein: Ein „Wir" existiert leichter, wenn es auch ein „Die-da-draußen"
gibt, gegen das man sich verschwören kann. Dadurch entsteht natür-
lich die bei Tajfel (1978) und Tajfel/Turner (1986) bestens beschriebene
„positive Gruppenidentität". Diese ist bei einer geteilten *emotionalen*
Beteiligung besonders gut ausgeprägt (Tajfel/Turner 1986), was für den
Fußball-Fandom-Kontext sicherlich zutreffend ist.

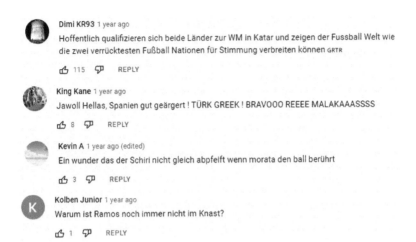

Abb. 12: Zusammenschnitt von Beispielen zur Abwertung der Fremdgruppe und Othering.

Die Selbstkategorisierung als Gruppenmitglied fundiert auf einem positiven Selbstkonzept der Eigengruppe (Abb. 12). Dieses ist gekennzeichnet durch eine Überhöhung des Selbst („die zwei verrücktesten Fußballnationen") bei gleichzeitiger Abwertung der Fremdgruppe (Othering) bis hin zu Ethnozentrismus. Gerade diese Relation zur Fremdgruppe ist besonders bedeutsam (Tajfel 1978, zitiert nach Petzold 2013: 164; Tajfel/Turner 1986). Dahinter steht das Ziel, dass die eigene Gruppe im sozialen Feld besser gestellt sein soll als die Fremdgruppe (Petzold 2013: 165). Das ist umso wirksamer, wenn das Narrativ erzählt werden kann, dass die eigene Gruppe der sportliche Underdog ist, also eigentlich die (sportlich) relativ schlechtere, unterprivilegierte Ausgangsposition hat („Spanien gut geärgert"), was einen Heldenmythos heraufbeschwören kann und den eigenen Erfolg überhöht. Folglich wird die Fremdgruppe umso mehr abgewertet bis hin zur Dämonisierung („Warum ist Ramos noch immer nicht im Knast?"; Anm: *Sergio Ramos* ist ein spanischer Fußballspieler, der zum einen für seine harten Zweikämpfe bekannt ist und zum anderen wegen eines Steuervergehens zu einer Geldstrafe verurteilt wurde). Schließlich geht es ja wie häufig bei Intergruppenkonflikten (Tajfel/Turner 1986) um umstrittene, beschränkte Ressourcen. Hier ist diese beschränkte

Ressource der Kampf um die Weltmeisterschaftsqualifikation, bei dem sich nur 13 der 55 teilnehmenden Teams der europäischen Konföderation qualifizieren können.

3.4 Aktivierung des Kollektiven Gedächtnisses

Schon die vorherigen Andeutungen über Sergio Ramos und über den vermeintlichen Schwalbenkönig Álvaro Morata („Ein wunder das der Schri nicht gleich abpfeift, wenn Morata den Ball berührt" (sic)) sind in ihrer Vollständigkeit nur im High-Kontext, also unter Berücksichtigung von Kontext- und Hintergrundwissen, zu verstehen. Es sind Andeutungen, die von Insider*innen, die über den kollektiven Wissens- und Deutungsvorrat verfügen, unmittelbar verstanden werden und damit auch als Narrativ verwendet werden können. Dies ist eine immanente Funktion des kollektiven Gedächtnisses (Assmann 1988), welches den Angehörigen eines Kollektivs einen „Vorrat gemeinsamer Werte, Erfahrungen, Deutungen und Wertungen anbietet". Dieses kollektive Gedächtnis zirkuliert innerhalb der Eigengruppe und bleibt gerade durch eben jene Zirkulation und Tradierung am Leben und aktualisiert sich wieder (Assmann 1991: 24). Laut Sharifian (2017: 2) wird Sprache als primärer Mechanismus für die Archivierung und Kommunikation von kulturellem Wissen und Bewusstsein genutzt („primary mechanism for ‚storing' and communicating cultural cognition") und fungiert als Datenspeicher („memory bank") und veränderliches Verkehrsmittel („fluid vehicle") für die Weiterverbreitung des kulturellen Bewusstseins.

Auch die nachstehenden Kommentare (Abb. 13) sind für die Eigengruppe bestimmt, die über dieses gemeinsame kollektive Gedächtnis verfügt. In allen Wir-Gruppen wird memoriert, was besonders auffällig, eindrücklich und emotional aufgeladen ist und damit als bedeutsam erfahren wurde. Im hier dargestellten Fall wird an den sensationellen griechischen Europameisterschafts-Triumph von 2004 erinnert, der ein ebensolches emotionales Geschehnis war. Auch mit solchen Narrativen, die über ein implizites Wissen funktionieren, schafft man Gemeinsamkeit, stillschweigendes *Sich-vertraut-sein* und eine Abgrenzung zu denen, die den Kontext nicht teilen.

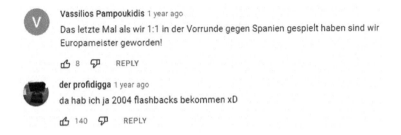

Abb. 13: Zusammenschnitt von Beispielen zur Aktivierung des Kollektiven Gedächtnisses.

3.5 Reziprozität und Anerkennung als wechselseitiger Prozess

Ein Grundpfeiler sozialer Kohäsion generell, aber vor allem auch der digitalen sozialen Medien, ist die Reziprozität, also Wechselseitigkeit in der Interakteurssituation. Reziprozität kann ganz banal, explizit, verbal ausgedrückt werden („supportet ihr uns supporten wir euch") im vorliegenden Beispiel (Abb. 14) auch mit dem entsprechenden Sprachregister und der kongruenten nonverbalen Ebene, das bedeutet in zeitgenössischer Internetkommunikationskultur natürlich: Emojis.

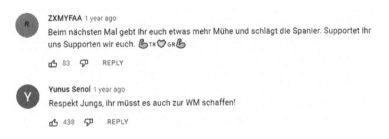

Abb. 14: Zusammenschnitt von Beispielen zu Reziprozität.

Auf Akteursebene ermöglicht es die YouTube-Kommentarsektion relativ einfach, Reziprozitäten wirksam werden zu lassen, indem Beiträge geliked werden können (semiotisch durch das Daumen-Hoch-Symbol) oder auf vorangehende Beiträge geantwortet wird. In Kommentarsektionen sehen wir damit auch Elemente von Michel Foucault (zitiert nach Krönert/

Hepp 2015: 26), nach dem ein Diskurs nicht nur aus einzelnen Aussagen besteht, sondern im Zusammenhang mehrerer Aussagen ein „strukturiertes Bedeutungsnetz" entstehen lässt.

Vor allem sind Likes die harte Währung im Austausch von Anerkennungen und beim Gewinn von Credibility in sozialen Medien. Der hier hervorgehobene scheinbar belanglose Kommentar von *Yunus Senol* ist mit 475 Reziprozitätshandlungen (438 Likes und 37 Antworten) der populärste Kommentar dieser Kommentarsektion.

Likes, Kommentare oder geteilte oder retweetete Beiträge unterliegen häufig Reziprozitätsdynamiken und – ganz wichtig – Reziprozität*serwartungen*. Sie gehören ins Feld der „politeness research" (Brown/Levinson 1987), bei dem es um „face" und „ways to achieve harmonious interactions" geht (Sharifian/Tayebi 2017: 390). Damit schließt sich auch wieder der Kreis zur Identitätskonstruktion, denn die aufeinander aufbauenden Schritte diskursiver Konstruktion von Identität (a) „Aufmerksamkeit bekommen", (b) „positive Bewertung erhalten" und (c) daraus „Selbstanerkennung erzielen" (Keupp et al 2008: 256) sind eng mit Sprache, sprachlichem Austausch und Handlungen wie dem Likebutton verwoben. Identität kann eine Person vollumfänglich nicht für sich selbst konstruieren. Die Person bedarf dafür der Wahrnehmung durch andere, der Anerkennung für das, was man ist („Wer bin ich?") und zieht daraus ein identitätsstiftendes Selbst-Bewusstsein („Wer will ich sein?").

4. Konklusion

Im vorliegenden Artikel sollte exemplarisch gezeigt werden, wie die Identität von Personen und die soziale Kohäsion innerhalb von Gruppen im virtuellen Raum diskursiv hergestellt werden. Mit Verweis auf Keupp et al. (2008) wurde kenntlich gemacht, dass Identität dabei den Spagat zwischen dem „Eigensinn" (*Ich-Identität, Unverwechselbarkeit*) und der „Anpassung" (*Wir-Identität, Integration*) herstellt. Bei Online-Identitäten geht es keineswegs nur um imaginierte oder verkleidete Darstellungen des Selbst, sondern durchaus um den Wunsch nach einer sehr authentischen Selbstrepräsentation und einer Anerkennung durch andere dafür, insbesondere durch die Eigengruppe. Anhand einschlägiger Äußerungen lässt sich nachvollziehbar die narrative Identität (cf. Lucius-Höhne/

Deppermann 2002) nachzeichnen, wird das Verbindende innerhalb von Gruppen, die soziale Kohäsion, anhand verschiedener Mechanismen diskursiv erzeugt. Die selbst- und gruppennarrativen Elemente des Diskurses führen zu einer Dynamik, nach der Identität ein kollektives Produkt zu sein scheint (cf. Hall 1994: 26). Sie formt sich aus (gemeinsamer) Sprache, (geteilten) Umgangsformen, (einenden) Grundannahmen zur Eigen- und zur Fremdgruppe, kollektiven Erinnerungen sowie aus Reziprozitätshandlungen und -erwartungen. Die Identität und soziale Kohäsion bilden sich – natürlich nicht nur im virtuellen Raum, sondern generell – in einem andauernden, meist unbewussten und höchst diskursiven Prozess. Sie benötigt dabei einerseits ständige Tradierungen, andererseits auch Aktualisierung und ist in permanenter Veränderung (cf. Hall 1999: 410). Die Suche nach der Antwort auf die Frage „Wer bin ich" setzt sich im digitalen Zeitalter nahtlos auch in virtuellen Räumen fort.

Bibliografie

Assmann, Jan, 1988: „Kollektives Gedächtnis und kulturelle Identität". In: Assmann, Jan/Hölscher, Tonio (Hrsg.): *Kultur und Gedächtnis*. Berlin: Suhrkamp, 9–19.

Assmann, Jan, 1991: „Der zweidimensionale Mensch: das Fest als Medium des kollektiven Gedächtnisses". In: Assmann, Jan/Sundermeier, Theo (Hrsg.): *Das Fest und das Heilige. Kontrapunkte des Alltags, Studien zum Verstehen fremder Religionen 1*, Gütersloh: Bertelsmann, 13–30.

Bamberg, Michael/Dege, Martin, 2021: „Decentering Histories of Identity". In: Bamberg, Michael/Demuth, Carolin/Watzlawick, Meike (Hrsg.): *The Cambridge Handbook of Identity*. Cambridge: Cambridge University Press, 25–56.

Bamberg, Michael/Georgakopoulou, Alexandra, 2008: Small Stories as a New Perspective in Narrative and Identity Analysis. *Text and Talk* 28/3, 377–396.

Bauman, Zygmunt, 2009: „Identity in a Globalizing World". In: Elliott, Anthony/Du Gay, Paul (Hrsg.): *Identity in Question*. London: SAGE, 1–12.

Beck, Ulrich, 2004: *Der kosmopolitische Blick*. Frankfurt am Main: Suhrkamp.

Bhabha, Homi, 1994: *Die Verortung der Kultur*. London: Routledge.

Bolten, Jürgen, 2011: „Unschärfe und Mehrwertigkeit: ‚Interkulturelle Kompetenz' vor dem Hintergrund eines offenen Kulturbegriffs". In: Hoessler, Ulrich/Dreyer, Wilfried (Hrsg.): *Perspektiven interkultureller Kompetenz*. Göttingen: V&R, 55–70.

Brown, Penelope/Levinson, Stephen, 1987: *Politeness: Some Universals in Language Usage*. Cambridge: Cambridge University Press.

De Fina, Anna/Perrino, Sabrina, 2017: „Storytelling in the Digital Age: New Challenges". *Narrative Inquiry* 27(2), 209–216.

Deppermann, Arnulf, 2013: „How to Get a Grid on Identities in Interaction" In: Bamberg, Michael (Hrsg.): *Narrative Inquiry*. Amsterdam: Benjamins, 62–88.

Döring, Nicola, 2003: *Sozialpsychologie des Internet. Die Bedeutung des Internet für Kommunikationsprozesse, Identitäten, soziale Beziehungen und Gruppen*. Göttingen: Hogrefe.

Fairclough, Norman, 2003: *Analysing Discourse*. London: Routledge.

Fleishman, Glenn, 2000: Cartoon Captures Spirit of the Internet. *New York Times* vom 14.12.2000. retrieved 14.6.2022 from https://web.archive.org/web/20171229172420/http://www.nytimes.com/2000/12/14/technology/cartoon-captures-spirit-of-the-internet.html.

Ganguin, Sonja/Sander, Uwe, 2008: „Identitätskonstruktionen in digitalen Welten". In: Sander, Uwe/von Gross, Friederike/Hugger, Kai-Uwe (Hrsg.:) *Handbuch Medienpädagogik*. Wiesbaden: VS Verlag für Sozialwissenschaften, 422–427.

Hall, Stuart, 1994: *Rassismus und kulturelle Identität*. Hamburg/Zürich: Argument-Verlag.

Hall, Stuart, 1999: „Kulturelle Identität und Globalisierung". In: Horning, Karl/Winter, Rainer (Hrsg.): *Widerspenstige Kulturen. Cultural Studies als Herausforderung*. Frankfurt am Main: Suhrkamp, 393–442.

Hansen, Klaus P., 2009: *Kultur, Kollektiv, Nation*. Passau: Stutz.

Jensen, Sune Qvotrup, 2011: „Othering, Identity Formation and Agency". *Qualitative Studies* 2(2), 63–78.

Kelly, Kevin, 2005: „We are the Web." *Wired*, retrieved 21.6.2022 from https://www.wired.com/2005/08/tech/.

Keupp, Heiner/Ahbe, Thomas/Gmür, Wolfgang/Höfer, Renate/Mitzscherlich, Beate/Kraus, Wolfgang/Straus, Florian, 2008: *Identitätskonstruktionen. Das Patchwork der Identitäten in der Spätmoderne.* 4. Auflage. Reinbek: Rowohlt.

Kraus, Wolfgang, 1996: *Das erzählte Selbst. Die narrative Konstruktion von Identität in der Spätmoderne.* Pfaffenweiler: Centaurus.

Krönert, Verena/Hepp, Andreas, 2015: „Identität und Identifikation". In: Hepp, Andreas/Krotz, Friedrich/Lingenberg, Swantje/Wimmer, Jeffrey (Hrsg.): *Handbuch Cultural Studies und Medienanalyse.* Wiesbaden: Springer, 265–274.

Lanza, Elizabeth, 2020: „Digital Storytelling: Multilingual Parents' Blogs and Vlogs as Narratives of Family Language Policy". In: Kulbrandstad, Lars Anders/Bordal Steien, Guri (Hrsg.): *Språkreiser. Festskrift til Anne Golden på 70-årsdagen 14. juli 2020.* Oslo: Novus Forlag, 177–192.

Lietz, Roman/Lenehan, Fergal, 2023: „Tweeting the World a Better Place – Motivations and Values Underpinning the Creation of a Digital Cosmopolitan Persona." *Persona Studies* 8(3), 17–34.

Lucius-Höhne, Gabriele/Deppermann, Arnulf, 2002: *Rekonstruktionen narrativer Identität.* Wiesbaden: Springer VS.

Lukin, Annabelle/Moore, Alison/Herke, Maria/Wegener, Rebekah/Wu, Canzhong, 2008: „Halliday's Model of Register Revisited and Explored". *Linguistics and the Human Sciences* 4(2), 187–213.

Marshall, P. David/Barbour, Kim, 2015: Making Intellectual Room for Persona Studies: A New Consciousness and a Shifted Perspective. *Persona Studies* 1(1), 1–12.

Mayring, Phillipp, 2015: *Qualitative Inhaltsanalyse – Grundlagen und Techniken.* 12. Auflage. Weinheim: Beltz.

Petzold, Knut, 2013: *Multilokalität als Handlungssituation – Lokale Identifikation, Kosmopolitismus und ortsbezogenes Handeln unter Mobilitätsbedingungen.* Wiesbaden: Springer VS.

Röll, Franz Josef, 2020: „Social Networks". In: Friese, Heidrun/Nolden, Marcus/Rebane, Gala/Schreiter, Miriam (Hrsg.): *Handbuch Soziale Praktiken und Digitale Alltagswelten.* Wiesbaden: Springer, 117–128.

Sen, Amartya, 2006: *Identity and Violence. The Illusion of Destiny.* Norton: New York/London.

Sharifian, Farzad, 2017: „Cultural Linguistics – The State of the aArt." In: Sharifian, Farzad (Hrsg.): *Cultural linguistics*. Amsterdam: John Benjamins, 1–28.

Sharifian, Farzad/Tayebi, Tahmineh, 2017: „Perceptions of Impoliteness from a Cultural Linguistic Perspective". In: Sharifian, Farzad (Hrsg.): *Cultural linguistics*. Amsterdam: John Benjamins, 389–410.

Shore, Susan, 2015: „Register in Systemic Functional Linguistics". In: Agha, Asif/Frog (Hrsg.): *Registers of Communication. Finnish Literature Society*, 54–76.

Strick, Simon, 2021: *Rechte Gefühle*. Bielefeld: transcript.

Tajfel, Henri, 1978: *Differentiation between Social Groups: Studies in the Social Psychology of Intergroup Relations*. London: Academic Press.

Tajfel, Henri/Turner, John C., 1986: „The Social Identity Theory and Intergroup Behavior". In: Worchel, Stephen/Austin, William J. (Hrsg.): *Psychology of Intergroup Relations*. Chicago: Nelson-Hall, 7–24.

Thelwall, Mike, 2013: „Society on the Web". In: Dutton, William (Hrsg.): *The Oxford Handbook of Internet Studies*. Oxford: University Press, 69–85.

Thon, Christine, 2012: „Individualisierte Geschlechterordnung?" In: Moser, Vera/Rendtorff, Barbara (Hrsg.): *Riskante Leben? Geschlechterordnungen in der Reflexiven Moderne*. Opladen: Budrich. S. 27–44.

Watzlawick, Meike/Demuth, Carolin/Bamberg, Michaeal (2021): „Identity – With or Without You?" In: Bamberg, Michael/Demuth, Carolin/Watzlawick, Meike (Hrsg.): *The Cambridge Handbook of Identity*. Cambridge: Cambridge University Press, 1–24.

Zeit, 2020: „Entschuldigung, seit wann siezen wir uns?" *Zeit-Online* vom 28.01.2020. retrieved 18.06.2020 from https://www.zeit.de/kultur/2020-01/soziale-medien-hoeflichkeit-anrede-twitter-saskia-eskenrezo/komplettansicht.

Fergal Lenehan

Digitaler Europäismus: #DenkEuropaMit, @PulseOfEurope und europäisierte Referenzialität vor der Bundestagswahl 2021

Abstract English: This article argues that the scholarly study of literary Europeanism should be extended to the discourse of a broader textual Europeanism, understood here as a *digital Europeanism*, which examines digital texts in the broadest sense and contextualizes them within the norms of digital culture. The focus here is on the hashtag #DenkEuropaMit, created and disseminated by the Twitter account @PulseOfEurope in September 2021 in an attempt to "Europeanise" the election for the German federal parliament. This was seen especially in connection with referentiality, i.e. the use of already existing and circulating digital cultural materials for one's own online cultural production, in this instance largely tweets from other accounts. This was evident in commented and uncommented retweets, occasional internet memes, and targeted social TV practices tagging politicians, journalists, and academics, which can be seen as a type of political activism since they were chiefly aimed at directly influencing the political discourse on TV. Last but not least, we also see the development – with partners – of Pulse of Europe's own digital tool, the Euromat, with the purpose of helping the account's Twitter audience to discover which German political party has the most European, cosmopolitan perspective. Some of these actions took place under the hashtag #DenkEuropaMit. Also on display here was an analogous intertextuality that referred to the book Europe for Future (Herr/Speer 2021). Therefore, the Twitter account tried to combine digital Europeanism with a more 'traditional' literary, ideas-oriented type of Europeanism.

Abstract Deutsch: Der Artikel plädiert dafür, die wissenschaftliche Betrachtung des literarischen Europäismus auf den Diskurs eines umfassenderen textuellen Europäismus auszuweiten. Letzterer wird hier als *digitaler Europäismus* verstanden, der Europäismus im digitalen Kontext im weitesten Sinne untersucht und innerhalb der Normen digitaler Kultur kontextualisiert. Im Mittelpunkt steht das Hashtag #DenkEuropaMit, das im September 2021 vom Twitteraccount @PulseofEurope mit dem Ziel, die Bundestagswahl zu „europäisieren", kreiert und verbreitet wurde. Das Hashtag erscheint vor allem im Zusammenhang mit

Referenzialität, also der Nutzung bereits vorhandener, zirkulierender digitaler Kulturmaterialien für die eigene Online-Kulturproduktion, in Form von kommentierten und unkommentierten Retweets, gelegentlichen Internet-Memes und gezielten Social-TV-Praktiken wie Tagging einflussreicher Politiker*innen, Journalisten*innen und Wissenschaftler*innen. Die Social-TV-Praktiken können als eine Art politischer Aktivismus zur direkten Beeinflussung des politischen Diskurses im Fernsehen betrachtet werden. Nicht zuletzt ist auch der von Pulse of Europe mit Partner*innen entwickelte Euromat zu nennen – ein digitales Tool, welches das Twitter-Publikum des Accounts dabei unterstützen soll, die politischen Parteien Deutschlands mit der europäischsten, kosmopolitischsten Perspektive zu ermitteln. Einige dieser Handlungen erfolgen unter dem Hashtag #DenkEuropaMit. Hier ist auch eine analoge Intertextualität festzustellen, die sich auf das Buch *Europe for Future* (Herr/Speer 2021) bezieht. Somit versuchte der Twitteraccount, den digitalen Europäismus mit einem eher ‚traditionellen' literarischen, ideenorientierten Europäismus zu verbinden.

Keywords: Europäismus, Twitter, Referenzialität, digitaler Europäismus, Bundestagswahl, @PulseOfEurope

1. Einführung

Im Zuge der Bemühungen der Europäischen Kommission, die Digitalisierung in der Europäischen Union auszubauen und zu verbessern, ist der Begriff *Digitales Europa* in den letzten Jahren zu einem Schlagwort geworden. In der Tat leistete das EU-Programm *Digitales Europa* (Laufzeit 2021–2027) durch Finanzierung von Projekten in Bereichen wie Künstliche Intelligenz und Cybersicherheit umfangreiche und wichtige Arbeit. Europa versucht im Gewand der EU, direkt in die digitale Welt einzugreifen. Doch die digitale Sphäre und die hier allseits produzierten Texte beeinflussen auch Europa und die Wahrnehmung von Europa. Digitalität hat zudem unsere Beziehung zu Texten im Allgemeinen verändert, da Texte jetzt auf verschiedenen Plattformen und Apps von einer Vielzahl unterschiedlicher Personen produziert und mit großer Geschwindigkeit online verbreitet werden können. Digitalität hat also den kommunikativen Kontext verändert, was wiederum die Kommunikation und den Diskurs über Europa beeinflusst; als materielle Realität, als sich entwickelnde Institution in der Europäischen Union und als eine Reihe von Ideen, die grundsätzlich mit der Demokratie verflochten sind. Dieser Artikel plädiert dafür, die

wissenschaftliche Betrachtung des literarischen Europäismus auf den Diskurs eines umfassenderen textuellen Europäismus auszuweiten, der hier als *digitaler Europäismus* verstanden wird, digitale Texte im weitesten Sinne untersucht und sie innerhalb der Normen digitaler Kultur kontextualisiert.

2. Theoretischer und methodischer Ansatz

2.1 Europäismus/Europeanism

Die Vorstellung einer europäischen Zusammengehörigkeit – Europäismus – definiert Ostrowski (2021: 1) in einer sehr offenen Art und Weise als „a commitment to the political, economic, and cultural consolidation of the European continent". Europäismus, als Diskurs und Sammlung von Bemerkungen, bleibt auch der Idee einer europäischen Identität verbunden, verstanden als eine supranationale Identität, eine Art identitäre „Lingua franca" für den Kontinent (Mocanu 2022: 36/37). Ostrowski (2021: 2) kritisiert zudem die Erforschung des Europäismus als gekennzeichnet durch „an excessive ahistoricism and a narrow reductionism", nicht zuletzt, wenn Europäismus ausschließlich in Zusammenhang mit einer sozialdemokratischen Politik konzeptualisiert wird (vgl. z.B. McCormick 2010). Im politischen Europäismus sieht Ostrowski (2021: 5) „many competing tendencies to 'naturalise' the borders of 'Europe' in completely different ways." Der Autor erkennt jedoch, dass die sechs Kernstaaten des europäischen Integrationsprozesses im Kontext des Kalten Krieges einen Europäismus eigener Art vertraten, der gekennzeichnet war und ist durch: 1) christliche und sozialdemokratische Formen des „right-left economic bargaining" nach dem Zweiten Weltkrieg; 2) „electoral-parliamentary democratic politics" und 3) „shared post-Enlightenment (Christian) confessional-secularist cohabitation" (Ostrowski 2021: 6). Der von den sechs Gründerstaaten auf diese Weise institutionalisierte europäische Kern wurde „not just a geographical label but also a political, economic and cultural signifier" (Ostrowski 2021: 6), was auch als dominierender diskursiver Europäismus gesehen werden kann.

Dabei handelte es sich jedoch hauptsächlich, das muss betont werden, um einen institutionell stark an Nationalstaaten orientierten Europäismus (Ostrowski 2021: 7), selbst wenn die Europäische Union im Sinne

von Delanty (2008: 223) zweifellos auch ein Projekt des normativen Transnationalismus ist, der die „preconditions for European cosmopolitanism" schaffen sollte. Nationalstaaten bleiben immer noch die Hauptakteure der europäischen Konsolidierung. Ostrowski (2021: 9) unterstreicht zudem die Bedeutung des „Anderen" in der Konstruktion *aller* Europäismen, die er mit einer freilich nicht immer wohlwollenden Vorstellung europäischer kultureller „Eigenständigkeit" verbindet: „(...) one aspect that has remained ideologically unwavering is the clear sense of European cultural 'distinctness' – which some Europeanisms raise to the level of blatant claims of superiority – compared impressionistically to the 'backwardness' (Russia, Africa), 'incompatibility' (Turkey, Asia), or 'vulgarity' (Anglo-America) of Europe's constitutive others".

Der Europäismus im Zentrum dieses Artikels ist im Wesentlichen ein diskursiver „Kern-Europäismus", der sich an Ideen von Demokratie und Meinungsfreiheit jenseits des Nationalen orientiert. Europäismus erscheint hier als eine Form von normativ-philosophischem Kosmopolitismus, als eine „expansive form of solidarity" „attuned to democratic principles and human interests", „without the restriction of territorial borders" (Cheah 2006: 19). Der kosmopolitische Europäismus im Zentrum dieses Artikels ist nicht nur eine philosophische Idee, sondern bleibt im Twitter-Diskurs auch „a practice, a cultural form", „a way of ‚being in the world' " (Sluga/Horne 2010: 370); und eine Reihe von „behaviours, [and] social habits" (Jacob 2006: 4). Wir haben es also mit Verhaltensmustern und sozialen Gewohnheiten zu tun, die sich vollständig im digitalen Kontext abspielen, und deren Prämisse darauf abzielt, die politischen Diskussionen in Deutschland und die deutsche Demokratie zu „europäisieren" und zu erweitern. Das heißt: An Europa zu denken und nicht nur an Deutschland.

2.2 Kultur der Digitalität

Der hier analysierte Europäismus ist vor allem ein digitaler Europäismus; das diskursive „commitment to the economic, political and cultural consolidation of the European continent" (Ostrowski 2021: 1), aber ausgedrückt in einem spezifisch digitalen Kontext und innerhalb der Normen digitaler Kultur. Unter „Kultur der Digitalität" versteht Stalder (2019: 10)

im Wesentlichen die „enorme Vervielfältigung der kulturellen Möglich-
keiten", gekennzeichnet durch ganz spezifische Kultur-, Austausch- und
Ausdrucksformen. Drei dieser zentralen Formen nennt er: Referenzialität,
Gemeinschaftlichkeit und Algorithmizität (Stalder 2019: 13). *Referenzia-
lität* bezieht sich auf „die Nutzung bestehenden kulturellen Materials für
die eigene Produktion" verbunden mit der Erkennbarkeit der Quellen und
dem freien Umgang mit ihnen; mit *Gemeinschaftlichkeit* meint der Autor,
dass „nur über einen kollektiv getragenen Referenzrahmen" „Bedeutun-
gen stabilisiert, Handlungsoptionen generiert und Ressourcen zugänglich
gemacht werden" können. *Algorithmizität* bezieht sich auf den automa-
tisierten Entscheidungsprozess, durch den enorme Mengen potenziel-
ler Daten reduziert und Online-Nutzer*innen entsprechend zugänglich
gemacht werden (Stalder 2019: 13). Die „europäisierte" Referenzialität –
die Benutzung bereits existierenden Materials für die eigene kommuni-
kative Produktion – steht hier im Mittelpunkt. Gemeinschaftlichkeit und
Algorithmizität stellen zwar wichtige implizite Strukturierungselemente
des untersuchten Diskurses dar, liegen aber außerhalb des Rahmens die-
ser Studie.

2.3 Twitter und das hermeneutische Lesen von Tweets

Die 2006 in den USA gegründete Online-Plattform Twitter hatte 2016
monatlich 313 Millionen aktive Nutzer*innen, darunter auch zahlreiche
und engagierte Nutzer*innen außerhalb der englischsprachigen Welt,
zum Beispiel in Japan, Indien, Indonesien und Brasilien (Burgess/Baym
2020: 3). Als soziale Plattform hat Twitter einen elitären Ruf erworben.
Burgess und Baym (2020: 4) sind der Ansicht, viele Journalisten*innen,
Akademiker*innen und Politiker*innen seien praktisch abhängig von
Twitter als Instrument sozialen Zuhörens, professionellen Dialogs und
der Öffentlichkeitsarbeit. Trotz der Existenz mehrerer bekannter rechts-
extremer Nutzer*innen legen Untersuchungen mit US-amerikanischem
Schwerpunkt nahe, dass die Plattform zumindest in den USA überpro-
portional viele liberale, junge und gut ausgebildete Menschen anzieht,
die überwiegend für die Demokratische Partei stimmen (Wojcik/Hughes
2019). Als neues Medium, das den gesellschaftlichen Diskurs im Live-
Modus widerspiegelt, ist Twitter in jüngster Zeit für Forscher*innen

attraktiv geworden, die an den Beziehungen zwischen Internet und Gesellschaft interessiert sind (Cardoso/Liang/Lapa 2013: 219). In der Vergangenheit wurden beispielsweise Untersuchungen zum medialen Agenda-Setting der Plattform (z. B. Vastermann 2018 und Abdi-Herrle 2018), zur Wahlkampf-Rolle (z. B. Galdieri/Lucas/Sisco 2018 und Kamps 2020), zur Bedeutung von Twitter bei Straßenprotesten (z. B. Gerbaudo 2012 und Dang-Anh 2019) und zur Funktion von Twitter als Bühne für die Erschaffung einer Online-Persona (z. B. De Kosnik/Feldman 2019 und Burrough 2016) vorgelegt.

Quantitative und statistische/numerische Datenanalyseverfahren sind zu den vorherrschenden Methoden der Analyse von Online-Textproduktion avanciert, wobei häufig eine sehr große Datenmenge „geerntet" wird. Bright (2018) beispielsweise verwendet datenanalytische Methoden, um Interaktionen zwischen parteipolitischen Twitteraccounts zu verfolgen, und stützt sich dabei auf einen Bestand von 1,4 Millionen Tweets. Solche quantitativen Methoden können viele wichtige und nützliche Ergebnisse bringen, schließen aber eine nähere Analyse von Sprache, Bildern, Narrativen und Bedeutungsbildung im Allgemeinen aus. Aus diesem Grund wurden hermeneutische Zugänge zu digitalen Technologien und den von ihnen produzierten Daten adaptiert, weiterentwickelt und diskutiert (vgl. Capurro 2010, Dang-Anh 2019 und Romele 2020). Die schiere Masse und Veränderlichkeit digitaler Texte stellt auch ein methodisches Problem dar, und die oft unsystematische Natur der Verbreitung von Online-Diskursfragmenten zwingt Forscher*innen, eigene Systematisierungen und Strategien zu entwickeln (Sommer 2020: 426). Als Reaktion auf den vorherrschenden „quantitative bias" der digitalen Forschung hat Gerbaudo (2016: 96) den Ansatz der „Datenhermeneutik" (Data Hermeneutics) entwickelt, um die qualitativen Fragen nach der kulturellen Bedeutung und den sozialen Motivationen zu beantworten (im Gegensatz zu Methoden der Data Analytics). Anstatt sich auf die mathematische Analyse von Social-Media-Gesprächen zu konzentrieren, beschäftigt sich die Datenhermeneutik mit der symbolischen Analyse der Bedeutungsstrukturen von Online-Gesprächen in Anbetracht verbundener sozialer Diskurse und Motivationen (Gerbaudo 2016: 99). Die angewandten Methoden orientieren sich an einer literaturwissenschaftlichen Perspektive, mit dem „aim of interpreting, reconstructing and explaining the overarching

narratives that underpin social media conversations", durch den Einsatz von „Close Reading", der tiefen analytischen Auseinandersetzung mit einem Text, die „language, tone, imagery, and rhetorical figures" untersucht (Gerbaudo 2016: 99). So findet die Datenhermeneutik „ways to read data as text, that is as a partly coherent and discrete web of meaning." (Gerbaudo 2016: 102). Die Datenhermeneutik bietet auch klare und logische Vorschläge zu Datenstichproben (Top-Sampling, Zufallsstichprobe und Zoom-in-Stichprobe), Kodierungs- und Kategorisierungsprozessen sowie zur Erstellung verschiedener Arten von Datensätzen gemäß den spezifischen Forschungsanforderungen (Gerbaudo 2016: 102–107).

Auch Tweets – kurze Texte, die oft in Verbindung mit Bildern, Filmen oder anderen kurzen textlichen Äußerungen auf der Plattform Twitter veröffentlicht werden – werden von Forscher*innen zunehmend als eigenständige Textformen betrachtet, die einen hermeneutischen Ansatz erfordern. Hui (2019: 1) argumentiert, dass Tweets in den kontinuierlichen literaturhistorischen Kontext des Aphorismus gestellt werden können: „a basic unit of intelligible thought, this microform has persisted across world cultures and histories, from Confucius to Twitter". Tatsächlich besteht wenig bis kein Konsens darüber, wie genau der Aphorismus als literarische Gattung definiert werden kann (Spicker 1997: 2 und Spicker 2004: 6–8). Morson (2003: 411) ist der Meinung, dass Aphorismen ein gewisses Maß an Mysterium behalten und nicht aus dem Lösen von Rätseln, sondern aus vertiefenden Fragen bestehen sollten. Maddocks (2001: 175) betont die Bedeutung des Spagats zwischen Ironie und moralischer Verurteilung in einem Aphorismus, während die Soziologen Crosbie und Guhin (2019: 383) nahelegen, dass Aphorismen oft verwendet werden, um für komplexere Thesen einzustehen. Tatsächlich können Tweets möglicherweise all diese Dinge tun, abhängig vom einzelnen Tweet selbst. In seiner Studie über die Aphorismen von Franz Kafka kommt Gray (1987: 37) zur Erkenntnis, dass die spezifische Art jener von ihm untersuchten Aphorismen, Wurzeln schlägt, und zwar weder als Ausdrucksform, die in den Dienst traditioneller Werte gestellt wird, noch als dogmatische Darstellung neuer Werte. Vielmehr strebten Kafkas Aphorismen danach, statischen, starren Werten und Wahrheiten Flüssigkeit und Flexibilität zu verleihen. Hui (2019: 5) definiert den Aphorismus als ein kurzes Sprichwort, das der Interpretation bedarf. Er sieht den Tweet als digitalen Abkömmling des

analogen Aphorismus und Twitter als das größte Archiv, das die Welt je gesehen hat (Hui 2019: 177–178). In der Tat enthält Twitter eine große Anzahl sehr unterschiedlicher Textfragmente, die außerhalb ihres größeren kontextuellen Rahmens oft schwer zu interpretieren sind. Sadler (2021: 49) konzipiert Tweets als narrative Fragmente, bei denen die Texte v. a. intertextuell zu verstehen sind. Isolierte Tweets sind demnach häufig belang- oder bedeutungslos.

Während die hier untersuchten Tweets manchmal textlich komplex sind und oft die Wörter und Bilder anderer Konten verwenden, sind viele von ihnen zwar ernsthafte, argumentative, aber auch undogmatische Kurztexte, die nach mehr Fließfähigkeit und Flexibilität in Bezug auf Werte und Wahrheiten suchen. Damit sind sie im zuvor erwähnten Aphorismus nach Gray (1987: 37) angesiedelt. Die Tweets arbeiten vor allem konstant daran, eine *Idee* der Notwendigkeit europäischer statt nationaler medialer Öffentlichkeit zu erzeugen. Mit ihr sollen die Realität besser wahrgenommen und zukünftige Krisen besser bewältigt werden.

3. Empirische Untersuchung und Thesen

3.1 Digitaler Europäismus: Die Hauptargumente

Die Auseinandersetzung mit dem literarischen Diskurs über Europa ist ein klarer, eigenständiger Strang in der Erforschung des Europäismus. Die Behandlung von europäisch orientierten Essays und Reden hat diesen Strang zweifellos dominiert (Király 2019: 3–4; sowie Biendarra/ Eigler 2020), teils als Untersuchung eines eigenen literarischen Diskurses (Lützeler 1998, 2007, 2019) oder auch aus eher kontextueller kulturhistorischer Perspektive (Passerini 1999, 2009). Király (2019: 3–4) sieht auch innerhalb der literarischen Europastudien eine Bewegung weg von der Beschäftigung mit „Europa-Essayistik" hin zu Migrantenliteratur, Übersetzung und Reiseliteratur; Orientierungen, die natürlich nicht zwingend einer eindeutigen europäischen Codierung bedürfen. Im Zuge der Digitalisierung ist es natürlich möglich, Texte so zu publizieren, dass andere sie sofort lesen können, wobei auch die Leserschaft unmittelbar aktiv sein muss (oder: ist). Wie wir bereits gesehen haben, können Tweets demnach als Texte innerhalb einer breiteren literarischen Untersuchung von Aphorismen betrachtet werden (Hui 2019). Die Beschäftigung mit einem

literarischen Europäismus kann auf den Diskurs eines umfassenderen textuellen Europäismus ausgeweitet werden, der insbesondere ein (bisher nicht erforschter) *digitaler Europäismus* ist, da er digitale Texte – im weitesten Sinne – untersucht und hinsichtlich digitaler Kulturalität, insbesondere Referenzialität, kontextualisiert.

Die Tweets des explizit pro-europäischen/pro-EU Twitteraccounts @PulseofEurope im Vorfeld der deutschen Bundestagswahl 2021 wurden für die Zeit vom 1. August bis zum 30. September analysiert, um herauszufinden, ob und wie der Kontext der Wahl von dem Account genutzt wurde, um eine Vorstellung einer europäischen Zusammengehörigkeit zu propagieren. 75 Tweets waren für die Fragestellung in diesem Zeitrahmen thematisch von Bedeutung und bilden das Corpus, das hier untersucht wird. Die Tweets wurden zusammenhängend gelesen und ausgewertet, um Verbindungen zwischen der Botschaft und den dahinterliegenden Diskursen herstellen zu können (Gerbaudo 2016: 106). ,Europäisierte' Referenzialität zeigte sich in vielerlei Hinsicht. Sehr wichtig war hier die Prägung des Hashtags #DenkEuropaMit. Hashtags können sehr bedeutungsvoll sein, weil sie Tweets in Themen, Öffentlichkeiten und Communitys bündeln (Majewski 2018: 118 und Bernard 2021: 2). Hashtags stehen oft im Zentrum von PR-Kampagnen, die die Wirklichkeit „dramatisch inszenieren" wollen, eine weite Aufmerksamkeit suchen und „von Symbolen und damit von Vereinfachungen" leben (Röttger 2009: 9–11). Hashtags können zudem mit politischem Aktivismus verbunden sein (Burgess/Baym 2020: 67). Bernard (2021: 15) sieht den politischen Aktivismus und die Welt des Marketings als die zwei Hauptbereiche, in denen Hashtags auf Twitter und Instagram verwendet werden. Bei dem Hashtag #DenkEuropaMit kommen diese zwei Verwendungen zusammen, da mit dem Hashtag versucht wird, die mediale Darstellung der laufenden politischen Kampagne zu beeinflussen. Der Hashtag kann als (elitäre) PR-Kampagne zur Verbreitung bestimmter politischer Themen verstanden werden. #DenkEuropaMit repräsentiert den Versuch, den öffentlichen Diskurs kosmopolitischer zu gestalten und deutsche Politiker*innen und Journalisten*innen dazu zu bewegen, Europa in den Diskussionen vor der Bundestagswahl zu thematisieren und zu reflektieren.

„Europäisierte" Referenzialität zeigt sich sowohl in der großen Zahl kommentierter Retweets durch andere Accounts (das Duplizieren fremder

Tweets, kommentiert durch einen eigenen Kurztext) als auch in kommentarlosen Retweets – beides oft auch mit Links zu Online-Artikeln über europäische Themen. Hinzu kommt die Beteiligung an dem, was Bruns (2020: 92) „,Social-TV‘-Praktiken" und Burgess und Baym (2020: 72) „Second Screen Television Watching" nennen: die Schaffung eines Twitter-Diskurses, der auf ein bestimmtes Fernsehereignis reagiert. Thiemann und Moutchnik (2021) fassen mehrere Funktionen des Hashtags innerhalb der Social-Media-Kommunikation zusammen, einschließlich Social TV und Aktivismus. Die Gründe für die Nutzung von Social-TV-Praktiken sind (Thiemann/Moutchnik 2021: 128) zum einen „die Absicht des Zuschauers, sich gemeinschaftlich über Meinungen und Gefühle bezüglich des TV-Formates auszutauschen und zum anderen das Interesse, sich mit weiteren Informationen über das genutzte Programm und die verfolgte Sendung zu versorgen". Das generelle Ziel des Hashtag-Aktivismus besteht nach Thiemann und Moutchnik (2021: 131) darin, „auf der einen Seite die eigene Unterstützung für eine bestimmte Position in Bezug auf ein gesellschaftliches Thema zu zeigen und auf der anderen Seite, die Aufmerksamkeit einer Gegenposition auf sich zu ziehen." Thiemann und Moutchnik sehen an Hashtags orientierte Social-TV-Praktiken und Hashtag-Aktivismus als getrennte Aktivitäten und stellen keine Bezüge zwischen diesen beiden Formen her.

Social-TV-Praktiken können in diesem Kontext als eine Art versuchter digitaler politischer Aktivismus gesehen werden, da sie darauf abzielen, den politischen Diskurs im Fernsehen durch Tagging von Beteiligten und das Sammeln von Retweets direkt zu beeinflussen. Social-TV-Praktiken und Hashtag-Aktivismus sind hier als miteinander verbundene Online-Aktivitäten zu sehen. Das war vor allem vor und nach dem zweiten und dritten TV-Triell zwischen den Spitzenkandidat*innen Armin Laschet, Olaf Scholz und Annalena Baerbock am 12. und am 19. September zu beobachten. Zusammen mit europäischen föderalistischen Partner*innen entwickelte die trans-europäische Bewegung Pulse of Europe den interaktiven *Euromat* als digitales Tool. Hier konnten Wähler*innen ermitteln, welche Wahlprogramme für die Bundestagswahl 2021 in Europafragen am besten zu ihren Ansichten passen – eine Art reflektierter und interaktiver, wahlorientierter digitaler Europäismus. Ein „europäisiertes" Meme passend zur

Diskussion wurde auch von dem Account retweetet (Abbildung 9). Shifman (2016: 201) versteht das Internet-Meme als eine Gruppe digitaler Elemente mit gemeinsamen Merkmalen in Bezug auf Inhalt, Form oder Haltung, die bewusst füreinander erstellt und von vielen Nutzer*innen über das Internet verbreitet, nachgeahmt und transformiert werden. Daher können Memes eine Ernsthaftigkeit enthalten, obwohl sie ursprünglich mit humorvollen Absichten verbreitet wurden. Auch eine analoge Intertextualität, die sich hauptsächlich auf das Buch *Europe for Future* (Herr/Speer 2021) bezieht, ist hier zu sehen. Damit regte der @PulseOfEurope-Twitteraccount auch zu komplexeren Debatten jenseits von Twitter und zur Auseinandersetzung mit relativ radikalen Ideen zum Umdenken des europäischen Kontinents an.

3.2 Die Pulse-of-Europe-Bewegung und @PulseofEurope auf Twitter

Der Twitteraccount @PulseofEurope hat mit Stand vom Mai 2022 ca. 25.300 Follower, so dass ein einzelner Tweet durch Retweeten und Favorisieren leicht über 100.000 Aufrufe erreichen und mit etwas Glück und einer gewissen Viralität von Millionen von Menschen gesehen werden kann. Pulse of Europe ist natürlich nicht nur ein Social-Media-Projekt, sondern im Wesentlichen eine unabhängige Bürgerlobby, die 2016 in Frankfurt am Main als direkte Reaktion auf den Brexit und die Trump-Präsidentschaft gegründet wurde. Die Gruppe organisierte zunächst Demonstrationen, um *für* die Europäische Union, ein europäisches Bewusstsein und die Demokratie im Allgemeinen zu demonstrieren. Kritisiert für seine vagen Ziele und Absichten (Kern 2017), hatte Pulse of Europe bis März 2017 in 60 Städten auf dem ganzen Kontinent Unterstützergruppen. Regelmäßig brachte es Sonntag nachmittags 30.000 Menschen auf die Straße, die oft in den Farben Blau und Gelb der Europäischen Union gekleidet waren, um für die EU zu demonstrieren (Dobbert 2017). Auch wenn das Jahr 2017 den zahlenmäßigen Höhepunkt der Proteste markierte, verfügt Pulse of Europe weiterhin über eine starke Online-Präsenz und organisiert gelegentlich noch europaweit Demonstrationen.

Das Selbstverständnis von Pulse of Europe ist hier wichtig und spiegelt sich in seinen Twitter-Inhalten wider. Laut ihrer Website (Pulse of

Europe): Web will die Bewegung „einen Beitrag dazu leisten, dass es auch in der Zukunft ein vereintes, demokratisches Europa gibt – ein Europa, in dem die Achtung der Menschenwürde, die Rechtsstaatlichkeit, freiheitliches Denken und Handeln, Toleranz und Respekt selbstverständliche Grundlagen des Gemeinwesens sind." Pulse of Europe betont, dass es sich um eine unabhängige Bürgerbewegung handelt, die überparteilich und nicht mit Interessengruppen, religiösen Bewegungen oder politischen Parteien verbunden ist. In der diesen Zielen gewidmeten Rubrik der Website (pulseofeurope.eu) heißt es: „Wir sind überzeugt, dass die Mehrheit der Menschen an die europäische Idee glaubt und sie nicht nationalistischen und protektionistischen Tendenzen opfern möchte. Wir stellen uns den destruktiven und zerstörerischen Stimmen entgegen, weil wir an die Reformierbarkeit und Weiterentwicklung der Europäischen Union glauben." Um Rechtsstaatlichkeit und freiheitliche Demokratie zu verteidigen und offen für Reformen und Veränderungen (nicht näher bezeichneter) Aspekte der Europäischen Union zu bleiben, positioniert sich Pulse of Europe sowohl gegen Nationalismus als auch gegen (vermutlich wirtschaftlichen) Protektionismus. Radikale Ideen zur Umstrukturierung der Gesellschaft und/oder eine Kritik bestehender Ungleichheiten sind hier nirgendwo zu finden. Die Bewegung bleibt gewissermaßen konservativ, da sie die weltoffene europäische Demokratie bewahren will. Pulse of Europe finanziert sich laut seiner Website ausschließlich über Spenden.

3.3 #DenkEuropaMit und ‚Europäisierte' Referenzialität

Das Hashtag #DenkEuropaMit ist in dem untersuchten Zeitrahmen zum ersten Mal am 15. August 2021 zu finden. Es erscheint zusammen mit dem Hashtag #DenkKlimaMit in einem Tweet mit dem Hinweis auf die im September stattfindende Bundestagswahl sowie einem Bild und Werbung für das „Umweltbuch" *Noch haben wir eine Wahl* von Luisa Neubauer und Bernd Ulrich. Das Denken an Europa und an die Umwelt wird hier als zwei Seiten derselben Medaille betrachtet. Das Hashtag wird am 17. August auch von dem Account Pulse of Europe verwendet, mit einem Link zum *Euromat* der Website, anhand dessen sich ermitteln lassen soll, „welche Partei Deine Vision zur Zukunft der EU am besten vertritt" (Euromat: Web). Der Tweet enthält außerdem Bilder von „Hanna aus Luxemburg", „Julius aus Wien" und „Martin aus Prag", die ihre Gedanken zur

Bundestagswahl darlegen. „Martin aus Prag" wird zitiert: „Ich wünsche Dir eine gute Wahl, weil sich Deutschland weiterhin für die Rechtsstaatlichkeit und gegen Machtmissbrauch in Europa einsetzen muss." Der gleiche Tweet wird am 21. August mit demselben Hashtag wieder verschickt. Die Botschaft ist dabei eindeutig: Deutsche Wähler*innen sollen berücksichtigen, dass die Auswirkungen der Bundestagswahl weit über Deutschland hinausreichen. Die Figuren, die ausgewählt wurden, um dies zu kommunizieren, wirken homogen und geskriptet: Sie sind weiß und sehen aus wie das Hauptpublikum von @PulseofEurope. Daher wird hier nur eine sehr weiche Art von transnationaler Andersartigkeit kommuniziert, eher sogar eine transnationale Homogenität.

In einem kommentierten Retweet vom 6. September heißt es, „#DenkEuropaMit sollte das Motto im Wahlkampf bis zum 26.9. sein!" Das Hashtag wird auch in kommentierten Retweets vom 9. und 10. September verwendet. Am Vortag und Tag des zweiten TV-Triells (12. September 2021) erscheint ein großer Twitter-Thread mit 31 Tweets vom @PulseOfEurope-Account. Im ersten Tweet sind die Twitteraccounts von Olaf Scholz, Armin Laschet und Annalena Baerbock sowie von der ARD und den Journalisten*innen, die die Fernsehdebatte leiten, getaggt. „#PulseOfEurope fordert #DenkEuropaMit", heißt es in dem Tweet, und das Twitter-Publikum wird aufgefordert, seine „#EuropeforFuture (EU Fahne) Ideen für's Triell" mitzuteilen. Das Tagging von Accounts der am Triell beteiligten Akteuren*innen und die Anregung einer Twitter-Debatte lassen sich als Versuch deuten, den TV-Diskurs und den allgemeinen politischen Diskurs direkt zu beeinflussen. Der schon erwähnte Twitter-Thread vom 11./12. September besteht hauptsächlich aus Retweets von einer Reihe von Tweetern, die sich für „mehr Europa" im deutschen Diskurs stark machen, und Tweets, die kurz zusammenfassen, welche Europathemen im kommenden Triell möglich wären. So wird zum Beispiel ein Tweet des Politikwissenschaftlers Nicolai von Ondarza vom 9. September retweetet, in dem der Autor schreibt: „The almost complete absence of any EU discussion in the German #btw2021 election campaign is bordering on the absurd". Retweetet wird auch ein Beitrag vom 10. September von Jakov Devčić, Mitarbeiter der Konrad-Adenauer-Stiftung, in dem es heißt: „Es wäre schön, wenn am Sonntag beim nächsten #Triell #BTWahl2021 die Kandidaten @ABaerbock @ArminLaschet

@OlafScholz das Thema #Europa diskutieren würden." Die Zusammenstellung möglichst vieler gleichgesinnter Tweets in einem Thread und das Tagging von Twitteraccounts der Akteure*innen des kommenden Triells in der Hoffnung, diese zu beeinflussen, stellen eindeutig einen Versuch von @PulseofEurope dar, den Diskurs zu europäisieren. Social-TV-Praktiken erscheinen hier als eine Art digitaler politischer Aktivismus, als Teil von einer weiteren Kampagne basierend auf europäisierter Referenzialität. @PulseofEurope benutzt hier auch die Organisationslogik von Twitter, um mehr Aufmerksamkeit zu generieren: Wenn andere Accounts getaggt werden, werden die Tweets von @PulseofEurope auch in dem Feed von den jeweiligen Accounts gezeigt. Dadurch gewinnt @PulseofEurope an Aufmerksamkeit bei Personen, die aktiv den Accounts der drei Kandidat*innen und der Journalistin Maybritt Illner folgen.

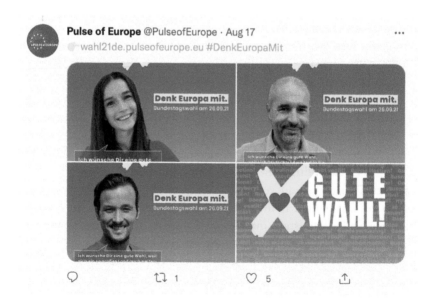

Abb. 1: Tweet vom 17. August 2022.

Abb. 2: „Martin aus Prag". (https://wahl21de.pulseofeurope.eu Zugriff am 27. Juli 2022.)

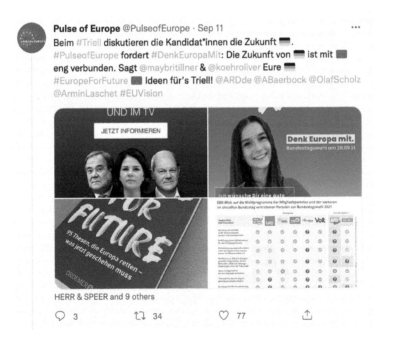

Abb. 3: @PulseOfEurope Tweet vom 11. September 2021.

Abb. 4: Retweet von Nicolai von Ondarza vom 11. September 2021.

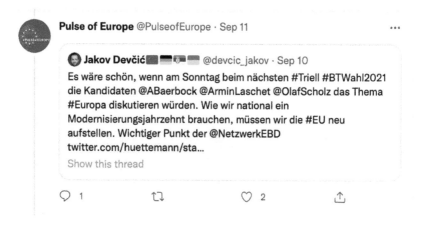

Abb. 5: Retweet von Jakov Devčić vom 11. September 2021.

Im Anschluss an das zweite Triell folgte am 12. September ein Twitter-Thread von @PulseofEurope mit einer Reihe von Retweets und kommentierten Retweets, die erneut enttäuscht die fehlende Thematisierung europäischer Anliegen kritisieren. Im kurzen Text eines kommentierten Retweets des Journalisten Wolfgang Blau, in dem die Twitteraccounts der das Triell leitenden ARD-Journalisten*innen getaggt sind, schreibt @PulseofEurope: „Nächstes #Triell bitte mit mehr Realismus der (Deutschlandfahne) #Zukunft (EU-Fahne)." Blau schreibt in

seinem Tweet: „Dieses seltsame #Triell war ein wohliger Ausflug in eine
prä-europäische Nationalstaats-Fiktion, in der auch die großen Probleme
primär in Berlin gelöst werden und in der außenpolitische Kompetenz
nicht der Nachfrage wert ist". Die Online-Kampagne wird also in der
Hoffnung, den Diskurs doch noch zu europäisieren, aufrechterhalten. Es
folgen am 13. September elf Retweets und kommentierte Retweets, die
die fehlende Europa-Thematik im Triell thematisieren, nur einer davon
mit dem Hashtag #DenkEuropaMit. Die Account-Nutzer*innen scheinen
vom Hashtag selbst nicht ganz überzeugt zu sein. Am 15. und 16. Septem-
ber werden doch noch drei Tweets mit dem #DenkEuropaMit-Hashtag
verschickt, darunter auch einer, in dem die am bevorstehenden drit-
ten Triell beteiligten Kanzlerkandidaten*in und die Journalistin erneut
getaggt werden. Der Tweet nimmt Bezug auf Jörg Wojahn, Beamter der
Europäischen Kommission, und erklärt, die Bundestagswahl sei „auch @
EUCouncil-Wahl". Er geht einen anderen Weg, um die Europäisierung der
Debatte voranzutreiben, und betont die Macht der Bundesregierung auf
EU-Ebene.

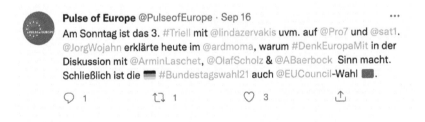

Abb. 6: Tweet vom 16. September 2021.

Das Hashtag #DenkEuropaMit erscheint am 18. September gleich zwei-
mal wieder, einmal im Retweet eines @PulseofEurope-Tweets vom
11. September und einmal in einem kommentierten Retweet des Publizis-
ten Bernd Hüttemann, in dem wieder die Hauptjournalistin des kommen-
den Triells getaggt ist und explizit gefordert wird: „#DenkEuropaMit!".
Am Tag des Triells werden 14 Tweets von dem Account verschickt. Acht
dieser Tweets haben den schon erwähnten Euromat zum Thema. Auf der
Website von Pulse of Europe wird der Euromat so erklärt: „Mit unserem

EUROMAT könntest du in wenigen Schritten herausfinden, wessen Wahl-
programm zur Bundestagwahl 2021 in Europafragen am besten zu deinen
Ansichten passt" (Wahl21de: Web). So nutzte Pulse of Europe nicht nur
bestehende digitale Tools, sondern entwickelte mit europäischen föderali-
listischen Partnern auch eigene interaktive Tools, um die Debatte vor der
Bundestagswahl zu europäisieren.

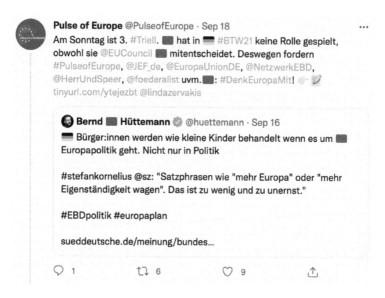

Abb. 7: Tweet vom 18. September 2021

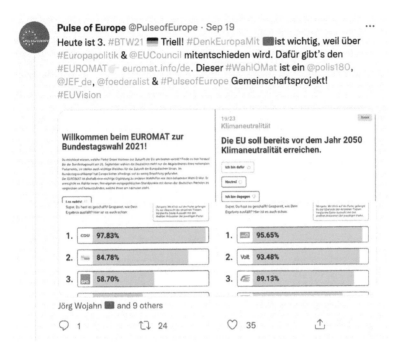

Abb. 8: Tweet vom 19. September 2021.

Am 20. und 21. September werden von dem Account sechs Retweets gesendet, die entweder für den Euromat werben oder erneut darauf hinweisen, dass im Triell nicht über Europa diskutiert wurde.[1] Am 24., 25. und 26. September twittert der Account erneut eine Reihe von Retweets und kommentierter Retweets, in denen für den Euromat geworben und die Wähler*innen aufgefordert werden, #DenkEuropaMit

1 Ein ausschließendes bzw. verzerrendes Element des Euromats wird zu keinem
 Zeitpunkt in einem Tweet erwähnt: Angesichts der Standpunkte von Pulse Of
 Europe ist es vielleicht wenig überraschend, dass euroskeptische Parteien wie
 die *Alternative für Deutschland* nicht als Option gewählt werden können.
 Der Euromat enthält insgesamt nur 9 politische Parteien, die gewählt wer-
 den können. Überraschender ist dabei, dass auch europafreundliche kleinere
 Parteien wie *Die Partei*, die *Partei der Humanisten* und *Team Todenhöfer*
 ausgeschlossen werden, Kleinparteien wie *VOLT* und *Die Piraten* jedoch zur
 Auswahl stehen.

bei der Abstimmung zu berücksichtigen. Am 23. September retweetet @PulseofEurope zudem einen Tweet des Twitteraccounts des Euromats. Es handelt sich um den Retweet eines von diesem Account erstellten Internet-Memes, das den „EU-Elefanten im Raum" zeigt (Abbildung 9) – das große Thema, das jeder sieht, aber niemand anspricht. Dieses Internet-Meme drückt erneut die Enttäuschung des Pulse-of-Europe-Accounts darüber aus, dass Europa als Thema in der Debatte fehle. Das Hashtag #DenkEuropaMit wird in diesem Zeitraum zum letzten Mal in Retweets von Zeitungsartikeln vom 27. und 28. September 2021 verwendet. Die begleitenden Kommentare von @PulseofEurope versuchen, die Wahlergebnisse aus einer breiteren europäischen Perspektive zu kontextualisieren. Das Hashtag #DenkEuropaMit erscheint fortan nur noch sporadisch auf Twitter – von Pulse of Europe und anderen Nutzer*innen. Zum letzten Mal ist es bei den vom Account Pulse of Europe kommentierten französischen Parlamentswahlen im Juni 2022 zu sehen.

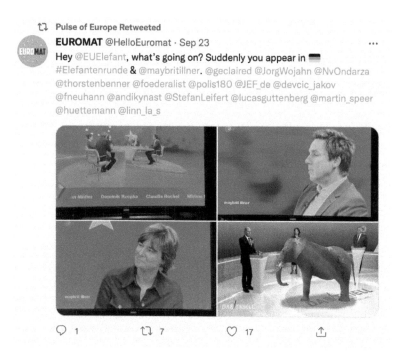

Abb. 9: Retweet vom 23. September 2021.

3.4 Pulse of Europe auf Twitter und *Europe for Future*

Fünf Tweets im untersuchten Zeitraum werben für das Buch *Europe for Future* (2021) von den Pro-EU-Lobbyisten Vincent-Immanuel Herr und Martin Speer, die sehr ähnliche Argumente wie Pulse of Europe in Bezug auf Europa vertreten, und die intellektuelle Überschneidungsinteressen mit Pulse of Europe haben. Am 11. September erscheint das Hashtag #EuropeforFuture neben einem Bild des Buches, Bildern der Kanzlerkandidaten*in und „Hanna aus Luxemburg", die alle #DenkEuropa-Mit betonen (s. Abb. 3). Am 11. September retweetet der Account von Pulse of Europe einen Tweet des Mitautors Martin Speer, der für das Buch wirbt. Speer schreibt passend zum europäisierenden Content von Pulse of Europe im September 2021: „Europapolitische Fragen spielen im Bundestagswahlkampf kaum eine Rolle. Wir haben da eine Anregung. #EuropeForFuture – 95 konkrete Ideen für eine demokratischere, gerechtere, ökologischere, feministischere und machtbewusstere EU. Gemeinsam stärker." Der erste Tweet vom 11. September wird am 18. September kommentiert retweetet: „Anregungen zum 3. #Triell: #DenkEuropaMit (deutsche Fahne) #EUVision (EU-Fahne)". Am 29. September retweetet der Account erneut einen Tweet von Martin Speer, und am 30. September twittert Pulse of Europe in Bezug auf die laufenden Koalitionsverhandlungen zwischen den Grünen und der FDP und fügt ein Bild des Buches *Europe for Future* in den Tweet ein.

Europe for Future ist ein ehrgeiziges Buch, das auf zunehmenden Nationalismus und Probleme im Zusammenhang mit Freiheit und Rechtsstaatlichkeit in Europa reagiert. Die Autoren bieten ihren Leser*innen 95 sehr konkrete Thesen und fordern „ein gestärktes politisches Bewusstsein" und eine „neue Europäische Renaissance" (Herr/Speer 2021: 15). Nach den Autoren sollte die Europäische Union eine „Werte-Supermacht (Softpower-Supermacht)" (Herr/Speer 2021: 20) werden, und sie fordern einen „Neustart der Europäischen Idee und damit der EU" (Herr/Speer 2021: 24). Ihre Änderungsvorschläge reichen von Fragen der kollektiven Identität über die Außen- und Militärpolitik, die Institutionen der EU und Sprachenfragen bis hin zur Stärkung der europäischen Demokratie. Anstatt also ihre Twitter-Inhalte nur auf Hashtags und Verweise auf Fernsehdebatten zu stützen, ermutigt Pulse of Europe sein Twitter-Publikum

auch dazu, sich mit Visionen von Europa und Möglichkeiten zur Neugestaltung des Kontinents auseinanderzusetzen. Daher versuchen sie, den digitalen Europäismus, der hier sehr stark in der Referenzialität eingebettet ist, mit einer eher „traditionellen" literarischen, ideenorientierten Art des Europäismus zu verbinden. Während radikale Ideen zur Umstrukturierung der Gesellschaft und/oder eine Kritik bestehender Ungleichheiten im untersuchten Zeitrahmen nirgendwo *direkt* im Content von @PulseofEurope zu sehen sind, lässt sich hier eine indirekte Verbindung zu durchaus radikalen europäisch-föderalistischen Ideen finden, die tatsächlich die Europäische Union neugestalten und nicht nur die europäische Demokratie bewahren wollen. Da die Pulse-of-Europe-Bewegung sich als überparteilich versteht, will sie es sicherlich vermeiden, bestimmte Arten konservativer demokratischer Pro-Europäer zu isolieren, so dass die digitalen Inhalte des Accounts zwar entschieden pro-EU sind, dabei aber absichtlich vage gehalten werden.

4. Schlussfolgerung

Der Artikel plädiert dafür, die wissenschaftliche Betrachtung des literarischen Europäismus auf den Diskurs eines umfassenderen textuellen Europäismus auszuweiten. Letzterer wird hier als *digitaler Europäismus* verstanden. Die Beschäftigung mit dem digitalen Europäismus untersucht digitale Texte im weitesten Sinne und kontextualisiert sie innerhalb der Normen digitaler Kultur. Im Mittelpunkt steht das Hashtag #DenkEuropaMit, das im September 2021 vom Twitteraccount @PulseOfEurope im Versuch, die Bundestagswahl zu europäisieren, kreiert und verbreitet wurde. Das Hashtag erscheint vor allem im Zusammenhang mit Referenzialität, also der Nutzung bereits vorhandener, zirkulierender digitaler Kulturmaterialien für die eigene Online-Kulturproduktion in Form von kommentierten und unkommentierten Retweets, gelegentlichen Internet-Memes und gezielten „Social-TV-Praktiken" wie Tagging einflussreicher Politiker*innen, Journalist*innen und Wissenschaftler*innen. Die „Social-TV-Praktiken" können als eine Art politischer Aktivismus betrachtet werden, da sie darauf abzielen, den politischen Diskurs im Fernsehen direkt zu beeinflussen. Nicht zuletzt ist auch der von Pulse of Europe mit Partner*innen entwickelte Euromat zu nennen – ein digitales

Tool, welches das Twitter-Publikum des Accounts bei der Ermittlung der politischen Partei Deutschlands mit der europäischsten, kosmopolitischsten Perspektive unterstützen soll. Einige dieser Handlungen erfolgen unter dem Hashtag #DenkEuropaMit. Hier ist auch eine analoge Intertextualität festzustellen, die sich auf das Buch *Europe for Future* (Herr/Speer 2021) bezieht. Somit versuchte der Twitteraccount, den digitalen Europäismus mit einem eher traditionellen literarischen, ideenorientierten Europäismus zu verbinden. Im Bereich des digitalen Europäismus besteht definitiv viel Raum für weitere Forschung, die neue Richtungen eröffnen und die kulturelle Auseinandersetzung mit Europa und mit Ideen von Europa stärken würde. Durch die Verbindung der literarischen Auseinandersetzung mit Europa und dem Bereich *Internet Studies* sowie der breiteren Auseinandersetzung mit digitaler Kommunikation sollte eine Art „digitale Europastudien" entstehen (Lenehan/Lietz 2023 and Lenehan 2023).

Bibliografie

Abdi-Herrle, Sasan, 2018: *Mediale Themensetzung in Zeiten von Web 2.0: Wer beeinflusst Wen? Das Agenda-Setting-Verhältnis zwischen Twitter und Online Leitmedien.* Münster: Nomos.

Bernard, Andrea, 2021: „Theorie des Hashtags". In: Bauer, Matthias Johannes/Goetz, Miriam (Hrsg.): *Der Hashtag als interdisziplinäres Phänomen in Marketing und Kommunikation: Sprache, Kultur, Betriebswirtschaft und Recht.* Wiesbaden: Springer Gabler, 1–27.

Biendarra Anke S./Eigler Friederike, 2020: „Introduction: Europe in Contemporary German-language Literature". *Colloquia Germanica: Internationale Zeitschrift für Germanistik* 51 (3–4), 231–233.

Bright, Jonathan, 2018: „Explaining the Emergence of Political Fragmentation on Social Media: The Role of Ideology and Extremism". *Journal of Computer-Mediated Communication* 23, 17–33.

Bruns, Axel, 2020: „Real-Time Applications (Twitter)". In: Friese, Heidrun/Nolden, Marcu/Rebane, Gala/Schreiter, Miriam (Hrsg.): *Handbuch Soziale Praktiken und Digitale Alltagswelten.* Wiesbaden: Springer, 87–96.

Burgess, Jean/Baym, Nancy K, 2020: *Twitter: A Biography.* New York: New York University Press.

Burrough, Xtine, 2016: „@IKnowTheseWords: A Twitter Bot Textual Performance". *Persona Studies* 2(1): 12–19, Zugriff 1. August 2022 https://doi.org/10.21153/ps2016vol2no1art529.

Cardoso, Gustavo., Liang, Guo & Lapa, Tiago 2013: Cross-National Comparative Perspectives from the World Internet Project. In: Dutton, William E. (Hrsg.), The Oxford Handbook of Internet Studies. Oxford: Oxford University Press, 216–236.

Capurro, Rafael, 2010: „Digital Hermeneutics: An Outline". *AI and Society* 25, 35–42.

Cheah, Pheng, 2006: *Inhuman Conditions: On Cosmopolitanism and Human Rights*. Cambridge: Harvard University Press.

Crosbie, Thomas/Guhin, Jeffrey, 2019: „On the Ambivalence of the Aphorism in Sociological Theory". *Sociological Theory* 37 (4), 381–400.

Dang-Anh, Mark, 2019: *Protest Twittern: Eine Medienlinguistische Untersuchung von Straßenprotesten*. Bielefeld: transcript.

De Kosnik, Abigail/Feldman Keith P (Hrsg.), 2019: #identity: *Hashtagging Race, Gender, Sexuality and Nation*. Ann Arbor: University of Michigan Press.

Delanty, Gerard, 2008: „The Cosmopolitan Imagination". *Revista CIDOB d'Afers Internacionals* 82/83, 217–230.

Dobbert, Steffen: „Pulse of Europe: Franz rettet die EU". *Die Zeit*, 25.03.2017, retrieved 9.12.2022 from https://www.zeit.de/politik/ausland/2017-03/pulse-of-europe-demonstrationen-pro-eu.

Galdieri, Christopher J./Lucas, Jennifer C./Sisco Tauna S. (Hrsg), 2018: *The Role of Twitter in the 2016 US Election*. London: Palgrave Macmillan.

Gerbaudo, Paolo, 2012: *Tweets and the Street: Social Media and Contemporary Activism*. London: Pluto Press.

Gerbaudo, Paolo, 2016: „From Data Analytics to Data Hermeneutics: Online Political Discussions, Digital Methods and the Continuing Relevance of Interpretive Approaches". *Digital Culture and Society* 2(2), 95–111.

Gray, Richard, 1987: *Constructive Destruction – Kafka's Aphorisms: Literary Tradition and Literary Transformation*. Tübingen: Max Niemeyer Verlag.

Herr, Vincent-Immanuel/Speer, Martin, 2021: *Europe for Future: 95 Thesen, die Europa retten – was jetzt geschehen muss*. München: Droemer.

Hui, Andrew, 2019: *A Theory of the Aphorism: From Confucius to Twitter*. Princeton: Princeton University Press.

Jacob, Margaret C, 2006: *Strangers Nowhere in the World: Cosmopolitanism in Early Modern Europe*. Philadelphia: University of Pennsylvania Press.

Kamps, Klaus, 2020: *Commander-in-Tweet: Donald Trump und die deformierte Präsidentschaft*. Wiesbaden: Springer.

Kern, Vera, 2017: „Pulse of Europe: Was bringen die Demos?" *Deutsche Welle*, 7.05.2017, retrieved 7.12.2022 from https://www.dw.com/de/pulse-of-europe-was-bringen-die-demos/a-38388415.

Király, Edit, 2019: „Zug um Zug: Konstruktionen des Europäischen bei Menasse, Schmale und Gauß". *Journal of Austrian Studies* 52 (1–2), 1–19.

Lenehan, Fergal, 2023: „Depicting European Federalists in Fiction: Richard Coudenhove-Kalergi in Bernhard Setzwein's Der böhmische Samurai (2017) and Heinrich Mann in Colm Tóibín's The Magician (2021)". *Journal of European Studies* (forthcoming).

Lenehan, Fergal/Lietz, Roman, 2023: „Digital Europeanism and Extending the Literary Europeanist Discourse: The Twitter Feeds of @PulseofEurope and @mycountryeurope". *Journal of European Studies* (forthcoming).

Lützeler, Paul M.,1998: *Die Schriftsteller und Europa: Von der Romantik bis zur Gegenwart*. Baden-Baden: Nomos.

Lützeler, Paul M., 2007: *Kontinentalisierung: Das Europa der Schriftsteller*. Bielefeld: Aisthesis Verlag.

Lützeler, Paul M., 2019: „Overcoming the Crisis of Disunity: Writers on a Constitution for Europe". *Journal of European Studies* 49(3–4), 239–251.

Maddocks, Melvin, 2001: „The Art of the Aphorism". *The Sewanee Review* 109 (2), 171–184.

Majewski, Markus, 2018: „#Erdogan-Diktatur – Hashtags als Elemente von Substantivkomposita in politischen Tweets", retrieved 30.11.2022 from https://publikationen.ub.uni-frankfurt.de/frontdoor/index/year/2018/docld/47331.

McCormick, John, 2010: *Europeanism*. Oxford: Oxford University Press.

Mocanu, Vasilica, 2022: „English as Lingua Franca and European Identity – Parallelisms in their Development". *Journal of English as a Lingua Franca* 11(1), 25–41.

Morson, Gary Saul, 2003: „The Aphorism: Fragments from the Breakdown of Reason". *New Literary History* 34 (3), 409–429.

Ostrowski, Marius S., 2021: „Europeanism: A Historical View". *Contemporary European History*, 1–18, retrieved 1.8.2022 from DOI: https://doi.org/10.1017/S0960777321000485.

Passerini, Luisa, 1999: *Europe in Love, Love in Europe: Imagination and Politics between the Wars*. New York: New York University Press.

Passerini, Luisa, 2009: *Love and the Idea of Europe*. New York et al.: Berghahn Books.

PulseOfEurope: *Startseite*; retrieved 1.8.2022 – 30.9.2021 from https://twitter.com/PulseofEurope.

PulseOfEurope: *Startseite*; retrieved 9.2.2022 from https://pulseofeurope.eu.

Romele, Alberto, 2020: *Digital Hermeneutics: Philosophical Investigations in New Media and Technologies*. Abingdon: New York et al.: Routledge.

Röttger, Ulrike, 2009: „Campaigns (f)or a better world?". In: Röttger, Ulrike (Hrsg.): *PR-Kampagnen: Über die Inszenierung von Öffentlichkeit*. Wiesbaden: VS Verlag für Sozialwissenschaften, 9–23.

Sadler, Neil, 2021: *Fragmented Narrative: Telling and Interpreting Stories in the Twitter Age*. New York: Routledge.

Shifman, Limor, 2016: „Meme". In: Peters, Benjamin (Hrsg.): *Digital Keywords: A Vocabulary of Information Society and Culture*. Princeton et al.: Princeton University Press, 197–206.

Sluga, Glenda/Horne, Julia, 2010: „Cosmopolitanism: Its Pasts and Practices". *Journal of World History* 21 (3): 369–373.

Sommer, Vivien, 2020: „Diskursanalyse". In: Friese, Heidrun/Nolden, Marcus/Rebane, Gala/Schreiter, Miriam (Hrsg.): *Handbuch Soziale Praktiken und Digitale Alltagswelten*. Wiesbaden: Springer, 424–433.

Spicker, Friedemann, 1997: *Der Aphorismus: Begriff und Gattung von der Mitte des 18. Jahrhunderts bis 1912*. New York: De Gruyter.

Spicker, Friedemann, 2004: *Der deutsche Aphorismus im 20. Jahrhundert: Spiel, Bild, Erkenntnis.* Tübingen: Max Niemeyer Verlag.

Stalder, Felix, 2019: *Kultur der Digitalität.* Berlin: Suhrkamp.

Thiemann, Tim/Moutchnik, Alexander, 2021: „Der Hashtag in der Social-Media-Kommunikation: Perspektiven, Strategien und Anwendungen". In: Bauer, Matthias Johannes/Goetz, Miriam (Hrsg.): *Der Hashtag als interdisziplinäres Phänomen in Marketing und Kommunikation: Sprache, Kultur, Betriebswirtschaft und Recht.* Wiesbaden: Springer Gabler, 113–149.

Vastermann, Peter (Hrsg.), 2018: *From Media Hype to Twitter Storm: News Explosions and their Impact on Issues, Crises and Public Opinion.* Amsterdam: Amsterdam University Press.

Wojcik, Stefan/Hughes, Adam, 2019: „Sizing up Twitter Users". Retrieved 5.4.2022 from https://www.pewresearch.org/internet/2019/04/24/sizing-up-twitter-users/.

Luisa Conti

Heimat als Netzwerk. Wie sie erlebt wird und imaginiert werden kann

Abstract English: At the center of this article lies the specifically German term *Heimat* which brings together a variety of partly contradictory meanings. The discussion of this term is here deemed to be highly important, as its understanding influences the attitude of individuals towards societal change and its diversity. Creating a common denominator among its various understandings, Heimat is defined in this paper as that individual but intersubjective space in which one feels – we could say – as small children feel in the safety and security of their parents' arms (safe, cozy, peaceful, acquainted). A reflection about the way we experience and construct our Heimat today, in our postdigital daily life, makes clear that Heimat is not necessarily bound to a physical space: Heimat is a network of things, people, and places. This model considers the plurality and dynamism of human identity, as well as the hybrid and dynamic character of the lifeworld. This understanding of Heimat as the result of one's actions in one's hybrid lifeworld invalidates fears against change and diversity and is, therefore, a promising tool which can be used consciously in the (intercultural) education field.

Abstract Deutsch: Heimat ist nicht gleich Heimat. Erstens, weil es viele verschiedene, sogar widersprüchliche Heimatverständnisse gibt; zweitens, weil Heimat im postdigitalen Zeitalter anders als früher erlebt und konstruiert wird. Nach einer Kategorisierung verschiedener Heimatverständnisse und der Erarbeitung einer Kerndefinition für den Begriff wird in diesem Beitrag dafür argumentiert, Heimat als Raum der Geborgenheit zu verstehen und als Netzwerk (von Dingen, Menschen und Orten) zu imaginieren. Dieses Modell ermöglicht es, die plurale und dynamische Identität der Menschen abzubilden und die Hybridität und Veränderlichkeit kultureller Räume zu dokumentieren. Heimat wird als Ergebnis der eigenen Handlungen in der eigenen hybriden Lebenswelt erkannt, was Ängste vor Veränderungen, die sich häufig in menschenfeindlichen Haltungen und Handlungen kanalisieren, entkräftet. Der Artikel endet mit einer Reflexion über die strategischen Vorteile der Anwendung dieses Modells im (interkulturellen) Bildungsbereich.

Keywords: Heimat, Integration, Populismus, Rassismus, Migration, Diskriminierung, Digitalisierung

1. Einleitung

Worte haben die Kraft, intersubjektive Vorstellungen hervorzurufen. Ihre gemeinschaftlich ausgehandelte Bedeutung setzt sich der Arbitrarität der Verknüpfung von *Signifikant* (Lautbild) und *Signifikat* (Vorstellung) entgegen und bildet die Grundlage für individuelle Interpretationen, worauf im Sinne einer „unbegrenzten Semiose" (Eco 1992: 427–431) künftige Interpretationen zurückgreifen können. In einer Dialektik zwischen über „Gewohnheit" (Peirce 1993: 135) funktionierender Tradierung und durch kreative individuelle Handlung vorangetriebener Veränderung entfaltet sich die Bedeutungsgeschichte eines jeden Wortes. Dabei wirkt die Gemeinschaft als „intersubjektiver Garant" (Eco 1992: 336) auf die Erhaltung von Konventionen hin. Aufgrund des permanenten Wandels dessen, was die Gemeinschaft jeweils als ihre Wirklichkeit begreift, wird der Gültigkeitsanspruch von tradierten und neuen Interpretationen jedoch immer wieder neu geprüft (vgl. Abel 1999; Eco 1992; Habermas 1981). Die Sprache dient aber nicht nur dem Ausdruck der Erkenntnis, sondern ist gleichzeitig ein Bedeutungssystem, das die Interpretation der Wirklichkeit und somit das Wahrnehmen und das Empfinden beeinflusst (vgl. Conti 2012: 63). Aufgrund dieses Wechselverhältnisses zwischen Sprache und Interpretation, in dem letztere zu einer realitätsfernen Vorstellung der Wirklichkeit führen kann, wird der Gültigkeitsanspruch bei besonderen Begriffen in der Sprachgemeinschaft explizit diskutiert. Das geschieht vor allem dann, wenn dieses Verständnis relevante Auswirkungen auf individuelle bzw. kollektive Handlungsentscheidungen hat.

Wie der Titel antizipiert, steht im Zentrum dieses Artikels der Begriff *Heimat*, der nach einem Höhepunkt in den frühen 1950er Jahren seit 2000 eine erneute Renaissance erlebt, wie seine hohe Frequenz im Zeitungskorpus des Digitalen Wörterbuches der Deutschen Sprache (DWDS) – mit Höhepunkt 2016 – zeigt.

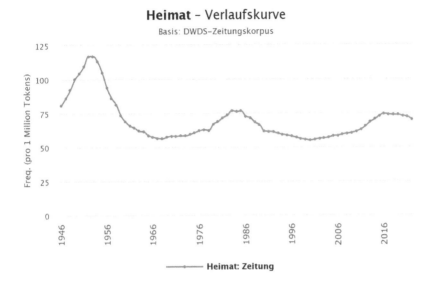

Abbildung 1: Verlaufskurve des Heimatbegriffs 1946–2022 (DWDS 2023)

Es gibt wenige Begriffe in der deutschen Sprache, die so viel Kulturge-schichte tradieren und so umstritten sind wie *Heimat*. Das stellt Hans Jürgen Heringer fest (2017: 181–182), der ihn als „Hotword" bezeichnet, also einen Begriff, der als kulturell so aufgeladen gilt, dass keine wört-liche Übersetzung möglich ist. Seine Bedeutung kann schwer angegeben werden, er ist jedoch bedeutsam für die kollektive Identität, strittig und aktuell (ebd.).

Gerade diese strittigen, historisch gewachsenen Heimatverständnisse sollen in diesem Beitrag kritisch betrachtet werden, um festzustellen, welches Verständnis sowohl dem durch Digitalisierung durchdrungenen Leben tauglich als auch für die kohäsive Entfaltung einer pluralen Gesell-schaft förderlich ist.

Dabei wird Heimat als etwas Individuelles und Konkretes einerseits und als etwas Kollektives und Abstraktes andererseits betrachtet, zwei Ebenen, die unmittelbar miteinander verbunden sind, jedoch für die Ana-lyse auch separat betrachtet werden.

In diesem Beitrag soll ein theoretisches Modell von Heimat entwickelt werden, das die Besonderheit der gegenwärtigen Zeit aufnimmt und ein

Werkzeug bietet, eine Vision von Heimat zu konstruieren, die eine kohäsive Entfaltung einer höchst heterogenen, postdigitalen[1] Gesellschaft wie der deutschen fördert. Sein Gültigkeitsanspruch soll zur Diskussion gestellt werden.

Der vorliegende Artikel folgt drei Schritten:

Erstens wird eine Kerndefinition von *Heimat* herausgearbeitet, die den gemeinsamen Nenner der im aktuellen Diskurs vorgebrachten Deutungen darstellt.

Zweitens werden die gängigen mit Heimat verbundenen Vorstellungen anhand ihrer Zeitperspektive kategorisiert und in Bezug auf ihre potenziellen Auswirkungen auf soziale Kohäsion kritisch betrachtet.

Drittens wird geprüft, welche Form *Heimat* – im Sinne der Kerndefinition – im postdigitalen Alltag annimmt. Daraus wird das bereits angesprochene ideelle, verbal dargestellte Modell entwickelt, dessen mögliche Vorteile im Bereich der interkulturellen Kommunikation und Pädagogik zum Schluss skizziert werden.

2. Heimat: Kerndefinition

Heimat ist ein Begriff, der Gefühle hervorruft. Dieser Tatbestand ist so charakteristisch, dass Beate Mitzscherlich (2019: 185) diesen als dessen wichtigste Dimension identifiziert.

> Fragt man Menschen danach, was für sie Heimat ist, was sie unter diesem Begriff verstehen bzw. analysiert man Texte von Menschen über (ihre persönliche) Heimat systematisch, sieht man schnell, dass Heimat ein multidimensionales Konzept ist, in dem einige Dimensionen sehr zentral sind. Die zentralste ist das Heimatgefühl: In meiner eigenen Untersuchung haben alle befragten Personen Heimat in Verbindung mit einem positiven Heimatgefühl gebracht, auch in anderen, quantitativen sozialwissenschaftlichen Befragungen wird das Heimatgefühl als zentral für die Konstruktion von Heimat erkennbar (ebd.).

1 Das Adjektiv *postdigital* wird im Kapitel 3 detaillierter erläutert, an dieser Stelle kann *postdigital* als *hybrid* verstanden werden.

Kern des „Heimatgefühls", wie sie es nennt, sind die Gefühle der „Geborgenheit, Sicherheit und Vertrautheit" (ebd.). Diese nehmen auch die Autor*innen des 2018 dem Rahmenthema „Heimat Thüringen" gewidmeten Thüringen-Monitors zu den politischen Einstellungen der Bürger*innen dieses Bundeslandes wahr: „Im Gefühl, irgendwo und irgendwann heimisch zu sein, drücken sich Vertrautheit und Geborgenheit aus [sowie] die *Verbundenheit* mit einem *identitätsstiftenden Sozialraum* [...]" (Reiser et al. 2018: 10). „[Heimat] signalisiert – mit positiver Gefühlsbesetzung – Zugehörigkeit, Vertrautheit und Selbstgewissheit" (ebd: 38).

Womit aber hängen diese Gefühle zusammen? Worauf beziehen sie sich? An dieser Stelle werden vier weitere Dimensionen in den Blick genommen, die sich mit dem Heimatgefühl verbinden und es genauer deuten: Raum, Gemeinschaft, Kultur und Zeit (vgl. Handschuh 1990).

Als erste wird die Dimension *Raum* betrachtet, da hier die ursprüngliche Bedeutung des Begriffs liegt. *Heimat* ist in seinem Lautbestand bereits seit dem 15. Jahrhundert nachweisbar (Seifert 2021). Er stammt von der indogermanischen Wurzel „kei", was „liegen bzw. Ort, an dem man sich niederlässt" (Seifert 2021) bedeutet. So galt *Heimat* – und gilt teilweise noch – als Bezeichnung für den Ort, an dem Tiere, Pflanzen und *Menschen* ihr Habitat, also ihren *Lebensraum,* haben. Gerade die Grenzen dieses Lebensraums wurden mithilfe des Heimat-Begriffs schon sehr früh gezogen: Heimat war dort, wo Menschen an die Örtlichkeit gebundene Rechte hatten, wo die Zugehörigkeit zur Gemeinschaft anerkannt und dadurch erleichtert wurde.

> Bis zur zweiten Hälfte des 19. Jahrhunderts war ‚Heimat' ein juristischer Begriff mit geographischer Orientierung, d.h., er war an persönlichen Besitz von Haus und Hof gebunden und bezeichnete u.a. ein Aufenthalts- bzw. Bleiberecht, insbesondere bei altersbezogener Bedürftigkeit und in sozialen Notlagen (Seifert 2021).

Heimat stellt also nicht die bloße Verbindung zwischen einem territorialen Raum und einer Person dar, sondern inkludiert auch die sozialen Beziehungen, die dort entstehen und gepflegt werden. Wie Ina-Maria Greverus (1979: 13) schreibt, ist Heimat der Ort, an dem Menschen sich gut auskennen, aber auch der Ort, an dem sie bekannt und anerkannt sind. Die positiven Gefühle der *Geborgenheit, Vertrautheit* und *Sicherheit,* auf die sich Mitscherlich (2019: 185) bezieht, werden an dieser

Deutungsschnittstelle Raum/*Gemeinschaft* erzeugt, dort wo ein „[S]ense of [C]ommunity" (ebd.: 187) gespürt wird.

Der *Sense of Community* verbindet sich im Heimatgefühl mit „*Sense of Control* [... der] Erfahrung von Verhaltenssicherheit und Handlungsfähigkeit" und „*Sense of Coherence*", der Erfahrung von Deutungssicherheit und Interpretationsfähigkeit (ebd.: 187–189, Herv. durch Verf.). „*Sense of Control*" und „*Sense of Coherence*" verweisen auf die dritte Dimension von Heimat: die der *Kultur*. Gemeinschaft entsteht durch kommunikative Handlungen, die durch kulturelles Wissen geformt werden. Dieses kulturelle Wissen ermöglicht die Empfindung von Sinnhaftigkeit, Plausibilität, Normalität in der eigenen, „fraglos gegebenen" (Schütz/Luckmann 2003: 49) intersubjektiven Lebenswelt, in der Menschen in der Lage sind, in Routinen zu handeln (Bolten 2018: 58). Gerade durch den „Prozess des gemeinschaftlich Machens" (ebd.) wird die Lebenswelt vertraut und Menschen fühlen sich sicher in ihr. Auch sichtbare, greifbare, konsumierbare Kulturprodukte und Artefakte können Symbole der Heimat und Auslöser des Heimatgefühls werden.

In diesem Sinne impliziert Vertrautheit eine Geschichte des Vertrautwerdens und des Aufbaus von Vertrauen. Heimat ist also etwas, das in der *Zeit* auf diese Weise entsteht und so Vergangenheit, Gegenwart und Zukunft miteinander verknüpft. Die Gegenwart ist die Vergangenheit der Zukunft und die Vergangenheit ist die Zeit, in der bedeutende soziale Beziehungen geknüpft werden und sinnstiftendes kulturelles Wissen angeeignet wird, was in Zukunft – zumindest als Erinnerung – bleibt.

Alle diese Dimensionen berücksichtigend, wird an dieser Stelle Heimat als *vertrauter, intersubjektiver Raum der Geborgenheit* definiert. Dieser kann im abstrakten Sinne als imaginierte Heimat verstanden werden und im konkreten Sinne als persönliche Heimat, die in der individuellen, intersubjektiven Lebenswelt, gerade dort, wo Geborgenheit empfunden wird, angesiedelt ist und aus der unmittelbaren Erfahrung der Einzelnen entsteht.

Aus der Untersuchung der vielfältigen Auslegungen dieses Konzepts kristallisieren sich zwei Makrokategorien heraus, die eine diametral entgegengesetzte Zeitorientierung haben: die, die als erste vorgestellt wird, bezieht sich auf das abstrakte Heimatverständnis, charakterisiert sich durch die Verankerung in einer idealisierten Vergangenheit und ist in

diesem Sinne Ausdruck eines geschlossenen Kulturbegriffs: territorial, statisch, kohärent (Bolten 2007: 15–19). Die zweite bezieht sich primär auf Heimat als konkretes Phänomen und sieht sie als dynamisches Ergebnis menschlichen Handelns. In diesem Sinne ist sie zukunftsorientiert und harmoniert mit einem offenen Kulturverständnis: relational, dynamisch, kohäsiv (ebd.). Diese beiden Modelle werden im folgenden Kapitel dargestellt und in Bezug auf ihre jeweiligen Konsequenzen für den Zusammenhalt einer pluralen Gesellschaft diskutiert.

2. Entgegengesetzte Auslegungen des Heimatbegriffs

2.1 Heimat als Reproduktion der Vergangenheit

Heimat als emotional kodierter Begriff ist mit der Wende zum 20. Jahrhundert und ihren Veränderungen als Folge von Industrialisierung, Urbanisierung und Arbeitsmigration entstanden (Müller/Steber 2018: 646) und führt auf emotionaler Ebene das im 19. Jahrhundert abgeschaffte Heimatrecht fort, das den damaligen Freizügigkeitsbemühungen entgegengestanden hatte (Schmoll 2016: 35). Diese Umwälzungen wurden als „Bedrohung traditioneller Lebenswelten wahrgenommen, als ‚Entwurzelung' des Menschen, als zerstörerischer Eingriff in die Landschaft und ins vertraute Städtebild" (Müller/Steber 2018: 646). Der moderne Heimatbegriff entsteht also aus der Sehnsucht nach einer idealisierten Vergangenheit, die von diesem Wort repräsentiert und somit greifbar gemacht wird.

Als Hafen für die „Sehnsucht nach bereits verlorenen oder verschwindenden Lebenswelten" (ebd.) erlebt der Heimatbegriff immer wieder in Momenten besonders starken Wandels eine Hochkonjunktur. Gestern die Industrialisierung, heute das Leben in der sogenannten ‚VUCA-Welt', einer Gesellschaft, die durch Volatilität (Unbeständigkeit), Unsicherheit, Komplexität und Ambiguität (Mehrdeutigkeit) geprägt ist.[2] Die Vergangenheit wird zu einem Fluchtort aus der Gegenwart, deren Entwicklungen mit Widerstand begegnet wird.

Laut Edoardo Costadura, Klaus Ries und Christiane Wiesenfeldt (2019) ist der Begriff Heimat für diese Projektion prädestiniert, da er mit

2 Zur Bedeutung des VUCA-Konzeptes aus der Perspektive der Interkulturellen Kommunikation vgl. Bolten/Berhault (2018).

„Behausung" (Costadura et al. 2019: 18) verbunden ist, also mit dem, was uns vor der Urangst schützt, der Natur ausgeliefert zu sein. Indem sie diesen idealen Zustand greifbar macht, löst die abstrakte Vorstellung einer Heimat geborgenheitsspendende Sehnsucht aus, ähnlich wie die Erinnerung an die Kindheit als der Phase des Lebens, in der Menschen sich der Umwelt normalerweise noch nicht schutzlos ausgeliefert fühlen (Costadura et al. 2019: 19–20). Dieses vergangenheitsbezogene, abstrakte Heimatverständnis ist also „Teil eines Seins-Zustandes unseres Selbst, der unwiederbringlich verloren ist" (ebd.: 20).

Das vergangenheitsbezogene Heimatverständnis geht immer einher mit der Wunschvorstellung, die imaginativ erinnerte Heimat und was von ihr bleibt, zu verewigen. Ein solches Heimatverständnis kann der Realität nicht standhalten: Es ignoriert die immanente Veränderlichkeit der Gemeinschaft und ihrer Mitglieder, die im kreativen Charakter menschlichen Handelns begründet liegt und sich in der inneren Heterogenität jeder Gemeinschaft und jedes Menschen widerspiegelt (Conti 2012: 160–161).

Der Erfolg dieser besonderen Spielart des Heimatbegriffs, die zuerst die Empfindung einer idealisierten Illusion als etwas Reales zu forcieren sucht und dann Sehnsuchtsgefühle danach befeuert, geht Hand in Hand mit dem sich hartnäckig haltenden Erfolg des geschlossenen Kulturbegriffs und einem essentialistischen Verständnis kultureller Identität. Dabei erscheint die Existenz der ersehnten homogenen, an sich gleichbleibenden Gemeinschaft im Sinne Andersons „Imagined Community" (1991) plausibel, indem die Vorstellung der Welt als ein Nebeneinander homogener Kulturräume in der Alltagswelt tradiert wird und die Praxis der Kategorisierung von Menschen auf der Grundlage ihrer Herkunft unhinterfragt bleibt.

Auf Grundlage der durch den geschlossenen Kulturbegriff postulierten Homogenitätsprämisse und des Kohärenzdenkens wird also Veränderungen mit Widerstand begegnet und werden jene Menschen, die als Träger von Vielfalt angesehen werden, als Gefahr wahrgenommen. Wie Friedemann Schmoll (2016: 44) schreibt, „findet die Doppelbödigkeit von Heimweh-Sehnsucht und Fremdenfurcht ihre Fortschreibung". Paradoxerweise gefährdet schließlich gerade der Wunsch nach Bewahrung bzw. Wiederherstellung der eigenen *idealisierten* Heimat die friedliche, freie und partizipative Entfaltung eines *echten, bewohnten*

vertrauten intersubjektiven Raums der Geborgenheit, da die Entwicklung reziproker Beziehungen und somit von Vertrautheit, Sicherheit und Geborgenheit erschwert wird.

Zusammenfassend lässt sich festhalten, dass die vergangenheitsbezogene Spielart des abstrakten Heimatbegriffs Schließungstendenzen fördert, da sie gerade durch den Wunsch nach Bewahrung von unwiederbringlich Verlorenem die Neugestaltung reziproker Beziehungen gefährdet. In diesem Sinne erschweren – nicht begünstigen! – diese das Gedeihen eines Heimatgefühls, sowohl seitens derjenigen, die gegen Windmühlen kämpfen, als auch derjenigen, deren Wohlbefinden in der eigenen intersubjektiven Lebenswelt durch Diskriminierungserfahrungen aufgrund von vermeintlicher Nichtzugehörigkeit erschwert wird.

Dennoch ist die imaginierte, vergangenheitsbezogene Vorstellung der abstrakten Heimat ein erfolgreiches Ideal, das Handlungsorientierung bietet. Sie stellt eine „Retrotopie" (Bauman 2017) dar, deren Fluchtpunkt nicht in einer idealen Zukunft liegt, die Schritt für Schritt konstruiert werden kann, sondern in der idealisierten Vergangenheit, die mit aller Kraft fortgesetzt oder wiederhergestellt werden soll. Anstatt Dialog und Kooperation werden Gewalt, Unterdrückung und Ausgrenzung als zukunftsweisende Strategien wiederaufgenommen. Mauern werden sowohl an den Grenzen wieder aufgebaut als auch innerhalb der nationalen Gesellschaft gegenüber Mitgliedern, die nicht als Teil der „Imagined Community" (Anderson 1991) zugelassen werden.

Die „mediale Inszenierung" (Wasserloos 2019: 375) von Heimat, die nicht selten folkloristische, realitätsferne und exklusionsfördernde Züge annimmt (Ulbricht 2019: 142–143), fördert also die Verbreitung von Schließungstendenzen zum Schutz einer imaginierten Normalität. Paradebeispiel ist der Slogan der Wahlkampagne der Alternative für Deutschland (kurz: AfD) 2021 „Deutschland. Aber normal", der in einer über die Jahre hinweg sich entfaltenden, heimatzentrierten politischen Kommunikation eingebettet ist. Wie die Studie von Georg Schuppener (2021) zu Heimat-Lexik und Heimat-Diskursen in AfD-Wahlprogrammen zeigt, wird der Heimatbegriff strategisch eingesetzt, um in euphemistischer Weise „xenophobe Botschaften" (ebd.: 131) zu verbreiten. Der Autor zeigt, dass „von [der] AfD der Begriff Heimat in einem geschlossenen Verständnis verwendet wird. Mit diesem Konzept wird Heimat gegen Migration positioniert.

Andererseits werden Heimat-Diskurse genutzt, um die Rückführung bzw. das Fernhalten von Migranten zu motivieren" (ebd.).

Solche Kampagnen bieten aber auch Gelegenheit, die Vorstellung davon, was ,normal' ist und wer und was zum imaginierten ,uns' gehört, zu hinterfragen und Gegenentwürfe vorzuschlagen. Soziale Medien übernehmen die Funktion der altgriechischen Agorá, dem zentralen Treffpunkt der Gemeinschaft, jedoch mit einer örtlich ungebundenen und zeitlich flexiblen Zugänglichkeit. So griff beispielsweise der Satiriker Shahak Shapira kurz nach der Veröffentlichung der AfD-Kampagne „Trau Dich Deutschland" die Wahlplakate auf und kreierte daraus Memes, die sich zu einem Element des Counter Speech entwickelten (s. Abb. 2). So schrieb er am 10.06.2017 auf Facebook: „Die AfD hat letztens neue Wahlkampfplakate vorgestellt. Als leidenschaftlicher AfD-Fan und Werbeexperte nahm ich mir die Freiheit, die Plakate etwas zu optimieren. Anbei meine Vorschläge."[3] Der Post, der den Hashtag der Kampagne aufnimmt (#TrauDichDeutschland) und diesen zum Schauplatz einer breiten öffentlichen Diskussion macht, wurde 723 Mal geteilt, bekam 320 Kommentare, und folgende Emojis: 4994 👍 854 😄 210 ❤ 6 🤝 2 😟 5 😮.

Im Folgenden werden zwei seiner Memes gezeigt: Im ersten mit der Aussage „Bunte Vielfalt? Haben wir schon", illustriert mit der Abbildung dreier Frauen in traditionellen Trachten verschiedener Regionen Deutschlands, werden diese durch eine Gruppe rechtsradikaler Demonstranten ersetzt. Im zweiten wird die Behauptung „Der Islam? Passt nicht zu unserer Küche" durch das Bild von AfD-Bundessprecherin Beatrix von Storch mit einem Döner ironisch konterkariert.

3 Shahak Shapiras Post auf Facebook, veröffentlicht am 10.06.2017: https://www.facebook.com/ShahakShapira/posts/die-afd-hat-letztens-neue-wahlkampfplakate-vorgestellt-als-leidenschaftlicher-af/1864173880572649/ (Letzer Zugriff: 10.03.2023).

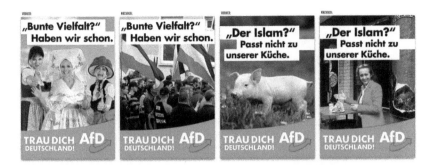

Abbildung 2: AfD-Plakate und Counter Speech Memes von Shahak Shapira (2017)

Mit der „Trau Dich Deutschland"-Kampagne und Slogans wie „Unser Land, unsere Heimat" erreichte die AfD 2017 einen Stimmenanteil von 12,6 Prozent bei der Bundestagswahl (Die Bundeswahlleiterin 2017). So kehrt Heimat als politisches Kampfwort zurück, jedoch, interessanterweise, nicht nur im retrotopischen, exklusionsfördernden Sinne, wie diese auf Twitter geteilte Kampagne des hessischen Landesverbands von Bündnis90/Die Grünen aus dem Jahr 2018 zeigt (s. Abb. 3).[4]

4 Das Bild wurde von den Grünen Hessen (@gruenehessen) mit weiteren drei Bildern am 13.08.2018 auf Twitter gepostet: https://twitter.com/gruenehes sen/status/1028936545024262144 (Letzter Zugriff: 10.03.2023).

Abbildung 3: Wahlplakat der Grünen Hessen, 2018

In einer Pressemitteilung erklärten die Grünen Führungspersonen Priska Hinz und Tarek Al-Wazir dazu, dass ihre Plakate ein „Gegenbild zur Hetze der Rechtspopulisten und Rassisten, die von Heimat reden, aber Ausgrenzung meinen" darstellen sollen.[5] Ein vergangenheitsfixiertes Heimatverständnis fördert jedoch nicht nur die Ausgrenzung migrantischer und migrantisch gelesener Menschen sowie ethnischer Minderheiten wie bspw. Roma und Sinti, sondern erschwert auch die Entwicklung hin zu echter – ja ohnehin gesetzlich garantierter – Gleichberechtigung. Dies wird in einem Meme veranschaulicht, das die AfD Sachsen im Oktober

5 https://www.gruene-hessen.de/partei/presse/heimat-natuerlich-tarek-statt/
 [Letzter Zugriff: 17.03.2023].

2022 auf ihrem Twitter-Account veröffentlichte und aufgrund der negativen Resonanz kurz danach löschte (s. Abb. 4).[6] Dort wird die „moderne ‚befreite' [sic]" Feministin der „traditionellen Frau" gegenüber gestellt und mit all den für Gleichgesinnte als negativ geltenden Eigenschaften dargestellt, die u. a. auf die Ungleichwertigkeitsideologien des Lookism, Sizeism und Sexism zurückgreifen.

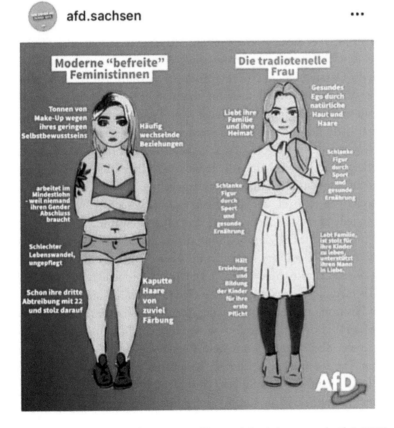

Abbildung 4: AfD-Version des Memes „liberated feminist vs. tradwife", 2022

6 Vgl. dazu den auf Blick.de am 26.10.2022 veröffentlichten Artikel „Sächsische AfD schockt mit Post über traditionelles Frauenbild": https://www.blick.de/sachsen/saechsische-afd-schockt-mit-post-ueber-traditionelles-frauenbild-arti kel12507206 [Letzter Zugriff: 12.03.2023].

Eine Google-Recherche anhand dieses Bildes zeigt, dass es eine englische Version dieses Memes gibt (s. Abb. 5), die mindestens seit dem 22.05.2019 online ist, als Henry Yu es in der öffentlichen Gruppe „We are against Pinkdot [sic] in Singapore"[7] postete (s. Abb. 5).[8] Eine Vergleichsanalyse der para- und non-verbalen Elemente des Memes zeigt, dass in der AfD-Version die Bilder der zwei Frauen nicht verändert werden, jedoch der Licht-Kontrast erhöht, der Hintergrund zum AfD-Blau gewandelt, die Schriftart des Textes entsprechend des AfD-Corporate-Designs verändert und das Logo eingefügt wird. Der die verbalen Elemente charakterisierende Stil wird in die deutschsprachige Adaption übernommen. Ausnahme ist die Entscheidung *„The ‚Liberated' Feminist"* zu entpersonalisieren durch die Darstellung im Plural: *„Moderne 'befreite' [sic] Feministinnen"*. „Die traditionelle Frau" wurde im Singular belassen, jedoch anstatt von Ehefrau wie auf Englisch (*wife*) wird von „Frau" gesprochen. Auf die fehlende stilistische Kohärenz wird weniger Acht gegeben genauso wie auf die Nutzung der im Deutschen korrekten Anführungszeichen, während die Übersetzung der Inhalte sehr bewusst durchgeführt wird. Dabei werden nicht alle Zuschreibungen wiedergegeben, sondern es werden lediglich sechs von elf bzgl. der modernen Frau und sechs von zehn bzgl. der traditionellen Frau für die deutsche Version ausgewählt. Diese werden teilweise umplatziert: Die Zuschreibung für die traditionelle Frau „Loves her family, race, and country in that order" wird von unten links nach oben links, gleich als erste unter den Titel „Die traditionelle Frau" verschoben. Die Übersetzung dieser Aussage, in Zusammenhang mit der hervorgehobenen Position im oberen Bereich des Plakats, ist für diesen Beitrag höchst interessant: „Loves her family" wird wortwörtlich übernommen, während „race, and country" mit dem Begriff „Heimat" zusammengefasst werden. Daraus wird also folgende Kundgabe unterbreitet: „Die traditionelle Frau [l]iebt ihre Familie und ihre Heimat". Dieses Meme illustriert, wie der Heimatbegriff als Katalysator antiemanzipatorischer Entwicklungen dienen kann und soll damit als Werkzeug verstanden werden, das Fortbestehen traditioneller Machtverhältnisse zu sichern.

7 *Pink Dot* ist eine jährliche Veranstaltung, die seit 2009 die LGBT-Community in Singapur feiert.

8 https://www.facebook.com/groups/waapd/posts/2268667429836708/ [Letzter Zugriff: 10.03.2023].

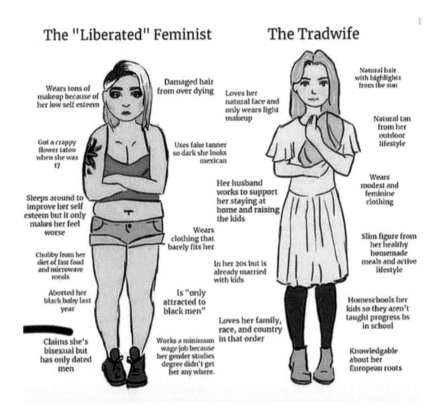

The "Liberated" Feminist

Wears tons of makeup because of her low self esteem

Damaged hair from over dying

Got a crappy flower tatoo when she was 17

Sleeps around to improve her self esteem but it only makes her feel worse

Chubby from her diet of fast food and microwave meals

Aborted her black baby last year

Claims she's bisexual but has only dated men

Uses fake tanner so dark she looks mexican

Wears clothing that barely fits her

Is "only attracted to black men"

Works a minimum wage job because her gender studies degree didn't get her any where.

The Tradwife

Loves her natural face and only wears light makeup

Natural hair with highlights from the sun

Natural tan from her outdoor lifestyle

Wears modest and feminine clothing

Her husband works to support her staying at home and raising the kids

Slim figure from her healthy homemade meals and active lifestyle

In her 20s but is already married with kids

Loves her family, race, and country in that order

Homeschools her kids so they aren't taught progress bs in school

Knowledgable about her European roots

Abbildung 5: Englische Version des Memes „liberated feminist vs. tradwife", 2019

In den bisherigen Abschnitten wurde die enge Verbindung zwischen der idealisierten Vorstellung einer vergangenen Heimat und dem Widerstand gegen Veränderungsprozesse dargelegt. Es wurde auch gezeigt, dass die damit einhergehenden Schließungstendenzen die Entfaltung von Heimat, im Sinne eines vertrauten Raums der Geborgenheit, behindern. In der Tat behindert die entsprechende Haltung gegenüber den imaginierten Feinden die Entstehung von positiven Beziehungen, die dieses Gefühl der Geborgenheit fördern.

Im Folgenden skizziere ich die zukunftsorientierte Auslegung des Heimatbegriffs, nach der Heimat nichts ist, was gegenwärtig nur in der

Vergangenheit zu suchen ist, sondern etwas, was für die Zukunft konstruiert wird. Diese konstruktivistische Vision von Heimat geht einher mit einer weiteren Charakteristik der zukunftsorientierten Perspektive: das kosmopolitische Verständnis vom Raum. Auch wenn der Raum als spezifischer geographischer oder geo-politischer Raum verstanden wird, wird er als Teil eines damit verbundenen Kosmos anerkannt.

2.3 Heimat als Konstruktion von Zukunft

Gregor Reimann, Sophie Seher und Michael Wermke (2019) heben in ihrem Artikel zum „Heimatbegriff im Bildungsauftrag des modernen Schulwesens" hervor, dass der Heimatbegriff schon vor 200 Jahren einem kosmopolitischen Verständnis unterlag, wonach Heimat – so wie heute noch (Thüringer Ministerium für Bildung, Jugend und Sport 2015) – als „Teil dieser ‚einen Welt'" (Reimann/Seher/Wermke 2019: 277) wahrgenommen wurde. Sie beziehen sich dabei auf die Arbeit von Christian Wilhelm Harnisch (1816; 1827) in Thüringen, der das Fach Heimatkunde konzipierte, um die Erschließung des eigenen Lebensraums zu fördern, Kindern durch die bewusste Auseinandersetzung mit ihm die Möglichkeit zu geben, sich damit zu identifizieren, und ihnen gleichzeitig Zugang zum Weltwissen zur Verfügung zu stellen (Reimann/Seher/Wermke 2019: 239–240). Harnisch erkennt also erstens eine Verbindung zwischen lokalem Lebensraum und Welt und zweitens sieht er die Identifikation mit der Heimat als Ergebnis eines Lernprozesses. Nach dieser Definition ist Heimat, wie die AutorInnen argumentieren, nicht etwas Gegebenes, sondern etwas, was Menschen sich aktiv aneignen, gar konstruieren. „Heimaten sind keine regressiven Zufluchtsstätten, sondern Gestaltungsorte gemeinschaftlichen Lebens von Menschen unterschiedlichster Herkünfte" (Reimann/Seher/Wermke 2019: 277). Dabei wird das ideelle, vom altgriechischen Philosophen Diogenes von Sinope imaginierte universelle Staatsbürgerschaftsrecht der Kosmopoliten vorausgesetzt: „The question was put to him what countryman he was, and he replied, ‚A Citizen of the world'" (Laërtius/Yonge 1915: 241). Dies impliziert wiederum, dass Heimat nicht exklusiv ist: Sie gehört nicht exklusiv denjenigen, die dort am längsten waren und sie ist nicht exklusiv im Sinne, dass Menschen nicht nur eine, sondern mehrere Heimat*en* haben können. Dies spiegelt sich wider im Erfolg (vgl. faz.net 2018) des Hashtags #MeTwo der 2018

von Ali Can – Autor des Buches „Mehr als eine Heimat. Wie ich Deutsch-
sein neu definiere" – auf Twitter eingeführt wurde. Unter diesem Hashtag
können als migrantisch gelesene Menschen, die sich in Deutschland – und
gegebenenfalls auch in einem anderen Land – zu Hause fühlen, auf ihre
alltäglichen Rassismuserfahrungen aufmerksam machen, während sie das
Verständnis verbreiten, dass Identität plural ist und multiple Zugehörig-
keiten nicht in Widerspruch zueinander stehen.

Beispielhaft wird im Folgenden (Abb. 6) ein mit #MeTwo versehener Tweet
abgebildet, der die für diesen Hashtag übliche autobiographische Erzähl-
struktur verwendet: die eines Dialogs, der dem Aufbau eines Witzes gleicht.
Inhaltlich ist gerade die hier dargestellte Situation interessant, weil sie zeigt,
wie bei migrantisch gelesenen Menschen immer wieder das Zuhause weit
entfernt von ihrem alltäglichen Leben in Deutschland lokalisiert wird.[9]

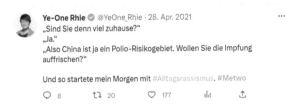

Abbildung 6: Tweet mit Darstellung eigener Rassismuserfahrung

Folgender Tweet (Abb. 7) kombiniert diesen Hashtag mit anderen Hash-
tags, die sich auf weitere Formen von Diskriminierung beziehen. Die
Nebeneinandersetzung von Hashtags drückt Anerkennung und Solidari-
tät gegenüber „allen" Diskriminierten aus und ermöglicht gleichzeitig ver-
schiedene Ungleichwertigkeitsideologien zusammen – intersektional – zu
thematisieren. Inhaltlich ist gerade dieser Tweet für diesen Beitrag rele-
vant, weil er die ‚Wir-vs.-ihr'-Logik explizit übernimmt, dabei wird aber
nicht deutlich, wer genau gemeint ist. Plausibel könnte an dieser Stelle
das ‚Wir' alle rassismusbewussten Menschen bezeichnen und das ‚Ihr'

9 Der Tweet von Ye-One Rhie ist unter folgendem Link zu finden: https://twit
ter.com/YeOne_Rhie/status/1387299142834270209?s=20 [Letzter Zugriff:
12.03.2023].

diejenigen, die dies (noch) nicht sind. Darüber hinaus wird in diesem Post „die Angst vor Veränderung und der Widerstand dagegen" als Hindernis zur inklusiven Gesellschaft identifiziert und dazu aufgerufen, diese zu überwinden.[10]

Abbildung 7: Tweet mit „Call to Action" gegen jegliche Diskriminierung

Während #MeTwo es ermöglicht, Rassismus sichtbar zu machen, rücken mit dem Hashtag #GermanDream und des damit verbundenen Projektes die Erfolgsgeschichten vieler Menschen mit Migrationserfahrung ins Rampenlicht (s. Abb. 8).[11] So wird nicht nur Migrant*innen Mut gegeben, sondern auch Raum für positive Narrationen geschaffen, der dazu

10 Der Tweet von *Mo I Freddy Mo Wenner* (@EinfachFreddy) ist unter dem folgenden Link abrufbar: https://twitter.com/EinfachFreddy/status/15456639 64629065729?s=20 [Letzter Zugriff:12.03.2023].

11 Dieser Tweet von *GermanDream* (@germandream_de) ist unter dem folgenden Link abrufbar: https://twitter.com/germandream_de/status/163311845590 0647424?s=20

beitragen soll, die im vorigen Post angesprochene „Angst vor Veränderung und den Widerstand dagegen" zu überwinden.

#GermanDream @germandream_de · 7. März

„Ich habe mich in vielen Dingen auch durchboxen müssen, aufgrund meiner Geschichte (...).", erzählt uns Esra. Anlässlich des #Weltfrauentag am Mittwoch stellen wir euch heute #Synchronsprecherin Esra vor. Im folgendem Video redet sie über ihren #GermanDream:

▶ 118 Mal angezeigt 0:04 / 0:45

○ ↻ ♡ 3 ılıl 287 ⬆

Abbildung 8: Tweet mit einem 2022 bei der Verleihung des #GermanDream-Award gedrehten Video-Interviews

Bei der Konstruktion des #GermanDreams fühlt man sich an Ciceros Ausspruch *Ubi bene, ibi patria*[12], wo man sich wohl fühlt, ist die Heimat, erinnert. Andererseits hören Orte auf, Heimat zu sein, „wenn es keinen emotionalen und sozialen Bezug dazu (mehr) gibt", und sei es auch nur ein erinnerter, wie Mitzscherlich (2019: 183) hervorhebt. An dieser Stelle lässt sich das Paradox der Migrant*innen lokalisieren, die sich an verschiedenen Orten gleichzeitig heimisch fühlen können, jedoch nicht

12 Dieser Spruch stammt aus Ciceros Satz „Patria est, ubicumque est bene": Heimat ist dort, wo man sich wohlfühlt (45 vor Chr.: Liber V, 108).

vorbehaltslos vollständig, sei es, weil sie nicht (mehr) als gleiche – ergo als zugehörig – anerkannt werden oder weil sie sich selbst teilweise fremd fühlen. Jedoch implizieren der dynamische Charakter der menschlichen Identität und deren Kulturräume für jede Person eine permanente Aushandlung mit der eigenen Lebenswelt.

Nach der zukunftsorientierten Perspektive wird Heimat als Ergebnis eines Prozesses der Beheimatung „im Sinne einer aktiven, freieren Aneignung und Gestaltung vertrauter Lebenswelten und Erzeugung sozialer Zugehörigkeit und Anerkennung" (Schmoll 2016: 45–46) verstanden. Heimat wird somit, wie z. B. im heutigen Thüringer Lehrplan für Heimat- und Sachkundeunterricht, zu einem „prospektiv-aktivierenden Begriff, […] [der alle] ermutigt, am Wandel ihres Umfeldes teilzuhaben und so die Zukunft der Heimat mitzugestalten" (Reimann/Seher/Wermke 2019: 275).

Beheimatung als kreativer, gestalterischer „Prozess des Sich-Verbindens mit Orten, Menschen, kulturellen und geistigen Bezugssystemen" ist eine „lebenslange Aufgabe" (Mitzscherlich 2019: 186), die nicht zwingend mit *territorialen* Räumen verknüpft sein muss. Heimat ist nach Hartmut Rosa (2019) der „anverwandelte Weltausschnitt", und zwar jener Weltausschnitt, der mit den Einzelnen resoniert. Dabei sieht Rosa (2019: 170) die Resonanz *per se* als einen Raum, und zwar den Ort, an dem Menschen in dialogische Beziehung mit einem Weltausschnitt treten. „Die komplette Anverwandlung von Welt als einem Ort, der nichts Widerständiges mehr bietet, den ich komplett verfügbar gemacht habe, könnte, selbst wenn sie möglich wäre, keine Resonanz mehr erzeugen. Das wäre nur noch ein Echo-Ort" (ebd.).

Heimat kann somit als ein individuelles und gleichzeitig gesellschaftliches Zukunftsprojekt mit utopischen Zügen gedacht werden: Für den Einzelnen geht es darum, die lebenswerteste Art des Weltverhältnisses immer wieder zu erleben und auszuleben; Für die Gesellschaft bedeutet es, fruchtbarer Boden dafür zu sein, eine offene, dialogische Gesellschaft zu werden, in der „Möglichkeiten gerecht verteilt sind" und „Menschen und alle anderen Wesen in Vertrauen und Geborgenheit miteinander zurechtkommen" (Meetz/Seeßlen 2019). In diesem Sinne ist vorauszusetzen, dass alle die Chance bekommen, „eine Resonanzbeziehung zur Welt einzugehen" (Rosa 2019: 153) und Heimat an dem Ort zu finden, wo

Resonanz entsteht. Das steht im Einklang mit Hannah Arendts Forderung, „the right of every individual to belong" (Arendt 1962: 298), was mit dem grundlegenden Menschenrecht „the right to have rights" (ebd.) eng verbunden ist. Wichtig ist an dieser Stelle hervorzuheben, dass die Wahrung jeglichen Rechts nicht von der Gesetzgebung abhängt, sondern von dem inneren Anspruch jedes Menschen, weil nur seine innere Motivation seine Handlung tiefgründig lenken kann. „We are not born equal; we become equal as members of a group on the strength of our decision to guarantee ourselves mutually equal rights" (Arendt 1962: 301). Um dieses Versprechen zu realisieren, ist die Fähigkeit notwendig, mit anderen empathisch zu sein. Diese muss gelernt werden und dafür werden Vorbilder gebraucht. Das Humane ist nach Hannah Arendt nicht gegeben und Weltentfremdung, Isolation, Gleichgültigkeit sowie Gedanken- und Beziehungslosigkeit stellen reale Gefahren für das (Zusammen)leben dar, weil sie das menschlich-weltliche Beziehungsgeflecht zerstören (Förster 2009: III; V). „Freiheit und Gleichheit als Rechtsansprüche erfordern deshalb [...] Engagement, damit sie zu einem weltlichen Phänomen werden. Sie sind [...] künstliche, von Menschen erfundene Konstrukte, um ihr Zusammenleben zu meistern" (Arendt 1994: 241–242). Die Verbreitung einer Kultur des Dialogs – der Gleichheit, der Anerkennung, der Teilhabe – ist zwingend notwendig und braucht das Vorbild der Einzelnen, was auch solidarisches Handeln, „um denjenigen in den Arm zu fallen, die die Rechte anderer verletzen", (Ignatieff 2002: 34) impliziert.

Mit Jürgen Förster (2009) kann das Problem, das dieser Beitrag behandelt, folgendermaßen zusammengefasst werden:

> Die Fähigkeit des Urteilens, die uns mit der Welt in Beziehung setzt und die die Menschen in kommunizierende Wesen verwandelt, macht es nahezu unmöglich, dass der Mensch Verbrechen gegen die Menschheit verüben kann. Die Maßlosigkeit dieser Verbrechen resultiert aus einem verheerenden Mangel an Einbildungskraft, einem Mangel an der Fähigkeit, sich von der eigenen Person zu distanzieren, um den Anderen und die Welt aus seiner Perspektive wahrzunehmen. Wenn man sich vergegenwärtigt, dass der Geschmack eine zentrale Kategorie der Urteilskraft ist, könnte man sagen, dass es um die Bildung des guten Geschmacks geht, dem böse Taten, Grausamkeiten und Ungerechtigkeiten nicht schmecken.

Diese „Geschmäcker" konkurrieren online, wie die oben präsentierten Memes und Tweets beispielhaft illustrieren. Während Isolation steigt

und Algorithmen – polarisierend – die Entwicklung sowohl des guten als auch des schlechten Geschmacks fördern, wird die Relevanz von Kampagnen wie #MeTwo und #GermanDream sowie des Engagements gegen menschenfeindliche Botschaften, wie das, was zur schnellen Rücknahme der von der AfD Sachsen geposteten Tradwife-Meme geführt hat, offensichtlich. Zukunftsorientierte Heimatverständnisse, wie die vorgestellte Heimat als Resonanzraum, Heimat als beständige Entwicklung und Veränderung und Heimat als Einladung/Selbstermächtigung zur Teilhabe, sind damit Bedingung für das Überleben von Gemeinschaften, da sie den Weg zu einem friedlichen und fruchtbaren Miteinander zeigen können.

2.4 Zwischenfazit

Die für diesen Artikel relevanten historisch gewachsenen Auffassungen des Heimatbegriffs wurden in zwei zeitliche Perspektiven auf Heimat eingeordnet: Nach der einen Perspektive wird Heimat als abstraktes Konzept einer territorial gebundenen, kulturell homogenen Gemeinschaft gesehen, die ihren Referenzrahmen in der Vergangenheit ansiedelt. Durch ihre Idealisierung wird Sehnsucht generiert, die einen Widerstand gegen Veränderung und Diversität erzeugen kann. Dieses als geschlossen definierbares Verständnis von Heimat ist – mit Becks reflexiver Modernisierung (Beck 1997) gedacht – Kind der ersten Moderne (exkludierende Denkmuster; Steuerungsbemühungen; Geschlossene Struktur; Kohärenz). Das es charakterisierende Strukturdenken kann mit folgendem Satz zusammengefasst werden: *Ein Mensch hat eine Heimat.*

Die zukunftsorientierte Perspektive auf Heimat entspricht hingegen im Verständnis von Beck der zweiten Moderne und ihrem Prozessdenken (inkludierende Denkmuster; Emergenz; Diversität; Kohäsion). Sie kann mit folgendem Satz zusammengefasst werden: *Ein Mensch stellt seine Heimat bzw. Heimaten her,* sie ist offen und kosmopolitisch, der Raum wird dabei nicht zwingend als territorialer Raum verstanden.

Heimat wurde im ersten Abschnitt des Artikels als *vertrauter intersubjektiver Raum der Geborgenheit* definiert und als alltägliche individuelle und intersubjektive Praxis verstanden. Im Sinne einer selbsterfüllenden Prophezeiung kann die individuelle intersubjektive Heimat dort, wo Schließungstendenzen vorherrschen, schwieriger gedeihen als dort, wo eine offene Haltung das Entstehen eines Miteinanders fördert, was

gleichzeitig als Bedingung und Ergebnis von Beheimatungsprozessen zu verstehen ist. „Heimat, das ist etwas Positives, etwas, das Zusammenhalt stiften kann, das gemeinsame Zukunft möglich macht", sagte Deutschlands Bundespräsident Frank-Walter Steinmeier bei einem „Heimatabend" am 6. Februar 2020 in Berlin. Ob Heimat jedoch ein die soziale Kohäsion fördernder Begriff ist oder nicht, hängt davon ab, wie die Einzelnen ihn imaginieren. In der Tat hat er eine Steuerungsfunktion in Bezug darauf, wie Menschen mit Veränderung und wahrgenommener Andersartigkeit umgehen.

Die Heimat – egal wie sie konkret imaginiert wird – drückt die Beziehung zwischen dem Mensch und der Gemeinschaft aus. In diesem Sinne ist sie von existenzieller Bedeutung. Egal ob es darum geht, sie zu bewahren oder Zugänge für sich bzw. andere zu schaffen, in beiden Fällen sind damit sehr große Ängste und Hoffnungen verbunden. Aus diesen heraus handeln Menschen, die in den sozialen Medien eine relativ leicht zugängliche Agorá finden, wo sie kreativ ihre Botschaften produzieren und verbreiten können. Während sie aus bestehenden Imaginären – intersubjektiven Wahrnehmungsschemata (Pintos 2005: 42–43) – schöpfen, entwickeln sie diese digital weiter. In diesem Sinne wird Heimat ein hybrides Imaginäres, oder wie Yolanda López García (2022: 122) es bezeichnet, ein „emaginary" [Emaginäre].

Gerade in Anbetracht der sehr hohen Relevanz der Digitalität in Bezug auf ihre Auswirkungen auf die Einzelnen und auf die Gesellschaft soll im nächsten und letzten Abschnitt des Beitrags der Frage nachgegangen werden, wie Heimat heute konkret erlebt wird und wie ein Modell aussehen kann, das dieses Erleben darstellt. Das skizzierte Modell nimmt eine zukunftsorientierte Perspektive auf Heimat ein, erhält aber gleichzeitig den Struktur- und Prozesscharakter aufrecht. Dabei soll das Modell die verschiedenen Heimatverständnisse berücksichtigen, sie aufnehmen und verbinden, gleichzeitig aber Orientierung für zukunftsweisende kommunikative und pädagogische Praktiken im interkulturellen Bereich bieten.

3. Heimat in der gegenwärtigen Realität

Die Digitalisierung hat den physischen Raum erweitert. Die Verflechtung der virtuellen und physischen Dimensionen des Alltags ist heute

so radikal und umfassend, dass sie nur bedingt voneinander getrennt gedacht – und untersucht – werden können. Die Perspektive des „digitalen Dualismus" (Jurgenson 2011), nach der die digitale Welt virtuell sei, die analoge hingegen *real*, ist offensichtlich überholt. Die postdigitale Zeit hat begonnen und Nicholas Negropontes Voraussage: „Like air and drinking water, being digital will be noticed only by its absence, not its presence" (Negroponte 1998) war noch nie so zutreffend wie heute. Das Präfix *post* ist, wie Cramer (2014: 13) erklärt, also nicht so zu verstehen, dass die Zeit der Digitalität vorbei ist – wie bei dem Begriff der Postmoderne zum Beispiel – sondern dass sie sich von einer diskreten Bruchstelle zu einem andauernden Zustand entwickelt hat. Dabei soll der Wandel von der Digitalität zur Postdigitalität als subtilere kulturelle Verschiebung und fortlaufende Mutation beschrieben werden. *Postdigitalität* als Begriff verhält sich in dieser Hinsicht analog zum *Postkolonialismus*, der in keiner Weise das Ende des Kolonialismus, sondern vielmehr dessen Wandel beschreibt (ebd.).

Im postdigitalen Zeitalter dehnt sich der Erfahrungsraum und transzendiert eine reine Territorialität. Darüber schreibt Frank Eckardt (2019: 202): „Mit der Überwindung von Entfernung ist die Virtualisierung nur eine logische Konsequenz moderner Raumproduktion, die als Befreiung von lokalen Fesseln und als Versprechen auf ein selbstbestimmtes Leben andernorts motiviert ist". In diesem Sinne sind Orte im virtuellen Zeitalter all die Räume, die einen „sozialisatorischen Effekt" (ebd.: 203) ermöglichen. Virtualisierung bietet somit neue Chancen, „eine Resonanzbeziehung zur Welt einzugehen" (Rosa 2019: 153), ja wie Ulbricht (2019: 142) feststellt: „[E]s existieren mannigfaltige Möglichkeiten, Heimat neu zu finden und zu entwerfen".

Alena Dausacker (2015) zeigt die Parallelen zwischen territorialer Heimat (vergangenheitsbezogene Auslegung) und virtueller protonationaler Heimat auf. Sie spricht in diesem Sinne von „Parapatria" und bezieht sich damit auf die medialen Räume, zu denen Menschen intensive Beziehungen pflegen können (Dausacker 2015: 53–54). Digitale Medien können Menschen beheimaten, da sie eine Vielfalt an Selbst-Verortungsmöglichkeiten bieten. Im digitalen Raum sind auch Habitualisierung und Vergemeinschaftungsprozesse möglich, selbst das Sehnsuchtspotenzial ist gegeben. Mediale Heimaten „produzieren gemeinsame Erfahrungen und Kultur, die

aber nicht historisiert sind und keine Manifestation in einer klar umrissenen (territorialen, politischen) Entität haben" (ebd.: 76). Sie bringt als Beispiel storyworld-zentrierte Fandoms, deren Kanon „die gemeinsame Basis der Gruppenidentität [ist]: Sie bietet eine eigene Sprache, eigene Legenden und eine eigene Symbolik" (ebd.: 77). Denselben Standpunkt vertreten auch Julian Biskamp und Roman Lietz, die den Prozess des ‚doing culture' wie folgt beschreiben:

> Fandoms verdienen insofern eine große Aufmerksamkeit, da die Fans nicht einfach den Gegenstand ihres Interesses passiv rezipieren, sondern ihn in einem dialogischen Austauschprozess innerhalb ihrer Community wieder und wieder reflektieren, diskutieren, analysieren, mit Emotionen beladen und selbst neue kulturelle (z. B. Fanfictions) oder soziale (z. B. Conventions, Subgruppen-Foren) Erzeugnisse kreieren (Jenkins 1992, zitiert nach Richardson 2017: 12). All dies ist mit einer für die Akteure hohen „Reziprozitätsintensität" (Bolten 2013: 7ff.) verbunden, also einem hohen Grad an kollektiver Zugehörigkeit, einer großen Bedeutung für die eigene Identifikation und mit emotionalem Investment. (Biskamp/Lietz 2022: 92)

Darüber hinaus, wie im Falle der *Imagined Communities,* kennen die Mitglieder sich nicht untereinander und werden sich nie alle begegnen, jedoch existieren sie in der Vorstellung der Einzelnen und bilden eine Gemeinschaft, der sie sich zugehörig fühlen (vgl. ebd.: 90).

Allerdings ist es so, dass „mehrere Parapatrien bewohnt werden" können (Dausacker 2015: 76), genauso wie territoriale Räume. Dabei verflechten sich die Zugehörigkeiten zu multiplen physischen und digitalen Gemeinschaften.

> We see that diasporic subjects [as well as] the jet-setting European professional business class members do precisely the same [...]: smartphones and the internet enable them to make calls home and to chat with their daughters before bedtime, and to inform their social network of their whereabouts by means of social media updates. (Blommaert 2018: 77–78)

Im postdigitalen Zeitalter entstehen also nicht nur digitale Heimaten, sondern die Heimaterfahrung an sich hybridisiert sich:

- Das Internet als *Archiv* ermöglicht die Begegnung mit Kulturprodukten eigener Heimat(en), die Auslöser des Heimatgefühls sein können. Beispiele dafür sind beliebte Lieder auf Spotify, Kindheitsfotos auf Instagram, alte E-Mails von guten Freund*innen, Videoaufnahmen

von einem vergangenen Geburtstag auf Whatsapp, Lieblingsfilm auf Youtube.

• Das Internet als *Kommunikationsmedium* ermöglicht die Aufrechterhaltung und Weiterentwicklung eigener Heimat(en) und die Entstehung neuer. Beispielsweise durch Videocalls mit alten Freund*innen, Interaktionen in der eigenen Fandom-Community, Besuch des Lieblingsnachrichtenportals, Lesen der Posts der eigenen Diaspora-Community auf Facebook, Live-Schaltung auf Instagram, Veröffentlichung eines Videos auf TikTok.

Heimat wird also *postdigital* geschaffen, erlebt und ausgelebt. Allerdings: Egal wie wichtig die Einführung der Pluralform von Heimat war (vgl. Conti 2012: 157), scheint diese Vorstellung – eine Person: mehrere Heimaten – heute doch nicht mehr stimmig: Diese orientiert sich sehr an einem territorialen Verständnis vom Raum, in dem man getrennte Heimatprojekte haben und bauen kann. In der postdigitalen Zeit ist die räumliche Trennung nicht mehr gegeben, Elemente der bis dato unterschiedlichen Heimaten sind viel schneller greifbar als zuvor, egal wo man sich befindet. Im postdigitalen Zeitalter ist das Tempo der Begegnung mit Menschen und Dingen, die resonieren oder resonieren könnten, potenziell *rasch*, was gelegentlich zu Überlappungen und Hybridisierungen führt. Die Zeit im Lockdown während der Covid-19-Pandemie hat das offengelegt: von zu Hause, ‚aus dem stillen Kämmerlein‘, wurde Heimat erlebt und Beheimatungsprozesse wurden täglich vorangetrieben. Da wurden z. B. Freundschaften per WhatsApp und Signal gepflegt, neuen Telegramgruppen beigetreten, ein neues kollektives Profil mit Mitstreiter*innen auf Instagram gemacht, Filme per Streaming gemeinsam angeschaut, Online-Konferenzen besucht, Sportgruppen über Twitch zusammengebracht, an Online-Benefizkonzert teilgenommen, Pizza von der Lieblingspizzeria online bestellt.

All diese physischen/digitalen Orte, all die Menschen, Tiere, Pflanzen, Rezepte, all die Gegenstände, Lieder, Gerüche, Memes, Plattformen und noch sonst alles anderes, wie auch besondere Wörter und Sprüche: All das, was einen das Heimatgefühl spüren lässt, ist Teil der eigenen Heimat. Heimat kann also als *Netzwerk* imaginiert werden: seine Knoten sind jene Lebewesen, Dinge und Orte, die das „Heimatgefühl" entstehen

lassen, sobald dort angedockt wird – egal ob mit oder ohne technologische Vermittlung. Die Kanten, die Verbindungen, sind Rosas Resonanzerfahrungen, also die Beziehungen, die schillernden Begegnungen, die zur Erinnerung, Aufrechterhaltung oder Erweiterung des eigenen vertrauten Raums der Geborgenheit führen.

Diesem theoretischen Modell, Heimat als Netzwerk, liegt die Definition von Heimat als vertrautem intersubjektivem Raum der Geborgenheit zugrunde und überlässt die Definition, was dazu gehört und was nicht, dem subjektiven Empfinden der Einzelnen. Auf dieser Grundlage versucht das Modell die zwei historisch gewachsenen Perspektiven auf Heimat zu verbinden und ihre Spannung aufzulösen: Einerseits – im Einklang mit der offenen, zukunftsorientierten Perspektive – stellt es Heimat als eine alltägliche und lebenslange Praxis dar. Wie breit bzw. wie dicht der vertraute Raum der Geborgenheit der einzelnen Menschen ist, hängt von der Offenheit des Einzelnen gegenüber der Umwelt und der Umwelt gegenüber dem Einzelnen ab. Andererseits, indem es Heimat als etwas Konkretes, Individuelles anerkennt, normiert es nicht, was sich als Heimat anfühlen kann oder nicht. Die imaginierte Idylle der Vergangenheit kann genauso Teil des Netzwerks sein wie die Fandom-Online-Community.

4. Ausblick

Abschließen möchte ich meinen Beitrag mit einigen Reflexionen über die Vorteile, die die Anwendung dieses Modells von Heimat im Bereich der Interkulturellen Kommunikation und Pädagogik mit sich bringt.

Das Modell *Heimat als Netzwerk* ermöglicht es, die Komplexität der Realität zu visualisieren. Dabei steht die Relationalität zwischen Lebewesen, Orten und Dingen im Mittelpunkt. Das Netzwerk ermöglicht es, die plurale und dynamische Identität der Menschen abzubilden sowie die Hybridität und Veränderlichkeit kultureller Räume zu dokumentieren. Wenn das starre Kategoriendenken überwunden wird, stehen die Türen für die Entfaltung einer kohäsiven Gesellschaft offen.

Ein weiterer Vorteil dieses Modells ist, dass es zeigt, wie wichtig es für alle Menschen ist, Vertrautheit, Sicherheit und Geborgenheit zu spüren. Gleichzeitig hebt es hervor, dass die Engmaschigkeit des eigenen Heimatnetzwerks auch von unserem Willen und der Fähigkeit abhängt, das

Miteinander mit anderen zu gestalten. Dadurch wird eine offene, inklusive Haltung gefördert.

Heimat als Netzwerk zu verstehen und Identitäten und Kulturen als hybrid und veränderlich zu erkennen, kann Pädagog*innen helfen, allen Kindern, Jugendlichen und Erwachsenen gleich offen gegenüberzustehen und eine Kultur des Dialogs zu vertreten und somit zu verbreiten.[13] Insbesondere jungen Menschen ein solches Verständnis von Heimat zu vermitteln, heißt erstens, sie gegen vergangenheitsbezogene, geschlossene, territoriale Heimatverständnisse zu immunisieren, zweitens heißt es, ihre vielfältige Identität und die Vielfalt ihrer Lebenswelt explizit zu erkennen und anzuerkennen. Drittens macht es sie neugierig, mehr über ihre Umwelt zu erfahren, sie besser zu verstehen, sie sich anzueignen und dadurch vertrauter zu machen. Viertens stimuliert eine solche Vision die Möglichkeit, ein echtes Miteinander mit anderen aufzubauen. Zusammenfassend kann es als pädagogisches Instrument und Leitmotiv fungieren, damit Kinder und Jugendliche zu verantwortungsvollen, aktiven und wertschätzenden Mitgliedern der postdigitalen und pluralen Gesellschaft heranwachsen.

Bibliografie

Abel, Günter, 1999: *Sprache, Zeichen, Interpretation.* Frankfurt am Main: Suhrkamp.

Anderson, Benedict, 1983/1991: *Imagined Communities: Reflections on the Origin and Spread of Nationalism.* Revised and Enlarged edition. London/New York: Verso.

Arendt, Hannah, 1958/1962: *The Origins of Totalitarianism,* 7. Aufl. The World Publishing Company: Cleveland/New York, retrieved 22.02.2023 from https://cheirif.files.wordpress.com/2014/08/hannah-arendt-the-origins-of-totalitarianism-meridian-1962.pdf.

Arendt, Hannah, 1994: *Über die Revolution,* 4. Aufl. München/Zürich: Piper.

Bauman, Zygmunt, 2017: *Retropia.* Berlin: Suhrkamp.

13 Diese Haltung und die damit einhergehenden Kompetenzen will das EU-Innovationsprojekt KIDS4ALLL für Kinder, Jugendliche und junge Erwachsene sowie für Lehrende und Sozialpädagog*innen mit seiner offen zugänglichen E-Learning-Plattform https://learn.kids4alll.eu/.

Beck, Ulrich, 1997: *Was ist Globalisierung. Irrtümer des Globalismus – Antworten auf Globalisierung*. Frankfurt a.M.: Suhrkamp.

Biskamp, Julian/Lietz, Roman, 2022: „Falcon als Schwarzer Captain America – Diskussionen über Repräsentation und (Cyber-)Rassismus im Marvel-Universum". *Interculture Journal* 21(36), 85–106 retrieved 24.1.2024 from https://zs.thulb.uni-jena.de/receive/jportal_jp article_01266018.

Blommaert, Jan, 2018: *Durkheim and the Internet. On Sociolinguistics and the Sociological Imagination*. London: Bloomsbury Academic. DOI https://doi.org/10.5040/9781350055223.

Bolten, Jürgen, 2007: *Interkulturelle Kompetenz*. Erfurt: Landeszentrale für politische Bildung, Thüringen, retrieved 10.3.2023 from https://www.db-thueringen.de/servlets/MCRFileNodeServlet/dbt_derivate_00020394/interkulturellekompetenz.pdf

Bolten, Jürgen, 2018: *Einführung in die Interkulturelle Wirtschaftskommunikation*, 3. Aufl. Göttingen: UTB.

Bolten, Jürgen/Berhault, Mathilde, 2018: „VUCA-World, virtuelle Teamarbeit und interkulturelle Zusammenarbeit." In: Helmolt, Katharina von/Ittstein, Daniel Jan (Hrsg.): *Digitalisierung und (Inter-)Kulturalität. Formen, Wirkung und Wandel von Kultur in der digitalisierten Welt*. Stuttgart: ibidem., 105–132.

Cicero, Marco Tullius, 45-44 v.Chr.: „Tusculanae Disputationes", retrieved 10.3.2023 from https://la.wikisource.org/wiki/Tusculan%C3%A6_Di sputationes.

Conti, Luisa, 2012: *Interkultureller Dialog im virtuellen Zeitalter. Neue Perspektiven für Theorie und Praxis*. Berlin/Münster: LIT Verlag.

Conti, Luisa/Szabó, Orsolya, , 2024: „Digital – Glocal – Social: A Learning Environment Targeting both Teachers and Students in Order to Promote Social Inclusion". In: Braselmann, Silke/Eibensteiner, Lukas/Volkmann, Lorenz (Hrsg.): *Teacher Education in (Post-)Pandemic Times*. Frankfurt am Main: Peter Lang.

Costadura, Edoardo/Ries, Klaus/Wiesenfeldt, Christiane (Hrsg.), 2019: *Heimat global. Modelle, Praxen und Medien der Heimatkonstruktion*. Bielefeld: transcript. DOI https://doi.org/10.14361/9783839445884.

Cramer, Florian, 2014: „What is 'Post-Digital'?". APRJA 3(1), 11–24, retrieved 01.12.2022 from http://lab404.com/142/cramer.pdf.

Dausacker, Alena, 2015: *Medien als Heimat*. (Masterarbeit) Bochum: Ruhr-Universität Bochum, retrieved 10.04.2022 from https://dausac ker.net/sites/default/files/texte/alena_dausacker_-_medien_als_hei mat.pdf.

Die Bundeswahlleiterin, 2017: Bundestagswahl 2017: „Endgültiges Ergebnis". Pressemitteilung Nr. 34/17 vom 12. Oktober 2017, retrieved 30.11.2022 from https://www.bundeswahlleiter.de/info/presse/mitte ilungen/bundestagswahl-2017/34_17_endgueltiges_ergebnis.html.

Digitales Wörterbuch der deutschen Sprache (DWDS), 2023: „DWDS-Wortverlaufskurve für ‚Heimat' ", retrieved 3.3.2023 from https://www.dwds.de/r/plot/?q=Heimat.

Eckardt, Frank, 2019: „Heimat ohne Tamtam. Ortsgebundenheit und Fernweh in der Kleinestadt". In: Costadura, Edoardo/Ries, Klaus/Wiesenfeldt, Christiane (Hrsg.): *Heimat global. Modelle, Praxen und Medien der Heimatkonstruktion*. Bielefeld: Transcript, 197–218. DOI https://doi.org/10.14361/9783839445884-011.

Eco, Umberto, 1992: *Die Grenzen der Interpretation*. München: Carl Hanser Verlag.

faz.net, 2018: #MeTwo gegen Alltagsrassismus. „Solche wie dich hat mein Opa früher erschossen". *Frankfurter Allgemeine Zeitung*, aktualisiert am 27.07.2018, 12:01, retrieved 10.3.2023 from https://www.faz.net/ aktuell/gesellschaft/menschen/metwo-macht-bei-twitter-auf-rassis mus-im-alltag-aufmerksam-15710604.html.

Förster, Jürgen, 2009: „Das Recht auf Rechte und das Engagement für eine gemeinsame Welt. Hannah Arendts Reflexionen über die Menschenrechte". *Zeitschrift für politisches Denken* 1(5), retrieved 10.3.2023 from https://www.hannaharendt.net/index.php/han/article/ view/146/258.

Greverus, Ina-Maria, 1979: *Auf der Suche nach Heimat*. München: Beck'-sche Verlagsbuchhandlung.

Habermas, Jürgen, 1981: *Theorie des kommunikativen Handelns*, Bd. 1, Handlungsrationalität und gesellschaftliche Rationalisierung. Frankfurt am Main: Suhrkamp.

Handschuh, Gerhard, 1990: „Brauchtum – Zwischen Veränderung und Tradition". In: Bundeszentrale für politische Bildung (Hrsg.): *Heimat*. Bonn: Bundeszentrale für Politische Bildung, 633–674.

Harnisch, Christian Wilhelm, 1816: „Leitfaden beim Unterricht in der Weltkunde". *Der Schulrath an der Oder*, 8. Lieferung, 27–63, darin ‚Kunde der Heimat', 38–63.

Harnisch, Wilhelm, 1827: *Die Weltkunde: ein Leitfaden bei dem Unterricht in der Erd-, Miner-, Stoff-, Pflanzen-, Thier-, Menschen-, Völker-, Staaten- und Geschichtskunde.* Teil 1. 4. Aufl., Breslau: Graß, Barth & Comp.

Heringer, Hans Jürgen, 2017: *Interkulturelle Kommunikation*, 5. Aufl., Tübingen: A. Francke Verlag. DOI https://doi.org/10.36198/978383 8548159.

Ignatieff, Michael, 2002: *Die Politik der Menschenrechte*. Hamburg: EVA Europäische Verlagsanstalt.

Jurgenson, Nathan, 2011: *Digital Dualism versus Augmented Reality.* Cyborgology, 24.02.2011, retrieved 5.12.2022 from https://thesocie typages.org/cyborgology/2011/02/24/digital-dualism-versus-augmen ted-reality/.

Laërtius, Diogenes/Yonge, Charles D., [1853]1915: *The Lives and Opinions of Eminent Philosophers*. London: G. Bell and Sons, retrieved 5.12.2022 from https://www.gutenberg.org/files/57342/57342-h/57342-h.htm# Page_224.

López García, Yolanda, 2022: „Exploring Narratives of Hate and Solidarity on Social Media: The Case of Yalitza Aparicio". *Interculture Journal* 21(36), 107–127, retrieved 10.3.2023 from https://zs.thulb.uni-jena.de/servlets/MCRFileNodeServlet/jportal_derivate_00330660/IJ_2022_36_107_127.pdf.

Meetz, Markus/Seeßlen, Georg, 2019: „Heimat – der offene Begriff." *Deutschlandfunk*, 03.10.2019, retrieved 1.12.2022 from https://www.deutschlandfunk.de/heimat-als-utopie-heimat-der-offene-begr iff-100.html.

Mitzscherlich, Beate, 2019: „Heimat als subjektive Konstruktion. Beheimatung als aktiver Prozess". In: Costadura, Edoardo/Ries, Klaus/Wiesenfeldt, Christiane (Hrsg.): *Heimat global. Modelle, Praxen und Medien der Heimatkonstruktion*. Bielefeld: Transcript, 183–196. DOI https://doi.org/10.14361/9783839445884-010.

Müller, Winfried/Steber, Martina, 2018: „‚Heimat'. Region und Identitätskonstruktionen im 19. und 20. Jahrhundert: Sachsen/Bayerisches

Schwaben". In: Freitag, Werner/Kißener, Michael/Reinle, Christine/Ullmann, Sabine (Hrsg.): *Handbuch Landesgeschichte*. Berlin: De Gruyter Oldenbourg, 646–677. DOI https://doi.org/10.1515/978311 0354188-022.

Negroponte, Nicholas, 1998: „Beyond Digital". *Wired Columns* 6(12), retrieved 10.4.2022 from http://web.media.mit.edu/~nicholas/Wired/WIRED6-12.html.

Peirce, Charles S., 1993: *Semiotische Schriften*. Bd. 3: 1906–1913, hrsg. und übers. von Christian Kloesel und Helmut Pape. Frankfurt a.M.: Suhrkamp.

Pintos, Juan Luis, 2005: „Comunicación, construcción de la realidad e imaginarios sociales". *Utopía y Praxis Latinoamericana* 10(29), 37–65, retrieved 12.3.2023 from https://www.redalyc.org/pdf/279/27910 293.pdf.

Reimann, Gregor/Seher, Sophie/Wermke, Michael, 2019: „Die Schule ‚pflegt die Verbundenheit mit der Heimat in Thüringen und in Deutschland' ". In: Costadura, Edoardo/Ries, Klaus/Wiesenfeldt, Christiane (Hrsg.): *Heimat global. Modelle, Praxen und Medien der Heimatkonstruktion*. Bielefeld: Transcript, 237–280. DOI https://doi.org/10.1515/9783839445884-013.

Reiser, Marion/Best, Heinrich/Salheiser, Axel/Vogel, Lars, 2018: „Heimat Thüringen. Ergebnisse des Thüringen-Monitors 2018." Friedrich-Schiller-Universität Jena/KomRex – Zentrum für Rechtsextremismusforschung, Demokratiebildung und gesellschaftliche Integration, retrieved 10.4.2022 from https://www.komrex.uni-jena.de/komrexme dia/literatur/thueringen-monitor-2018-mit-anhang.pdf.

Rosa, Hartmut, 2019: „Heimat als anverwandelter Weltausschnitt. Ein resonanztheoretischer Versuch". In: Costadura, Edoardo/Ries, Klaus/Wiesenfeldt, Christiane (Hrsg.): *Heimat global. Modelle, Praxen und Medien der Heimatkonstruktion*. Bielefeld: Transcript, 153–172. DOI https://doi.org/10.1515/9783839445884-008.

Schmoll, Friedemann, 2016: „Orte und Zeiten, Innenwelten, Aussenwelten. Konjunkturen und Reprisen des Heimatlichen". In: Costadura, Edoardo/Ries, Klaus (Hrsg.): *Heimat gestern und heute: Interdisziplinäre Perspektiven*. Bielefeld: Transcript, 25–50. DOI https://doi.org/10.1515/9783839435243-002.

Schuppener, Georg, 2021: „Heimat-Lexik und Heimat-Diskurse in AfD-Wahlprogrammen". *Revista de Filología Alemana* 29, 131–151, retrieved 10.3.2021 from https://revistas.ucm.es/index.php/RFAL/arti cle/download/78406/4564456559071/.

Schütz, Alfred/Luckmann, Thomas, 2003: „Die Lebenswelt als unbefragter Boden der natürlichen Weltanschauung". In: Bolten, Jürgen/Ehrhardt, Claus (Hrsg.): *Interkulturelle Kommunikation*. Sternenfels: Wissenschaft & Praxis, 43–58.

Seifert, Manfred, 2021: „Heimat. Online-Lexikon zur Kultur und Geschichte der Deutschen im östlichen Europa" retrieved 10.4.2022 from http://ome-lexikon.uni-oldenburg.de/p42287.

Steinmeier, Frank-Walter (2020): „Rede von Bundespräsident Dr. Frank-Walter Steinmeier bei einem Heimatabend mit Beiträgen aus Musik, Literatur, Theater und Film am 6. Februar 2020 in Berlin." *Bulletin Nr. 18-3*, 06.02.2020, Berlin: Presse- und Informationsamt der Bundesregierung, retrieved 30.11.2022 from https://www.bundesregier ung.de/breg-de/service/bulletin/rede-von-bundespraesident-dr-frank-walter-steinmeier-1720560.

Thüringer Ministerium für Bildung, Jugend und Sport, 2015: *Lehrplan für die Grundschule und für die Förderschule mit dem Bildungsgang Grundschule. Heimat- und Sachkunde.* Erfurt: Thüringer Ministerium für Bildung, Jugend und Sport, retrieved 23.2.2023 from https:// www.schulportal-thueringen.de/tip/resources/medien/13947?datein ame=lp_HSK_2015.pdf.

Ulbricht, Justus H., 2019: „Heimat ohne Ausländer! Sächsische Impressionen und nachdenkliche Reflexionen zum Konnex von Lokalpatriotismus, Populismus und Fremdenangst". In: Costadura, Edoardo/Ries, Klaus/Wiesenfeldt, Christiane (Hrsg.): *Heimat global. Modelle, Praxen und Medien der Heimatkonstruktion*. Bielefeld: Transcript, 133–149. DOI 10.1515/9783839445884-007.

Wasserloos, Yvonne, 2019: „‚Heimat bewahren'. Inszenierung und Verklanglichung des rechtsextremen Heimatbegriffs durch Monumentalästhetik". In: Costadura, Edoardo/Ries, Klaus/Wiesenfeldt, Christiane (Hrsg.): *Heimat global. Modelle, Praxen und Medien der Heimatkonstruktion*. Bielefeld: Transcript, 355–377. DOI https:// doiorg/10.1515/9783839445884-018.

Autorenbiografien

Luisa Conti hat am Lehrstuhl für Interkulturelle Pädagogik der Universität Padua und am Fachbereich Interkulturelle Wirtschaftskommunikation der Friedrich-Schiller-Universität Jena promoviert, wo sie 2022 ihre Habilitation mit Venia Legendi in Interkultureller Kommunikation und Interkultureller Pädagogik erfolgreich abgeschlossen hat. In ihren Forschungsprojekten (u. a. ReDICo, KIDS4ALLL, SHARMED) untersucht sie Exklusionsmechanismen und experimentiert Inklusionsstrategien.

Luisa Conti received a PhD in Education at the University of Padua and Intercultural Communication at the Department of Intercultural Business Communication at the University of Jena, where she successfully completed her Habilitation with Venia Legendi in Intercultural Communication and Intercultural Education. In her research projects (among others ReDICo, KIDS4ALLL, SHARMED) she investigates exclusionary mechanisms and experiments with inclusive strategies.

Adriana Fernandes Barbosa hat Anglistik und Germanistik an der Bundesuniversität von Minas Gerais, Brasilien, studiert. 2020 wurde sie an derselben Universität in Angewandter Linguistik promoviert. Derzeit ist sie Juniorprofessorin für deutsche Sprache an der Universität von Brasília, Brasilien. Ihre Forschungsinteressen liegen in den Bereichen Lehren und Lernen von Fremdsprachen sowie Multimodalität in Face-to-Face- und Online-Interaktionen an der Schnittstelle von kognitiver Linguistik, sozialer Semiotik und Gestenforschung.

Adriana Fernandes Barbosa studied English and German Languages and Literatures at the Federal University of Minas Gerais. Since 2020 she holds a PhD in Applied Linguistics from the same university. She is currently Assistant Professor of German Language at the University of Brasília. Her research interests are the teaching and learning of foreign languages and the multimodality in face-to-face as well as online interactions at the interface of Cognitive Linguistics, Social Semiotics and Gesture Studies.

Annalena Kolloch ist Anthropologin an der Universität Mainz. Ihre Forschungsinteressen politische Anthropologie, Polizeiarbeit und die Gestaltung von kulturellen Unterschieden.

Annalena Kolloch is an anthropoligist at Mainz University. Her research interests include political anthropology, policing, and the construction of cultural differences.

Beatrix Kreß wurde 2007 in Slawistik/Synchroner Sprachwissenschaft mit einer pragmalinguistischen Arbeit zur Konfliktkommunikation im Russischen und Tschechischen promoviert. Von 2009 bis 2013 war sie Juniorprofessorin für Interkulturelle Kommunikation in slawischen Ländern an der Universität Hildesheim, seit 2014 ist sie Professorin für Interkulturelle Kommunikation ebenda. Sie forscht zu Kommunikation in (politischen) Institutionen, Interkultureller Kommunikation, Mehrsprachigkeit und Herkunftssprachen.

Beatrix Kreß received her PhD in Slavic Studies/Synchronous Linguistics in 2007 with a pragmalinguistic thesis on conflict communication in Russian and Czech. From 2009 to 2013, she was a junior professor for intercultural communication in Slavic countries at the University of Hildesheim, and since 2014 she has been a professor for intercultural communication there. She researches communication in (political) institutions, intercultural communication, multilingualism and heritage languages.

Fergal Lenehan studierte am University College Dublin, promovierte in Kulturwissenschaften an der Universität Leipzig und habilitierte sich in Interkulturellen Studien in Jena. Er hat zahlreiche Publikationen zur europäischen Idee, zu deutschen Irlandbildern und theoretische und empirische Veröffentlichungen zur Schnittfläche von digitalen Studien und Interkulturalität vorgelegt. Er ist wissenschaftlicher Mitarbeiter im ReDICo-Projekt (Researching Digital Interculturality Co-operatively) an der Universität Jena.

Fergal Lenehan studied at University College Dublin, received a PhD in Cultural Studies from the University of Leipzig and completed Habilitation in Intercultural Studies in Jena. He has published widely on the European idea, German images of Ireland and the theoretical and empirical

meeting of digital studies and interculturality. He is a researcher in the ReDICo project (Researching Digital Interculturality Co-operatively) at the University of Jena.

Roman Lietz hat Romanistik und Interkulturelle Wirtschaftskommunikation an der Universität Jena studiert und wurde dort 2017 mit einer Arbeit über Integrationslotsen promoviert. Seit 2020 ist er wissenschaftlicher Mitarbeiter im ReDICo-Projekt (Researching Digital Interculturality Co-operatively) an der Universität Mainz. Seine Interessen liegen im Bereich Interkulturelle Kommunikation, Teilhabe, Identifikation (in online und offline Kontexten).

Roman Lietz studied Romance Languages and Intercultural Business Communication at the University of Jena and got his PhD there in 2017 with a study about "Integration Assistants". Since 2020 he is researcher in the ReDICo project (Researching Digital Interculturality Co-operatively) at the University of Mainz. His interests are in intercultural communication, participation and identification (in online and offline contexts).

Yarong Liu studierte TESOL (Teaching English to Speakers of Other Languages) und Kulturwissenschaften im Master an der Technischen Universität Chemnitz. Seit 2021 promoviert sie an der TU Chemnitz im Bereich interkultureller kommunikativer Kompetenz (ICC) im Englischunterricht. Ihre Forschungsinteressen sind interkulturelles Lernen, Englisch als Lingua Franca, Curriculumentwicklung und Tandemlernen.

Yarong Liu studied TESOL (Teaching English to Speakers of Other Languages) and cultural studies for her master's degree at Chemnitz University of Technology. Since 2021, she has been pursuing a PhD with a focus on intercultural communicative competence (ICC) in English language teaching (ELT). Her research interests are intercultural learning, English as a lingua franca, curriculum design, and tandem learning.

Milene Mendes de Oliveira wurde an der Universität Potsdam in Angewandter Linguistik promoviert und ist derzeit ebendort Wissenschaftlerin im ReDICo-Projekt (Researching Digital Interculturality Co-operatively). Ihre Forschungsinteressen liegen in den Bereichen (digitale) interkulturelle Kommunikation, Englisch als Lingua franca, soziale Interaktion, interkulturelle Pragmatik und Kommunikation am Arbeitsplatz.

Milene Mendes de Oliveira holds a PhD in Applied Linguistics from the University of Potsdam and is currently a researcher in the ReDICo project (Researching Digital Interculturality Co-operatively) at the same university. Her research interests are (digital) intercultural communication, English as a lingua franca, social interaction, intercultural pragmatics, and workplace communication.

Bernd Meyer ist Sprachwissenschaftler und Professor für Interkulturelle Kommunikation an der Johannes Gutenberg-Universität Mainz. Sein Forschungsinteresse gilt der linguistischen Analyse von mehrsprachiger Kommunikation in öffentlichen Einrichtungen und insbesondere dem Community Interpreting.

Bernd Meyer is a linguist by training and Professor of Intercultural Communication at Mainz University. His research interests include linguistic approaches to multilingual communication in public service institutions and, more specifically, community interpreting.

Jennifer Schluer ist Juniorprofessorin für Englische Fachdidaktik (Teaching English to Speakers of Other Languages, TESOL/Advanced Academic English) an der Technischen Universität Chemnitz. Sie promovierte in Angewandter Linguistik mit einer Studie zum Leseverstehen in Englisch als Fremdsprache. Ihre Forschungsinteressen im Bereich der Lehrkräftebildung sind digitaler Unterricht und digitale Feedbackmethoden sowie Sprachbewusstheit, Mehrsprachigkeit und kulturelles Lernen.

Jennifer Schluer is an Assistant Professor for TESOL (Teaching English to Speakers of Other Languages)/Advanced Academic English at Chemnitz University of Technology, Germany. She obtained her PhD in Applied Linguistics by studying reading comprehension in English as a foreign language. Her main specializations in the field of English language teacher education are digital teaching and digital feedback methods as well as language awareness, multilingualism and culture learning.

Tilman Schröder studierte Philologie und BWL an den Universitäten Mannheim und Buenos Aires und wurde 2012 an der Universität Mannheim promoviert. Nach beruflichen Stationen in Touristik und Wissenschaft wurde er 2017 als Professor für Wirtschaftskommunikation und

Interkulturelle Kompetenz an die Fakultät für Tourismus der Hochschule München berufen. Er forscht zu Sprache und Kultur im Tourismus, zum Sprachgebrauch in digitalen Medien und zur kontrastiven Medienlinguistik.

Tilman Schröder studied Philology and Business Administration at the University of Mannheim and the University of Buenos Aires. He received his PhD from the University of Mannheim in 2012 and has worked in the tourism industry and in academia. Since 2017 he is professor for Business Communication and Intercultural Competence at the Department of Tourism of Hochschule München. His research focuses on language and culture in tourism, language use in digital media, and contrastive linguistics.

Forum Angewandte Linguistik – F.A.L.

Publikationsreihe der Gesellschaft für Angewandte Linguistik (GAL)

Die Bände 1–17 dieser Reihe sind im Gunter Narr Verlag, Tübingen, erschienen.

Band	18	Bernd Spillner (Hrsg.): Sprache und Politik. Kongreßbeiträge zur 19. Jahrestagung der Gesellschaft für Angewandte Linguistik GAL e.V. 1990.
Band	19	Claus Gnutzmann (Hrsg.): Kontrastive Linguistik. 1990.
Band	20	Wolfgang Kühlwein, Albert Raasch (Hrsg.): Angewandte Linguistik heute. Zu einem Jubiläum der Gesellschaft für Angewandte Linguistik. 1990.
Band	21	Bernd Spillner (Hrsg.): Interkulturelle Kommunikation. Kongreßbeiträge zur 20. Jahrestagung der Gesellschaft für Angewandte Linguistik GAL e.V. 1990.
Band	22	Klaus J. Mattheier (Hrsg.): Ein Europa – Viele Sprachen. Kongreßbeiträge zur 21. Jahrestagung der Gesellschaft für Angewandte Linguistik GAL e. V. 1991.
Band	23	Bernd Spillner (Hrsg.): Wirtschaft und Sprache. Kongreßbeiträge zur 22. Jahrestagung der Gesellschaft für Angewandte Linguistik GAL e.V. 1992.
Band	24	Konrad Ehlich (Hrsg.): Diskursanalyse in Europa. 1994.
Band	25	Winfried Lenders (Hrsg.): Computereinsatz in der Angewandten Linguistik. 1993.
Band	26	Bernd Spillner (Hrsg.): Nachbarsprachen in Europa. Kongreßbeiträge zur 23. Jahrestagung der Gesellschaft für Angewandte Linguistik GAL e.V. 1994.
Band	27	Bernd Spillner (Hrsg.): Fachkommunikation. Kongreßbeiträge zur 24. Jahrestagung der Gesellschaft für Angewandte Linguistik GAL e.V. 1994.
Band	28	Bernd Spillner (Hrsg.): Sprache: Verstehen und Verständlichkeit. Kongreßbeiträge zur 25. Jahrestagung der Gesellschaft für Angewandte Linguistik. GAL e.V. 1995.
Band	29	Ernest W.B. Hess-Lüttich, Werner Holly, Ulrich Püschel (Hrsg.): Textstrukturen im Medienwandel. 1996.
Band	30	Bernd Rüschoff, Ulrich Schmitz (Hrsg.): Kommunikation und Lernen mit alten und neuen Medien. Beiträge zum Rahmenthema "Schlagwort Kommunikationsgesellschaft" der 26. Jahrestagung der Gesellschaft für Angewandte Linguistik GAL e.V. 1996.
Band	31	Dietrich Eggers (Hrsg.): Sprachandragogik. 1997.
Band	32	Klaus J. Mattheier (Hrsg.): Norm und Variation. 1997.
Band	33	Margot Heinemann (Hrsg.): Sprachliche und soziale Stereotype. 1998.
Band	34	Hans Strohner, Lorenz Sichelschmidt, Martina Hielscher (Hrsg.): Medium Sprache. 1998.
Band	35	Burkhard Schaeder (Hrsg.): Neuregelung der deutschen Rechtschreibung. Beiträge zu ihrer Geschichte, Diskussion und Umsetzung. 1999.
Band	36	Axel Satzger (Hrsg.): Sprache und Technik. 1999.
Band	37	Michael Becker-Mrotzek, Gisela Brünner, Hermann Cölfen (Hrsg.), unter Mitarbeit von Annette Lepschy: Linguistische Berufe. Ein Ratgeber zu aktuellen linguistischen Berufsfeldern. 2000.
Band	38	Horst Dieter Schlosser (Hrsg.): Sprache und Kultur. 2000.
Band	39	John A. Bateman, Wolfgang Wildgen (Hrsg.): Sprachbewusstheit im schulischen und sozialen Kontext. 2002.

Band 40 Ulla Fix / Kirsten Adamzik / Gerd Antos / Michael Klemm (Hrsg.): Brauchen wir einen neuen Textbegriff? Antworten auf eine Preisfrage. 2002.

Band 41 Rudolf Emons (Hrsg.): Sprache transdisziplinär. 2003.

Band 42 Stephan Habscheid / Ulla Fix (Hrsg.): Gruppenstile. Zur sprachlichen Inszenierung sozialer Zugehörigkeit. 2003.

Band 43 Michael Becker-Mrotzek / Gisela Brünner (Hrsg.): Analyse und Vermittlung von Gesprächskompetenz. 2004. 2. durchgesehene Auflage. 2009.

Band 44 Britta Hufeisen / Nicole Marx (Hrsg.): *Beim Schwedischlernen sind Englisch und Deutsch ganz hilfsvoll.* Untersuchungen zum multiplen Sprachenlernen. 2004.

Band 45 Helmuth Feilke / Regula Schmidlin (Hrsg.): Literale Textentwicklung. Untersuchungen zum Erwerb von Textkompetenz. 2005.

Band 46 Sabine Braun / Kurt Kohn (Hrsg.): Sprache(n) in der Wissensgesellschaft. Proceedings der 34. Jahrestagung der Gesellschaft für Angewandte Linguistik. 2005.

Band 47 Dieter Wolff (Hrsg.): Mehrsprachige Individuen – vielsprachige Gesellschaften. 2006.

Band 48 Shinichi Kameyama / Bernd Meyer (Hrsg.): Mehrsprachigkeit am Arbeitsplatz. 2006.

Band 49 Susanne Niemeier / Hajo Diekmannshenke (Hrsg.): Profession & Kommunikation. 2008.

Band 50 Friedrich Lenz (Hrsg.): Schlüsselqualifikation Sprache. Anforderungen – Standards – Vermittlung. 2009.

Band 51 Andreas Krafft / Carmen Spiegel (Hrsg.): Sprachliche Förderung und Weiterbildung – transdisziplinär. 2011.

Band 52 Helmuth Feilke / Katrin Lehnen (Hrsg.): Schreib- und Textroutinen. Theorie, Erwerb und didaktisch-mediale Modellierung. 2012.

Band 53 Iris Rautenberg / Tilo Reißig (Hrsg.): Lesen und Lesedidaktik aus linguistischer Perspektive. 2015.

Band 54 Bernd Rüschoff / Julian Sudhoff / Dieter Wolff (Hrsg.): CLIL Revisited. Eine kritische Analyse zum gegenwärtigen Stand des bilingualen Sachfachunterrichts. 2015.

Band 55 Alexandra Groß / Inga Harren (Hrsg.): Wissen in institutioneller Interaktion. 2016.

Band 56 Susanne Göpferich / Imke Neumann (eds.): Developing and Assessing Academic and Professional Writing Skills. 2016.

Band 57 Anja Steinlen / Thorsten Piske (Hrsg.): Wortschatzlernen in bilingualen Schulen und Kindertagesstätten. 2016.

Band 58 Rolf Kreyer / Steffen Schaub / Barbara Ann Güldenring (Hrsg.): Angewandte Linguistik in Schule und Hochschule. Neue Wege für Sprachunterricht und Ausbildung. 2016.

Band 59 Christian Ludwig / Kris Van de Poel (eds): Collaborative Learning and New Media. New Insights into an Evolving Field. 2017.

Band 60 Ina Pick (Hrsg.): Beraten in Interaktion. Eine gesprächslinguistische Typologie des Beratens. 2017.

Band 61 Saskia Kersten / Monika Reif (Hrsg.): Neuere Entwicklungen in der angewandten Grammatikforschung. Korpora – Erwerb – Schnittstellen. 2017.

Band 62 Britta Hufeisen / Dagmar Knorr / Peter Rosenberg / Christoph Schroeder / Aldona Sopata / Tomasz Wicherkiewicz (Hrsg.): Sprachbildung und Sprachkontakt im deutsch-polnischen Kontext. Unter Mitarbeit von Barbara Stolarczyk. 2018.

www.peterlang.com